£25·00

TS2

£15·00

SALE

£5—

SALE

Dreams of
an English Eden:
RUSKIN AND HIS TRADITION
IN SOCIAL CRITICISM

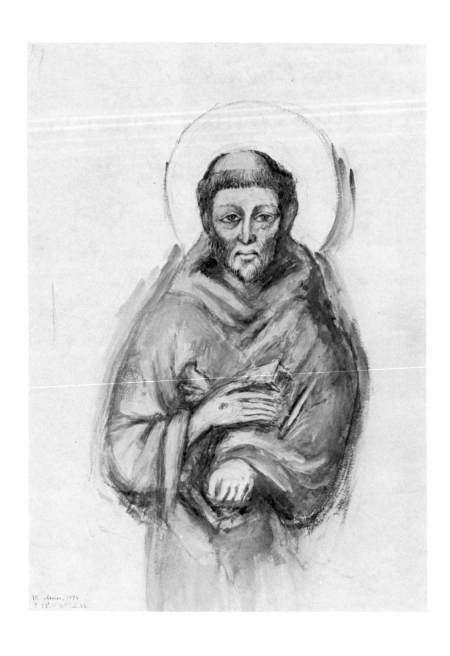

Dreams of
an English Eden:
RUSKIN AND HIS TRADITION
IN SOCIAL CRITICISM

Jeffrey L. Spear

Columbia University Press / New York
1984

Library of Congress Cataloging in Publication Data

Spear, Jeffrey L.
 Dreams of an English Eden.

 Bibliography: p.
 Includes index.
 1. Ruskin, John, 1819-1900--Political and social
views. 2. Carlyle, Thomas, 1795-1881--Influence--Ruskin.
3. Carlyle, Thomas, 1795-1881--Political and social
views. 4. Ruskin, John, 1819-1900--Influence--Morris.
5. Morris, William, 1834-1896--Political and social
views. 6. Social ethics in literature. 7. Great
Britain--Social conditions--19th century. I. Title.
PR5267.P6S65 1984 820'.9'008 84-5879
ISBN 0-231-05536-6 (alk. paper)
ISBN 0-231-05537-4 (pbk. : alk. paper)

Columbia University Press gratefully acknowledges
assistance from Princeton University that made
publication of this book possible.

Columbia University Press
New York Guildford, Surrey
Copyright © 1984 Columbia University Press
All rights reserved

Printed in the United States of America

Clothbound editions of Columbia University Press books
are Smyth-sewn and printed on permanent
and durable acid-free paper

For Abe and Sonia Spear

Table of Contents

Illustrations

Illustrations in this book were made possible by a subvention from Princeton University.

Preface

> When will you disembarrass yourself of the lymphatic ideology of that deplorable Ruskin. . . . With his morbid nostalgia for Homeric cheeses and legendary wool-gatherers, with his hatred for the machine, steam and electricity, that maniac of antique simplicity is like a man who, having reached full physical maturity, still wants to sleep in his cradle and feed himself at the breast of his decrepit old nurse in order to recover his thoughtless infancy.

MORE THAN SEVENTY years have passed since Filippo Marinetti ended his "Futurist Speech to the English" with this ringing denunciation of their "lymphatic ideology." The running conflict between organic, holistic modes of thought and mechanical, atomistic ones has forever passed both "that deplorable Ruskin" and Futurism by. Ruskin's persistent but diffuse influence has long since gone through too many intermediaries to be specifically traced. His writing life ended in the 1880s, and by 1910 he had become a name ready for debunking. Ruskin predicted that *"no true* disciple of mine will ever be a 'Ruskinian' "* (XXIV:371), and indeed the term today denotes not a follower of the Master but a student of his work. The challenge Marinetti's polemical caricature presents to the Ruskinian interested in social thought is not to defend the contemporary relevance of Homeric cheeses, nor to card a current form of vitalism from thirty-nine volumes of gathered wool, but to understand a mode of thought that looked to Homer and Plato, Shakespeare and Scott, Tintoretto and Turner, King Solomon and the hypothetical carvers of the real stones of Venice for the understanding and even the solution of Victorian problems. By the time of the First World War such a set of

mind had become so alien to literary moderns that Virginia Woolf could only admire Ruskin's style if she divorced it from his meaning, reducing him to an authority solely on his own life. To be thought a fountain of insignificant eloquence was the literary fate he feared above all others. *Dreams of an English Eden* places Ruskin and his work in a set of historical contexts intended to make his social thought seem less anomalous than it has heretofore, so that it may address us more directly and lay claim to sympathetic understanding. The establishment of historical contexts requires the successive narration of much that was simultaneous in the consciousness of writer and audience. It can be neither perfect nor complete. *Dreams of an English Eden* is my attempt to understand one aspect of Ruskin's thought as the product of a particular mind in a particular tradition with roots in the work of Thomas Carlyle and branches in that of William Morris. My emphasis is upon Ruskin's sanity, rather than his madness; his eloquence in the literal sense of speaking out on a subject matter, rather than verbal display.

Like all work of historical reconstruction, *Dreams of an English Eden* is indebted to the editors, scholars, and critics who mediate one's experience of even primary materials and are the scholar's tradition. My own effort depends on that of E. T. Cook and Alexander Wedderburn, creators of the invaluable Library Edition of Ruskin's works and their many diligent successors; H. D. Traill, May Morris and subsequent editors of the works and letters of Carlyle and Morris. My obligations to those who have made the current study of Ruskin and his peers increasingly a matter of intellectual rather than clinical curiosity go beyond what can be expressed in notes, though I have done my best to record them there. For the opportunity to study and reproduce unpublished manuscripts, letters, or drawings of Ruskin, Carlyle, Morris, and their contemporaries, I am grateful to the administration and staff of the following libraries and museums: the Beinecke, Yale; the Bodleian, Oxford; the British Library; the John Rylands, Manchester; the Houghton, Harvard; the New York Public Library; the Ruskin Museum, Coniston; the university libraries of Princeton, Reading, and British Columbia; the Fitzwilliam, Fogg, and Victoria and Albert Museums; and the William Morris Gallery, Walthamstow. My special thanks go to Mr. James S. Dearden for sharing his unequaled knowledge of the collections at the Ruskin Galleries, Isle of Wight, and at Brantwood, and to Mr. Herbert Cahoon of the Pierpont Morgan Library for allowing me to examine uncatalogued materials. For all manner of advice, support, and encouragement, I thank William A. Madden, director of my doctoral

dissertation on Ruskin, E. D. H. Johnson, Ulrich Knoepflmacher, A. Walton Litz, Maria DiBattista, Margaret Doody, John Dixon Hunt, Robert Hewison, John D. Rosenberg, whose *The Darkening Glass* was my introduction to Ruskin studies, and my editor, William P. Germano of the Columbia University Press. I owe the translation of my drafts into a computer typesetting program to the generous efforts of Patricia Halliday and Hannah Kaufman.

My work has been supported by a fellowship from the National Endowment for the Humanities, which enabled me to finish this project and begin the next, and a summer grant from the Surdna Foundation. Some travel and typing expenses were covered by Princeton's Committee on Research in the Humanities and Social Sciences. My thanks as well to Ruskin's literary executors, George Allen and Unwin Ltd., for permission to quote from unpublished materials; Routledge and Kegan Paul, publisher of *New Approaches to Ruskin;* the University of Manchester Press, publisher of *The Ruskin Polygon;* and the New York Academy of Sciences, publisher of *Victorian Science and Victorian Values* for permission to reprint portions of my contributions to those collections. All illustrations appear by permission of the stated owners.

For support of another and finer kind I thank my wife, Laura, and our children, Sonja, Rachel, Margaret and Daniel—this quester's home.

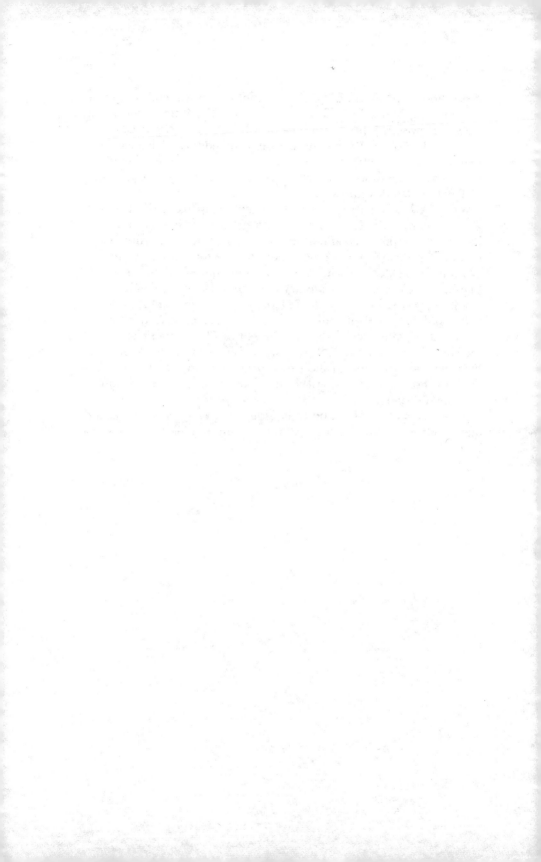

Dreams of
an English Eden:
RUSKIN AND HIS TRADITION
IN SOCIAL CRITICISM

Abbreviations

All Ruskin quotations, unless otherwise noted, are from the Library Edition of *The Works of John Ruskin*, E. T. Cook and Alexander Wedderburn, eds., 39 vols. (London: Allen, 1903–12), cited in the text by volume number (roman) and page, thus (XVII:50).

All Carlyle quotations, unless otherwise noted, are from the American printing of the Centenary Edition of *The Works of Thomas Carlyle*, H. D. Traill, ed., 30 vols. (New York: Scribner, 1903–4), cited by volume number (arabic) and page, thus (20:55).

All Morris quotations, unless otherwise noted, are from *The Collected Works of William Morris*, May Morris, ed., 24 vols. (London: Longmans, 1910–15), cited as M with volume numbers (arabic) and page, thus (M22:55).

Citations from the various collected works include short titles where deemed appropriate.

BD *The Brantwood Diary of John Ruskin*, Helen G. Viljoen, ed. (New Haven: Yale University Press, 1971).

D *The Diaries of John Ruskin*, Joan Evans and J. H. Whitehouse, eds., 3 vols. (Oxford: Clarendon Press, 1956).

EV *Effie in Venice*, Mary Lutyens, ed. (London: John Murray, 1965).

FL *The Ruskin Family Letters*, Van Akin Burd, ed., 2 vols. (Ithaca: Cornell University Press, 1973).

FR I,II,III *The French Revolution*, Carlyle's *Works*, vols. 2, 3, 4.

LV *Ruskin's Letters from Venice 1851–1852*, J. L. Bradley, ed. (New Haven: Yale University Press, 1955).

MR *Millais and the Ruskins*, Mary Lutyens, ed. (London: John Murray, 1967).

M-T *The Letters of John Ruskin to Lord and Lady Mount-Temple*, J. L. Bradley, ed. (Columbus: Ohio State University Press, 1964).

P&P *Past and Present*, Carlyle's *Works*, vol. 10

RG *The Ruskins and the Grays*, Mary Lutyens, ed. (London: John Murray, 1972).

SR Carlyle's *Sartor Resartus*, C. F. Harrold, ed. (New York: Odyssey Press, 1937).

WL *The Winnington Letters*, Van Akin Burd, ed. (Cambridge: Harvard University Press, 1969).

Introduction

Render honour to whom honour is due. The command is a good one, even if it were not found in the Bible. . . . But then the question now is—To whom *is* honour due: Is it due to vice and villainy—to those who impoverish and oppress mankind—to those who will give no right and hear no reason? . . . to call a downright scoundrel a Right Honourable Gentleman, is *practical* falsehood, and such an inversion of the order and fitness of things as must ultimately subvert both *Justice* and *Peace,* the two grand pillars on which the moral and the civil world entirely depend.

> *The Beggar's Complaint Against Rack-rent Landlords,*
> *Corn Factors, Great Farmers, Monopolizers* . . . by One
> Who Pities the Oppressed, 1812

We will have . . . chivalry gentle always and lowly, among those who deserved their name of knight; showing mercy to whom mercy was due, and honour to whom honour.

It exists yet, and out of La Mancha, too (or none of *us* could exist), whatever you may think in these days of ungentleness and Dishonour. It exists secretly, to the full, among you yourselves, and the recovery of it again would be to you as the opening of a well in the desert.

> *Fors Clavigera, Letter 9* (September 1871)

HE CALLED himself "the Don Quixote of Denmark Hill,"[1] —not without a certain bitterness. The chivalry of Cervantes' woeful knight was real to Ruskin and his story one in which "the most touching valour and tenderness are rendered vain by madness" (XXXVII:17). In his

1

Denmark Hill days Ruskin launched a crusade to transform England into at least an approximation of his ideal vision of her only to have his own efforts broken, if not rendered entirely vain, by madness. Unlike the Don, Ruskin remained acutely aware of the difference between the world as it was and the order he wished to impose upon it. Nevertheless the transformation he strove for corresponds to that wrought by the successful quester in a traditional romance: "a final reconciliation with nature as something to be attained after the human community has been reordered."[2] It is a regaining of Eden: "For what can we conceive of that first Eden which we might not yet win back, if we chose?" (VII:13).

To later generations Ruskin's means of recovering Eden seemed a singular blend of the prophetic and the quixotic. He combined trenchant attacks upon Victorian capitalism and proposals anticipating the social welfare legislation of the twentieth century with his call for a neofeudal order in which bishops, true to their title, would oversee public assistance, knightly merchants would swear to suffer any loss rather than leave their fellow citizens unprovided, and a set of medieval customs as eclectic as any piece of Gothic Revival architecture would govern everything from daily dress to weddings and public festivals.

Faced with such extremes of apparent sense and nonsense, sensitive to the aura of willfulness that so often emanates from the thought of those who set themselves against the wave of the future, many commentators on Ruskin's social criticism have read the mania that ended Ruskin's mental life back into his work. The "arrogance" and "endless caprice and irrelevancy" that so repels them they attribute to psychic disturbances; yet they also assert that "the experience that gave rise to Ruskin's pathology was at the same time a source of strength in his social criticism." Thus, somehow, the irrational basis of Ruskin's strictures produces "the clarity and force with which he assails the irrationalities of the industrial system."[3] Such appeals to an "irrational rationalism" relieve Ruskin of responsibility for his words only to deny him credit for his thoughts. It is not, as his first biographer feared, "the reproach of insanity"[4] that has cast its shadow back over Ruskin's work, but the excuse of insanity. Rooting Ruskin's work in mental aberration does not explain his social vision; rather it explains it away.

Ruskin himself recognized that knowledge of the formation of his mind and character was a key to an understanding of his social outlook. He worked personal anecdote into the social and political arguments of *Fors Clavigera* and ended his life with a fragmentary

autobiography that was composed between attacks of mania. But *Praeterita* is anything but a madman's manifesto. It is notable rather for the lucidity with which it records so many of the forces that shaped his life.

The familiar opening of *Praeterita*—"I am, and my father was before me, a violent Tory of the old school;—Walter Scott's school, that is to say, and Homer's" (XXXV:13)—roots Ruskin's political outlook in childhood, in his parental inheritance, and in the literature that was "reading of my own election" after daily forced feeding from the Bible. That he should name Homer and Scott as his political masters in place of philosophers or historians—let alone Tory politicians—is characteristic of Ruskin. The essence of the Toryism he describes is Platonic, consisting in the willingness of governors to be guardians, to serve heroically beyond the capacity of others and for the benefit of society rather than their own aggrandizement. As the references to Homer and Scott indicate, Ruskin extends to certain fictions canonical status. He interprets character, situation, and moral application on the models of biblical type and fulfillment, or example and imitation, familar in Protestant sermons: "The best monument we can rear to the righteous is our copy of their excellence—. . . their example repeated in our actions and habits. If with Nehemiah, we would show respect to the dead, with Nehemiah let us strive to be useful to the living." The call to imitate Christ, his prophets and saints not only led Ruskin to measure the behavior of others against ideal types but to measure his own life against their standards and to identify himself in some measure with the holy or heroic figures of art and literature.[5]

On the continuum between the literature of fact and that of fable Ruskin's work, like that of Carlyle and other "Victorian Sages," lies near the border of fiction, recording alterations of his opinions and in his sensibility with the sensitivity of poetry.[6] Indeed, the most remarkable aspect of Ruskin's criticism in all fields is his extraordinary ability to locate the equivalents of his inner states in the outer world—to communicate sight and insight, to reveal to the reader not just *Ruskin's* depression and *Ruskin's* elation but "mountain gloom and mountain glory." It is only as his mind breaks down that this capacity fails; the images become invisible to others and the words lack apparent reference.[7] In field after field Ruskin presents himself both as being apart and as a representative man—the eye and conscience of his age. Each subject on which he passes judgments—be it painting or theology, architecture or geology, economics or mythology—has its own history in which Ruskin's contribution, whether

central or marginal, has a comprehensible place. But judgment of that contribution itself varies with the currents of intellectual history: with evaluation by the modern art historian of Tintoretto; the geologist, of glacial motion; the economic historian, of John Stuart Mill's *Principles;* the literary critic, of Ruskin's prose.

Ruskin's social criticism is itself part of a tradition deliberately forged after Turner's death when Ruskin turned to Carlyle for the support of a second father and a new earthly master, and when Ruskin's work, in its turn, gave shape to the discontent of the young William Morris. Examined in its private and public contexts, as both personal expression and part of a critical and literary tradition, Ruskin's social outlook assumes a coherence that cannot emerge in studies that try to assimilate Ruskin's wit to his madness or to thresh twentieth-century ideas from the Victorian chaff of his presentation. If Ruskin's attempt to move from social commentary to direct action arrived at an impasse, only its details, as Raymond Williams points out, were peculiar to Ruskin.[8] The deadlock was a cultural one that others such as Matthew Arnold were trying in their own way, just as vainly, to break.

The years of Ruskin's youth and Carlyle's maturity are called the Age of Reform, but that, of course, is a retrospective designation. At the time many in England feared theirs might be the Age of Revolution as upheavals periodically swept the Continent. Against the memory of the French Revolution and the Napoleonic wars, during continental revolutions, the rise of Chartism, and the social unrest that gave it impetus, the English saw a familiar, basically feudal, agrarian past giving way to an unknown, but almost surely more democratic, urban and industrial future. They knew that theirs was, in the words of the young John Stuart Mill, "an age of transition." Mill's phrase has been so often quoted as to lose all specific reference, but his meaning was particular and pervasive in Victorian thought. Society in a transitional state, argued Mill, can only be understood in relation to its contrary, society in a natural state. In a natural state: "worldly power, and moral influence, are habitually and undisputedly exercised by the fittest persons whom the existing state affords." In a transitional state, however, "Worldly power, and the greatest capacity for worldly affairs, are no longer united, but severed; . . . the authority which sets the opinions and forms the feelings of those who are not accustomed to think for themselves, does not exist at all, or, existing, resides anywhere but in the most cultivated intellects, and the exalted characters of the age."

Although Mill is virtually the last Victorian one would think of as a

medievalist, he contends that the last natural state was medieval Christendom. But, says Mill, in a phrase that brings to mind his friendship with Carlyle in the 1830s and their common interest in the St. Simonists, "mankind outgrew their religion, and that, too, at a period when they had not yet outgrown their government, because the texture of the latter was more yielding, and could be stretched."[9]

The form of the new natural state, the spirit or structure which would bring power, capacity, and moral influence into proper alignment, was debated into the mid-Victorian period with an intensity suggesting that formulating and propagating a new social order were thought virtually tantamount to bringing it into being. Writers of most every political, philosophic, or religious stripe sought to set opinions, and through opinions, policy. Even the majority faction of the Chartists seems extraordinarily idealistic in retrospect. Their rhetoric manifests a curious disjunction between economic ends and political means. Ruskin's social criticism belongs to the anti-Utilitarian strain in this Victorian debate. It is rooted in his own upbringing and his study of the relationship betwen art and society. His tradition was fed by the authoritarian idealism of Carlyle and later flowered, in good measure through Ruskin's agency, in the communism of William Morris.

Like historical writing, programs for the transformation of society are implicitly stories—plots in the literary, if not the political, sense. The underlying narrative form or *mythos* of what has been called the medievalist tradition in social criticism that runs from Carlyle through Ruskin to Morris is romance.[10] Romance with its schematicized characters, its dualistic conflicts (good and evil, light and dark, knight and dragon, fellow and other), its recurrent themes of individual rescue and social redemption, its aura of the supernatural, was a familiar vehicle for Christian allegory, whether on the high road with Spenser or the low road with Bunyan. It naturally appealed to many Victorians who had been raised in the severe dualism of fundamental Protestantism, only to have their childhood faith shaken by modern philosophy, science, or biblical criticism. Romance was at least as powerful a strain in Victorian literature as realism; indeed a tension between the two modes characterizes much Victorian fiction.

As heirs of the Romantics, Carlyle, Ruskin, and Morris all felt the pull of that "internalization of romance" Harold Bloom makes central to the modern literary tradition: "The quest is to widen consciousness as well as intensify it, but the quest is shadowed by a spirit that tends to narrow consciousness to an acute preoccupation with

the self."[11] Aware of the lure of solipsism both as a cultural phe-
nomenon and within themselves, all three writers sought, each in his
own way, to objectify and externalize conflict, to return the quest for
paradise from the internal to the external world, to impose the pat-
tern of romance on the process of history, to change England.

The opposition between social salvation and damnation takes nar-
rative form in the contrast between romance and irony, its demonic
parody. It is the contrast between the progress of Carlyle's Cromwell
or Abbot Samson, and Hudson the Railway King; between men fol-
lowing a hero into the promised land, and apes marching into chaos,
"that land of which Bedlam is the Mount Zion." It is the contrast be-
tween Ruskin's vision of a world in which honor and authority have
been reunited, in which his readers don the "armoury needful to the
husbandman, or Georgos, of God's garden" (XXVIII:216); and "this
yelping carnivorous crowd, mad for money and lust, tearing each
other to pieces, and starving each other to death" (XXVIII:207). It is
the contrast between the dream of Morris' John Ball, and the mod-
ern history narrated by his interlocutor, the dreamer; the working
class as collective hero, and the faction-ridden Socialist League; the
dream of Nowhere, and the nightmare of here and now.[12]

It was the underlying structural similarity between *The French Revo-
lution* and the fictional romance that made it so easy for Dickens to
transform Carlyle's history into *A Tale of Two Cities* poised between
the best and the worst of times, social heaven and hell, romance and
irony.[13] Just as Dickens so often set romance characters to the task
of redeeming the world his "realism" reconstructed, so Ruskin ap-
plied to society itself the redemptive pattern of romance, combining
his literal interpretation of biblical ethics with the application of an
ideal feudal order and chivalric manners to modern circumstances.
Of course, Ruskin did not believe that he was imposing a literary pat-
tern upon social reality; he believed rather that he was making ex-
plicit the principles of social order as exemplified in the Bible, in
history, in the literature and art he admired. Similarly, in the hu-
manistic phase of his art history, he insisted that the great artist and
writer revealed rather than imposed the Naturalist Ideal. Indeed,
the existence of a great English school of historical painting to be
based, as Ruskin thought all such schools were, upon contemporary
portraiture, became contingent in his mind upon the social creation
of living models of nobility. "The best patronage of art is not that
which seeks for the pleasures of sentiment in a vague ideality, not for
beauty of form in a marble image; but that which educates your chil-
dren into living heroes, and binds down the flights and fondnesses of

the heart into practical duty and faithful devotion" (XII:160).

As Ruskin's faith declined, the emphasis of his criticism shifted from revelation of the divine nature to the depiction of human nature. As God's ways became increasingly mysterious to him, history seemed less the fulfillment of types and prophecies and increasingly the product of human will. It became the projection, for good or ill, of man's moral being, whether in accordance with, or in contravention of, the moral principles of the Scriptures. What we know of salvation would be achieved only by a society that concentrated upon "painting cheeks with health rather than with rouge," and only a society intent upon such salvation would be rewarded with an art at once natural and ideal. Ruskin never gave as complete a picture of his redeemed society as Morris did in *News from Nowhere,* but it is at least an inchoate presence as an implicit positive in his attacks upon Victorian social values in general, and the political economists in particular, and is given piecemeal in his late work, especially *Fors Clavigera.*

Ruskin likened *Fors* to a mosaic, insisting that as its discrete pieces were put into place the governing design would emerge, but his late works were neither fully planned nor ever finished. While the total reconstruction of Ruskin's historical horizon is impossible, the more completely his fragmentary social thought can be set in its contemporary contexts, both public and private, the more clearly the pieces cohere and the uncertain boundary between psychological projection and rational analysis emerges. The overarching context in which I set Ruskin's work is the tradition I call "realized romance," the projection onto society of a literary pattern of redemption that creates in the case of Ruskin and Morris a link between the effort to order their private lives and their commitment to a reorganization of society as a whole. As Ruskin himself pointed out, knowledge of his childhood is a key to the understanding of his thought. My starting point is Ruskin's upbringing, the psychological and intellectual patterns formed in childhood that generated the central tensions of his adult life and established his peculiar set of mind.

Praeterita is Ruskin's Book of Chronicles recording both "things past" and "things passed over" in Ruskin's public testament that he thought would be of help to the readers of his books.[14] *Praeterita* also passes over things that are necessary, if not sufficient, for the understanding of his public life. Starting with Ruskin's analysis of the virtues and failings of his own upbringing as seen in the light of the surviving family papers, the first section of this book examines certain effects of Ruskin's rearing as an only child and his efforts to find

substitutes later in life for the parental attention and religious faith that had sustained him in childhood. Ruskin's yearning for emotional and intellectual self-sufficiency was never satisfied and left him, despite his Oxford education, with the sense of being a perpetual outsider, a feeling that was exacerbated by the failure of his marriage and, subsequently, his tortuous relationship with Rose La Touche, the unhappy girl he had hoped to marry when she came of age. Indeed, it was the collapse of hope in his private life that led Ruskin to attempt to live entirely for his public life; to virtually become, through his Guild of St. George, a public institution.

The second section moves from the personal and intellectual background of Ruskin's social thinking, from the question of his set of mind, to the singular influence of Carlyle. Although Carlyle was twenty-four years older, he did not become an influence upon Ruskin until after his disciple's mind had been formed. Consequently, I have chosen the chronology of influence over the ordinary sequence of literary history. I discuss what Ruskin sought from Carlyle before going back to examine the romance underpinning of much of the Carlylean history and criticism that Ruskin admired, their mutual debt to Scott's blending of romance with history, and the impasse in which Carlyle's career as a social critic ended—an impasse Ruskin felt honor bound to try to break.

Having established these personal and Carlylean contexts I turn to Ruskin's public "crusade." Ruskin found that while his two masters had made the dragon of Mammonism manifest—Turner in paint, Carlyle in prose—neither had been able to slay it. That task the disciple took upon himself. Considered as a crusade that involves one object but many changes in tactics, Ruskin's disparate activities in the 1860s and 1870s show an underlying consistency that has been generally overlooked. Ruskin's object remained that of Carlyle and writers on the "Condition-of-England question" from other camps—to change minds and urge people to action. His means at first were an extension of Carlyle's: periodical essays, books, lectures. But Ruskin's articles were driven from the journals, his books on political economy initially ridiculed in the press and neglected by the public, his lectures treated as entertainments. The failure of his words to have their intended effect led Ruskin to try additional steps. He published his own journal, *Fors Clavigera*, and founded a model organization, the Guild of St. George, in an attempt to demonstrate the reclamation of man and nature, where he could not otherwise persuade.

Ruskin's attempts at direct action forced him to confront the gulf

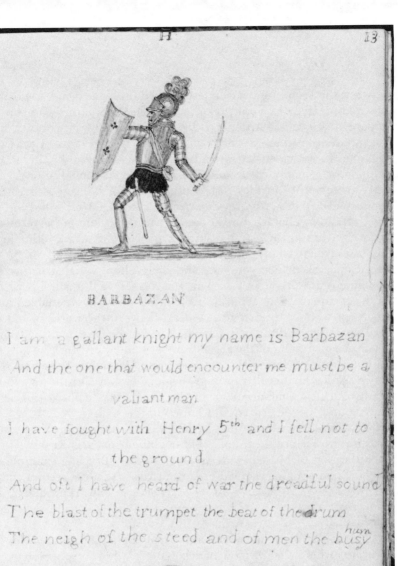

As early as "The Puppet Show" Ruskin composed at the age of ten an ironic Falstaff undercuts heroic Barbazon.

between the vision of a society established on his principles and the few halting steps he could take towards its realization. The consequence was a self-destructive irony symbolized by the contrast between identification of himself with St. George and with Don Quixote. It was given narrative voice in *Fors Clavigera* by the juxtaposition of romance ideals and passages of ironic undercutting.

My argument concludes with consideration of William Morris' extension of Ruskin's crusade. The circumstances of Morris' life and of his generation enabled him to transform the tradition he received from Carlyle and Ruskin by fusing his insular inheritance with Marxism. An egalitarian bias that I trace from his childhood led Morris to break the link beteen romance and hierarchical social structure so prominent in Carlyle and Ruskin. His socialist faith made his vision of the future an instrument in his political struggles. It enabled him to accept without despair the contrast between the world of industrial capitalism and the new Eden he forsaw; the frustration of laboring at the beginning of the social transformation for which he longed without hope of seeing the promised end. Although *News from Nowhere* retains medieval trappings, it looks forward to the establishment of a new egalitarian society by means of the social upheaval Carlyle and Ruskin feared and hoped to forestall.

It is with Morris' utopia that I conclude my study of Ruskin's social criticism in Victorian contexts. My beginning point is Ruskin's first identification of himself with St. George—the surviving example of his boyhood printing, copied onto the flyleaf from the second chapter of *The Seven Champions of Christendom* and reproduced in *Praeterita*:

> The noble knight like a bold and daring hero then entered the valley where the Dragon had his abode who no sooner had sight of him but his leathern throat sent forth a sound more. (XXXV:24)

It is characteristically, prophetically, a fragment.

1

Growth and Losses

I suppose you know that when I repeat a line of poetry that I am much taken with I involuntarily keep repeating it the whole day my Rhyme to day is ["] I see them on their winding way, About their ranks the moonbeams play &C. ["] Ogh ogh Ohonorie After all I shall not get what I have to say into this letter Things come pouring in upon me from all sides and after deafening me with their clamour fall to fighting who shall get first [,] kill each other [,] and do not get in at all But I'll let in those I can before they fight and when my letter . . . is filled, I must leave [them] to fight and go away.

Ruskin to his father, March 10, 1829

This, then, is the message, which, knowing no more as I unfolded the scroll of it, what next would be written there, than a blade of grass knows what the form of its fruit shall be, I have been led on year by year to speak, even to this its end.

Fors Clavigera, June 1877

Looking Backward

IF WE IMAGINE RUSKIN'S works, from the first letters to his father, through the long sequence of published texts, to the few painful scrawls of the 1890s, as the unfolding of an enormous illustrated scroll dominated in turns by the strongest interest of the moment, the margins would be filled with things fighting to get in from notes, sketches, letters, and diary entries. The scope of the scroll points to the difficulty in writing about his work. Both temperament and conviction led Ruskin to resist the trend towards specialization that our century inherited from his. Through all the stages of his religious belief he maintained his faith in a single natural law with both physical and moral aspects, a law that applied to all objects of study, each subject matter providing him with a different class of examples. Consequently, from the time of his childhood, Ruskin had few compunctions about mixing the modes of his inquiries. The art critic reading Ruskin for his views on architecture or painting necessarily encounters his social criticism; the economist, his religious views; the student of literature his geology, ornithology, and so on.

Ruskin's work is also intensely personal. The tension between confessional and objective modes that we associate with the romantic tradition in poetry is constant in his prose. From the beginning Ruskin based his work on personal experiences, impressions, reactions: a taking in by looking, or reading, or sketching, or measuring, or memorizing what he loved in literature, landscape, and art, and a rejection of all that struck him as opposed to it. ("My great mental gift is Digestion, and my great bodily defect, Indigestion.")[1] Theory and categorization came after conviction and experience and were throughout his life adjusted as his convictions changed and his experience broadened.

Ruskin's work through the second volume of *Modern Painters* set personal experience, whether of paintings or palaces, landscapes or town squares, into an elaborate and—as he then thought—objective theoretical framework. He founded that framework on his Evangelical faith and built upon it in a highly decorated style. Only through systematizing could Ruskin try to hold together interests and enthusiasms that would otherwise remain disparate. Ruskin's early work thus bears a formal resemblance to the synoptic scholarship of such Protestant divines as Thomas Hartwell Horne.[2] Ruskin's progressive loss of faith, however, soon precipitated a search for new bases of

objective judgment, new ways of holding things together. That search, begun as early as the 1840s, lasted until his return to a non-sectarian Christianity in the mid-1870s. The trend of his work after *The Stones of Venice*, despite its persistent allusiveness, was away from the long, elaborately stylized treatise unified by theory, and toward more directly colloquial and confessional modes unified by ad hoc arguments, personal association, and point of view: the lecture, the periodical essay, the epistle and, finally, autobiography itself.

The personal element in Ruskin's work is further complicated by the attacks of mania that racked him mentally and physically between 1878 and 1888, finally ending his literary and artistic life and leaving him essentially senile for his last decade. *Manic depression, schizophrenic reaction*, and like terms lie immediately at hand as tempting critical nostrums to apply whenever Ruskin, admittedly a man of genius, does or says something the critic finds unaccountable, inconsistent, incongruous, incomprehensible, or simply silly. There is no doubt that Ruskin's mental state from the mid-1870s on weakened his powers of sustained concentration. His breakdowns and the pathetic attempts to forestall their recurrence by directing his attention to topics that would not rouse anger made his late work even more fragmentary than it would otherwise have been. But the links between Ruskin's madness and his ideas—especially if projected back through the entire body of his work—are highly problematical and apt to reveal more about the critic and his age than about Ruskin. What seems mad to one generation of critics may be prescient to the next. Many Victorians who accepted Ruskin's authority as a critic of art thought his political economy insane and averted their eyes from the painful spectacle of a man degrading himself in public. Yet R. H. Wilenski, writing in the 1930s, found Ruskin's social criticism both sane and admirable, but thought his art criticism from first to last the product of a sick mind.[3] Again, Ruskin's insistence that, wherever possible, power for work beyond human strength be generated from the energy of wind and tide seemed as outlandish in the era of cheap petroleum as it had in his own age of coal. In the 1980s nothing in Ruskin's work seems more prophetic than his anticipation of what we like to call an ecologically sound energy policy (but nothing more archaic than the Guild of St. George that was to demonstrate its feasibility).

Ruskin's social ideas are more the product of experience and a particular set of mind than the elaboration of a theory, and the formation of his mind and character and the judgments he passed upon his upbringing bear upon the sympathetic understanding of his work.

Consequently, it is impossible to account for such things as Ruskin's insistence—in what is otherwise a progressive view of women's education for the time—that girls should not study theology, without making reference to Ruskin's ill-fated love for the Evangelical Rose La Touche, whose mental and physical collapse Ruskin attributed to religious mania. Ruskin himself came to realize how helpful understanding of his life, particularly his childhood, was for comprehension of his work. Indeed, his autobiography grew from passages in *Fors Clavigera* that connected his social ideas with the peculiarities of his upbringing.

Even if it had been finished as planned, however, *Praeterita* would have remained an essential, but uncertain, guide to Ruskin's life—a document revealing almost as much about its aged author as his youthful subject. The purpose of *Praeterita* was limited both by his own inclination and the urging of friends and doctors trying to keep Ruskin away from topics that seemed to threaten his mental stability to the record of "what it gives me joy to remember, . . . what I think it may be useful for others to know; and passing in total silence things which I have no pleasure in reviewing, and which the reader would find no help in the account of" (XXXV:11). Thus, of course, Ruskin's marriage finds no place, and even in regard to his family: "Very little of the deeper calamities of all that chanced and mischanced to us, will be shown in Praeterita."[4] Moreover, the passages taken over from *Fors* had been exaggerated for effect in their original polemical context, producing distortions that Ruskin tried on occasion to correct in later episodes, but for the most part let stand. *Praeterita* moves episodically from one complex of associated memories and attendant morals to the next with little regard for narrative development or strict consistency. It is true only to place, moment, and memory. *Dilecta*, the collection of documents that was to supplement *Praeterita*, would have contained corrections, including letters by friends who remembered differently people and events Ruskin commented upon, thereby offering multiple perspectives, but it was suspended after only three chapters when *Praeterita* ceased.[5]

Finally, *Praeterita* is Ruskin's myth of his own life, a spiritual quest ending in emotional isolation, professional disappointment, and periodic insanity. Recollections even of the greatest joys of his youth, the sustaining loves of his life, are thus tinged with melancholy. Even the first sight of the Alps from Schaffhausen, a "blessed entry into life" and the fountainhead of so much of Ruskin's positive activity, takes on an elegiac cast in this book of successive rebirths and exiles from paradise. "Infinitely beyond all that we had ever thought or

dreamed,—the seen walls of lost Eden could not have been more beautiful to us; not more awful, round heaven, the walls of sacred Death" (XXXV:115). "The seen walls of lost Eden" paraphrases Byron's Cain, the perpetual exile, and walled Death stands where the Evangelical Ruskin saw the image of paradise and Bunyan's Celestial City.[6] To the aged Ruskin the Alps are both a major locus of his life and a barrier between other such loci in Britain and Italy—the ruined paradises of his life. In memory the mountains form a wall in time as well as space, a partition between the past and the present wherein the cursed wanderer was increasingly confined to Joanna's care.

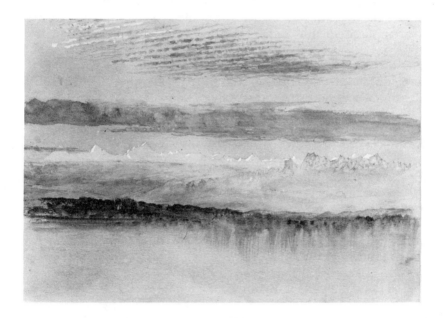

"The seen walls of lost Eden." Ruskin's watercolor of *Dawn at Neuchâtel,* May 11, 1866, where three days later his most trusted woman friend, Lady Paula Trevelyan, died in Sir Walter's arms as Ruskin knelt in prayer at the foot of her bed.

Ruskin refreshed his memory as he wrote *Praeterita* by referring to his diaries and the letters he had exchanged with his parents. But he ignored a wealth of family correspondence and documents at Brantwood extending even before his own birth that could have

given him a more objective understanding of the backgrounds and characters of his parents than he could summon in memory. The John James and Margaret Ruskin with whom he was trying to come to final terms, however, were less the parents who had passed away than the ones who survived in his mind. Behind the crusade Ruskin waged against the dragon of Mammonism and for the restoration of a domestic and national earthly paradise lay his own quest, his struggle for emotional self-sufficiency, for freedom from parental control, for love, for the courage to face death—battles in which he won at best Pyrrhic victories.

Ruskin exaggerated the austerity of his early life in the passages from *Fors* reprinted in *Praeterita*. Commentators influenced by psychoanalysis, who find behind Ruskin's mental and emotional problems the classic, domineering, man-eating mother, have overemphasized this rather harsh characterization of Margaret Ruskin. Even in excellent studies of Ruskin one finds this pious, but not, in her prime, inflexible Englishwoman (she was born, raised, and educated in Croyden) portrayed as a "stern, puritanical Scot."[7] Ruskin, who understood that while his mother "is always *saying* things which look as if she was the most conceited person in the world, she is really very uncomfortably humble,"[8] thought her, in retrospect, "an inoffensive prude." He attempted to correct his initial account, and objected to newspaper reviews of the first numbers of *Praeterita* that compared her to Esther's unbending aunt in *Bleak House*, recalling her "hearty, frank and even irrepressible laugh with its Smollettesque turn." She could laugh heartily at the Smollettesque turns of life, as when nurse Anne toppled immodestly backward over the railing before the monastery at the top of the Simplon "for the entertainment of the Holy Fathers" (XXXV:144), as well as those in *Humphry Clinker*. And surely the Ruskins were unusual among Evangelical families in taking Byron for the family poet, *Don Juan* and all. By the time visitors were coming to Denmark Hill intent on seeing the Turner collection and recording their impressions of a famous man's home, Mrs. Ruskin was in her seventies, infirm, hard of hearing, but nonetheless indomitable. She was recognizably the same woman who had put young John through the Bible every year as soon as he could read, "hard names, numbers, Levitical law, and all" (XXXV:40). But she was no longer the indefatigable hiker who, even at sixty-three, could walk "the ten miles from St. Nicholas to Visp as lightly as a girl" (XXXV:335), let alone the mother of Ruskin's boyhood who could find new life in the air of the Alps, who delighted in the beauty of nature, who loved to work her garden, and whose passion

for books was so extreme she considered it sinful.

Convent and Alpine Pass (1844) looking up the Visp Valley to
Monte Rosa, in later years Ruskin's "Central mountain of the
range between north and south Europe, which keeps the gift
of rain of heaven" (XXVII:296). The coincidence of name associ-
ated it with Rose La Touche and the work of social redemption
Ruskin attempted in her name.

The elder Ruskins' marriage was one that had a high probability of
harmony from the outset. At about the age of twenty Margaret Cock
moved from Croyden into the Ruskin home in Perth to assist
Catherine Ruskin. When Jessie Ruskin married in 1804, Margaret in
effect took the place of John James' beloved older sister. After John
James left home to recoup the family fortune and seek his own, it was
Margaret who helped Mrs. Ruskin in the thankless task of caring for
a husband whose moodiness had progressed by 1815 into recogniza-
ble insanity. Margaret considered herself to be beneath her cousin
socially and infinitely less accomplished, but worked conscientiously
throughout their nine-year engagement to improve herself. In all

likelihood there was no one better suited to care for John James after his mother's death than the familiar older cousin who was effectively a partner in sustaining his own family through its darkest days. Margaret Ruskin would be perpetually grateful to John James, whose success in business took her far beyond what she might have expected as the daughter of a widow who had been forced to support her children by keeping a public house. For his part, John James, who had given up the chance to be a gentleman for the sake of his family's honor and fortune, was gratified by his wife's admiration of his learning, taste, business acumen, and epistolary skill; and her piety and efficient housekeeping made his home a refuge from the burdens of the world, approximating the ideal Ruskin was later to describe in *Sesame and Lilies*.[9]

Beginnings

". . . mistakes which mama & you involuntarily fell into."
 J. R. to J. J. R., Dec. 17, 1863

MARGARET WAS THIRTY-SEVEN and John James thirty-four by the time they married on February 2, 1818. By then John James had lost both the mother to whom he had been so close and his hapless father. Margaret's mother died that same year. From the moment of his birth on February 8, 1819, John Ruskin became the focus of his parents' love, solicitude, pride, and ambition. Age and slow recovery from the birth meant that there would almost surely never be another child. (Mrs. Ruskin's "side" remained a source of concern for years.) From constant parental oversight came what Ruskin saw in retrospect as the blessings and the failures of his rearing.

The chief virtues Ruskin found in his upbringing were the direct consequence of his parents' harmonious marriage. He was free from anxiety and knew the meaning of peace. (Whatever its own merits, this domestic meshing of parental wills did little to prepare him for the encounter in marriage with "a self-will quite as dominant as my own.")[10] Because, for better or for worse, his parents were generally agreed on how to treat their child and consistent in it, he learned obedience and faith. Even the rigors imposed—the Bible reading, the comparative scarcity of playmates and playthings, the general absence of sweets—contributed to his precocious capacity for visual and mental concentration, and to "perfection of the palate."

The *Family Letters* display young John at the emotional center of his parents' lives. The daily letter Ruskin wrote them whenever he was away dates from the letters Ruskin addressed to his traveler father as soon as he could lift a pen. His mother encouraged him in the many projects he prepared to present to papa on his return, projects that naturally reflected John James' interest in literature, art, and travel, and his mother's piety and devotion to Maria Edgeworth's view of early education.[11] Anyone who has examined the maps Ruskin drew as a boy, looked at the imitations of printed children's books he composed and illustrated, read the early poems and the painstaking summaries of sermons would, I think, be impressed, as his parents were, by his precocity. But even more impressive are the unusual powers of concentrated effort in one so young (though, prophetically, most of the projects were so grandiose in conception as to be beyond his powers to complete them—to his mother's consternation). Only children quickly learn the kind of behavior that wins the approval of their parents and impresses other adults. If the family is harmonious there is no need to compete for attention or the affection of parents; it is freely, even overwhelmingly given. Ruskin absorbed the expectations of his parents so completely it is hardly surprising that in looking back he could not say that he had loved them in the ordinary sense, but that they "were— in a sort—visible powers of nature to me, no more loved than the sun and the moon: only I should have been annoyed and puzzled if either of them had gone out; (how much more, now, when both are darkened!)" (XXXV:44-45).

The calamities Ruskin found in his upbringing were not the product of severity or deprivation. On the contrary, Ruskin was most seriously affected by the dangers to which the only child of a close and loving family is most susceptible. And it needs to be emphasized that while they were probably not physically demonstrative, the Ruskins were a close and loving family, secure on their own grounds, whatever vestiges of insecurity the elder Ruskins carried from their relatively humble backgrounds into their dealings with the outside world. The loneliness Ruskin recalls looking back on his childhood is the other side of the self-absorbed activity recorded in the *Family Letters*. Ruskin had, in fact, the occasional company of relatives and approved acquaintances, and the steady companionship of pets. In 1828, after the death of his father's sister Jessie, his cousin Mary Richardson came to Herne Hill. She was five years older than Ruskin, and joined him in lessons and play ("Mary and I held up five hundred and thirty-eight at battledore and shuttlecock") but they

were not emotionally close. Mary remains a shadowy presence in the letters of all the Ruskins.[12] John's beloved dogs enter into his letters far more often and with far more animation than any human companion.

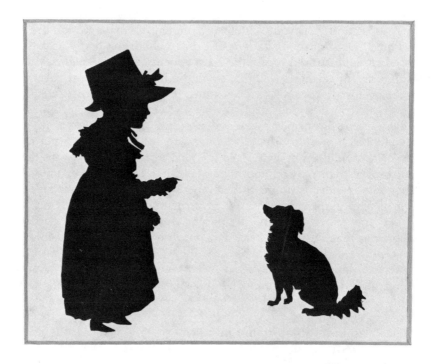

Master Ruskin admonishes the family dog in this silhouette, the earliest surviving representation of him (c. 1822).

The childhood ties that promised to be most enduring were to his other Richardson cousins, especially to Mary's younger sister Jessie, who was Ruskin's age. They exchanged vows of future marriage as children when the Ruskins visited Perth, but she died when they were eight. His older cousin Charles, of the Croyden Richardsons, who was a welcome visitor at Herne Hill while he worked at Smith and Elder, drowned in 1834 on the point of departure for Australia. Such losses could only confirm the young Ruskin in his seemingly self-sufficient, domestic emotional life. Putting *Praeterita* and the *Family Letters* side by side, the complaint both against his parents and

fate that he "had nothing to love" so that "when affection did come, it came with violence . . . unmanageable, at least by me, who never before had anything to manage," can be interpreted as a self-exculpatory way of saying that in the perfect security of childhood he loved nothing, having at the time no needs beyond those filled by mama, papa, and nurse. In these early losses and in the devotion of so much childhood energy to the pleasing of his parents in their private world by the imitation of adult activities we find the root of the feelings of emotional starvation and stunted development that are a recurrent motif in his letters as an adult, starvation that did not fade as he grew older, but became overwhelming when the death of his parents and then of Rose La Touche left him nearly bereft of people who could touch the quick of his emotional life.

The remaining calamities of Ruskin's upbringing were again the products of overprotection, not deprivation. That Ruskin had "nothing to endure"; "nothing to test his powers of judgment and courage against"; and "chief of evils," that his powers of judgment and independent action (as opposed to thought) were underdeveloped, testifies less to the fact that he was denied a chance to learn cricket, boating, or boxing (XXXV:lxii), or to act occasionally on his own initiative, than to his extreme internalization of his parents' standards and worries. Ruskin remained torn all his life between duty and impulse. The urge to play, so long repressed in childhood, came out with great force later in life and influenced the nature of Ruskin's social criticism, with its startling juxtapositions of earnest economics, games, and dreams.

One of Ruskin's earliest memories was of the fountain which sprang up in the street when the turncock opened a valve so that the water carts could be filled. Given this fascination with running water, the account of Harry's canal building in the third volume of Miss Edgeworth's *Harry and Lucy* naturally excited him. The industrious Harry, working so diligently under the approving eyes of his parents, the superior Harry who informs poor Lucy (while driving supports for his canal locks) that his expression, "*au refus de mouton,*" refers to pile driving and not sheep, was bound to appeal to the young Ruskin. He expressed admiration in typical fashion, not by building a canal, but by writing a continuation of *Harry and Lucy*. Similarly his love of rivers was expressed in verse from the age of seven on. ("Glen of Glenfarg, thy beauteous rill, / Streaming through thy mountains high" [II:262].) By the time Ruskin was twelve his mother was actually beginning to wish that he would spend less time writing verses and devote more to exercise (*FL:* 233). It was not until 1842,

after the long continental tour in celebration of his graduation from
Oxford, that Ruskin saw in the proposed move from the Herne Hill
house to the more spacious house and grounds at Denmark Hill his
chance for a canal.

> Did not *I* also want a larger house? No, good reader; but
> ever since first I could drive a spade, I had wanted to dig a
> canal, and make locks on it, like Harry in *Harry and Lucy*. And
> in the field at the back of the Denmark Hill house, now, in this
> hour of all our weaknesses, offered in temptation, I saw my
> way to a canal with any number of locks down towards Dul-
> wich. . .
>
> And I never got my canal dug, after all!. . . .The gardeners
> wanted all that was in the butts for the greenhouse . . . yet the
> bewitching idea never went out of my head, and some water-
> works, on the model of Fontainebleau, were verily set aflow-
> ing—twenty years afterwards, as will be told. (XXXV:317-8)

Much of Ruskin's work is an evolution, an unfolding of themes that
go back to his childhood. (The future author of the *Queen of the Air*
wrote of seeing a female form in the rising mist in *Harry and Lucy*, his
pastiche of Miss Edgeworth, Joyce's *Scientific Dialogues*, and *Manfred*.)
The frustrated desire to play freely persisted, undischarged, into
middle age. In 1862 Ruskin wrote to Dr. John Brown:

> Am I not in a curiously *unnatural* state of mind in this
> way—that at forty-three, instead of being able to settle to my
> middle-aged life like a middle-aged creature, I have more in-
> stincts of youth about me than when I was young, and am mis-
> erable because I cannot climb, run, or wrestle, sing, or flirt—as
> I was when a youngster because I couldn't sit writing metaphy-
> sics all day long. Wrong at both ends of life. (XXXVI:404)

Ruskin's love of waterways had its final fruition at Brantwood
where today the visitor willing (with due permission) to scramble up
the bank behind the house can see what remains of two reservoirs
with gates that could be opened at a signal from the Master below to
release a temporary mountain torrent for the pleasure of his guests.
But this private play had a public aspect. In the early 1860s when he
contemplated living high in the Alps in a house supplied with water
captured in reservoirs from the glacial runoffs, Ruskin devised a
scheme to save the valleys of Italy from the disastrous annual

flooding through construction of catch basins and reservoirs in the Alps; a plan which Ruskin as a private citizen of a foreign country could do little to realize, but which bears a striking resemblance to flood control measures undertaken since his time.[13] When he alluded to this plan in the nineteenth number of *Fors Clavigera* (July 1872) he described the adult "canal engineer" as someone who carries out for the benefit of society impulses that he first expressed by keeping the Atlantic Ocean out of a hole in Margate sands at the age of six (XXVII:331), a remark surely as self-revealing as generally applicable.[14]

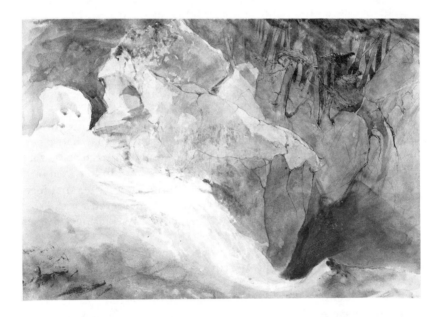

Untamed water, the *Falls of Schaffhausen* (1842). "The vault of water first bends, unbroken, in pure polished velocity, over the arching rocks . . . covering them with a dome of crystal twenty feet thick . . . and how the trees are lighted above it under all their leaves, at the instant that it breaks into foam" (III:529).

In addition to the uses of water, the topic of clean water recurs in Ruskin's work from the time of *The King of the Golden River* (written in 1841), with its freeing of the waters motif, through the five volumes

of *Modern Painters,* and into his last works. In the fifth letter of *Fors*
(May 1871), in one of those powerful denunciations of the fruits of
industrialism that makes him one of the prophets of the modern
ecology movement, Ruskin told his countrymen:

> You can bring rain where you will, by planting wisely and
> tending carefully;—drought where you will, by ravage of
> woods and neglect of the soil. You might have the rivers of
> England as pure as the crystal of the rock; beautiful in falls, in
> lakes, in living pools; so full of fish that you might take them
> out with your hands instead of nets. Or you may do always as
> you have done now, turn every river of England into a com-
> mon sewer, so that you cannot so much as baptize an English
> baby but with filth, unless you hold its face out in the rain; and
> even *that* falls dirty. (XXVII:92)

Eight months after this passage appeared, Ruskin's mother died.
The same combination of private association, religious sensibility,
and public concern reflected in his plans for controlling Alpine tor-
rents now led him to honor her memory by having one of the springs
of the Wandel, "the river of paradise" where his mother had taken
him to play as a child, cleaned of the sewage and industrial waste that
had polluted it. He placed an inscribed tablet there to her memory:
"In obedience to the Giver of Life, of the brooks and fruits that feed
it, of the peace that ends it, may this Well be kept sacred for the ser-
vice of men, flocks and flowers, and be by kindness called
MARGARET'S WELL" (XXII: xxiv).[15]
Given the fascination with waterways and the cluster of personal,
religious, moral, and social concerns that inform his attitude towards
clean water and its pollution, it is not surprising that when Ruskin
dedicated his Guild of St. George to the task of reclaiming waste land
he should have envisioned the draining of marshes to create farm-
land, or, should the land donated to the Guild prove too rocky for
agriculture, the creation of reservoirs to be stocked with fish
(XXXVIII:19). In practical terms the Guild was to be a mere beginning
in political and economic reorganization, taking advantage of such
opportunities for the purchase and working of land as could be
found; but in Ruskin's mythopoetic imagination its purpose was the
realization of a central motif of romance—the reconciliation of a
reordered mankind with a redeemed nature, the restoration of a
pastoral earthly paradise.[16]
The urge to play that came upon Ruskin in middle life after the

high seriousness of his youth (even more than most only children, young Ruskin was like a miniature adult—he was so very good at it) led to such acceptable adult recreation as hiking in the mountains, collecting geological specimens, and improving his grounds and gardens, as well as activities somewhat more eccentric but still tolerable in his time: construction of his backyard waterways, and romps with girls at the Winnington School. It most probably contributed as well to the element of play in Ruskin's experiments with physical labor. Though "for months of his boy's life he watched bricklaying and paving" it was not until he conceived of the Hincksey road project at Oxford in 1872 that he found in the need to educate young gentlemen in the dignity of physical labor a proper public excuse for getting paver's tools into his own hands. This combination of private impulse and public need is one key to the understanding of Ruskin's proposals for social reform.

The Outsider

". . . supposing myself a mere outlaw in public opinion . . ."
Ruskin to Burne-Jones

THE GESTURES OF defiance directed against the accepted order of things that act out impulses suppressed in childhood, such as the cleansing of the Wandel spring and the Hincksey road project (which created an astonishing furor, as Ruskin surely hoped it would, by affronting the popular idea of the gentleman), were the gestures of an outsider. They were hardly what proper Victorians would expect of a Christ Church man. They were not the gestures of a Matthew Arnold. Ruskin's idea of himself as a perpetual outsider reflects the last major calamity of his upbringing that he lists—one that seems at first surprising given the many stories of Ruskin's almost courtly deportment—"I was taught no precision nor etiquette of manners" (XXXV:45).[17]

At the center of his parents' world, an only child, particularly one of older parents, supported by constant attention and encouragement, generally becomes individualistic and confident of his own importance, but uneasy outside the family circle. As a child he is apt to find that the imitation of adult behavior so pleasing to his parents does not find favor with his peers. As an adult such a person may seem independent and capable to others and yet persistently feel

himself to be a child in an adult's world. Some of the most intensely
emotional scenes in *Praeterita* record moments of acute social embar-
rassment, and Ruskin actually recalls his lionization after the success
of *Modern Painters I* as the "torment and horror" of having "to talk to
big people whom I didn't care about" (XXXV:502).

At the insistence of his father, Ruskin was registered as a gentle-
man commoner at Christ Church, a distinction usually reserved for
the titled or landed gentry.[18] Though softened by time, the stylized
and gently ironic recollection of Ruskin's university days in *Praeterita*
still conveys quite vividly his sense of being socially out of place, as
though he had been seated by accident in Tintoretto's S. Giorgio
Maggiore *Last Supper*.

> The change from our front parlour at Herne Hill, some fif-
> teen feet by eighteen, and meat and pudding with my mother
> and Mary, to a hall about as big as the nave of Canterbury Ca-
> thedral, with its extremity lost in mist, its roof in darkness, and
> its company, an innumerable, immeasurable vision in vanish-
> ing perspective, was in itself more appalling to me than appe-
> tizing; but also, from first to last, I had the clownish feeling of
> having no business there. (XXXV:194)

Ruskin's very eagerness to perform well at Oxford led initially to
embarrassment. For a gentleman commoner to have his mother liv-
ing on the High Street was, for all Ruskin ever heard about it, a tol-
erable eccentricity; but to strive for excellence on the weekly essay
went against the gentleman's code. When he was privileged to read
his essay in Hall, and it proved, like the work of some vulgar student,
to be a serious matter that took fifteen minutes to read, Ruskin was
told in no uncertain terms "that Coventry wasn't the word for the
place I should be sent to if ever I did such a thing again"
(XXXV:196). The very gaps in his early education made the academic
side of Christ Church—then inferior academically to Balliol—more
useful to him than it might have been to a student equipped with the
standard preparation. Thus, Ruskin felt himself an anomaly at
Christ Church, a "cur among the dogs of race," to use his phrase.
Raised to admire the aristocracy, he found a few perfect specimens
of the breed at Oxford, but more often than not he found degener-
acy.[21]

In truth, as the *Family Letters* reveal, Ruskin was a considerable so-
cial success at Oxford. His drawing ability and the fact that he could
hold, and supply, a good deal of sherry were generally well received,

and his intellectual and artistic ability was noted by sympathetic tutors and appreciated by the more serious students. He won wide acceptance, made a few lifelong friends, and the letters do, as their editor remarks, "furnish an impression of Ruskin's experiences at the university quite different from his memories in *Praeterita*" (*FL*:xliii). But *Praeterita* is concerned primarily with what Ruskin felt, not with what he accomplished. If the letters are read carefully the social ambition of Ruskin's parents and his desire to please them are clearly connected to the apparent conquest of his shyness. "He was just this minute come in to lunch," wrote a glowing Margaret Ruskin:

> He brings word he has been elected member of the Ch[rist] Ch[urch] Club, the only serious club, in Oxford, very exclusive—at present only ten members, John being the tenth. Ld. Carew, Simeon, Ackland [sic], & Mr. Denison were among those who proposed John—one black ball is sufficient to exclude, almost all the Noblemen who have ever been at Ch[rist] Ch[urch] have been honorary Members; No riders, no Rowers, are admitted, none but the very steady of the *first classes*, so it is a great honour, and quite unsolicited, indeed when Mr. Ackland [sic] told John, that Lord Carew, Mr. Simeon, Mr. Broadhurst, & himself were desirous that he should become a member, John objected, saying he had little time for things of this kind, and that he might be black balled which he should not at all like to risk. "Oh, is that your objection, if I were to bring you word that you were elected, would you refuse to become a member[?]" John answered of course, the honour being great, he could not refuse, but begged he might not be proposed, at least till next term. In the afternoon Mr. Ackland [sic] returned, saying he had been elected. . . . I must wait till John comes in from *his Club* for matter to fill my paper. (*FL*:478)[22]

Ruskin mingled with the sons of the nobility at Oxford, but he was not of them. The sense of being out of place continued after Oxford, though, as his father hoped, his Christ Church years opened many doors to him socially. His father kept Ruskin out of the wine business and made a gentleman of him, but the assurance of the gentleman born in merely being not doing could not be assumed easily by an Evangelical one generation away from trade. It was not until his Oxford appointment in 1869 that Ruskin held an official position—something of which he must have been acutely aware,

Tom Tower, Christ Church Oxford (1838) in Ruskin's early Prou-
tesque manner.

especially when giving public testimony on social questions. Even
after he became Slade Professor, Ruskin felt uneasy in high company
until sure he was accepted. Invited to Hawarden to meet Gladstone
in 1878 he "secured, in view of a possible retreat, a telegram which
might at any moment summon him home; this telegram loomed
largely the first day, and we were constantly under its menace. But
as hour by hour he got happier, the references to its possible arrival
came more and more rarely, and finally it became purely mythi-
cal."[23]

The gentle pages of *Praeterita* do not reveal the depth of Ruskin's

feeling both about gentlemen who betray their heritage, and the pride of a John James Ruskin who insisted that his son mingle with them for reasons of rank alone. Having adopted his father's love of Scott's self-sacrificing noblemen, he could not help contrasting that ideal with the gaming and game preserving aristocrats denounced by Carlyle, a class well represented at Christ Church. When in later years the father objected that Ruskin kept too much company with such men of low birth as Burne-Jones he drew a stinging rebuke from his son.

> In nothing is that same "pride" more beautiful than in the way it has destroyed through life your power of judging noble character. You and my mother used to be delighted when I associated with men like Lords March & Ward—men who had their drawers filled with pictures of naked bawds—who walked openly with their harlots in the sweet country lanes—men who swore, who diced, who drank, who knew *nothing* except the names of racehorses—who had no feelings but those of brutes—whose conversation at the very hall dinner table would have made prostitutes blush for them—and villains rebuke them—men who if they could, would have robbed me of my money at the gambling table—and laughed at me if I had fallen into their vices—& died of them." (*WL*:369-70)

The social discomfort Ruskin experienced at Oxford, which led in later life to his angry response to what he saw as his parents' false pride and interest in social rank for its own sake, and formed a curious link between the Christ Church man and the "rough Annandale peasant" Carlyle, merely continued in a broader context the discomfort he had first and most acutely felt in 1833 during the family's first continental tour. In Paris the Ruskins visited the Domecq family whose Spanish vineyards were the source of Mr. Ruskin's sherry, and whose workers, in Ruskin's mature view, largely created the Ruskin family fortune by their labor. Here for the first time the intensely Evangelical John Ruskin, age fourteen, met the Domecq daughters, among them Adèle-Clothilde. Knowing but little French, unable to dance, ignorant of the games popular with the girls, Ruskin was—probably for the first time in his life—not only embarrassed, but nonplussed. The situation was saved by Elise, then nine, who chattered to Ruskin for an hour and a half without worrying about a reply. "The hour and a half seemed but too short, and left me resolved, anyhow, to do my best to learn French" (XXXV:85).

When the Domecq family returned this visit three years later, Adèle was fifteen and Ruskin fell in love with her.

> Virtually convent-bred more closely than the maids them-selves, without a single sisterly or cousinly affection for refuge or lightening rod, and having no athletic skill or pleasure to check my dreaming, I was thrown, bound hand and foot, in my unaccomplished simplicity, into the fiery furnace, or fiery cross, of these four girls,—who of course reduced me to a mere heap of white ashes in four days. Four days, at the most, it took to reduce me to ashes, but the *Mercredi des cendres* lasted four years. (XXXV:179)

In the course of the Domecq's stay at Herne Hill it was once again the younger sisters, Elise and, sometimes, Caroline, who provided sympathy for Ruskin whose company bored Adèle, and whose pas-sion poured into prose and verse merely moved her to laughter. I stress the sympathy Ruskin received from Elise (who, indeed, re-mained a friend until her death in 1868) because Ruskin's biogra-phers, intent on love rather than friendship, have ignored its significance. Ruskin's infatuation with an Adèle who was largely the creation of his own longing set the pattern of his disastrous love af-fairs, while the sympathy of Elise points to a source of solace. Again and again in later life when faced with situations he could not re-solve, Ruskin turned to young girls for sympathy. This pattern may well have been established through the memory of his cousin Jesse, the lost bride of his early childhood, and the sympathy of Elise.

In the miserable last days of his marriage in the first months of 1854, when he was obviously unable to turn to his parents for help, Ruskin evidently tried to make special friends with Effie's ten-year-old sister, Sophie. We have only Effie's account of the attempt, but Ruskin's *Diaries* for January and February do confirm that he spent time alone with her. Even if we allow for the possibility that Sophie may have overdramatized and Effie exaggerated what went on, it seems evident that Ruskin complained of Effie's behavior and tried to get the child to side with him (*MR:*20). In the late fifties and early sixties, a time of great stress between Ruskin and his parents, Ruskin took frequent refuge at the Winnington girls' school and, as his repu-tation increased, he acquired any number of girls as disciples and correspondents.

Ruskin's pleasure in the company of girls and young women grew out of the craving for affection that his childhood left unsatisfied,

and his tendency to seek their uncritical company was exaggerated by the scandal following the annulment of his marriage.[24] But Ruskin's friendship with the girls at Winnington is also part of a larger pattern. With the exception of a few old and trusted friends like Dr. Acland, Ruskin was rarely able to be close to people on a basis of equality. (Acland himself had been like an older brother to Ruskin at Oxford.) His marriage became a miserable parody of the domesticated courtly love, the mutual submission of wills, he was to project in "Of Queens' Gardens." In the majority of his close adult relationships Ruskin cast himself either as child or mentor, as reflected in personal, half-playful forms of address. True, there was "Brother John" Simon, but Carlyle and, upon occasion, Rawdon Brown were addressed as "papa"; Mrs. Cowper-Temple, the personified *"Phile,"* "Isola Bella" and, ultimately, "Grannie."[25] Mrs. Talbot was "mama." As a girl, Mrs. Severn was "Doanie," or "Fernie," but after nursing Ruskin during his illness at Matlock in 1871, and attending to him after the death of his mother, she became "di ma" to Ruskin as well as her own children. To Joan he was the "coz" or "di pa"; to her husband Arthur, the Professor, and so on. To his servants and the companions of his Guild of St. George, Ruskin was the Master, a title he took seriously, as he told Charles Eliot Norton:

> I never felt more—(—though I often feel intensely—) the deep spirituality of Horace's question—"ignavis amicis," than when I read your question how I could bear the 'cant' of a man's calling me Master, who has been my faithful servant these thirty years! Nothing ever showed me the impossibility of the American mind ever understanding the deepest motives of the English one, so hopelessly.
>
> But 'Master' is now my *legal* address by members of the St G. Guild—as much as 'colonel' or 'captain' in the army or navy. The ex-mayor of Birmingham writes to me so—as naturally & simply as my own servant.[26]

The artists Ruskin aided were his children, particularly Burne-Jones, who, together with his wife, responded by frequently addressing Ruskin as "papa." Many of Ruskin's letters to Dante Gabriel Rossetti and Elizabeth Siddal were written in the tone of an indulgent parent. Rossetti tolerated Ruskin's patronage for a time, but never became a dutiful son, and his resentment of the paternal role Ruskin sought to play in his life contributed to the rupture of their friendship.

The title "St. C.," first bestowed by Rose La Touche but used by Ruskin as a signature at one time or another in letters to most of his close friends, symbolizes Ruskin's vacillation between the role of child and of mentor. Ruskin became Rose's St. Crumpet in 1859 "because their governess was 'bun'" and he was kind to beggars; but his acceptance of the nursery pet name aligned him with the children and served as a playful cover for the devotion to Rose he was fated never to express to her directly, wholly, and without restraint. To the older "Wisie" La Touche and to Mrs. Cowper-Temple, "St. C." was Saint John Chrysostom, the martyr known as "the Golden-mouthed," eloquent in his denunciation of abuses by the state (and the women) of Constantinople.[27]

The dual nature of Ruskin's St. C., split between a public and private martyrdom, has its parallel in the identification of himself with St. George that dates from childhood. It is an identification that is manifest in his public battles with the evils of his time, as we shall see. This identification also had its private side, however, a battle with dragons of wrath within paralleling the public struggle: "I have a hard time of it and curious Dragon battle, about Rosie. I was nearly beaten yesterday,—lance in worse splinters than Carpaccio's and not at all so well through the back of the throat—but it holds, I am thankful to say."[28] The antithesis of the identification of himself as a knight of holiness, distanced with playfulness, is with the boar John James Ruskin adopted for the family crest. It too has a doubleness. Ruskin regularly wrote rhymed letters to Joan Severn in his heraldic character of "Little Pigs," having, he tells us, studied pigs since the days the Ruskins first raised them at Denmark Hill and gave pork as special gifts, and having accepted in some measure the piggish side of his character—the swine being "the type of consumption" (XVII:213). Ruskin's heroic St. George was the archetypal conqueror of the wasteland and provider of food, the fruit of the earth, as the root of his name would suggest. It is hardly surprising that Ruskin took violent exception to Emerson's characterization of the historical St. George as "a low parasite who got a lucrative contract to supply the army with bacon."[29]

The most important hierarchical relationship of Ruskin's life was, of course, with his parents, and it lasted in some form all through their lives. His doting parents stood between young Ruskin and the world, so by manipulating them he could get most of what he wanted. Judging from the *Family Letters* the young Ruskin was nearly as successful in wheedling favors out of his "dour" mother as most well-loved children are—at least on weekdays.[30] As he grew older it

was his father who held the key to his desires. As the gentleman John James never had the chance to be, his son could of course have nothing to do with the sherry trade, and as Ruskin did not go into the Church or a profession he had no income that was truly his own during his father's lifetime. He was, like his mother, dependent on his father financially. (The expense of producing his books in those years far outweighed royalties.) If there was something Ruskin wanted—a Turner, minerals, rare books, money to disburse in a good cause—he had to account for it to his father.[31] To justify expenditures that filled his own needs rankled, yet he preferred to remain, in effect, a child overspending his allowance rather than establish a fund that was entirely his or, generally, to sell a part of his collection to obtain something else—a frequent practice after his father died. Even after his father's death Ruskin was nagged by a sense of unmanly dependence, that somehow, no matter how many hours he wrote, or drew, or studied, he had not earned his bread as he thought every man should.

Ruskin's financial dependence upon his father persisted through the period of his marriage and played no small part in its failure. John James was uncommonly generous with his money. There would, for example, have been no *Stones of Venice* had he not financed John and Effie's two stays there and underwritten the costs of publication. But like many self-made men who have converted careful personal habits and business acumen into a fortune, he could be generous in large things, yet overscrupulous, even mean, in small ones. John James expected a return on his money in the form of gratitude and dependence. He also expected to have his say on how the money was spent even if he did not finally insist that he be obeyed. John could use his work as an excuse for extra expenses and get, as he always had, most of what he wanted through his father, but Effie had no such recourse and was continually reprimanded, directly and indirectly, for her alleged extravagance.

After the annulment of Ruskin's marriage, most of the financial correspondence between father and son concerned the payment of debts already incurred. (The major exception seems to have been the discussion of Ruskin's contemplated home in the Alps in 1862.) But when he acquiesced to his father's will and did something he would have preferred not to, Ruskin was capable of exacting payment as a virtual *quid pro quo*. In March 1861, for example, John James insisted that Ruskin accept an invitation from Lord and Lady Palmerston to spend the weekend at Broadlands (later the Mount-Temple estate). After giving his reasons for not wanting to go, Ruskin set his

conditions: "However, if you are really set up on it, give me four more of Griffith's or Mrs. Cooper's sketches (which will I suppose be soon in the market) for the four days I lose—and I'll leave on Thursday, call at Chepstow to see what it is like and go to Broadlands on Friday morning" (*WL*:287).

That Ruskin should have remained so much a child in the presence of his parents even after he had established himself in the outside world as an authority on art and, in the 1860s, as a popular lecturer whose talks were upon occasion reported in the *Times*, may seem anomalous, but in this as in so many things Ruskin fits a pattern common to only sons born of relatively old parents. When Ruskin married, his parents were in their sixties, as old as a typical young couple's grandparents, and set in their ways. Ruskin's Victorian deference to his aged and infirm parents may seem excessive today, but was admired by most everyone who knew him. It is the degree of emotional independence Ruskin achieved, more than the issue of physical proximity and his patience under the reprimands of a mother old and hard of hearing, that is important to judge when considering Ruskin's life.

Faith

"If thou be the Christ, tell us *plainly*." Well: that question was only wrong because asked in the face of clear evidence; and wrong as it was—it was answered.
<div style="text-align:right">To the Rev. W. L. Brown, 1850</div>

THE SELF-ABSORPTION that an only childhood is apt to produce was certainly reinforced in Ruskin's case by the family's Evangelical religion. The Evangelical emphasis upon the struggle between God and the devil for control of the individual soul; the constant exercise of the will to resist temptation, to do good, to remain pure; the watch for signs of God's grace or displeasure, can lead quite naturally to the feeling that one's inner conflicts are a specific instance of a general pattern and thus of universal validity and interest. Ruskin's successive critical stances are resolutions of inner conflicts as well as engagements with genuine external artistic and social problems. Indeed his ability to match the two is the hallmark of his genius. When Ruskin left Evangelicalism behind him (at least formally; he was never to be utterly free of it, and the struggle between God or his

saints and Satan for his soul recurred as his mind was overborn by mania) he was fond of pointing out the egocentric basis of Protestant religion: "There probably never was a system of religion so destructive to the loveliest arts and the loveliest virtues of men, as the modern Protestantism, which consists in assured belief in the Divine forgiveness of all your sins, and the Divine correctness of all your opinions" (XXII:81). Ruskin was, unhappily, unsure for most of his adult life about the forgiveness of his sins, but, though his views changed, they were marked even in post-Evangelical days by a conviction of the divine correctness of John Ruskin's opinions that never completely faded.

In addition to reinforcing the tendency towards solipsism that a secure only childhood is apt to encourage, and converting inner conflicts into a model of the larger struggles in the world arena between the forces of good and evil, Ruskin's Evangelicalism formed the literalistic, typological habit of mind that conditioned his response to art and literature from beginning to end, and influenced his mode of argument in every field. Already in the sermon summaries Ruskin composed at the age of nine, in addition to the usual presentations of type and antitype—foreshadowing, fulfillment, and prophecy; old law and new—there was the equation between economic law and divinely ordained natural law characteristic of his social thinking.

> All things are valued by their scarcity & there is no value attached to that which is in rich abundance. Gold is valued because it is scarce, but the rock in which it is found is not valued, because it is plentiful. As God therefore can call every creation into existence with equal facility no creature can be of value in his eyes and we are compelled to seek a sacrifice beyond creatures, which sacrifice must be Christ.[32]

Typology could reconcile the Old and the New Testaments, and literal reading with figurative interpretation, because both type and antitype were believed to be historical actualities and thus distinct from allegorical fiction. In the course of a typical event time and eternity momentarily interpenetrate. Thus a biblical man or woman, confined in the chronological time of the fallen world, performs an action that is simultaneously an event in his or her own time and in providential or *kairos* time. The action is simply part of the individual's life, yet has its completion in a later historical occurrence as part of progress toward that divine event to which all creation moves.[33] The doctrine did not demand that (to take an example dear to

Margaret Ruskin) in her song of praise thanking God for the child for whom she had so fervently prayed, Hannah should know that her words applied equally to her own child and to the coming Messiah. The first event does not cause the second, but their connection is preordained. Typology in the strictest sense, ritual or legal typology, was confined to the prefigurations of Gospel events in the Mosaic law. But historical typology was applied to prophecies extending beyond New Testament times, forming, wrote the Rev. Patrick Fairbairn:

> a double prophecy—a typical prophecy in action, coupled with a verbal prophecy in word; not uniformly combined, however, but variously modified: in one class a distinct typical action, having associated with it an express prophetical announcement; in another, the typical lying only as the background on which the spirit of prophecy raised the prediction of a corresponding but much grander future; and in still another, the typical belonging to a nearer future, which was realized as present, and taken as the occasion and groundwork of a prophecy respecting a future, at once greater and more remote.[34]

Thus in the first half of Hannah's song we see "the germ of sacred principle unfolded in the type; in the latter, it exhibits this rising to its ripened growth and perfection in the final exaltation and triumph of the King of Zion."[35]

Prophetic typology was particularly important to the Protestant forerunners of Evangelicalism. Hans Frei argues that it was not the rise of deistic rationalism and skeptical modes of thought alone, but also, paradoxically, the eagerness of seventeenth-century Protestants to see the fulfillment of types and prophecies in the events of their own times that led to the "breakup of the cohesion between the literal meaning of the biblical narratives and their references to actual events." The effect of this breakup was to change narratives that had been the means of access to historical events into a verification of their meaning so that "the depicted biblical world and the real historical world began to be separated at once in thought and in sensibility."[36] Typology retained its traditional structure, but where the emphasis had once been upon the enclosure of the believer in the world of biblical narrative, it was now placed upon the application of types to the believer's own time. Although the implicit split between biblical time and a providentially governed modern history was

inadvertently opened within Protestantism by believers in the literal
truth of the Scriptures, it opened the way for the eventual testing of
the factual truth of the Bible against rival explanations.

Ruskin himself, as George Landow points out, was introduced to
typology largely through Evangelical sermons. For the Evangelical,
his own spiritual pilgrimage in imitation of the pattern set by the
Redeemer forms the core of religious experience, of saving faith.
While there are Evangelical sermons that concentrate on the explica-
tion of types, they more often emphasize their application, particu-
larly if that application can be connected to the pattern of salvation.
Thus Henry Melvill, Ruskin's favorite preacher, expounding upon
the death of Moses goes beyond the text to insist that Moses upon
Pisgah has sight not merely of Canaan, but his antitype: "the Being
by whom that landscape would be trodden, and who would sanctify
its scenes by his tears and his blood." By the nondoctrinal step of
making Moses typologically self-conscious, Melvill can turn from
explication to an application that makes the death of Moses a pattern
for Christian dying:

> when a Christian comes to die, . . . his eye, with that of Moses,
> must be upon the manger, the garden, and the cross. . . . O
> that we may all be living in such a state of preparedness for
> death, that, when summoned to depart we may ascend the
> summit, whence faith looks forth on all that Jesus hath suf-
> fered and done, and exclaiming, "we have waited for thy salva-
> tion, O Lord," lie down with Moses on Pisgah, to awake with
> Moses in Paradise.[37]

It is easy to picture typical acts as moments of arrested action: Isaac
bearing the altar wood up the mountain in Moriah; Abraham, knife
raised, beholding the ram in the thicket. Typological interpretation
reconciled the visual and literary aspects of Ruskin's youthful imagi-
nation under religious sanction, and as Landow has explained, gave
the Oxford Graduate a ready-made critical tool when he turned to
the analysis of religious art. But while Ruskin recognized and com-
mented upon the representations of typological subjects, his own use
of the method and its vocabulary was heterodox long before his
"unconversion."

> The earth of the Sistine Adam that begins to burn; the
> woman-embodied burst of Adoration from his sleep; the
> twelve great torrents of the Spirit of God that pause above us

there, urned in their vessels of clay; the waiting in the shadow
of futurity of those through whom the Promise and Presence
of God went down from the Eve to the Mary . . . and perhaps
more than all, those four ineffable types, not of darkness nor
of day—not of morning nor evening, but of the departure and
the resurrection, the twilight and the dawn of the souls of
men—together with the spectre sitting in the shadow of the
niche above them; all these . . . retain and exercise the same
inexplicable power. (IV:281-83)

Although the comment upon the "shadow of futurity" suggests
conventional typology, Ruskin's actual use of the word *type* in the
passage refers to statues usually described as allegorical; that is, he is
using the word to describe personified abstractions that are not types
in the doctrinal sense at all, and his critical typology often verges into
allegory. Looking back on his early work Ruskin defined *type* as "any
character in material things by which they convey an idea of imma-
terial ones" (IV:76). Ruskin's use of the word *type* is more often in its
general sense as essence, pattern, or even symbol than in the strictly
religious sense. Ruskin even uses *type* negatively upon occasion, as in
his objection to the conventional symbolism of the descending dove
as the holy spirit, the repetition of which "hardens us, and makes us
look on it as *a mere type or letter,* instead of the actual presence of the
Spirit" (IV:267; my italics).

Ruskin is heir not only to the Evangelical tradition of exegesis, but
to the more general tradition of abstracted typology described by
Paul Korshin, which since the seventeenth century had been extend-
ing typology into history, politics, fiction, poetry, and natural relig-
ion, whether through confusion in exegetical terminology or
deliberate adaptation. Evangelical typology is actually less important
as a key to Ruskin's criticism than as a clue to his habit of mind. The
fact that a type may be said to symbolize its antitype yet remain an
historical reality rather than an abstraction lies behind Ruskin's habit
of thinking in terms of historical analogues, connected, but not cau-
sally connected. Such thinking leads Ruskin to suggest that the fate
of Tyre lamented in Ezekiel prophesies that of Venice, which may in
turn anticipate the fate of an unrepentant England; to analyze the
effect of the corruption of city life upon the artist by contrasting the
boyhoods of Giorgione and Turner; to ground pagan myths in natu-
ral phenomena and then pair Greek gods and biblical personages;
even, in *Fors,* to draw conclusions about the English national charac-
ter by analyzing that of Richard Coeur de Lion. The Evangelical

emphasis upon prophetic type and fulfillment left Ruskin particu-
larly sensitive to the manifestations in life of prophetic images, which
retained their imaginative potency for him far longer than any secta-
rian interpretation of them. Thus the sight of the face of a Venetian
boy selling "half rotten figs, shaken down, untimely, by midsummer
storms" before the Ducal Palace was to Ruskin a kind of epiphany.

> [It] brought the tears into my eyes, so open, and sweet, and
> capable it was; and so sad. I gave him three very small half-
> pence, but took no figs, to his surprise: he little thought how
> cheap the sight of him and his basket was to me, at the money;
> not what this fruit "that could not be eaten, it was so evil," sold
> cheap before the palace of the Dukes of Venice, meant, to any
> one who could read signs, either in earth, or her heaven and
> sea. (XXVII:336)

Like a biblical type figure the boy acts without awareness of the
symbolic significance of his action, at least in the eyes of his peculiar
customer. And we, the readers of *Fors*, must have in mind the refer-
ence to vile figs in Jeremiah, Amos, and Revelation in order to un-
derstand the sign Ruskin is reading, and what it is doing in a chapter
devoted to the topic of blessing and cursing, for the figs are the por-
tion of Israel that God will curse and "consume from off the land"
(Jer. 24:10). The sin for which in these latter days judgment is to fall
is suggested in the verses that follow the reference to figs in Amos 8,
though Ruskin never specifically alludes to them. It is the curse upon
those who "swallow up the needy," who "buy the poor for silver, and
the needy for a pair of shoes; *yea* and sell the refuse of the wheat."
These verses lie behind the paragraph following the encounter with
the fig seller in which Ruskin accuses the churches of having lost the
will either to provide material help to the poor or to curse their ex-
ploiters.[38] Ruskin's type figures are very close to Carlyle's "intrinsic
symbols" and have a common Protestant root. This parallel in histor-
ical typological thinking accounts for much of the sympathy between
them to be explored in the next chapter.[39]

Understanding of Christ and his revelation had, of course, a more
immediate and personal aspect for the Evangelicial than the recogni-
tion of types and their historical unfolding. He was to empathize
with the experience of Christ, his types, his saints, a practice that
Ruskin extended to their artistic representation and continued
through his period of doubt. Having a saint name himself, Ruskin
was naturally attentive to the lives of others who had borne it, as he

wrote to his mother in 1870:

> Yesterday—on St. John's day I saw a picture of the religious
> schools by a man whom I had never before much looked
> at[Filippo Lippi], which is as much beyond all secular paint-
> ing—curiously enough—St John Baptist is also the principal
> figure in it—and I am really beginning, for the first time in my
> life—to be glad that my name is *John*. Many thanks for giving it
> to me.[40]

In 1874, in flight from Rose's year of dying, Ruskin settled in Assisi
for a time and, in imitation of his patron saint, Anthony of Padua,
took up residence in the Sacristan's cell. In the Lower Church he
encountered the fresco of the *Madonna and Child Enthroned* by
Cimabue (himself a Giovanni), in which he saw united "the intellect
of Phidias with the soul of St. John" (XXXVII:114), leading him to reas-
sert the power and authority of medieval art. He busied himself
copying not only the Madonna, but the attendant figure of St. Fran-
cis drawn as if from life, heightening the already remarkable resem-
blance of the saint to that self-proclaimed brother of his Third
Order, John Ruskin (see frontpiece).

Typological Science

> The true and divine distinction between "genera" of animals,
> and quite the principal "origin of species" in them, is in their
> Psyche: but modern naturalists, not being able to vivisect the
> Psyche, have on the whole resolved that animals are to be
> classed by their bones. (XXVIII:719)

KATA PHUSIN, "According to Nature," was Ruskin's first nom de
plume, and the signature would have been appropriate for nearly all
his prose. Through the various stages of his religious belief Ruskin
held firmly to the conviction he shared with Carlyle, that there was a
link between the laws of nature and the principles of right conduct;
that somehow, despite all his uncertainty about doctrine and per-
sonal salvation, he could read both the face of the sky and the signs
of the times; indeed, each in the other. This association, like so much

in Ruskin, goes back to earliest childhood.

As soon as he could speak Ruskin shared his mother's concern for John James' safety on his extended business trips, her eagerness for letters, and her joy at his return. When Ruskin was three, mother and child joined the merchant errant on a trip to the Cumberland Hills and John was *born again*, beginning the sequence of pilgrimages and rebirths memorialized in *Praeterita* (XXXVIII:399). That the emphasis upon conduct already evident in the first line of his childhood sermon—"people, be good"—would harmonize with his love for nature was confirmed as principle and literary experience by his early reading of Pope and Wordsworth. The early taste for picturesque and sublime scenery encouraged by his father on the family travels (reinforced by love of Byron, and recorded in creditable verse at the age of eleven in the *Iteriad*) set the stage for Ruskin's response to Turner. These enthusiasms in their turn encouraged Ruskin to find in landscape and seascape correspondences to emotional and moral states.

Travel became the one authorized escape from Mrs. Ruskin's closely managed household. To see the places his father described in his letters (and surely spoke of in detail when home); then to see the Scotland of Scott, the lake country of Wordsworth; the continental scenes familiar through Byron's verse, Turner's art, Roger's *Italy*, Shakespeare's plays, and his first geology books—these were overwhelming experiences. Not surprisingly a constant testing of place against its representation became part of Ruskin's critical method, and travel practically a mode of life—all the more so after failures in marriage and love. The scenes of his early travels—the Lake District, Switzerland, and northern Italy in particular— became permanent parts of Ruskin's sensibility, places to which he returned for renewal in secular pilgrimage, places fixed in mind in the state in which he first beheld, studied, and drew them. When year after year he saw them transformed—hills carved up for railroad beds, Alpine glaciers in retreat, buildings and paintings destroyed or "restored"—he experienced these changes as assaults upon part of himself.

The tendency to equate inner states with the landscape (the basis of what he came to call "the landscape feeling" in *Modern Painters III*) was a Romantic version of ancient correspondence between the individual microcosm, its collective extension (society), and the macrocosm that Ruskin found in one form or another in most of his favorite writers, men he quotes time and again in his mature work: Plato, Spenser, Shakespeare, Milton, Wordsworth, and Carlyle. Ruskin's religious training coupled with his enthusiasm for Scott

Ruskin's childhood Venice: Turner's illustration in Rogers' *Italy.*

> steering in,
> And gliding up her streets as in a dream,
> So smoothly, silently—by many a dome
> Mosque-like, and many a stately portico,
> The statues ranged along an azure sky;
> By many a pile in more than Eastern pride,
> Of old the residence of merchant-kings;
> The fronts of some, tho' Time had shattered them,
> Still glowing with the richest hues of art,
> As tho' the wealth within them had run o'er.

ensured from the first that the middle link of this chain of correspondences, society, was not ignored. From the beginnings of his continental travels, Ruskin, like Saussure, his master in geology, observed the living conditions in the countries he visited. At first these observations were little more than contrasts between the clean Protestant and slovenly Catholic cantons of Switzerland, confirmations of Protestant bigotry. But they formed the habit of comparing and

contrasting societies in relation to their physical, religious, and political environment that is essential to his social thought.

From youth Ruskin's interest in mineralogy and geology rivaled his interest in landscape, painting, and literature, and his early travels were as much devoted to the collection of specimen rocks as the recording of specimen views. Ruskin's geological studies became one of the standards by which he measured the truths represented in paintings. The science Ruskin learned and subsequently practiced was Aristotelian in its paradigm and in its procedures. It was a science of observation, collection, and classification that revealed the inherent order of nature. It was a science of surfaces and visible structures, not of dissection and analysis. By comparing the morphology of specimens—animal, vegetable, or mineral—the Aristotelian scientist tries to distinguish essential similarities from accidental differences. He considers the essence defined, not as an abstraction, but rather the absolute nature of the thing described.

> Methodological essentialism, i.e., the theory that it is the aim of science to reveal essences and to describe them by means of definitions, can be better understood when contrasted with its opposite, *methodological nominalism.* Instead of aiming at finding out what a thing really is, and at defining its true nature, methodological nominalism aims at describing how a thing behaves in various circumstances, and especially, whether there are any regularities in its behavior. . . . The methodological nominalist will never think that a question like '*What is energy?*'. . . is an important question for physics; but he will attach great importance to a question like: 'How can the energy of the sun be made useful?'[41]

Essentialists from Greek times on have seen the universe as the product of a first cause, which, in the Christian tradition, became God as divine designer. Natural Religion was still part and parcel of the teaching of science when Ruskin was at Oxford. His science tutor the Rev. William Buckland devotes a chapter of his Bridgewater Treatise to the "Consistency of Geological Discoveries with Sacred History" and begins every chapter on fossils with a proof of design. Buckland reconciled the time scale of the creation story with the revelations of geology by arguing that the "*beginning*" of Moses expressed "an undefined period of time, which was antecedent to the last great change that affected the surface of the earth, and to the creation of its present animal and vegetable inhabitants; during

which period a long series of operations and revolutions may have been going on."[42]

Adjusting the interpretation of Genesis to allow for an extended "beginning" and "days" of indefinite duration, made a place for the fossil record within a time scheme that, however expanded, still had scriptural shape, bore evidence of God's molding hand in nature, and left man the central, final form of a teleological creation. The apparent movement up the scale of being from fossils found in lower strata to those located in more recent formations suggested to some an analogy with the structure of progressive revelation in the Bible itself. Thus Patrick Fairbairn inserted into late editions of *The Typology of Scripture* a section on typical forms of nature:

> as geology has now learned to read with sufficient accuracy the stony records of the past, to be able to tell of successive creations of vertebrate animals, from fish, the first and lowest, up to man, the last and highest; so here also we have a kind of typical history—the less perfect animal productions of nature having throughout those earlier geological periods borne a prospective reference to man, as the complete and ultimate form of animal existence. In the language of theology, they were the types, and he is the antitype, in the mundane system. . . . what a striking analogy does the history of God's operations in nature furnish to His plan in providence, as exhibited in the history of redemption! . . . certain remarkable personages, institutions, and events, which rise prominently into view as the course of providence proceeds, but all marred with obvious faults . . . until at length the idea, in its entire length and breadth, is seen embodied in Him . . . —the God-man, *fore-ordained before the foundation of the world.*[43]

It is one of the quirks of intellectual history that the progressivist doctrine of successive creations, which appears in retrospect to be a preliminary step on the road to Darwinism, was seized upon by religious conservatives as a vindication of the traditional structure of history and of God's active role in its unfolding. Unless and until advocates of the developmental hypothesis could devise a natural mechanism for, and find evidence of, transmutation of species, the fossil record itself could be plausibly presented as the successive record of the creative hand of God at work in His creation.

While Buckland's work gave credence to an Evangelical natural typology, the emphasis of his Oxford teaching was more upon

science than religion; his purpose not merely to show the congruity between geology and Genesis, but to stress how little they need overlap. He could thereby present a science at once doctrinally sound yet unfettered by dogma. Sir Charles Lyell, who had been Buckland's student a decade before Ruskin, carried this stance to its logical conclusion and fused divine intention and natural law in the processes of nature, developing not only his uniformitarian geology but also a nonprogressivist biology. Despite his Evangelical background, Ruskin followed Lyell, at least in geology. Although he probably accepted the literal truth of Old Testament narrative as dogma in childhood, his schoolboy essays on literature indicate that he found the Mosaic narrative less believable than Scott's historical novels. Likewise, though he was certainly raised to take the Genesis creation literally, his early *Letters to a College Friend* show that he considered the account of Eden to be incompatible with natural science (not simply geology but chemistry as well). He preferred that the story be read as something "very like an Eastern Allegory" with a readily accessible moral significance than that it be constantly reinterpreted in the light of scientific discoveries, a process that tacitly concedes the logical priority of science to revelation.

Uniformitarian geology and Darwinism together had the effect of transforming the spatial paradigms of Aristotelian science into temporal, developmental ones. While Ruskin's scientific thinking remained in the essentialist tradition of Dr. Buckland, his study of Lyell, and his reluctant acceptance after 1859 of the plausibility of Darwin's account of evolution, left him dubious of the accessibility of God's purposes to human reason. It cut him off from the sense of conscious participation in the divine scheme of creation that had been part of his childhood faith. The beginnings of things and their end became incomprehensibly remote termini of a single sequence in which providential time had no meaning. God's will and the signs of his grace became fearfully obscure and, as Ruskin wrote to Elizabeth Barrett Browning in 1861, "the idea of looking for God's hand" in the course of history had become absurd:

> You cannot tell *why* God acts, unless you could see not only the Hearts and minds of every man in the nation . . . [but] know all God's final purposes respecting them. What seems to you good may be evil, and *vice versa*. . . . God's *laws* you can trace. His Providence *never*. If you could, you would share in that Providence—you would be seeing with God's eyes. . . . I am stunned—palsied—utterly helpless—under the weight of

the finding out the myriad errors that I have been taught
about these things; every reed that I have leant on shattering
itself joint from joint—I stand, not so much melancholy as
amazed—I am not hopeless, but I don't know what to hope
for. I have that bitter verse pressing me, "I am a worm, and no
man." What is a worm to hope for?—to keep out of the spade's
edgeway and crawl its time in the twilight, while the great
Providence lights all the stars in their Courses. Many a year
ago I wrote this verse:—

> "God guides the stars their wandering way,
> He seems to cast their courses free,
> Yet binds them to Himself for aye,
> And all their chains are charity!"

I saw the terrible *Seeming* then; the charity I see still—but not
the Form of it in this time or that; for this person or that. And
you can't conceive how lonely I am in all this—and in more
than this. (XXXVI:363-64)

Ruskin never became a true agnostic, let alone an atheist, but with-
out doubt he lost faith in the promised end—personal salvation and
eternal life.

> That I am no more immortal than a gnat, or a bell of heath,
> all nature, as far as I can read it, teaches me, and on that con-
> viction I have henceforward to live my gnat's or heath's life.
> But that a power shaped both the heath bell and me, of
> which I know and can know nothing, but of which every day I
> am the passive instrument, and, in a permitted measure, also
> the Wilful Helper or Resister—this, as distinctly, all nature
> teaches me, and it is, in my present notions of things, a vital
> truth. (XXXVI:596)

Deprived of a vision of God's Providence, he tried to content him-
self with the examination of His laws and pursued the studies whose
truths had been fatal to his early faith, geology and philology, which
seemed to be a kind of natural history of language.

> The derivation of words is like that of rivers; there is one real
> source, usually small, unlikely, and difficult to find, far up
> among the hills; then, as the word flows on and comes into

service, it takes in the force of other words from other sources, and becomes quite another word—often much more than one word, after the junction—a word as it were of many waters, sometimes both sweet and bitter. Thus the whole force of our English "charity" depends on the guttural in "charis" getting confused with the c of the Latin "carus"; thenceforward throughout the Middle Ages, the two ideas ran on together, and both got confused with St. Paul's ἀγάπη, which expresses a different idea in all sorts of ways; our "charity" having not only brought in the entirely foreign sense of almsgiving, but lost the essential sense of contentment, and lost much more in getting too far from the "charis" of the final gospel benedictions. (1871 Appendix to *Munera Pulveris*, XVII:292)

When the Bible lost its literal truth and became for Ruskin, as it had for Carlyle, merely the first book of world literature, he increasingly valued wisdom from secular sources. Having in the 1850s countered the effect of his doubts by acting as if the Bible were true, so he began to read secular literature and pagan mythology as if true, and to treat it typically as preachers do the Bible, abstracting the type from its narrative context. (Thus the mad lover of Tennyson's Maud bidding her to "come into the garden" becomes a "type" of Christ calling the good women of England to labor in the garden of lost souls, at the end of "Of Queens' Gardens" [XVIII:143-44].) As his Evangelicalism faded, his tolerance of other religions, whether Christian or pagan, past or present, grew. As the presence of the Christian God faded from the face of nature, leaving Ruskin's lifelong concern with the effects of landscape and weather on man's sensibility and moral nature without its original rationale, his interest in the gods that had animated nature in pagan religion grew, and he wrote to Charles Eliot Norton only half in jest: "I've become a Pagan, too; and am trying hard to get some substantial hope of seeing Diana in the pure glades; or Mercury in the clouds" (1862, XXXVI:426).

Truth from whatever source now served as the basis of typically structured analogies and arguments, and its factual basis expanded from history to include science. Even anticipations of scientific findings may be invoked to provide the necessary grounding in fact. Thus in reading Turner's *Garden of the Hesperides* Ruskin is not content to show that both the Greek myth and Turner's version of it have a natural meaning, but insists that Turner's dragon anticipates paleontological discoveries. "The strange unity of vertebrated action . . . together with the adoption of the head of the Ganges

crocodile, the fish-eater, to show his sea descent (and this in the year 1806, when hardly a single fossil saurian skeleton existed within Turner's reach), renders the whole conception one of the most curious exertions of the imaginative intellect with which I am acquainted in the arts" (VII:403).

Myth was to Ruskin founded upon physical and moral fact. In his work in the 1860's Ruskin often moves with great rapidity from myth to physical fact, to moral fact, and thence to contemporary application, often by way of a biblical parallel. He developed, in short, an allusive style akin to the less mannered passages of Carlyle. One can virtually watch it unfold in the *Munera Pulveris* essays. Although Ruskin came to regret what he called its "affected concentration of language," *Munera Pulveris* is not incomprehensible, particularly to readers used to finding sense in Eliot, Pound, and Joyce.

In *Modern Painters II* Ruskin described that "unity of Membership, which we may call Essential Unity, which is the unity of things separately imperfect into a perfect whole" (IV:95). God is, of course, the all-embracing entity in which all of His created particulars participate. It is He who assures that the universe is meaningfully organized. Had contemporary science provided a purposive, teleological model of organization that Ruskin in his state of religious doubt could have turned to, an organization that would have preserved the human meaning he saw in nature, Ruskin would not have needed to rely upon etymologies and myth. But science was moving in the opposite direction. Geology could provide examples of order, but its revelation of purposes was being insistently questioned. Darwinian biology broke down even that absolute distinction between species upon which any stable system of symbolism based on the essential nature of animals or plants must rest. In 1883 Ruskin added a sardonic note to his announcement in *Modern Painters II* of a grand plan to set forth the characteristic beauties and truths of every division of creation from stones through plants to animals "from the mollusc to man; . . . the scientific world professed itself to have discovered that the mollusc was the Father of Man; and the comparison of their modes of beauty became invidious" (IV:143).

Ruskin was quite aware of the Darwinian controversy, and indeed, on the urging of the Nortons exchanged visits with Darwin in 1868 while he was composing *The Queen of the Air* (XIX:xliv-xlv). Unable any longer to invoke with confidence the creator's intention to explain the fact that species have a "distinct relation to the spirit of man," Ruskin posits a typological biology resting on reception rather than generation, arguing that "the aesthetic relations of species are

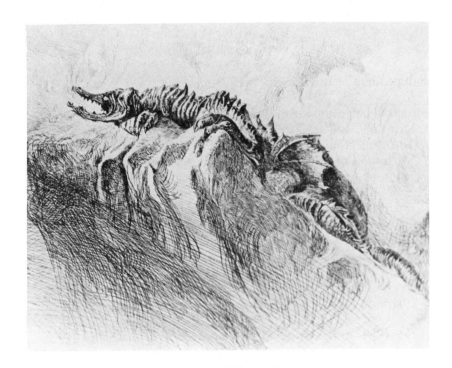

Ruskin's drawing of Turner's dragon as Dante's Pluto: "Quivi travammo Pluto il gran nemico" (VII:402).

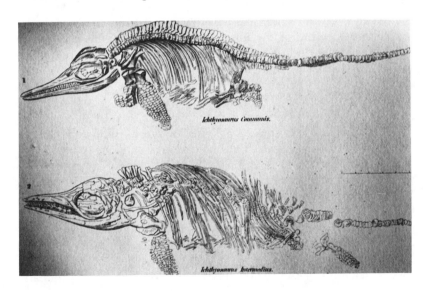

Fossil saurians from William Buckland's Bridgewater Treatise (1836).

independent of their origin."

> It is perfectly possible, and ultimately conceivable, that the
> crocodile and the lamb may have descended from the same
> ancestral atom of protoplasm; and that the physical laws of the
> operation of calcereous slime and of meadow grass, on that
> protoplasm, may in time have developed the opposite natures
> and aspects of the living frames; but the practically important
> fact for us is the existence of a power which creates that calca-
> reous earth itself . . . that the aspects and qualities of these two
> products, crocodiles and lambs, may be, the one repellent to
> the spirit of man, the other attractive to it, in a quite inevitable
> way, representing to him states of moral evil and good, and
> becoming myths to him of destruction or redemption, and, in
> the most literal sense, "Words" of God. (XIX:358-59)

Regardless of the efforts of such Evangelical divines as Fairbairn to
digest aspects of the new science, this mysterious deity who operates
through the mechanism of evolution to produce species and a hu-
man mind properly fitted to one another was to Ruskin a far cry
from the God who, by forming the common essence in which all cre-
ation participated, was perpetually present in his creation, let alone
the personal savior of the Christian religion. For him the products of
the proper meeting of the mind of man and the material creation
became myths, including the myths of gods present in nature. It is no
wonder that Ruskin's imagination responded to these myths as if
they were not only emblematically, but also literally, true: "the rubies
of the clouds, that are not the price of Athena, but *are* Athena." The
truths of typology no longer lay in anticipation or fulfillment of spe-
cifically Christian doctrines or prophecies, but in the type, or, as we
would say, archetype, itself. Thus he can substitute Greek mythology
for the Old Testament in the pattern of typological interpretations
without giving the absolute priority to Revelation that such patterns
had in Ruskin's models—pre-eminently Dante. "And so the Spirit of
the Air is put into, and upon, this created form; and it becomes,
through twenty centuries, the symbol of Divine help, descending, as
the Fire, to speak, but as the Dove, to bless" (XIX:361). Longing to de-
tect the presence of the divine in nature, Ruskin, in effect, creates
such a deity out of the various myths of and allusions to Athena in
the classics.
Even so distinguished a scientist as Lyell clung to the notion of
purpose and resisted the logical implications of Darwin's theory even

after he reluctantly abandoned his nonprogressivist biology. It is hardly surprising that Ruskin, like his fellow member of the Metaphysical Society, the Duke of Argyll, should have retained a teleological bias and, like Carlyle, refused to draw a line between physical and moral law.

> I always use the term "science," merely as the equivalent of "knowledge." I take the Latin word, rather than the English, to mark that it is knowledge of constant things, not merely of passing events: but you had better lose even that distinction, and receive the word "scientia" as merely the equivalent of our English "knowledge," than fall into the opposite error of supposing that science means systematization or discovery. It is not the arrangement of new systems, not the discovery of new facts, which constitutes a man of science; but the submission to an eternal system, and the proper grasp of facts already known. (*Eagle's Nest*, XXII:150)

To grasp a fact properly is to know its essence: to define it correctly and give it its proper name; to see its place in a hierarchy of essences. The natural science of Ruskin's late years was deliberately archaic and Linnaean in conscious opposition to Darwinism, and designed to sustain the faith in the moral significance of nature so deeply rooted in Ruskin's early life. To found the moral sense as Darwin did in social instincts acquired through natural selection was to play fast and loose with the concept of morality. To study the structure and possible evolutionary descent of animals without regard for either their beauty or the meaning that might be inferred from their place in nature was to divide harmfully man's own consciousness.

Ruskin's Pastoral Fairytale

> You will do well to form your own conclusions.
> (Manuscript Epilogue, I:348)

IN JULY 1841 during the unsettled time between the end of Ruskin's Oxford residence (cut short by illness and thus not the triumph his father had envisioned) and his pass examination, the family received a visit from Ruskin's cousin Euphemia Gray, who questioned the ability of the poet of *Friendship's Offering* and contributor to Loudon's

magazines to write a fairytale. The *Arabian Nights* and the *German Popular Stories* of the brothers Grimm with illustrations by George Cruikshank had been among the delights of Ruskin's childhood. He responded to his cousin's challenge by blending motifs from the tale of "The Golden Water" ("The Two Sisters who Envied their Cadette") with an Alpine setting, Dickensian grotesque, and an imitation of the Grimm narrative mode into *The King of the Golden River*. The story was written to amuse and distract both his cousin (three of whose sisters died in 1841) and himself (he wrote most of the story while undergoing Dr. Jephson's cure at Leamington, drinking saline waters less golden than green). Written without an overt didactic purpose or parental supervision, *The King of the Golden River* emerged as a relatively uninhibited expression of Ruskin's imagination at the age of majority, anticipating in graphic descriptions of mountain scenery and sunsets the prose of *Modern Painters*, and in theme his later writing on political economy and the proposed work of the Guild of St. George.[46]

The title of the first chapter of *The King of the Golden River* announces a conflict between natural and economic forces: "How the Agricultural System of the Black Brothers was Interfered with by South-West Wind, Esquire." Three brothers own the uncommonly fertile Treasure Valley; the elder two manage its economy.

> They lived by farming the Treasure Valley, and very good farmers they were. They killed everything that did not pay for its eating. They shot the blackbirds, because they pecked the fruit; and killed the hedgehogs, lest they should suck the cows. . . . They worked their servants without any wages, till they would not work any more, and then quarreled with them, and turned them out of doors without paying them. It would have been very odd, if with such a farm, and such a system of farming, they hadn't got very rich; and very rich they *did* get. They generally contrived to keep their corn by them till it was very dear, and then sell it for twice its value; they had heaps of gold lying about on their floors, yet it was never known that they had given so much as a penny or a crust in charity. (I:314)

The Black Brothers get their living by exploiting both nature and their fellow men, and morally these two forms of exploitation amount to the same thing: violation of the laws of nature, the laws of kind. The brothers—in Ruskin's later terminology—mistake riches for wealth and, ultimately, death for life. Nature and the brothers'

fellowmen are conflated in the figure of the South-West Wind. The contrast between the instinctive generosity of Gluck, the youngest brother, to the personified wind, and the elder brothers' callous inhospitality is a judgment upon the Black Brothers' agricultural system which, like any economic system, can survive only with the sufferance of nature and mankind. Rebuffed by the elder brothers, the South-West Wind passes moral judgment and takes his revenge, and "what had once been the richest soil in the kingdom, became a shifting heap of sand"—not through a caprice of climate, but because the Black Brothers' economic and social system was what it was.

The remainder of the tale concerns the efforts of each of the brothers in turn to restore the now waste valley by following the directions of the King of the Golden River, who had told Gluck that for the person who poured three drops of holy water into the headwaters the river would turn to gold. In keeping with the folktale tradition's "law of three,"[47] it is the virtuous youngest brother who succeeds, and the water he carries to the river's mountain source is made holy not by verbal blessing, but by the acts of kindness he performs on his journey up the mountain—acts which seem to require that the goal of the quest be sacrificed and which, therefore, the Black Brothers were incapable of performing, being stone morally before being turned into stone physically.

Gluck is now the owner of the restored valley's great estate, and like his brothers he has principles of political economy. "And Gluck went, and dwelt in the valley, and the poor were never driven from his door: so that his barns became full of corn, and his house of treasure. And, for him, the river had, according to the dwarf's promise, become a River of Gold" (I:347). Gluck, and the biblical style emphasizes the point, bases his economic practices upon Christian charity and does well by doing good. In *The King of the Golden River*, as in Ruskin's later economic writings, economics is subsumed under ethics and illustrated by parable. The single-minded devotion of the Black Brothers to the accumulation of capital is both an expression of their immoral nature and an unwitting denial of the ultimate source of their gold. They separate themselves from both physical and human nature by treating both as objects of exploitation rather than as parts of a living whole. Gluck, on the other hand, through his kindness to man and beast aligns himself with the powers of nature, and the water he casts into the headwaters of the Golden River, the baptism of a reborn garden, is dew that had condensed upon the leaves of a lily. Thus "the Treasure Valley became a garden again, and the inheritance, which had been lost by cruelty, was regained by

love" (I:347). But the Eden restored has no Eve, the love is all *caritas*, though the source stories end in the restoration of a family or in marriage.

It is part of the Black Brothers' crime against nature that they submit the necessities of life to the vagaries of supply and demand. They hold their corn from the market to drive up the price and then sell it for "twice its value." That value, Ruskin implies, is fixed and directly related to the power to sustain life. Grain, not metal, is the treasure of the Golden River. The valley itself is either a garden or a wasteland depending upon how it is spiritually, not merely physically, used. If it is tended as Gluck tends it, the valley produces the wealth that sustains its inhabitants; if it is exploited, as the Black Brothers exploited it, the valley may yield riches, but is destroyed in the process. The opposition of garden and wasteland is one of the most important in Ruskin's work.[48] That Englishmen choose, indeed, without thinking about it, in their actions *daily* choose between the two was the lesson Ruskin found in Turner's late work and the primary message of his economic writing.

The King of the Golden River is not simply a moralized folktale with a calculated didactic end, but a projection of the moral imagination. Before Ruskin had given any systematic thought to social problems he had already envisioned the happy society as a version of pastoral—the rural, agricultural community depicted as the garden of a restored earthly paradise. Gluck's charitable governance of the Treasure Valley adumbrates Ruskin's ideal society, a hierarchical, basically agrarian community in which there is concord between rich and poor, man and nature; a society in which the imagery of Christian pastoral is incarnate, in which, for example, bishops would truly oversee their spiritual flock as a shepherd his sheep.[49]

Art and Effie: A Semi-Independent Life

> I am afraid this matrimony will alter for both of us our notions of the proper as well as the pleasant.
>
> Ruskin to Euphemia Gray

GRADUATION FROM OXFORD left Ruskin with a range of interests but no vocation. When the Graduate of Oxford published the first volume of *Modern Painters*, however, the course of his career was set. While the prose of *Modern Painters* was as poetic as his father might

wish, and its preachment as moral as his mother could desire, Ruskin's path was independent of his parents' specific ambitions: he would be neither a Byron nor a bishop. As if in recognition of this new independence, Ruskin set off for the Continent in 1845 to gather materials for the second volume of *Modern Painters*, traveling abroad without his parents for the first time. It was to be Ruskin's great voyage of discovery, the tour which laid the foundation for most of his future writing on the history of art—the writing that moves beyond Turner and the beauties of Switzerland to consider the Italian primitives, the school of Florence, Tintoretto, and the Venetian tradition in painting and architecture. It was also the trip which took him far beyond his father's largely eighteenth-century taste in art and confirmed in his own mind, to his father's great disappointment, that his future work was to be in prose and not poetry.

John James Ruskin remained his son's literary agent and John still, as he had since childhood, submitted his manuscripts to his father for approval; but the elder Ruskin no longer had much influence on his son's judgments, though he might delay their public airing. The most notable example of the elder Ruskin's interference was the suppression of letters on social questions Ruskin wrote in Venice in 1852. He sent them to John James to forward to the *Times* with a prophecy of the future direction of his career: "Twenty years hence, if I live, I should like to be able to refer to them—and say, 'I told you so. . . .' And that would give me some power, then, however little it may be possible to do at present." The elder Ruskin suppressed the letters knowing that, regardless of the truth of his son's arguments, or of what might transpire in the course of twenty years, few readers of the *Times* would appreciate being told: "the first duty of a state is to see that every child born therein shall be well housed, clothed, fed, and educated, till it attain years of discretion. But in order to the effecting this, the government must have an authority over the people of which we now do not so much as dream" (XI:263).

Ruskin's development has its own shape, a logical progression from a concern with art as the expression of individual genius, to evaluation of art as the expression of a culture, to the envisioning of the kind of society that will produce great art and whose every worker is an artisan—the tradition carried forward by William Morris. When, after the breakup of his marriage, Ruskin determined to publish his social criticism without tying it to art, parental opposition was to no avail.

Ruskin now had a career, albeit one with no official status in either the world of business or the world of art. His reputation upon

publication of the second volume of *Modern Painters* seemed firmly established, and the next logical step for Ruskin to take toward an independent life was marriage. Marriage ought, after all, to put some distance between himself and his parents without any violation of religious or filial duty. After a vain and typically indirect attempt to impress Charlotte Lockhart by reviewing Lord Lindsay's *Sketches of the History of Christian Art* in her father's *Quarterly*, Ruskin's attention shifted to his cousin Euphemia Gray, who was on a visit to London from her native Perth in 1847.[50] After a largely epistolary courtship, the cousins married. The marriage proved a disaster that influenced the future course of Ruskin's life far more than he ever acknowledged.

It is easy to see how it was that the cousins were initially drawn to one another. John Ruskin, in addition to whatever personal attraction he may have had for Effie, was becoming an established figure in London literary and artistic society. "A queer being" John may have seemed to her for his dislike of going out, but there is no doubt that he *was* going out while Effie was visiting in 1847. He attended a private view of the year's Royal Academy show on a ticket sent by Turner himself, he was dining with the likes of the poet Rogers, the painter Edwin Landseer, and Thomas Babbington Macaulay. That Ruskin combined an almost fanatical devotion to his work with an uneasiness in company that gave him an intense and deeply rooted aversion to the purely social occasions Effie enjoyed was by no means obvious to her as she chronicled his engagements in her letters home. For his part Ruskin was bound to be flattered by Effie's attention and her professions of interest in his life and work. She was attractive, intelligent, and above all, as he had seen Effie at intervals since her girlhood and knew where he stood socially in relation to her, he had no reason to feel with her the awkwardness that afflicted him in high company and in the presence of most women not safely attached or maternal. Like his lost cousin Jessie, she was associated with Perth and the "crystal spring of Bower's Well" (XXXV:67).

Had they seen more of each other after Effie's 1847 visit, had the curious plan Ruskin originally formed for Effie to tour the Continent with the Ruskin family before marriage been carried out, dangerous illusions might have been broken. As it was, Ruskin was free to idealize Effie as he had Adèle, and to write her love letters filled with effusive outpourings of romantic cliché. There is an odd disjunction in the tone of the letters between passages of romantic posturing and those of analysis written in his customary style. (In literary terms the love letters are some of his worst written and least

characteristic; but in passages they are oddly like the pseudo-Byronic effusions John James occasionally sent to Margaret, especially if he was away on their anniversary.) These letters in turn hardly prepared Effie for the fact that of all people on earth John Ruskin was one of the most likely to confirm her greatest fear about marriage:

> finding that the only being perhaps in the world whose affection is necessary to you as a part of your being not loving and assisting you in all your joys and cares, leaving you with the utmost indifference when you are in trouble to get out of it the best way you can, and in Joy not partaking the feeling but perhaps trying to subdue it if not in a similar mood, this would be I think the summit of wretchedness and misery. (*RG*:89)

The only child of a close family with the solipsistic bias such an upbringing tends to give is even more likely than most people to fall in love with a projected ideal or complement to his own personality.[51] There are in some of Ruskin's letters and in his diary entries in the period before his marriage occasional notes of foreboding:

> I thought Glen Farg and the hill of Moncreiff as lovely as ever, allowing for the desperate change in *me*—but Perth not. And I have had the saddest walk this afternoon I ever had in my life. Partly from my own pain in not seeing E [uphemia] G [ray] and in far greater degree, as I found my examining it thoroughly, from thinking that my own pain was perhaps much less than hers, not knowing what I know. And all this with a strange deadly shadow over everything, such as I hardly could comprehend; I expected to be touched by it, which I was not, but then came a horror of great darkness—not distress, but cold, fear and gloom. I am a little better now. After all, when the feelings have been so deadened by long time, I do not see how the effect on them can be anything else than this. (*D*:364)

The note of anxiety and dread on which the entry ends goes beyond Ruskin's concern for his own or Effie's feelings about his impending proposal of marriage. Presumably these feelings long dead are connected with his love and loss of Adèle but one can only speculate as to precisely what feelings could effect such fear and horror. Whatever they were, Ruskin nevertheless pressed ahead with his plans with all the haste decently possible.[52]

Although Effie was ten years younger than Ruskin, she was the oldest child in the Gray family. Of her fourteen siblings only five were alive at the time of her marriage (two were born after 1848). She was particularly close to her brother George, who was only a year her junior. The next seven children (four boys, three girls) had all died at ages ranging from eight months to seven years so that by the time of her marriage there was a gap of fourteen years between Effie and George and their oldest surviving sibling. I stress Effie's position in her own family because though much younger than Ruskin, she was used to being an oldest sister, to having her wishes deferred to. As her expression of her fears about marriage clearly indicates, she was thoroughly used to being the center of attention.[53]

For his part, Ruskin could only imagine personal intimacy in terms that made him the object of something approximating maternal care, or the object of his care something like a pet. He insisted that he would call Effie a girl until she was twenty-five. In writing to his "Dear, dear, dear girl" of his picture of their first night at home he even addresses her in the third person. "I kneeling at her knees—and looking into her eyes, and hiding my head in the folds of her soft, loose hair; . . . and she loving me, and suffering me—only trembling a little—and at last putting her white arms about me and bidding me be still."[54]

When the marriage did take place it was under inauspicious circumstances. Mr. Gray's railway speculations suddenly left Effie dowerless. The £10,000 in trust Mr. Ruskin provided put her uncomfortably in her in-laws' debt, and no doubt licensed in the minds of the elder Ruskins some of the interference that helped to poison the marriage. Ruskin, used to being the center of the family universe, a person for whom everything was done, suddenly found himself responsible for a wife whose health was suffering under the strains of family misfortune that he was expected in some fashion to ease. The Grays particularly hoped that something could be done to launch Effie's favorite brother, George, on a London commercial career. Having no fortune of his own, Ruskin was put in the position of having to ask his father to help George take a social step downward, something he was loathe to do knowing the probable response to any further connection of his family with trade.

To cap the pressures and disappointments with which the marriage began on both sides, the 1848 revolutions meant cancellation of the continental tour to which Ruskin had been looking forward as much, perhaps, as to his marriage. Four months after the still unconsummated marriage, the elder Ruskins joined the newlyweds at Salisbury

where John fell ill. Mrs. Ruskin assumed her traditional prerogative as chief nurse, ordered medicine and, on top of that, insisted that Effie leave the connubial bedroom. The authoritarian side of Effie's personality that Ruskin both admired and feared resembled that of his mother and brought the older and younger woman into a conflict Effie could not win. The showdown came in a dispute about the administration of a blue pill that Mrs. Ruskin wanted John to take and Effie wanted him to refuse. He took the pill. Having failed to persuade the Ruskins to help her brother George, Effie resented all the more being set aside in a prime area of wifely prerogative, told John so in private, and hinted as much to her family (*RG*:126-32).[55] How different John Ruskin, husband, must have seemed to Effie from the suitor who wrote: "I am quite passive—in your power—you may do what you will with me—if you were to put me into Bowers *Well* and put the top on, I should think it was all right and the kindest thing in the world." And how different the strong-willed Effie must have seemed from the "imaginary Effie Gray—presiding over a sort of Council of Trent of sagacious Friends" that Ruskin held in his imagination in the months of separation prior to the marriage.[56] Effie thought John's illness nervous in origin; he saw her reaction to his rebuke for objecting to his mother's influence, and her subsequent fluctuations in mood and health, as signs of "nervous disease affecting the brain" (To Mr. Gray, July 5, 1849, *RG*:231). The events at Salisbury rankled and became a symbol to both parties of the tensions in the marriage. Allusions to them run through the family correspondence, even into the final letter Effie sent to Mrs. Ruskin in company with the household keys the day she left John and fled to the north.

Effie's bitter complaint in later years that Ruskin made gods of his parents has an element of psychological truth. Writing to his father in 1852 about religious doubts, Ruskin unconsciously places himself in the garden after the fall, and not as Adam to his father's God, but as Eve: "it is a difficult thing for a son to write a father respecting that father's religious opinions: . . . I suppose a kind of shame is at the bottom of it. It is like stripping the soul naked. But it is not a wholesome shame—it is Eve's taking to fig leaves" (*LV*:245). Likewise, looking back after his father's death he described their relationship to Acland as a ludicrous, commercial *Lear* with himself as a surviving Cordelia "remaining unchanged and her friends writing to her afterwards—wasn't she sorry for the pain she had given her father by not speaking when she should?" (XXXVI:471). After meeting Ruskin, contemporaries often noted something feminine in his makeup. In

general when Ruskin asserted his authority over Effie it was when his will was aligned with that of his father. In any event, throughout their marriage the first loyalty of both John and Effie was to their own families. Ruskin expected Effie to fit into the routine of his own and his parents' lives as she had given promise of doing as a youthful visitor. When she would not, he let her make such proper accommodations as she could. To Effie this was neglect and she increasingly found marriage an exile. Nonconsummation stands for the marriage itself whether consummation failed or, more likely, was withheld—ultimately by both parties.

Ruskin grew impatient with Effie's periodic ill health—which seemed mysteriously female—with her moods, even with her mourning as disaster after disaster hit the Gray family. Having a wife with a strong will, who could ride all day and dance all night, but who, unlike his mother, would not climb Alps (climbing became fashionable for women only later in the century) perplexed him. Writing from Switzerland to Effie in Perth where she was recuperating and consoling her mother for the loss of a son, he tried a year after their marriage to explain his disappointment. He did so in typically literary terms that anticipate *Sesame and Lilies*. Ruskin could not help looking at life as the fulfillment of texts, an imitation if not of Christ than of the characters whose lives in his youthful reading had seemed more real than those of the patriarchs, and who had become as "types" to him.

> I had been in the habit unfortunately of looking for a some-what romantic perfection in women—and my ideas of this perfection had been chiefly taken from Shakespeare and Walter Scott. . . . Now neither in Shakespeare nor Walter Scott is there a single *nervous* woman—on the contrary they have usually more nerve than the men—unless the two of whom in some of your ways you used now and then [to] remind me—Cleopatra & Fenella. But for the most part there is a tranquil and holy pride—and a loving submissiveness—in their female characters, which had become in some sort my type of womanhood. I had not allowed for its physical weakness.[57]

Although the letter is addressed to Effie as an effort at understanding, and the ostensible topic is nervous women, the allusions compare her to characters notable for outbursts of passionate anger and for deception. Ruskin's association of Effie with the feigned mute, the fiery and vindictive Fenella of *Peveril of the Peak* is particularly

revealing given his emotional history and the conflict between the Ruskins and the Grays. Fenella (Zarah) is party to a plot against the hero's family and fortune, and would win him away from his childhood sweetheart, Alice Bridgenorth. Alice, whose "romantic perfection" Effie should presumably emulate, manages to remain true to Julian Peveril without violating filial duty, and the eventual marriage of the lovers unites rival houses at the novel's end. (Ruskin's literary models tended to give out just where his real troubles began.) The suggestion of a deceitful nature implicit in the comparison of Effie to Fenella became explicit after Effie's flight, when John equated her character with that of the temptress Lady Olivia in Maria Edgeworth's *Leonora*. When Effie insisted that he come to her in Perth rather than travel herself to London on his return from Switzerland in 1849 he compared her unfavorably with Imogen in *Cymbeline*:

> " 'oh, for a horse with wings'—Look at the passage. Her husband sends word he is to be at Milford on such a day—She does not 'think he might have come nearer', . . . She only thinks—only asks—how far is it to this same *blessed* Milford and how far she can ride a day." (*EV*:37)

The happiest years of the Ruskins' married life were spent in Venice where they largely went their separate ways yet appreciated each other's accomplishments. This compromise was shattered when Ruskin's father, having paid for the Venetian sojourns, determined to substitute a modest suburban house in Camberwell for the fashionable Park Street address he had leased after the marriage only to see it remain empty much of the time. Although he knew it would remove Effie from the social life that had been her major solace, Ruskin aligned his wishes with those of his father, asserted his authority, and refused even to discuss the matter with his wife. She was predictably miserable in Camberwell and began to complain of her fate to her friends.[58] Her misery was intensified after she met Millais and, most probably, fell passionately in love for the first time in her life. She became extremely anxious and suspicious, developed nervous tics, and had she not managed to leave John might well have suffered some sort of nervous breakdown.[59] The compensation Ruskin tacitly offered Effie for her loveless marriage was a remarkable degree of freedom for a Victorian woman of her background, but to her such freedom was neglect. It was not what she wanted.

Effie's clandestine flight was virtually dictated by the law of the

time (collusion would have invalidated her suit for annulment), but it was distasteful to her and could only be justified by making Ruskin not only a bad husband, but a bad man. A conventionally pious Protestant—she had often fretted over Ruskin's seeming flirtations with Rome—at once socially ambitious and proper, she was put in the paradoxical position of having to do something highly unconventional and damaging to her reputation in hope of finding a more normal life, not only sexually, but socially. The social price she had to pay was bitter for her, and in retrospect the torments of her marriage seemed to her, and the Grays then and after, as terrible as the sufferings of St. Euphemia herself.

Ruskin knew that Effie's feelings for Millais had precipitated her flight. ("I have, myself, no doubt that Effie's sudden increase of impatience and anger—and the whole of her present wild proceeding is in consequence of her having conceived a passion for a person, whom if she could obtain a divorce from me, she thinks she might marry.")[60] Had he chosen to argue that his offers to consummate marriage after a mutually agreed upon wait had been refused because his wife planned to sue for annulment in order to marry another man, he might have won an unwanted legal victory. That contest would, moreover, have exposed the reputations of everyone concerned to the mercies of the penny press and its public. Throughout Ruskin was more concerned with Millais' reputation than either his own or Effie's, but "if Effie *can* escape with some fragment of honour," he wrote to Acland, "let her."[61] Ruskin made no public defense. His pride badly hurt, John James Ruskin was overheard in public places defending his son and attacking Effie, but Ruskin maintained a stoic silence. As if to show that nothing would deter him from his life's work, he stood for an hour before Holman Hunt's *Light of the World* on display at the Royal Academy and reported his analysis of the painting, and the public reaction to it, in a letter to the *Times*, May 5, 1854, before leaving for Switzerland with his parents.

Ruskin took the concept of annulment literally and acted as though his marriage had never taken place and should be, therefore, of no consequence in his relations with other people—even Millais with whom he sought to maintain his connection. His overtures were rebuffed, bowever, and in the tones of one of Scott's ingenuous heroes caught up in a conspiratorial web not of his own making, he was forced, he told Millais, to "conclude that you either believe I had, as has been alleged by various base or ignorant persons, some unfriendly purpose when I invited you to journey with me to the

Highlands, or that you have been concerned in machinations which have for a long time been entered into against my character and fortune" (*MR*:247-9). Ruskin was extremely sensitive to the charge (broadcast most vigorously by Effie's confidante, Lady Eastlake) that he had deliberately thrown his wife in Millais' way during their joint 1853 tour of the Highlands in order to compromise her and then sue for divorce—an accusation Ruskin indignantly declared he "should as soon think of simply denying as an accusation of murder."[62]

Knowing what the world would think, Ruskin needed to have even his oldest friendships reconfirmed. ("Effie has said such things to me that sometimes I could almost have begun to doubt of myself.") He was more pleased than Effie was disappointed when their mutual friend Lady Trevelyan volunteered her faith in him.

> So far from drawing back from sympathy—and distrusting my friends—I never felt the need of them so much. I am only afraid of *their* distrusting me. For indeed that a young wife—in Effie's position, should leave her husband in this desperate way, might well make the world inclined to believe that the husband had treated her most cruelly. . . . I am not used to being looked upon as Effie will make some people look upon me—and am very grateful to my unshaken friends.[63]

The friend for whose approbation Ruskin had the greatest need, however, was Dr. Acland. He had joined the expedition to the Highlands, was a witness to the apparent neglect of his wife for which Ruskin was being roundly criticized, and was the person in whose judgment and moral rectitude Ruskin had the greatest trust. It was to Acland that Ruskin addressed his only unsolicited account of the failure of his marriage and, to Ruskin's intense dismay, his confidant proved at first uncertain what to think. Ruskin remonstrated: "I wish you would not be so *elliptical.* . . . I do very much wish that you had said—not 'that you could not defend my *judgement*' but exactly and plainly how wrong you thought me."[64] When the satisfactory letter came at last Ruskin recorded his relief "from the anxiety which I have so long laboured under . . . Deo Gratias. Gloria."[65] After briefly defending himself to a few friends who asked it of him, he made reference to his marriage only when circumstances absolutely demanded it (as in the letter of October 1858 to Anna Blunden, who wanted to marry him).[66] Ruskin virtually expunged Effie from the record of his life until, like a nightmare from the past, her letters to the La Touches ended what faint chance there was that he might be

permitted to marry their daughter Rose.

While a number of Ruskin's friendships survived the annulment, many did not, and being made the subject of scandal exacerbated Ruskin's native unease in society. The recoil of Chichester Fortescue who encountered him at the Palmerstons' must have been typical of many acquaintances: "Saw Ruskin solitary . . . and talked to him for the first time since the days when Harriet & I used to be with his wife & himself. He spoke in highest terms of Harriet, & of D. Urquhart also. I don't like Ruskin."[67] The failure of Ruskin's marriage required a restructuring of his social life as he entered middle age, made increased conflict with his parents almost inevitable, and left him an emotional exile from English society. More than ever he saw himself as an outsider.

Leaving Home

The 'wist ye not that I must be about my Father's business'
has to be spoken, I believe, to all parents—some day or other.
Advice to Miss Eleanor Stuber,
Nov. 23, 1876

ALTHOUGH RUSKIN REMAINED close to his parents throughout the period of his marriage, he could no longer live comfortably with them when it ended. His parents' house had been a place of refuge from Effie in the stormy last days of their marriage but, the marriage over, Ruskin found that he needed a refuge from his parents. Not only did he face the problem of living with elderly people set in their ways who could not help treating him as a child, he was also driven by the nature of his insights and his innate honesty to disagree with his parents on fundamental issues of belief. In the late fifties and early sixties Ruskin became increasingly open with them about his religious doubts. He became absolutely determined to elaborate upon and to publish the radical economic views foreshadowed in the letters to the *Times* he had allowed his father to suppress for the sake of reputation in 1852. The break in Ruskin's social life precipitated by the annulment was dramatized by his decision not simply to give support to the newly founded Working Men's College—which was all his friend F. J. Furnivall hoped for in soliciting his help—but actually to teach drawing there.[68] The failure of his marriage increased Ruskin's hostility to the drawing room society into which, curiously

enough, both Effie and his father had tried to push him. The annulment actually increased tensions between father and son and made Ruskin more sympathetic with the working class, and critical of the idle rich, than he had been before.

Both the religious and the economic questions show how inextricably psychological need and intellectual conviction, personal psychology and the intellectual currents of a man's time, can be bound together. John James Ruskin disapproved of his son's social and economic views, feeling most keenly that their publication would jeopardize Ruskin's hard-won fame in the world of art and letters. He was convinced that his son had been led astray. To the end of his father's days Ruskin had to insist that he had arrived at his economic and religious views himself and had not been seduced by "either Carlyle, Colenso, or Froude, much less anyone less than they" (WL:457). In a psychological sense, then, Ruskin's insistence upon public advocacy of his economic views in lectures and in print was a step in the direction of emotional and intellectual independence, of self-support, albeit under the aegis of a new intellectual father, Carlyle.

Ruskin's rejection of the Evangelical religion so diligently instilled in him by his mother was also, in psychological terms, a step toward independence. In his writings Ruskin makes his unconversion a dramatic event.

> I was still in the bonds of my old Evangelical faith; and, in 1858, it was with me, Protestantism or nothing: the crisis of the whole turn of my thoughts being one Sunday morning, at Turin, when, from before Paul Veronese's Queen of Sheba, and under quite overwhelmed sense of his God-given power, I went away to a Waldensian chapel, where a little squeaking idiot was preaching to an audience of seventeen old women and three louts, that they were the only children of God in Turin; and that all the people in Turin outside the chapel, and all the people in the world out of sight of Monte Viso, would be damned. I came out of the chapel, in sum of twenty years of thought, a conclusively *un*-converted man. (XXIX:89)

While there is no reason to doubt the event, the twenty years of thought he mentions at the end of this passage says more about the nature of Ruskin's unconversion than the episode in the chapel. In Ruskin's letters to his father from Venice, as in his postgraduate correspondence with his Oxford tutor in religion, the Reverend Walter

Lucas Brown, religious questions form a recurrent motif, the main burden of which is that God, if he is not, in Cartesian terms, a deceiver, must surely make the requisites of salvation clear. "The *doctrine* is God's affair. But the revelation of it is mine, and it seems to me that from a God of Light and Truth, His creatures have a right to expect plain and clear revelation touching all that concerns their immortal interests" (*LV*:149). Ruskin's literalistic bias led him to demand that prophecy should be clear in regard to its initial, present, and future circumstances, so that it could serve as a guide to behavior. It does no good to realize that a prophecy has been fulfilled after the fact. Moreover, to accept enigma as a legitimate rhetorical mode of revelation is but a step away from accepting dependence upon that established priesthood of interpreters so repugnant to Evangelical Protestants. As his doubts deepened, Ruskin began to apply the criteria of classical scholarship he had acquired at Oxford to the Bible. "As a means of Salvation (so called), it [the Bible] must be plain, or it is useless:—If its plain, palpable, acceptable-to-every-reader sense is a true one—it is a useful book. But if not—it is only one of the 'curiosities of literature'—a collection of noble poems, to be read by Scholars—precisely as we read Dante or Aeschylus."[70] Having from childhood found Scott's historical romances with their division of sympathy across religious lines in the deepest sense more believable than Old Testament narrative, he began in his doubt to read St. Paul with the Greek ideas about life after death in mind, identifying himself with the pagan Corinthian who asks: "How are the dead raised up? and with what body do they come?" (I Cor. 15:35), rather than with the Apostle. He consequently finds St. Paul's answer both intemperate ("Thou fool") and, worse, unconvincing, because based upon a false analogy between the dead body and a seed. The analogy, Ruskin argues, is contrary to the laws of God's own creation: "burying being Dissipation while Sowing is Nourishment."[71] Ruskin's early aesthetics assumed the harmony of God's two books, Scripture and Nature, which the apparent falsity of St. Paul's analogy calls into question.

Like his heretical economic views, Ruskin's religious doubts were astir during his married years, but publicly held in check. Just as Ruskin's insistence upon publishing his economic views was, from a psychological perspective, an assertion of independence from his father, so his unconversion asserted independence from his mother whose joyless Sabbath he had kept at home and abroad as if mindful of an ever present voice. Nevertheless, it is misleading in the extreme to consider Ruskin's social and religious thinking as merely the

symbolic projection of conflict with his parents. Ruskin's disagreement with his parents about religion and social policy are particular instances of general Victorian cultural tensions. Thus Markham Sutherland, the protagonist of Froude's *Nemesis of Faith*, attempting to reconcile "Science and Revelation," is driven back to:

> The very thing which Descartes, at the outset of his philosophy, thought it necessary to examine the probability of, whether, that is, *Deus quidam deceptor existat*, who can intentionally deceive us. Nor is the difficulty solved in the very least by the theory of an infallible interpretation of Scripture [*pace* John Henry Newman]. For, by hypothesis, the interpretings are by the Holy Spirit; the same spirit which has played one such strange trick, and may therefore do it again; nay is most likely to do it again and again.

Sutherland arrives, as so many others did, at a humanistic faith: " 'These many men so beautiful, they should be neither God's children or the Devil's children, but children of men.' " But the personal consequence of his humanism is an impossible and destructive attachment to a married woman and ultimately a life "strewed with wrecked purposes and shattered creeds; with no hope to stay him, with no fear to raise the most dreary phantom beyond the grave."[72]

The coupling of religious doubts with a redoubled concern for the conflict between Christian social values and capitalist practices is a hallmark of the Victorian age. Ruskin's political economy is an attempt to resolve the contradiction noted by Carlyle, Dickens, Tennyson, and many others between the belief that man is a social being, a member of a mutually responsible community whose basic unit is the family, and an economic system which treated each individual as a separate economic unit joined to other units only by what Carlyle called "the cash nexus."

Ruskin was always more interested in ethics than doctrine. (The message of his first sermon, delivered at the age of four, was "people, be good," not "people, believe.") Long before his unconversion in 1858 he had emphasized that national fidelity was measured by works. But far from easing his doubts and fears, the loss of his Evangelical faith deepened his torment. Ruskin's radical economics was a natural development of his work on art, not in essential conflict with it. But Ruskin's faith had been part and parcel of all that he had written on art through *The Stones of Venice* (though after *The Seven Lamps* he showed an increasing tolerance of other faiths). Suffering acutely

from his own loss, Ruskin thought it heinous to undermine the faith of others. Having confessed his doubts to a shocked Mrs. La Touche in 1861, he promised not to publish them for at least ten years, though he realized that the basis of his early work had been undermined.

> I have to rewrite all my books—at least to take out the little good there's in them—of matter of fact—or faithful description or analysis. This, to the mere *author*, is not pleasant—but it is far the least of the business, as far as I am concerned. It is very difficult, at 43, to live a quite desolate life—believing that God cares for one precisely as much as He does for a midge—or a leech—or an ape—or an archangel—what you will—. (*WL*:381)

Ruskin believed he could salvage descriptive passages and matters of fact, while sacrificing the sections in which his aesthetics rest upon his theology, because his examples tend to be logically prior to the theoretical framework that organizes them. With the religious awe that was part and parcel of his early response to nature gone, the rhetoric of his great emotive passages seemed hollow to him. The fits of infidelity he suffered in Venice in the 1850s undercut his enjoyment of nature and his ability to write in his previous religious temper, and so contributed to the evolution of a new style after *The Stones of Venice*.[73]

Ruskin knew that "living with two old people, however good, is not good for a man" (XXXVI:407). He stayed away from home more and more frequently and began a fitful search for a new residence. He wrote to Lady Trevelyan from Milan in 1862:

> I know my father is ill, but I cannot stay at home just now, or should fall indubitably ill myself, also, which would make him worse. He has more pleasure if I am able to write to him a cheerful letter than generally when I'm there—for we disagree about all the Universe, and it vexes him, and much more than vexes me. If he loved me less, and believed in me more, we should get on; but his whole life is bound up in me, and yet he thinks me a fool—that is to say, he is mightily pleased if I write anything that has big words and no sense in it, and would give half his fortune to make me a member of Parliament if he thought I would talk, provided only the talk hurt nobody, and was all in the papers.

This form of affection galls me like hot iron, and I am in a state of subdued fury whenever I am at home, which dries all the marrow out of every bone in me. (XXXVI:414)

When his father sought to suppress or alter the second chapter of *Munera Pulveris*, which he had sent from Milan to be forwarded to *Fraser's Magazine*, Ruskin's reply was blunt to the point of cruelty.

All interference with me torments me and makes me quite as ill as any amount of work . . .—now the putting off this publication disheartens me—checks me in what I was next doing, and has very considerably spoiled my two last days. I don't mind this a bit if it does you any good to stop the paper—only, don't think of me in such matters—the only thing I can have is liberty. The depression on that German tour was not in writing the letters [On the Italian Question, 1859], but in having them interfered with. The depression I am now under cannot be touched by any society. It can only lessen as I accomplish what I intend, and recover in some degree the lost ground of life. My opinions will never more change—they are now one with Bacon's and Goethe's—and I shall not live long enough to be wiser than either of these men. (XXXVI:415)

In Margaret Alexis Bell Ruskin found someone who was herself struggling with religious doubt and could sympathize with his. Her girls' school at Winnington became for a time his chief refuge from tensions at home.

You can't conceive how few people I know with whom I can be myself—They are all half doubters—believers in the *least* parts of what I want to get believed—or—often—occult enemies—sneerers & so on. My Father & mother themselves, much as they love me—have no sympathy with what I am trying to do—The nice people who, here & there, would be glad to help me, are always modest, & keep out of the way. . . . I'm just like Mr. Pickwick in the Pound—*"You* ain't got no friends." I've no sisters—no relations who have an idea in common with me—I *had* some nice ones, but all whom I used to care for are drowned—or married far away—or otherwise dead or departed . . .—or absurdly put under ground—somehow. (WL:120-121)

Ruskin had, in my judgment, managed to free himself from the most burdensome aspects of his parental heritage—the parts least congruous with his own character—before his father died in 1864. The unwonted turmoil at Denmark Hill, his willingness to leave against his parents' wishes, and the very frankness of the letters he sent to his father are indications of his new independence. The complaints about his upbringing Ruskin voices might seem more appropriate for a man in his early twenties than his early forties, but what independence Ruskin managed came late. The fact that he remained ever the obedient son in the presence of his parents does not cancel the psychological distance he had achieved, however precarious it may have been. One of Ruskin's last letters to his father, while it probably expresses too much blame and contains an element of excuse, still demonstrates that he had made judgments about his upbringing that he could freely express, and that he saw the psychological necessity of indulging some of the impulses he had so diligently repressed in the name of duty.

> I stopped at this "Bishop's castle" to draw, and if I could have drawn well, should have been amused, but the vital energy fails (after an hour or two) which used to last one all day, & then for the rest of the day one is apt to think of dying, and of the "days that are no more. . . ." Men ought to be severely disciplined and exercised in the sternest way in daily life. They should learn to lie on stone beds and eat black soup, but they should never have their hearts broken—a noble heart, once broken, never mends: the best you can do is to rivet it with iron and plaster the cracks over—the blood never flows rightly again. . . .You fed me effeminately and luxuriously to that extent that I actually now *could* not travel in rough countries without taking a cook with me!—but you thwarted me in all the earnest fire of passion and life. About Turner you indeed never knew how much you thwarted me—for I thought it my duty to be thwarted—it was the religion that led me all wrong there—for if I had courage & knowledge enough to insist on having my own way resolutely, you would now have had me in happy health, loving you twice as much—(for, depend upon it, love taking much of its own way, a fair share, is in generous people all the brighter for it—), and full of energy for the future—and of power of self-denial. Now, my power of *duty* has been exhausted in vain, and I am forced for life's sake to indulge myself in all sorts of selfish ways, just when a man ought

to be knit for the duties of middle life by the good success of
his youthful life. *No* life ought to have *phantoms* to lay.
(*WL*:458)

Rose

If I do not get her I shall have no home.

<div align="right">To John Richmond</div>

I love you & shall love you always, always—& you can make
this mean what you will.

<div align="right">Rose to Ruskin, March 1870</div>

UNFORTUNATELY, AT THE very time that Ruskin was laying parental
ghosts to rest with some success, he was conjuring the spirit that was
to haunt the rest of his days. The very fact that Ruskin was gaining
some emotional distance from his parents and achieving on his own
some of the independence his marriage had failed to provide made
him more than ever in need of someone to love, someone to serve,
someone in whose name he could carry on his work. Rose La Touche
became that person. Although Ruskin remained at the time of the
annulment of his marriage outwardly indifferent to public opinion,
a person with his deep-rooted strain of social insecurity could hardly
have remained undisturbed by it. I have already noted how Ruskin
tended in times of stress to look to young girls for sympathy and
companionship. Ruskin's need for uncritical acceptance was acute
after Effie's suit and the gossip it stirred, which portrayed him, he
later remarked, as domestically worse than Bluebeard. The unaccus-
tomed conflicts with his parents that were the consequence of his
combined assertion of intellectual and—it is hard to divide the
two—emotional independence could only deepen that need. It was
in this period of Ruskin's unconversion, and the consequent turning
toward a frank humanism in religious and social thought so painful
to his parents, that Ruskin for the only time fell in love with a prea-
dolescent girl, Rose La Touche, who was a precocious child of ten
when her mother applied to Ruskin for drawing lessons for her two
girls in 1858.[74]

Although Ruskin's feelings for Rose were from the time of their
first meeting more intense than the feelings of a master for even the
most favored pupil, it was the relationship in which they both were

most comfortable. Ruskin would, as numerous commentators have pointed out, have preferred Rose to remain a child, but when she grew too old to be made a pet of he did not blind himself to the fact or turn to another child.[75] So much attention has been paid to Rose's age when Ruskin first met her that it is easy to forget that it was the maiden Rose and not the little girl who gave and suffered so much pain. Unable to see Rose between 1862 and 1865 Ruskin bided her coming of age, intending to claim her as a woman even to the point of insisting that he would indeed marry her, not live with her as he had with his first wife. Ruskin's problem was not failure to accept the fact that Rose had grown up, but that he did accept it (perhaps more than she did) however much the girlish slightness accentuated by her illnesses may have attracted him. By piety, sympathy, birth, and—he thought until 1866—upbringing, she was meant to be the lady he would serve and, paradoxically, whose mind he would mold. He came to identify himself with Guido Guinicelli, some of whose poems Rossetti translated in his *Early Italian Poets*: "Love to my lady's service yieldeth me,/Will I or will I not the thing is so."[76]

Ruskin's parents knew about his affection for Rose almost from the beginning, and when he began to make regular visits to Winnington he had to reassure his father: "You need'nt think I'm in love with any of the girls here, and get me out of it therefore—Rosie's my only pet" (March 26, 1861, (*WL*:287). Ruskin could leave Denmark Hill for solace at Winnington without trouble to his conscience, but even there his religious uneasiness pursued him. The very lessons he set the girls in accordance with his educational theories, such as etymologies of biblical terms, show the influence of scholarship that was, along with the sciences, spreading doubt about the literal inspiration and truth of the Scriptures. One of the reasons he suspended his visits to the school for a time in 1862 and sought refuge in the Alps was fear that his religious doubt would influence the faith of the children.

When the Colenso controversy broke in late 1862 much of Ruskin's anxiety about undermining other people's faith seems to have been assuaged, for Colenso's questioning of the internal consistency of the Bible resembled Ruskin's own investigations.

> Now for these last four years, I've been working in the same directions alone, and was quite unable to tell any one what I was about. . . . I could'nt speak of anything—because all things have their root in that—and when you, or any of my friends used to speak to me as if I was what I had been—it worried me.

And the solitude was terrible—and the discoveries & dark-
nesses, terriblest—and all to be done alone.

But now the Bishop has spoken, there will be fair war di-
rectly, and one must take one's side, and I stand with the
Bishop, and am at ease, and a wonderful series of things is
going to happen—more than any of us know—but the *indeci-
sion* is over. (Nov. 15, 1862, *WL*:387)

While the publication of Colenso's *Pentateuch* may have eased
Ruskin's mind about the propriety of giving public expression to his
religious doubts, his private expression of them had stirred anxiety
in Rose who, unknown to Ruskin, had been exposed to religious
skepticism. "I used to hear conversations in London . . . of which I
understood more than anyone thought, doubt about truth said ear-
nestly, unbelief of Christ's faith spoken of lightly (this was not by him
[Ruskin]) and indeed more pains taken by them how all might be
false, then how the whole thing I lived by might be true."[77] Even at
the age of thirteen Rose was possessed by that worry about the state
of Ruskin's soul that was to cause them so much misery.

Rosie's mightily vexed about my heathenism, (her mother
has let her see some bits of letters I never meant her to
see)—and sends me a long little lock of hair, to steady me
somewhat if it may be; of sending which, nevertheless, she
won't take the grace—or responsibility—herself, but says
"Mama cut it for you." "But for the sake of all truth, and Love,
you must not give the one true Good—containing all others,
God—up." I can set her little wits at rest on that matter at any
rate, and tell her that being a heathen is not so bad as all that.
(To JJR, Dec. 28, 1862, *WL*:391)

But Rose's concern was never to be appeased nor was that of her
parents, particularly her father, who had been converted in 1863 by
an acquaintance of Ruskin, the famous London evangelist Charles
Spurgeon, and possessed the typical convert's sectarian zeal.[78]

On December 10, 1865 Ruskin saw Rose for the first time in three
years and briefly, as her eighteenth birthday approached (January
3), the walks and waters of Denmark Hill became a new Eden still
vivid in memory and given the air of spring twenty years later at the
end of *Praeterita*: "Elysian walks with Joanie, and Paradisiacal with
Rosie, under the peach-blossom branches by the little glittering
stream which I had paved with crystal for them. . . . 'Eden-land' Rosie

calls it sometimes in her letters" (XXXV:560-61). Ruskin proposed mar-
riage and was told on February 2, his parents' wedding anniversary
and the date of the feast of the Purification of the Virgin (according
to tradition the annual day for the celebration of weddings in early
Venice),[79] that he was to wait three years for his answer. (Ruskin's
subsequent fixation on the date was projected as public principle a
year later in the marriage letter of *Time and Tide*, "Rose-Gardens"
[XVII:417-27].) The thirty-year difference in age between them was
not, it seems, the primary worry of either Rose or her parents, who
initially seemed most concerned about the religious question, and
subsequently Rose's health and the possible illegality of the match
given Ruskin's annulment. Whether wise or not it was quite common
for Victorian men to marry women many years younger than them-
selves. In the midst of Ruskin's difficulties friends advised him to
find another girl, but no one to my knowledge bothered to recom-
mend someone his own age.[80]

Ruskin loved Rose more passionately than he ever did Effie, and
with Rose's childhood irrevocably past he believed he had come to
love her as a woman. Part of his unconversion in Turin had been an
acknowledgment of the claims of the flesh.

> Certainly it seems intended that strong and frank animality,
> rejecting all tendency to an asceticism, monachism, pietism,
> and so on, should be connected with the strongest intellects.
> Dante, indeed, is severe, at least, of all nameable great men; he
> is the severest I know. But Homer, Shakespeare, Tintoret,
> Veronese, Titian, Michael Angelo, Sir Joshua, Rubens,
> Velasquez, Correggio, Turner, are all of them boldly Animal.
> Francia and Angelico, and all of the purists, however beauti-
> ful, are poor weak creatures in comparison. I don't under-
> stand it; one would have thought purity gave strength, but it
> doesn't. A good, stout, self-commanding, magnificent Animal-
> ity is the make for poets and artists, it seems to me. (VII:xl))

In 1877 Ruskin wrote that for the education of boys in his proposed
schools of St. George he would "at least ask of modern science so
much help as shall enable me to begin to teach them at that age
[fifteen] the physical laws relating to their own bodies, openly, thor-
oughly, and with awe" (XXXIV:529). Surely Ruskin's proposal reflects
the unhappy effect of Victorian sexual prudery on his own life.

Whether or not Ruskin's desire would have survived marriage to a
healthy Rose will, of course, never be known. At the time of her first

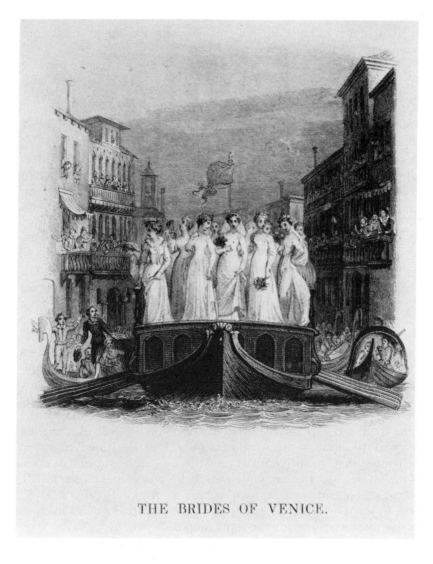

THE BRIDES OF VENICE.

Stothard's illustration of "The Brides of Venice" in Rogers'
Italy: "the Brides / Lost and recovered," unlike Rose.

Communion Rose had suffered some form of breakdown, and she
endured periodic episodes of insanity and intense pain as long as she
lived. Whatever the root cause of her illness, she clearly could never
master the conflicts aroused in her between Ruskin, her spiritual fa-
ther turned lover, and Mr. La Touche; between her own faith, which

combined her father's fundamentalism with Ruskinian social con-
sciousness ("I think it was Mr. Ruskin's teaching when I was about
twelve years old that made me first take to looking after the poor")[81]
and her mother's worldly pride of place, and culture; between faith
itself and the doubt that engulfed Ruskin and seemed rampant in the
outer world.

The impact Rose's rejection had upon Ruskin, and the length of
time it took him to recognize truly how seriously ill and disturbed
Rose was, are comprehensible only in light of the fact that for a dec-
ade she had been at the center of his imagining. As a child she had
accepted him at a low point in his life, centered her thoughts on him,
and given those thoughts precocious expression. After acknowledg-
ing the legitimate claims of the flesh in 1858 it was, he said, thoughts
of Rose that kept him "pure." She was constantly on his mind as he
worked in what was virtually a self-imposed European exile on *Unto
This Last* and *Munera Pulveris*. Her name was on his lips unaware. His
fierce economics alternated with playful verse ("Rosie pet, and Rosie,
puss, / See, the moonlight's on the Reuss"). Analysis of the root
meaning of economic terms alternated with lessons by letter for Rose
in New Testament Greek. That he should have resisted all tempta-
tion in her name only to have her perfect sympathy replaced by a
rejection that cast aspersions on his moral nature resulted in an emo-
tional explosion beyond all bounds of reason.[82]

In the late sixties, as his romantic interest in Rose began to be
known, gossip about Ruskin's marriage revived. In 1868, about the
time Rose was forbidden further correspondence with Ruskin, she
learned the cause of the annulment (*M-T*:138). By June Ruskin was
convinced that the influence of the Millaises had been brought upon
Rose (*M-T*:170). In that same month he wrote to Margaret Bell,
whose school had been a place of refuge for Ruskin for almost a dec-
ade, to warn her that the outcry of fifteen years before was likely to
revive and he feared for the reputation of Winnington.

The Millaises did, in fact, formally provide at the request of the La
Touches their version of Effie's first marriage in October 1870.
Ruskin's diary entry for November 28, 1870, records the following
dream: "Sadly tired and ill nervously yesterday. Dreamed of getting
a nice girl to flirt with, and of a horrid witch up in a recess
among—no one could tell what—but high up, who threatened me
like a ghost. She was at a kind of window, and I ended by throwing
stones at her and breaking everything. After that, slept sound. Better
this morning" (*D*:708). The ghostly witch that Ruskin dreamed of
can only speculatively be identified with "that cursed woman of

Perth,"[83] but the identification seems singularly appropriate. Whatever the identity of the figures in the dream, its central message seems clear. Ruskin slept better after dreaming of direct aggresive action against the forces that threatened him, thus producing the kind of direct and angry confrontation that he was always so loath actually to enact, but which increasingly affected the tone of his prose.

Rose's affection for Ruskin was deeply rooted, and to counter it Mrs. La Touche obtained a legal opinion that, erroneously, disputed Ruskin's right to remarry.[84] Because of this legal opinion, the La Touches, and perhaps the Millaises as well, were convinced that if Ruskin remarried, Effie's second marriage might be nullified. But it was morality not law that most influenced Rose, and Mrs. Millais' letters to her mother portrayed Ruskin as a man whose acts could only be excused on the grounds of insanity, an arch-hypocrite at once perfidious and, most horrible to Victorian ears, "unnatural." Ruskin never realized that the accusations of immorality put him in an impossible double bind. If he somehow proved himself capable of performing the duties of a husband it was bound to be interpreted as evidence that he had mistreated Effie; if he failed of proof he was seeking to lure Rose into a sham marriage.

The legal question was more easily resolved than the moral dilemma, but resolving it meant digging up the nullity documents and submitting the question of his right to remarry to the proper authorities, actions that made Ruskin terribly anxious. It was at Matlock in June 1871, while suffering the double strain of estrangement from Rose and the resurrection of a past thought dead and buried, that Ruskin, uncertain now of even his legal right to marry, was prostrated by continual vomiting and fever so severe that the Severns feared for his life.[85] He was working on *Fors* at the time and obsessed with fate. As anxiety over his prospects with Rose threatened to "throw me back into the grave," he thought in his delirium that he was saved like a latter-day Aeneas for his social mission by the words of the Cumaean Sibyl, who "murmured in my ears, at every new trial, one Latin line, 'Tu ne cede malis, sed contra fortior ito.' "[86]

Denied direct access to Rose, Ruskin began to make indirect appeals or explanations to her in his writings. Believing she would be in the audience, Ruskin covertly composed part of his Dublin lecture, "The Mystery of Life and Its Arts" to and about Rose. Its story of the arrested development of Irish artistic and religious character corresponds to his analysis of her. Surely in Ruskin's eyes it was Rose, of all girls, who had cast her "innate passion of religious spirit . . . into

grevious and vain meditation over the meaning of the great Book, of
which no syllable was ever yet to be understood but through a deed;
all the instinctive wisdom and mercy of [her] womanhood made vain,
and the glory of [her] pure conscience warped into fruitless agony"
(XVIII:186). Rose is the Irish Angel displayed in the lecture who
"thinks it is all right" in contrast to the Saxon and Florentine angels
he showed to the audience who make themselves useful as muses of
agriculture and astronomy, and "know that they are in many ways
wrong" (XXXVIII:172). ("I cannot reject the thought of her being in
some way inspired and commissioned to teach & save me," he wrote
to his Phile [*M-T*:99]). Ruskin's poignant account of failure in the
great enterprises of his life is his implicit confession of his need for
Rose.

Ruskin tried every conceivable means of obtaining a hearing so he
could be told once and for all whether Rose would have him or no.
He even wrote to her aunt a letter of astonishing frankness for the
period in which, weighing his virtues and vices, he confessed the only
sexual sin of which he considered himself guilty, only to have the let-
ter shown to Rose two years later as proof in his own writing of his
debased nature and sins against God's law. Rose replied:

> Better not to have known the way of righteousness than after
> you had known it to turn aside. & while speaking the words of
> man whose "eyes are opened" to wallow in the mire.
> And I, who have loved you cannot alter you, could not blot
> out one single stain, not if I could lay down my life for you,
> cannot even give myself the certain hope of meeting you here-
> after—All I can do is speak of you to Christ—at His feet we
> might meet—in His love our hearts might be drawn together
> again.[88]

Less than a month after Rose sent this letter Ruskin was racing home
from Venice, where he had been studying Carpaccio's St. George se-
ries in the San Georgio de'Schiavoni, to a meeting with her arranged
by the George MacDonalds. For a moment all seemed well. After-
wards Rose wrote to Mrs. MacDonald:

> His last words to me were a blessing. I felt too dumb with
> pain to answer him; yet God knows if any heart had power to
> bless another, mine used that power for him—though I could
> only yield him up to a greater Love than mine. I cannot be to
> him what he wishes, or return the vehement love which he

gave me, which petrified and frightened me, Motherbird, as you perhaps will understand. Don't be hard on me. When we come "face to face" in that Kingdom where love will be perfected—and yet there will be no marrying or giving in marriage—we shall understand one another. Meantime, God cannot have meant nothing but pain to grow out of the strange link of love that still unites us to one another. Somehow or other it must work for good.[89]

It did not work for good. Rose could neither accept Ruskin nor give him up. In his presence she would momentarily succumb to his vision of her and they would be reconciled, only to be estranged again when she returned to her parents. Despite her refusal to marry Ruskin, Rose agonized over the state of his soul and sent him periodic messages, often enigmatic ones, such as pressed rose leaves, that he could interpret according to his desires. Every time the wound seemed closed at last it was opened anew in a cycle of acceptance and rejection that lasted until Ruskin was called for a last reunion to the bed where she lay intermittently mad and, it proved, slowly dying. The "blight" which, as Rose once wrote Joan Severn, had "got at the very stalk of my life," finally claimed her in May 1875,[90] taking most of Ruskin's affective life with it. She was twenty-seven.

In 1869 Ruskin was appointed the first Slade Professor of Fine Art at Oxford. In many ways the professorship was the crowning achievement of his life. His writings had helped to make the study of art a respectable academic discipline in England. Though his father was dead, the fact that the prestigious appointment brought the kind of public recognition he had always sought for his son naturally pleased Ruskin. On May 9, 1873, he wrote in his diary: "Tomorrow is my father's birthday. If he could have known that yesterday his son should have come down to Oxford—one of its most honoured teachers, and with one of the Princes of England [Leopold]." The professorship gave the lay preacher his pulpit, and in the very milieu in which he as a student felt himself to be such an outsider. But his tortuous relationship with Rose took the joy of accomplishment from him. "It is not nearly what it should have been," he wrote Mrs. Cowper on February 6, 1870, of his Innaugural Lecture "chiefly because of that unlucky child—the three weeks work after that had all to be done again—they were so stupid with the pain. I have not got over it, nor shall,—but it has got itself into a lump now—which I can throw into a corner out of the way at work times instead of mixing itself all through me" (*M-T*:259).[91] It is hard to conceive of a more

graphic example of the process of supression in the name of work.

In the last year of Rose's life, Ruskin wrote to his friend Susan Beever: "*You* expect to see your Margaret . . . in heaven. I wanted my Rosie *here*. In heaven I mean to go and talk to Pythagoras and Socrates and Valerius Publicola. I shan't care a bit for Rosie there, she needn't think it. What will grey eyes and red cheeks be good for *there*?" (XXXVII:117). In the 1870s Ruskin could only work through a strenuous exertion of retroflective will that suppressed his desire for Rose, his anger at her for her vacillations and rejections, his anger at her parents for keeping Rose from him. Even her death could not resolve this tension. Perhaps because Ruskin's Rose was so much a projection of his own needs, a kind of epipsyche, he could not lay her ghost to rest. In death as in life she dominated his thoughts whenever he was not buried in work. The terrible diary entry of September 8, 1872, following Rose's most sudden violent reversal of feeling, might stand as an epigraph to Ruskin's work of the seventies and eighties: "Fallen and wicked and lost in all thought; must recover by work."[92]

Through Mrs. Cowper-Temple, his confidante in the tortured progress of his relationship with Rose, Ruskin was introduced to spiritualism, and gradually Rose blended with the figures of Beatrice, Proserpine, and St. Ursula (Little Bear) in his literary and artistic studies. In 1876, Ruskin spent weeks of work, day after day, copying Carpaccio's *Dream of St. Ursula*, and on Christmas of that year found himself caught up in a psychomachia in which his good angel (St. Ursula-Rose) set him to lessons which, when properly understood, saved him from the Evil One in the form of an ominous, red-eyed gondolier. The long series of letters Ruskin wrote in an attempt to explain these phenomena to Joan Severn are the first clear indication that the typological habit of mind that is at the heart of Ruskin's work in art and social criticism had begun to dominate his everyday life; that his extraordinary ability to find objective correlations of his inner conflicts was failing; that he was losing his hold on reality. On December 29, in one of those symbolic events that dot his life, Ruskin took the oar of his gondola, the fog closed in, and he rowed canal post by canal post to the madhouse.[93]

Ruskin's frustrated sexual desire for Rose seems to have persisted even after her death, and the disjointed entries in the *Brantwood Diary* in the days preceding his lapse into madness on the night of February 23, 1878, suggest that he was in imagination Othello to her Desdemona, Hamlet to her Ophelia, even Iachimo to her Imogene. ("Devil puts me in mind of Iachimo—Imogene dear—& the mole

cinq spotted—we'll beat him, won't we.")[94] Manic attacks are fre-
quently preceded by euphoric fantasy:

<div align="right">21st February 1878</div>

> Dear *George*
> We've got married—after all after all—but such a sur-
> prise!—Tell the Brown Mother—and Lily.—*Bruno's* [Rose's
> dog] out of his wits with joy up at the Chartreuse Grande—I
> meant—and so am I for that matter but I'm in an awful hurry
> such a lot of things to do—
> Just got this done before breakfast—the fourth letter. Ever
> your lovingest John Ruskin—oh—Willie—Willie—He's
> pleased too, George dear.[95]

The proximate cause of Ruskin's breakdown is a matter of conjec-
ture, but even if it was inherited and biochemical in nature his condi-
tion was surely worsened by the incredible psychic tension under
which he labored almost from the beginning, which was exacerbated
beyond endurance by his difficulties with Rose.

Ruskin's attacks of madness were like prolonged nightmares. In the
Brantwood Diary he heads the page following February 23,
"February,—to April—the Dream." The rest of the page is blank
(*BD*:102). In the periods of blankness he was at times violent and
abusive. It is as if his personality in the periods of madness was or-
ganized by the rage and longing his dominant personality labored
through "dragon battle" to repress. The attacks left him prostrated
and at times apparently unconscious. These were not attacks that
simply affected Ruskin's mind. After the first attack he seemed to
have aged ten years. He suddenly looked old. His mental recovery
from the first attacks appeared to be nearly complete, but he grew
progressively less flexible in mind, more and more of a character:
Professor Ruskin, The Prophet of Brantwood.

The first attack of madness virtually ended Ruskin's creative life.
The Guild of St. George continued, fitfully, a partial incarnation of
his ideas of the sixties and early seventies. He continued to publish,
but the research and the observation were largely the work of better
days. Much even of *Praeterita*, the great work of his last years, had
appeared, piecemeal, in *Fors*, or was adapted from diaries and let-
ters. Ruskin attempted to return to the Slade Professorship in 1883,
but could not sustain sufficient concentration or control to lecture
regularly. It is from this period that most of the stories of Ruskin's
eccentric improvisations on the lecture platform can be traced.

Ruskin's failure to marry Rose, and his subsequent failure to find a way to deal with her loss, mark the turning point in his emotional life. Increasingly he regretted the misunderstandings he had had with his parents, and as attack followed attack in the eighties, Joan Severn became virtually a second mother to him—both nurturer and dragon. His struggle for emotional independence was nearly over. In 1888 Ruskin made one last attempt to realize his desires and close the situation that had plagued him in various forms since the days of his unrequited love for Adèle Domecq a half-century earlier. He proposed marriage to Kathleen Olander, a young Evangelical art student he had met the year before who increasingly reminded him of Rose. His desperate proposal shows the link he himself made between his attacks of madness and repressed sexuality. "—And you *will* be happy with me, while yet I live—for it was only love that I wanted to keep me sane—in all things—I am as pure—except in thought—as you are—but it is *terrible* for any creature of my temper to have no wife—one cannot but go mad."[96]

Miss Olander, indeed, seriously considered being the companion of Ruskin's last years but was prevented by her shocked parents and by Mrs. Severn, who was now, in effect, Ruskin's guardian. (The sad history of Ruskin's last love is recorded with Kathleen Olander Prynne's commentary in *The Gulf of Years*.) The collapse of this last hope was followed in December 1888 by a severe attack that completely ended Ruskin's creative life. In his last years Ruskin could barely sign his name.

That Ruskin could not in the end make of Rose a true Beatrice and in that way be free of her; that he could not, or would not, discover the qualities he loved in Rose in someone else until it was far too late, these were the tragedies of Ruskin's last thirty years. Most of Ruskin's writing on social questions was done during his years of anguish over Rose La Touche, some even in her name. That anguish, a background of undischarged pain, though it rarely determines the content of his writing until he was near to breaking down, affects the tone of almost everything. The social crusade of the 1870s and the 1880s was both a fight against social injustice and a flight from emotional anguish, a struggle against Dante's furies of Phlegethon without and within, a desperate and ultimately futile attempt to escape from the agony of his private life by, in effect, making himself into a public institution: the antitype of St. George.

I knew not, till this very last year in Venice, whether some noble of England might not hear and understand in time, and

take upon himself Mastership and Captaincy in this sacred war: but final sign has just been given me that this hope is vain; and on looking back over the preparations made for all these things in former years—I see it must be my own task, with such strength as may be granted me, to the end. (XXIX:137)

He became, like Nerval's "El Desdichado":"le Ténébreux,—le veuf,—l'inconsolé."

> Dans la nuit du tombeau, toi qui m'as consolé,
> Rends-moi le Pausilippe et la mer d'Italie,
> La *fleur* qui plaisait tant à mon coeur désolé,
> Et la treille où le pampre à la rose s'allie.[97]

Dragon battle: detail of Carpaccio's *St. George and the Dragon*, a watercolor by Professor C. H. Moore who was studying drawing with Ruskin in Venice, 1876.

2

Papa Carlyle

Read your Carlyle, then, with all your heart, and with the best of brain you can give; and you will learn from him first, the eternity of good law, and the need of obedience to it: then, concerning your own immediate business, you will learn farther this, that the beginning of all good law, and nearly the end of it, is in these two ordinances,—That every man shall do good work for his bread: and secondly, that every man shall have good bread for his work.

<div align="right">

Fors Clavigera, Letter 10
(October 1871)

</div>

Your "Fors," two numbers of it at once, came punctually on May 1st and were, as always, eagerly read. Winged words, tipped with empyrean fire; not in my time has the dark, weltering, blind and base mass of things been visited by such showers and torrents of an Element altogether amazing to it. *Euge, Euge.*

<div align="right">

Carlyle to Ruskin, May 13, 1874
Ruskin Galleries

</div>

Faith and Fathers

> He stood a true man on the verge of the old, while his son
> stands here . . . on the verge of the new.
>
> Carlyle's *Reminiscences*

RUSKIN'S FIRST SURVIVING comments on Carlyle date from June 6,
1841, when in reference to *Heroes and Hero-Worship* he noted in his
diary: "Read some of Carlyle's lectures. Bombast I think: altogether
approves of Mohamet, and talks like a girl of his 'black eyes'"
(*D*:199). At twenty-one Ruskin was still a thoroughgoing Evangelical
unable to see the need for a new "mythus" that would put the divine
spirit of Christianity in another vesture, and unwilling as yet to see
the virtue of belief itself as opposed to the correct belief. Apprecia-
tion of Carlyle's writings and the personal intimacy that eventually
made him Ruskin's "second papa" came with the decline of Ruskin's
childhood faith, the collapse of his marriage, the increased conflict
with his parents over religious and economic questions that followed
in its wake. It came with the merging of his work on art and architec-
ture with Carlyle's "Condition-of-England question." By 1855
Ruskin had already publically declared that he owed more to Carlyle
than to any living writer and explained privately to him (for they
were not yet on intimate terms) that while he had arrived at many of
the older writer's conclusions independently, he could not say how
much he might have been unconsciously guided by "a stronger
mind."[1] Carlyle became one of the few contemporaries whose work
Ruskin read and reread, the most modern figure in a line of writers
running back through the English literary tradition to Dante, Plato,
and the Bible, who served Ruskin as authorities and whose principles
Ruskin liked to argue he was merely extending and applying to
modern circumstances.

The intimacy between Carlyle and Ruskin that built up through the
fifties and sixties reached a peak from 1865, when they joined forces
on the Eyre Defense Committee, until their temporary estrangement
in 1867 over Ruskin's indiscreet publication of some of Carlyle's con-
versational hyperbole. Although the emotional effects of the es-
trangement on Ruskin were never entirely repaired, the two
remained on intimate terms until Carlyle's death in 1881. In other
words, Ruskin's close association with Carlyle began when the pro-
tracted struggle with *Frederick the Great* and the publication of his last

essays were bringing Carlyle's career to a close, allowing Ruskin to act the part of an Elisha in preparation for his master's mantle.

Ruskin, like so many of his contemporaries, found in the conversion experience recorded in *Sartor Resartus* a paradigm for movement from loss of faith through doubt to a new order of belief, a new ground for action. But he could never master his doubts for long nor be content in uncertainty.[2] He had defied *Das ewige Nein*, but the Everlasting Yea seemed to recede before him. He continued to be plagued by the questions of personal salvation and damnation that Carlyle, whether by act of faith or act of will, managed to put behind him when he discarded his Hebrew Old Clothes and then the perception of the universe as a mechanism to become a nonsectarian theist and believer in belief.

The earliest record of conversation between the two men has Ruskin interrogating Carlyle on the religious question.[3] Twenty-four years later, in 1874, Ruskin was still pressing Carlyle on the question of faith. Ruskin wrote from Assisi where in emulation of his patron saint, Anthony of Padua, he had taken temporary residence. At Assisi he rediscovered the authority of medieval art through the power of Cimabue's Madonna with the attendant St. Francis so like himself. Carlyle he saw in the image of Taddeo Gaddi's "leading Wise King" (XXXVII:118) and he wrote to ask: "What sympathy you have with the faith of Abbot Samson, or St. Adalbert" and complained that "you don't say what a Master ought now to teach his pupils to believe, or at least wish them to believe" (XXXVII:116,118). Driven at last to reply, Carlyle gave as specific a declaration of faith as he ever supplied, referring Ruskin to the passage in *Past and Present* following the Earl of Essex's vision of St. Edmund: "a little word or two which had much more meaning to myself; but which I now see can have had none to anybody else" (a sad admission).[4]

Thus does the Conscience of man project itself athwart whatsoever of knowledge or surmise, of imagination, understanding, faculty, acquirement, or natural disposition, he has in him; and, like light through colored glass, paint strange pictures 'on the rim of the horizon' and elsewhere. Truly, this same 'sense of the Infinite nature of Duty' is the central part of all with us; a ray as of Eternity and Immortality, immured in dusky many-coloured Time, and its deaths and births. Your 'coloured glass' varies so much from century to century;—and, in certain money-making, game-preserving centuries, it gets so terribly opaque! Not a Heaven with cherubim surrounds you

then, but a kind of vacant leaden-coloured Hell. One day it
will again cease to be *opague*, this 'coloured glass.' Nay, may it
not become at once translucent and *un*coloured? Painting no
Pictures more for us, but only the everlasting Azure itself?
That will be a right glorious consummation! (*P&P*:109-10)

Carlyle's redaction of Shelley's "dome of many-coloured glass" sug-
gests that the objective manifestations of religion are projections of
the conscience given outward form by the believer's culture. The
analysis was no comfort to Ruskin whose imagination was increas-
ingly in need of civet, however close it may be to his own treatment of
pagan mythology. Ruskin badly needed the stability of external au-
thority, having inside not a single sense of duty but divided obliga-
tions and many voices.

John James Ruskin's sometimes bitter feeling that as his own au-
thority over his son waned that of Carlyle grew was well founded.
Ruskin wrote to his father in 1852 that he was by act of will sticking to
the path of religion rather than that of "philosophy," which led to
active attempts to improve this world without hope of reward in the
next. "Philosophy" soon became explicitly Carlyle, who "is continu-
ally enforcing the necessity of being virtuous and enduring all pain
and self denial, without any hope of reward"—something Ruskin felt
at the time was beyond his capacity (*LV*:247). Though eventually
driven to Carlyle's position by the collapse of his sectarian faith he
could not sustain it after the final loss of Rose, from whose year of
dying he was taking refuge when writing to Carlyle from Assisi. The
pattern of Ruskin's relation to Carlyle was, as George Allen Cate
remarks, similar to that between Ruskin and his father—"one of in-
dependence in the midst of dependence, conducted under Ruskin's
changing concepts of himself."[5] Attempting to close the breach that
followed from Carlyle's repudiation of statements Ruskin attributed
to him in *Time and Tide* Ruskin wrote: "I come to you exactly as I
would to my father—if he were alive—and I should say:
Now—father—if you are going to speak a league to me, on such and
such matters—I won't come. I had no mind to come merely to be
scolded & still to find fault with you."[6]

Although Ruskin's parents associated him with their son's eco-
nomic and religious infidelities, Carlyle wholeheartedly approved of
Ruskin's devotion to his parents, filial piety being a strong trait in
both men and reflected in their social thinking. Carlyle's father had
worked with his hands, whereas the elder Ruskin rose from an un-
paid clerkship to become the "entirely honest merchant"

commemorated by his son, but both fathers were associated by their sons with the preindustrial social and economic order that the social historian Peter Laslett calls *The World We Have Lost*.[7] Both the honest, pious laborer, and the clerk who rises—in the old, literal sense—to journeyman, and finally, to riches are stock figures in the folklore that has survived the industrial revolution. Both Carlyle and Ruskin were educated by their parents for church positions that they could not in good conscience fill, and found their education, their work, their social experience to be both a fulfillment of the hopes of their fathers and a barrier between them.

Carlyle's case was the more extreme, the distance both physical and mental between father and son greater than that of the Ruskins. Both the respect for his father and the gap between them was expressed in Carlyle's earnest wish at the time of his father's death in 1832: "Could I write my Books, as he built his Houses."[8] Carlyle preferred to associate himself with the mason of the old economic order, the skilled laborer who had literally built the house in which Carlyle was born, rather than the farmer James Carlyle had been forced to become as his son grew up.

In his *Reminiscences* Carlyle stresses the strength given both by a religion the son could no longer believe in and by the community of which his father was a part in which there was no rigid barrier of class between master and man, in which families and the community at large took care of their own. It was a world, as Carlyle pictures it, of simplicity and integrity like the Middle Ages of *Past and Present* that so colored the historical imaginations of Ruskin and Morris. "He wisely quitted the Mason trade, at the time when the character of it had changed; when universal Poverty and Vanity made *show* and *cheapness* (here as everywhere) be preferred to substance; when as he said emphatically honest trade 'was done.' "[9]

Carlyle heard of his father's death and wrote his reminiscence of him while visiting London in 1832. Recording his response to the metropolis in his *Note Books* at that time, he wishes a third of its population away and then remarks, in a striking contrast to the evocation of his father's world:

> How men are hurried here; how they are haunted and terrifically chased into double quick speed; so that in self-defence they *must not* stay to look at one another! . . . Each must button himself together, and take no thought (not even for *evil*) of his neighbor. . . .
> Everywhere there is the most crying want of GOVERNMENT, a

true all-ruining anarchy: no one has any *knowledge* of London
in which he lives; it is a huge aggregate of little systems, each of
which is again a small Anarchy, the members of which do not
work together but *scramble* against each other.[10]

The visit and later move to London only exaggerated in his mind the
gap between the scrambling, materialistic present and the spartan
Scottish paradise that had nurtured his father. Despite all their dif-
ferences, the contrast between past and present both individually
and socially is central to the work of Carlyle and Ruskin as it would
later be to Morris.

The Lesson of Scott: Romance and History

I refer to Scott, now and always, for historical illustration, be-
cause he is far and away the best writer of history we have.
 Ruskin, "Protestantism: The Pleasures of Truth"

PRIOR TO AND underlying the personal relationship between the
two men and the ways in which their programs and prejudices
agreed and differed lies the literary affinity of their work. Despite
the classification of most of their work as "nonfiction," that affinity
places them within what Northrop Frye defines as the romance tradi-
tion: "the quest-romance is the search of the libido or desiring self
for a fulfillment that will deliver it from the anxieties of reality but
will still contain that reality."[11] In social terms it is a call for the
transformation of society into the pattern of a lost paradise of order
and integration, a world that both Carlyle and Ruskin in their differ-
ent ways associated with the social structure of the Middle Ages and
the secure, uncritical faith they had known in childhood.

Although mention of Carlyle and romance quite properly brings to
mind the influence of the Germans on Carlyle's fiction and his-
tory,[12] there was an influence closer to home and shared with
Ruskin and Morris. In his long review of Lockhart's *Memoirs of the
Life of Sir Walter Scott* (1838) Carlyle passes judgment on the preemi-
ment Scottish writer throughout the period of his struggle for rec-
ognition. Not surprisingly he finds the most popular romancer of
his day to be a good deal less than an heroic man of letters. Never-
theless, there is one virtue so important to Carlyle that he states it in
regard to Scott's poetry and again in comment on his fiction. It is his

power to animate the past, to demonstrate that "the bygone ages of the world were actually filled by living men, not by protocols, state-papers, controversies and abstractions of men History will henceforth have to take thought of it" (29:77-78). Indeed, history had taken thought of it. The account of the storming of the Bastille in Carlyle's newly completed *French Revolution* owes a clear debt to the depiction of the Porteus riots in the *Heart of Midlothian*. Carlyle's confidence in the essential truth of Scott's historical characterization is such that in *Past and Present* Gurth the Swineherd is pressed into the historical argument as though, at some level, *Ivanhoe* and *Jocelin's Chronicle* were documents of equal historical validity.

Carlyle's real debt, of course, is not to Scott's characters, but to his placing of them in documented historical settings. Carlyle sympathized with Schelling's demand that history be at one and the same time philosophical, dramatic and teleological, but as a writer of history he was acutely aware of a problem that the theorist of history's high mission did not have to face. Carlyle knew he necessarily stood within that "most marvelous drama, which only an infinite mind could have composed."[13] So placed, his retrospection can provide only the illusion of divine objectivity in a drama infinitely extended through time. For Carlyle "Action is *solid*," composed of interlocked atoms of cause and effect, whereas "Narrative is *linear*," treating successively things simultaneous in occurrence. Historical narrative should be "Philosophy teaching by Experience" (27:89); that is, the reading of a history should, like Scott's fiction, approximate the effect of actual experience yet with an end to reinforcing ideas. Carlyle's justification for writing history is still that of Lord Berners: to "shewe, open, manifest and declare to the reder by example of olde antyquite, what we shulde enquere, desyre, and folowe; and also, what we shulde eschewe, avoyde, and utterly flye."[14]

Scott's novels suggested that strands of linear narration inspired by properly documented events in the lives of real people could be created that would give the same illusion of reality as episodes in fiction, forming, in effect, a cycle of stories within the larger context of the unfolding history. The breaking up of the linear sequence of narration is again typical of romance which "presents a *vertical* perspective which realism, left to itself, would find very difficult to achieve."[15] By combining a vertical emphasis in his rhetoric with the sense of inevitable sequence provided by a series of actual events and documents, Carlyle can give at least the impression of complex solidity, of simultaneity and sequence, in his histories.

Scott's historical romances were also, of course, among the earliest

literary influences upon both Ruskin and Morris. Ruskin's declaration of himself to be, like his father, a Tory of the old school of Homer and Sir Walter Scott recalls some of his earliest reading of secular texts (the Homer, of course, was Pope's, though by age thirteen Ruskin was attempting the Greek) and indicates not only his desire to impose the values of a heroic past as reflected through fiction upon life itself, but also that he saw his work as a continuation of his father's outlook, however they may have differed over the specifics of his economic works and the wisdom of their publication.

Ruskin's love of Scott was lifelong and, typical of the reading of his youth, it is a frequent subtextual influence even when Ruskin himself may not be entirely aware of it. Ruskin says, for example, that he derived his concept of "Clavigera" the club- or nail-bearing aspect of his personal fate by adapting the "clavos" of Horace, but the most obvious, and clearly the earliest, source for the image is the club transfixed by a spike that Mr. Oldbuck keeps in his study in *The Antiquary*. It is a club with which the Antiquary declares, the monks of old armed their peasants making them "Clavigeri, or club-bearers."[16] The connection of fate with an armed peasantry dovetails with the vision of the revolutionary mob as social nemesis that Ruskin shared with Carlyle, and whose advent the work of St. George's Guild as described in *Fors Clavigera* was intended to forestall.[17]

Like Ruskin, William Morris absorbed Scott almost as soon as he could read and finished the Waverley series by the age of seven. As late as 1882 he acknowledged that rereading the description of the Green Room in *The Antiquary* always revived the emotion attendant upon his first sight of an actual early Flemish tapestry. Scott's description of the Flemish figures on the walls of the Green Room and of the "grim old tapestry" depicting Gwain's wedding to the loathly lady in the Antiquary's study must have contributed to Morris' fondness for the worn tapestry of the blinding of Samson that he, to Rossetti's disgust, insisted on keeping in the bedroom at Kelmscott Manor. Morris insisted he would "yield to no one, not even Ruskin, in [his] love and admiration of Scott."[18]

Carlylean Romance

Here and there a *Tom Jones*, a *Meister*, a *Crusoe*, will yield no little solacement to the minds of men though immeasurably less than a *Reality* would, were the significance thereof

impressively unfolded.

Carlyle, "Biography"

CARLYLE'S FIRST ATTEMPT to blend fact and fiction was not histori-
cal, but like many later Victorian novels, an autobiographically in-
spired *bildungsroman*. Carlyle, however, could not turn experience
into convincing realistic fiction. The hero of *Wotton Reinfred* has a
sensibility formed like his creator's (and Ruskin's) on a double child-
hood diet of fiction (plays, tales, *Arabian Nights*) and the contents of a
theological library, but his consequent oscillations between romantic
histrionics and earnest discussion make him seem neither fish nor
fowl. Indeed the eagerness of Carlyle's characters to cut the small
talk and get down to philosophic business is downright unmannerly.

The underlying romance structure of Carlyle's tale proving in-
tractable and the characters unconvincing, Carlyle reversed his field,
abandoned, in Frye's terms, the realistic displacement of his ro-
mance, and substituted for it confession and anatomy in the creation
of *Sartor Resartus*. *Sartor* presents the confessions of an editor dealing
with a manuscript that is itself confession in a romance pattern, and
exposition of a "clothes philosophy."[19] For the knowledge of man-
ners and social contexts necessary in a convincing novel Carlyle sub-
stitutes something he knows and commands much better, the
apparatus of scholarship, as he caricatures the difficulties of transla-
tion, biographical research and editing. He bends to didactic ends
his literary experience as Ruskin did his knowledge of landscape,
geology, and Turner.

The clothes philosophy itself is a marvelously flexible instrument:
from clothes described as simple covering, or as an indicator of social
or professional status, it can move inward and discover the body it-
self to be the vesture of the soul, or outward to find in nature the
"living garment of God." The clothes philosophy is at once conserva-
tive, reviving in new dress the old interreflecting microcosm and
macrocosm, and radical, taking traditional symbols out of their con-
ventional contexts and recombining them in a pattern of meaning
only partially contingent upon their conventional associations. Like
Ruskin after him, Carlyle takes a preacher's license with both relig-
ious and secular texts. He lifts phrases and symbols from context
and presses them one after another into his service producing the
storm of correspondences typical of Carlylese.

In the third book of *Sartor*, Carlyle provides a guide to perplexed
readers in the form of a chapter on symbols. There Carlyle distin-
guishes between what he calls "extrinsic symbols," such as regimental

or revolutionary standards, and "intrinsic symbols," such as great works of art through which we discern "Eternity looking through Time; the Godlike rendered visible" (*SR*:223). Great men are at one and the same time mere mortals and, in relation to the people they inspire both in their own time and in the future, intrinsic symbols. Great artists and their works function in Ruskin's criticism like Carlyle's intrinsic symbols. Turner holds a place in *Modern Painters* roughly equivalent to Goethe in the early works of Carlyle.

In an age of faith both extrinsic and intrinsic symbols are arranged into a vocabulary expressive of the concepts of the dominant religion, which either absorbs or rejects the symbols of other faiths. In an age of doubt, of transition, items from the symbolic sets of different religions, even intrinsic symbols, can be shuffled together without depriving them of their remaining significance, since the value they retain lies in the symbols themselves. Attachment to an outside referent, an organized belief, has been severed. Carlyle's theory of symbolism allowed him to synthesize details of scientific systems with the older religious outlook and create a personal equivalent of German *Naturphilosophie*. "The centre of indifference" between the Everlasting Nay and the Everlasting Yea is the neutral point of a bar magnet; the pull of the moral law is like that of gravity. Society is either sick or well and reproduces itself through the life cycles of the individuals it contains.[20]

While Ruskin does not adopt Carlyle's terminology, their thought has a common root in Protestant figuralism. Carlyle's concept of the intrinsic symbol blends perfectly with Ruskin's secularized extension of his typological training evident in his treatment of myth after *The Stones of Venice*. Both Carlyle and Ruskin anticipate the modern concept of the archetype in which the equivalent of Carlyle's eternal and godlike made visible becomes the projection of an eternal aspect of the human psyche or the collective unconscious. Ruskin's interpretation of the Demeter and Persephone myth that makes of the mother the origin and end of all life and the daughter the "avenger and purifier of blood" (XIX:304), for example, virtually defines the Great Mother archetype. Neither Carlyle nor Ruskin, however, will reduce the godlike to the natural without making nature somehow divine. Carlyle identifies the inner voice of conscience with that of nature. Ruskin animates nature and makes her laws purposeful even after loss of faith made both God's intentions and nature's essence mysteries to him. But whereas Carlyle's nature is either a conventionalized setting for human action, a symbol of the divine, or a mysterious process of being, Ruskin's is the substantial world of Lyell's

uniformitarian geology, whatever its spiritual significance.

Although Carlyle replaces the social context of the novel in *Sartor* with a parody of historical scholarship, the progressive action of the work still depends on a quest romance plot. After a childhood in which he is at one with a paradisiacal nature Teufelsdröckh loses his Blumine—his light ray, his flower—to Herr Towgood and nature herself grows dark: " 'Thick curtains of Night rushed over his soul, as rose the immeasurable Crash of Doom; and through the ruins as of a shivered Universe was he falling, falling, towards the Abyss' " (*SR*:146). While there is an element of mockery in Carlyle's treatment of the descent theme, the fall from a presexual paradise into the spiritual gulf that alienates Teufelsdröckh from man and nature, and his recovery from the effects of the loss of his beloved, form the very serious burden of the central chapters of Book II: the movement from the Everlasting No, through the Centre of Indifference, to the Everlasting Yea. Carlyle brings out the identity between individual and social quests latent in romance as "the Everlasting Yea" moves quickly from the sense an inner transformation described, in part, in political terms ("a 'glorious revolution' "), outward to a pastoral vision of a "new Heaven and a new Earth" made possible by "Annihilation of Self." Teufelsdröckh's vision is not of the descent of the New Jerusalem but of an earthly paradise: "fair Castles that stood sheltered in these Mountain hollows; with their green flower-lawns, and white dames and damosels, lovely enough: or better still, the straw-roofed Cottages, wherein stood many a Mother baking bread, with her children round her:—all hidden and protectingly folded-up in the valley-folds; yet there and alive, as sure as if I beheld them" (*SR*:187).

This Swiss Pisgah vision of mankind living in harmony with nature is Carlyle's version of the symbolic landscapes of the German *Kunstmärchen*,[21] and Ruskin's Treasure Valley. Female in morphology, containing women baking for their children and housewives "boiling their husbands' kettles," Carlyle's verbal landscape is strikingly maternal and familial. With this pastoral vision comes the security of childhood, the conviction that the universe is not dead, but "godlike, and my Father's"; belief that the Earth is not a cruel stepdame but "my needy Mother" (*SR*:189). Accepting himself as a child of the natural order, Teufelsdröckh can turn outward and claim man as his brother. If Teufelsdröckh's change in perception leads to a vision of a harmonious, unalienated earthly existence, a vision of human potentiality, the question that follows from that progression, for Ruskin and Morris as much as Carlyle, is how to realize the vision.

For Carlyle the first step toward the reformation of the external, social world is reformation of the internal, individual one. However much Teufelsdröckh may believe that nature is the "Living Garment of God," that inner conviction is no longer supported by a "mythus," a communal belief, a sacred story and its catechism. In their absence it is duty that must transform conviction into action—action that overcomes the paralysis induced by the hopeless attempt to understand the world through ratiocination, action that can be undertaken without certainty as to its end. When doubt is overcome by action, the need to decide made subservient to duty, then internal chaos becomes cosmos. By becoming yourself a small world in action, Carlyle implies, you contribute to the development of new order in the larger world, a process too broad for one person to wholly comprehend, too lengthy for one person to experience. Ruskin's activism was an attempt to enact this process.

For Carlyle personally the work that lay at hand was from first to last the act of writing itself, for he was painfully lacking in Ruskin's facility. ("If I could *write*, that there were my practical use. But alas! alas! Oh! Schiller what secret hadst thou for creating such things as Max and Thekla when thy body was wasting with disease?")[22] Between them, Teufelsdröckh and his Editor-translator perform a schematic reenactment of Carlyle's own literary career through the Craigenputtock period. Consequently when Teufelsdröckh looks for signs of hope in the exterior world he turns first to literature and hails Goethe as a prophet of the new order. The elevation of the writer as adumbrated in *Sartor* and spelled out in his lecture "The Hero as a Man of Letters" gave impetus to the special authority the Victorians accorded to literature.[23]

Carlyle saw the means to reach an increasingly literate public steadily expanding—books, pamphlets, newspapers, periodical essays and reviews, reprints of sermons, lectures, and speeches. Under these conditions it was possible for Carlyle to think of commitment to a literary career as a commitment to the forming of a new social order as well, if only authority and the best opinions could be brought together, if only one could expose falsehood and show to whom honor and authority are due. Carlyle tried to convert the writers who came under his influence to his view of the literary vocation, Ruskin not least among them.[24]

Carlyle's presentation of writing as a particularly modern form of heroism, and of the writer as prophet and priest of a new "Church-Homeletic," conveys his sense of his own literary and political mission in the flush of his first popular success. It answers

affirmatively the question he posed for himself in 1833: "Is not perhaps the very want of this time, an infinite want of Governors, of Knowledge how to govern itself? Canst *thou* in any measure spread abroad Reverence over the hearts of men? That were a far higher task than *any* other."[25]

Spread Reverence, yes, but reverence for what or whom? In the old order, when the Christian "mythus" was generally believed, its catechism provided the answer. Honor thy father and thy mother and, by extension:

> To submit myself to all my governors, teachers, spiritual pastors and masters: To order myself lowly and reverently to all my betters: . . . To keep my hands from picking and stealing, and my tongue from evil-speaking, lying, and slandering: To keep my body in temperance, soberness, and chastity: Not to covet nor desire other men's goods; but to learn and labour truly to get my own living, and to do my duty in that state of life, unto which it shall please GOD to call me.[26]

Such was the old codification of the natural laws of social organization; where do we find the new ones? That was the question both Carlyle and Ruskin faced as they tried to formulate a stable modern order.

In the third book of *Sartor* Carlyle presents the social equivalent of Teufelsdröch's conversion. In Sartor's individual, but presumably representative, experience, Carlyle suggested larger implications by describing it in terms appropriate to a public event; so here he describes a social transformation in individual terms as a disease of the body politic, society being: "the vital articulation of many individuals into a collective individual" ("Characteristics," 28:12).

> "For the last three centuries, above all for the last three quarters of a century, that same Pericardial Nervous Tissue (as we named it) of Religion, where lies the Life-essence of Society, has been smote-at and perforated, needfully and needlessly; till now it is quite rent into shreds; and Society, long pining, diabetic, consumptive, can be regarded as defunct; for those spasmodic, galvanic sprawlings are not life; neither indeed will they endure, galvanize as you may, beyond two days." (*SR*:232)

By describing the decline of religion in the rational terms of physiol-

ogy and scientific experiment Carlyle connects the diagnosis with the disease—eighteenth-century rationalism with the inner and outer machinery of the new age. But "Creation and Destruction proceed together" in an age of transition and Carlyle takes one of his symbols for the emergence of a new order from the vocabulary of physiology as well. As the "World-Phoenix" burns, "as ashes of the Old are blown about, do organic filaments of the New mysteriously spin themselves" (*SR*:244).

Organic filaments are germ cells, elemental fibers with the vital power to grow, to absorb nutritive particles, to spin themselves, and through interweaving, form tissue.[27] Because tissue could still be thought of as interwoven fibers rather than cells, Carlyle's call for science to turn from the examination of muscular to vestural tissue readily combines scientific description with a traditional trope for the incarnation, the Word made flesh. Language itself is born of metaphor (*SR*:73), and Carlyle's play upon *tissue* revives its root in the French and, ultimately, Latin verbs to weave, *tisser*, *texere*. (The Latin verb is also, of course, the root of the *text*, the material upon which the Editor demonstrates his sartorial skill.) The body properly seen is clothing of the soul; nature, argues Sartor, citing the speech of the Erdgeist in *Faust*, is "*the living visible Garment of God*" (*SR*:55). The infinitely expansive metaphor of clothes allows Carlyle to join the material, scientific significance of *tissue* to the religious and poetic associations of flesh as cloth or garment into a perfect expression of "natural supernaturalism."

That nature should have endowed the merest thread of living matter with the capacity to weave itself into the astonishing complexity of a human being forms a suggestive parallel to the power of individuals acting on their own volition to make up an organic whole, an *aggregate* in both the zoological sense (distinct animals united into one organism) and the legal one (an organization). Social life is not merely the total of separate lives in a given location, but "the aggregate of all the individual men's lives who constitute society; History is the essence of innumerable biographies." (By *essence* Carlyle means specifically "the living principle round which all detached facts and phenomena . . . would fashion themselves into a coherent whole, if they are by any means to cohere" [27:342].) It is in the language of philosophy the equivalent of an organic filament. The process that binds one generation together also binds generation to generation.

> Hast thou ever meditated on that word, Tradition: how we inherit not Life only, but all the garniture and form of Life;

and work, and speak, and even think and feel, as our Fathers, and primeval grandfathers, from the beginning, have given it us?—Who printed thee, for example, this unpretending Volume on the Philosophy of Clothes? Not the Herren Stillschweigen and Company; but Cadmus of Thebes, Faust of Mentz, and innumerable others whom thou knowest not. (*SR*:246)

To discern and nurture the organic filaments of a new order means to build upon what is natural in human relations. The most basic of ties, essential to the continuation of any society, are those between men and women; adults and children. While the wording of the old catechism may no longer apply, and the economic role of the household may be giving way to industrialism, the family remains for Carlyle, as for Ruskin, the basic social unit. Marriage is not one of the institutions whose clothes grow old; its miseries are rather a measure of decay. Marriage is a model of permanence to be emulated in the social relationships that must be retailored to fit new means of production, as Carlyle makes clear in his letters. "I would stand by my argument that the Covenant of Marriage m[ust] be perennial; nay that in a better state of society there will be other pere[nnial] covenants between man and man, and the home-feeling of man in this world [of] his [cf. Teufelsdröch vision] be all the kindlier for it."[28]

Beyond the family, the organic filament of political order must incorporate man's natural reverence for a superior, the Hero-Worship that connects each person to the next in a heroarchy of mutual obligation and dependence. Any society that attempts to substitute a form of government or a set of abstract rules for this organic truth denies nature: "Nature's Laws, I must repeat, are eternal: her small still voice, speaking from the inmost heart of us, shall not, under terrible penalties, be disregarded. No one man can depart from the truth without damage to himself; no one million of men; no Twenty-seven millions of men *Un*nature, what we call Chaos, holds nothing in it but vacuities, devouring gulfs" (*P&P*:142-43).

The institutions of the church may decay and its dialect change, but the moral truths it once clothed remain laws of nature. A false Gospel, like that of Mammonism, which would make the pursuit of economic self-interest a social good and substitute a "cash nexus" for the obligations of mutually recognized interdependence, ignores the laws of nature that give society its human form. The mill owner who, when faced with starving workers, argues that he has paid what the

contract calls for, who insists on paying for hours of work rather than hiring men, echoes Cain's unholy question. Denied or rejected, these laws of nature assert themselves in terrible ways. "The forlorn Irish Widow applies to her fellow-creatures, as if saying, 'Behold I am sinking, bare of help: ye must help me!' . . . They answer, 'No, impossible; thou art no sister of ours.' But she proves her sisterhood; her typhus-fever kills *them*: they actually were her brothers, though denying it! Had human creature ever to go lower for a proof?" (*P&P*:149). Dr. Alison's "Scotch fact" implies that the English laws replacing the old system of parish relief, by allowing charitable institutions to shut their doors to the needy, deny the laws of nature, the laws of kind.[29]

Just as in contemporary society the eternal truth of the social bond will assert itself in terrible ways if denied, so too must essential ties to the past be maintained if a new order is to emerge without a period of social chaos, of anarchy. To cut all ties to the past because some are rotten, to attempt to create a new order through legislative formulae, is the attempt to join inorganic filaments—"cutting asunder ancient intolerable bonds; and, for new ones, assiduously spinning ropes of sand" (*FR, I*:220).[30] This was for Carlyle one of the great lessons of the French Revolution.

For Carlyle's generation the French Revolution was the grand fact of the time whose implications for the present and future of England had to be properly understood so that its horrors might be avoided. Even most Chartists used the threat of revolution as a means of promoting the reforms that would forestall it.[31] The work that could penetrate the phenomena of the revolution and reveal its essence would be, Carlyle wrote to Mill, "the grand Poem of our Time." As Carlyle began his history he wrote of it (albeit, hyperbolically) as "Quite an Epic Poem of the Revolution: an Apotheosis of Sansculottism!"[32] He opened the last chapter with an analogy between "Homer's Epos" which "does not conclude, but merely ceases," and "the Epos of Universal History Itself," (*FR, III*:321) a selection of which, Carlyle implies, he has just narrated.

But if history itself is an epic or, as Carlyle terms it elsewhere, a Bible, it is not only all canonical, but beyond human comprehension. Consequently the historian's posture is not that of the epic poet, lifted by the goddess or the heavenly muse to a superhuman perspective, rather it is analogous to *Sartor*'s Editor-narrator. Carlyle does not present himself taking dictation from Clio but actively selecting, interpreting, comparing, and judging people and events so as to give history a comprehensible shape. Punning on the meaning of the

"culottic and sansculottic" he tailors a history of the death of a dan-
diacal body politic and the clothing of its naked successor. Carlyle is
as active a presence in his history as Ruskin is in his criticism when he
selects, interprets, compares, and judges painters and paintings.

Taking his cue from Carlyle, Mill opened his review of *The French
Revolution* by calling the work "not so much a history, as an epic
poem; and notwithstanding, even in consequence of this, the truest
of histories."[33] He goes on, however, to praise Carlyle's qualities as a
storyteller at the expense of his virtues as an historian. Carlyle's
strength—his power to combine fact with the ability to project him-
self into historical personalities, to animate them as if from
within—produces historical weaknesses—a slighting of abstract prin-
ciples and an overemphasis upon individuals as opposed to institu-
tions.

The narrative posture of *The French Revolution*, as Froude points
out, extends that of "The Diamond Necklace," which Carlyle called
an "attempted *True Fiction*,"[34] insisting: "Romance exists . . . strictly
speaking, in Reality alone" (28:328). The Carlylean historian is the
recorder of a theoretically endless series of true stories, the Sartorian
editor of the "Bible of Universal History." The device common in
romance fictions of embedding (*enchâssement*), that is, the placing of
narratives within narratives which Carlyle exploited so brilliantly in
Sartor, is modified in *The French Revolution*, where plots and subplots
are narrated in the same voice but in such different genres as the
material suggests. The downfall of figures of order such as Mira-
beau, Danton, and Madame Roland Carlyle makes tragic, the story of
Couthon satiric, that of Charlotte Corday a perverted comedy in the
ironic mode substituting assassination and social discord for the
embrace of lovers and social integration. (Thus Adam Lux, Charlotte
Corday's proper "light of life," can only follow her to the guillotine.)
The formula for modern epic pronounced by his fictional Professor
Gottfried Sauerteig, the substitution of the reality of biography for
superannuated machinery, produces in Carlyle's practice a blend of
the heroic and mock-heroic in the tradition of heroic romance rather
than a latter-day *Iliad*.

Carlyle shapes his episodes to points where the characters can
speak for themselves out of the texts he cites in his footnotes. This is
not simply scholarly reference, but testimony, an embedding that
makes linear narration momentarily congruent with solid history.[35]
The French Revolution has no hero but, like many romances, has a
sequence of figures taking the role in turn. Where the novelist
achieves verisimilitude within a romance structure by what Frye calls

the realistic displacement of romance, Carlyle substitutes historical events. Thus history saved Carlyle the necessity of pure invention that he found so difficult in his attempt at fiction, leaving him only the selection of incident and the realization of characters such as he had praised in Scott, and for which he in turn was praised by Mill, John Sterling, and many after them. While *The French Revolution* has heroic passages, its structure is less that of an epic than what Hayden White terms "realism emplotted as romance."[36]

As Mill noted, Carlyle pays far more attention to individuals, to the private lives of public figures, to the backgrounds that shaped them, than does the conventional historian even of his own time. Although he was suspicious of many of them, his method demanded that he give credence to memoirs (which have a narrative line) and focus upon key moments that, like the typologically significant acts in the Bible, seem to reveal the essence of personality. The narrative is shot through with interpretive commentary. Characters are praised or blamed, satirized or sympathized with, lamented or hooted off the stage by the narrator. Carlyle's rhetoric is even more polarized than his narrative, which is restrained by events, and ranges from heaven to hell, from Olympus to Hades, whether for direct panegyric or for denunciation, or for ironic contrast. (A similarly polarized rhetoric characterized Ruskin's criticism from the start. He could scarcely praise Turner or Tintoretto without denigrating Claude or Rembrandt.)

The central narrative line from which individual episodes in varying degree digress records the decline and fall of the "realized ideal" of monarchy, the consequent loosing of "anarchic sanscullotism," the "Insurrection of Women," the progress of the "Apocalyptic Convention, or black *Dream become real*" (*FR, III*:70), and the efforts of a series of potential heroes to restore order, to become "intrinsic symbols" of a new regime: Mirabeau, Danton and, ultimately, Napoleon. Sanscullotism is the nemesis roused by the systematic violation of what Carlyle insists are the natural laws of social organization; revolution the fate of a society in which the hierarchy of classes has ceased to embody mutual dependence and responsibility, and has hardened into a mechanism of exploitation sustaining an increasingly dysfunctional ruling class. This analysis Carlyle, and Ruskin after him, applied to England.

The captive state of the French monarchy in Paris, the prelude to the abortive flight of the king and queen to the frontier and their subsequent execution, grew from what conventional historians call the journées of October 1789, but Carlyle names the "Insurrection of

Women," stressing the breakdown of order in the family—for Carlyle and Ruskin the basic social unit: "Men know not what the pantry is, when it grows empty; only house-mothers know. O women, wives of men that will only calculate and not act! Patrollotism is strong; but Death, by starvation and military onfall, is stronger Will Guards named National thrust their bayonets into the bosoms of women?" (*FR, I*:250). What follows is a vision of the world turned upside down, of women gathering, impressing others into their ranks, storming buildings, seizing arms—the women an irresistible force of nature finally marching under the leadership of Usher Maillard to Versailles, demanding: "Du pain, et parler au Roi." "It is the cause of all Eve's Daughters, mothers that are, and that ought to be" (*FR, I*:256).

The picture of mothers baking bread with children round them in the folds of a valley was central to Teufelsdröckh's vision of nature restored to him in "The Everlasting Yea." The Insurrection of Women is the antithesis of that vision, an inevitable response of the nurturers of mankind to the combination of deprivation and the breakdown of legitimate authority, political and domestic, capable of resonding to their needs. Carlyle's vivid depiction of the Insurrection of Women and the storming of Versailles was revived in the popular press with each French Revolution and was, of course, absorbed by Ruskin who characteristically transposed it into a prophetic typology of architecture: Gothic versus Renaissance.

> The love of nature was uprooted from the hearts of men, base luxuries and cruel formalisms were festered and frozen into them from their youth; and at last, where, from his fair Gothic chapel beside the Seine, the king St. Louis had gone forth, followed by his thousands in the cause of Christ, another king was dragged forth from the gates of his Renaissance palace, to die, by the hands of the thousands of his people gathered in another crusade; or what shall that be called—whose sign was not the cross, but the guillotine? (XII:100)

The spatial metaphor typical in romance which associates evil with a demonic lower realm and the hero with a beneficent higher one is carried out in the division between the demonic energy of anarchy boiling up from the depths of society and within individuals that may justifiably destroy but cannot build, and the natural tendency to order which the hero must finally command from above. The command of magic whether for good or evil that is characteristic of

romance fiction has its equivalents in the mysterious powers of nature and spirit Carlyle regularly evokes, even when he conjures them with the vocabulary of science.

At the conclusion of Carlyle's history, "Citoyen Buonaparte" steps ashore from "the miraculous Convention ship . . . there shall we figuratively say, changed, as Epic ships are wont, into a kind of *Sea Nymph*, never to sail more; to roam the waste Azure, a Miracle in History!" Whereupon he gives the armed resisters to the Convention the long promised "whiff of Grapeshot," and "the thing we specifically call *French Revolution* is blown into space by it" (*FR, III*:320).

The allusion to the transformation of the Trojan fleet would seem to make of Napoleon a latter-day Aeneas, and indeed the "Apotheosis of Sanscullotism" Carlyle announced to his brother John has become that of Napoleon. But the parallel shifts in the direction of the mock heroic as Carlyle turns aside from the generic logic of his history to celebrate the ending of anarchy rather than the establishment of Napoleon's empire. Napoleon represents no principle other than that of order—an order that was to prove temporary at that. "The End of the dominion of IMPOSTURE" (*FR, III*:323), rather than the positive reconciliation between man and nature, is the revelation that concludes Carlyle's romance-history.

The "aggregative principle" proved incapable of generating social stability without the imposition of personified leadership, but the leader was imperfect. Unlike Michelet, who took the people for his hero and foresaw their eventual triumph, thereby projecting the millennium of romance beyond the close of his *History*, Carlyle turns aside the revolutionary implications of his mode of historiography. From Marx and Engels' perspective Carlyle's problem seems clear:

> The whole process of [Carlyle's] history is determined not by the development of the living masses themselves, naturally dependent upon specific but in turn historically created changing conditions, it is determined by an eternal law of nature With this mode of thinking, the real class conflicts, for all their variety at various periods, are completely resolved into the one great and eternal conflict, between those who have fathomed the eternal law of nature and act in keeping with it, the wise and the noble, and those who misunderstand it, distort and work against it, the fools and the rogues. The historically produced distinction between the classes thus becomes a natural distinction which itself must be acknowledged and revered as a part of the eternal law of nature by bowing to

nature's noble and wise: the cult of genius The process of historical development is reduced . . . to the simple morality we find in the *Magic Flute*.[37]

Applying lessons of the French Revolution to the English scene in *Chartism,* Carlyle sees "the revolt of the oppressed lower classes against the oppressing or neglecting upper classes" the way Ruskin would a generation later as a demand for justice, a demand for true government to be met through a peaceful equivalent of revolution. "These Chartisms, Radicalisms, Reform Bill, Tithe Bill and infinite other discrepancy, and acrid argument and jargon that there is yet to be, are *our* French Revolution: God grant that we, with our better methods, may be able to transact it by argument alone!" (29:149).

Yet Carlyle's severely polarized imagination cannot respond to conventional politics. The very listing of bills and "Radicalisms" is contemptuous. What England needs is evolutionary change, the new growing out of the old, but personified in leadership that can command its direction. The masses of Europe "must and will find governors." " 'Laissez-faire, Leave them to do?' The thing they will *do* if so left, is too frightful to think of! It has been *done* once, in sight of the whole earth, in these generations: can it need to be done a second time?" (29:160).

Carlyle reinforced in Ruskin the hope for evolutionary change that would produce stable authority, hope for new forms of aristocracy, for "the rights of man" embodied in "the mights of man," together with the fear of revolution should the laissez-faire principle triumph. "Ever since Carlyle wrote that sentence about rights and mights," said Ruskin, "all blockheads of a benevolent class have been declaiming against him, as a worshipper of force. What else, in the name of the three Magi, *is* to be worshipped? Force of brains, Force of heart, Force of hand;—will you dethrone these, and worship apoplexy?" (XXVII:230).

Quackery

Lo! thy dread Empire, CHAOS! is restor'd;
Light dies before thy uncreating word:
Thy hand, great Anarch! lets the curtain fall;
And Universal Darkness buries All.

Alexander Pope

TRIUMPHANT HEROISM is a combination of the man and the moment: the time may cry for a hero and get none; the man himself must perceive and offer what the times demand. (This movement is the very structure of *Cromwell* with its alternations between historical overviews and embedded narrative, here in the form of specific documents recording the progress of the Protector's private thoughts and public actions.) Carlyle's Napoleon is a less admirable man than either his Mirabeau or his Danton. But Napoleon is heroic because he drills sansculottism into order, he tames the French Revolution "that it may become *organic*, and be able to live among other organisms and *formed* things (*Heroes*, 5:240)." The Napoleon of *Heroes and Hero-Worship*, however, is a divided man: Hero and Quack, St. George (or rather St. Denis), and Archimago in one body. "The fatal charlatan-element got the upper hand" (5:241) and Napoleon betrayed not the revolution in any strict political sense, but Truth, Justice and Nature who in consequence cast him out. (The only specific betrayal he holds against Napoleon is of Carlyle's favorite revolutionary scheme—" 'La carrière ouverte aux talens, The implements to him who can handle them': this actually is the truth, and even the whole truth; it includes whatever the French Revolution, or any Revolution, could mean" (5:240).

Carlyle's belief in heroes, as one would expect in a writer of romance, is inseparable from his fascination with quacks. In the essays preparatory for *The French Revolution*, the tale of the Diamond Necklace and Count Cagliostro figure as prominently as Diderot and Mirabeau. In *The French Revolution* itself the antagonism between contending parties and individuals becomes a contest between Imposture and Reality in which Reality, as in the case of Danton, can occasionally lose. But in all of Carlyle's histories the demonic element is finally checked both historically and formally. While *The French Revolution* may be said, in Carlyle's own terms, to "merely cease," the end point is one he had chosen and toward which he pointed his narrative. Even the most despicable character thus plays a role that in retrospect seems fated and Carlyle can spare at least some sympathy for them all, even the demonic antiheroes Marat and Robespierre.

In *Past and Present*, the rise of Abbot Samson, which came to Carlyle as a ready-made *True Fiction*, retains the sense of formal completeness he created in *The French Revolution*— the working out of what seems an ordained destiny. The antithesis between that self-renewing world of organic, hierarchical relationship with a place for everyone, and most everyone in his place, and the empty frenzy of modern "phenomena" produces some of Carlyle's most powerful

social commentary. As the "mythus" of St. Edmund, the soldier and "landlord," inspired the very different social order of Abbot Samson and his monks, so Carlyle implies, might the "mythus" of Samson now retold provide a model for new forms of the eternal connections, new sets of formal relations between those who command (particularly captains of industry) and those who follow. But whereas the struggle between good and evil, order and anarchy, in *The French Revolution* was dynamic and part of a single historical development, the contrast between natural election and anarchy, between panegyric and denunciation, in *Past and Present* is split, as the title indicates, historically.

The contrast between a past of familial and social connectedness and a present in which economic and family life are being broken apart (or at least reorganized), and lives are fragmented and disconnected, has been confirmed by modern historians using very different methods from those of Carlyle.

> Those changes of scale, that sense of alienation of the worker from his work, that breach in the continuity of emotional experience in which we have sought for the trauma inflicted at the passing of the traditional world, cannot be referred to Tudor or to Stuart England. When factory life did at last become the dominant feature of industrial activity it condemned the worker, as we can now see, to the fate previously reserved for the pauper. But the threat of this did not become apparent until the early nineteenth century.[38]

Past and Present combines perception of a verifiable shift in social arrangements with a yearning for the return of an Edenic past (albeit stiffened, as in the case of Morris, with an element of primitivism) that reflects the nostalgic side of romance. The dichotomy of *Past and Present* is largely that of the rest of Carlyle's career: praise of dead heroes and an increasingly intemperate denunciation of his own times.

In the *Latter-Day Pamphlets* Carlyle retained neither the parallel between the process of history and its literary revelation that made *The French Revolution* so powerful, nor the implicit dialectic of *Past and Present*. In effect he recreated the exclusively present chapters of *Past and Present*, and issued them in expanded form in separate numbers. Freed from the bonds of history in which the triumph of the hero and the defeat of the impostor seem fated; unrestrained by a dialectic suggesting that shams will ultimately give way to a

"Chivalry of Labour," the diabolic aspect of quackery is given free reign. The very open-endedness of the *Pamphlets* suggests the possibility of a perpetual reign of the Quack resembling the vision of the reign of Dullness at the end of Pope's *Dunciad*.

Within the closed world of Carlyle's historical romance order was achieved, as it is in romance fiction, at the expense of the "other," the outsider. In *Past and Present* the outsiders were the Jews, whose discomforture Carlyle makes even more vivid than Jocelin by bringing into his account incidents from outside the *Chronicle*. Distanced by both history and a closed narrative, Carlyle's treatment of Benedict the Jew in *Past and Present* has never stirred the controversy roused by his depiction of Quashee in the "Occasional Discourse on the Nigger Question," though Carlyle implies it has present application. (The open-endedness and contemporary focus of the late essays have the rhetorical effect of unleashing Carlyle's demons, exposing the danger of treating individuals and classes of people as symbols whether of order or disorder—a practice which runs through Carlyle's work from first to last.)

The emphasis in Carlyle's social criticism up to midcentury was upon the possibility of social rebirth according to nature's laws of organization. Just as the marriage vow formalizes a natural tie and reinforces it with social sanctions, both positive and negative, so, Carlyle hoped, might the emerging industrial order be organized according to "the principle of Permanent Contract instead of Temporary" (*P&P*:277). Carlyle recognized that the dominant form of relationship between employer and employee was changing from one based upon the model of the household to one restricted to a contract for labor. By making contracts permanent the employer would, as in the old model, be hiring a worker, not buying so many hours of labor. (Ruskin underscored Carlyle's point by taking the title of his most important economic work from the Parable of the Vineyard Laborers: "I will give unto this last, even as unto thee.")

In retrospect the hope Carlyle and Ruskin shared for the hiring of men rather than "hands" seems chimerical. But one need not look as far away as Japan for examples of industrialization carried out on a feudal, familial model. There is a paternalistic streak that runs through the history of British capitalism, and one of the major industrial enterprises of the eighteenth century was run according to principles Carlyle and Ruskin would have approved. *The Law Book of the Crowley Ironworks*[39] preserves the record of a mixed industrial organization that combined factory with community and provided

welfare services from teachers, doctors, and ministers for the families of employees. The rise of Ambrose Crowley to Sir Ambrose, and his neofeudal organization of labor, were all that Carlyle desired from Plugson of Undershot, but the Crowley system remained an anomaly.

The "fabric of law" in industrial relations he desired would, Carlyle thought, assure that the duties of government would be those of a father, not those of a constable enforcing such limits on everyone's pursuit of self-interest as might be necessary to keep the machinery of society in gear. But what Carlyle saw as the greatest act of paternal statesmanship of his day—the repeal of the Corn Laws—led not to the strengthening of Sir Robert Peel's power, but to his downfall. The revolutions of 1848 came and passed leaving neither a stable new order nor a revivified kingship in place of the forces Carlyle associated with chaos and anarchy. At midcentury Carlyle saw, instead of social rebirth on the familial and neofeudal model of hierarchical interdependence, instead of a new social marriage, an apocalyptic divorce.

> From the "Sacrament of Marriage" downwards, human beings used to be manifoldly related, one to another, and each to all But henceforth, be it known, we have changed all that, by favour of Heaven: 'The voluntary principle' has come-up, which will itself do the business for us; and now let a new Sacrament, that of *Divorce*, which we call emancipation, and spouted-of on our platforms, be universally the order of the day. ("Present Time," 20:25)

Ruskin picked up the theme in *Fors Clavigera* noting that in "many an age, women have been compelled to labour for their husbands' wealth, or bread; but never until now were they so homeless as to say, like the poor Samaritan, 'I have no husband' " [John 4.17]. It was "contempt of the Middle Ages and of their chivalry" that had in Ruskin's view, led women "to claim the privilege of isolation" (XXVII: 80).

Always convinced that the mere ballot box elections could not express the real will of a people, Carlyle found to his horror that the people had in truth elected not the industrial duke, fit hero of "Tools and the Man," but the speculator, Hudson the railway king. The "Apotheosis of Hudson" is, to Carlyle's dismay, the product of genuine hero worship, the manifestation of the religion of the latter day.

Hudson solicited no vote; his votes were silent voluntary ones, not liable to be false: he *did* a thing which men found, in their inarticulate hearts, to be worthy of paying money for; and they paid it Without gratitude to Hudson, or even without thought of him, they raised Hudson to his bad eminence, not by their voice given once at some hustings under the influence of balderdash and beer, but by the thought of their heart, by the inarticulate, indisputable dictate of their whole being. ("Hudson," 20:264-65)

Carlyle's influence on the Victorians was such that in 1855 George Eliot could say with some justice that "there is hardly a superior or active mind of this generation that has not been modified by Carlyle's writings."[40] It was an influence that went beyond the world of literature. Whether or not Carlyle's call for mine inspection had any influence upon Lord Ashley's Act of 1842, it is worth noting that the man who was to be the first Inspector of Mines, H. S. Tremenhere, wrote in his 1839 diary of conditions in Wales: "Nearly the whole body of employers acted on Bentham's theory that the masters had no responsibility beyond paying the men their wages In the words of Carlyle, 'Cash payments were the sole nexus between man and man.' "[41] But by and large the minds Carlyle influenced could not produce change even as regulators, let alone as producers. Even an heroic man of letters could be no more than a prophet of social reform. The heroes of the new epic "Tools and the Man," the heroes who would break down the walls of the workhouse Bastille to free the prisoners for productive labor, had to wield economic power. Looking around him Carlyle saw neither a general willingness on the part of employers to recognize their paternal obligations to their workers, nor a demand on the part of the people that a true hero be placed over them. Neither his own writings nor literature in general had acted as the organic filament of a new "Church-*Homilectic*" as he had hoped in the more optimistic *Sartor* period. The "firm regimented mass" Carlyle called upon his captains of industry to organize in *Past and Present* was to be an organic growth based upon a mutual recognition between men who know in their hearts that they must be led and those whose conscience prompted them to leadership. "You *cannot* drill a regiment of knaves into a regiment of honest men Give us the honest men, and the well-ordered regiment comes of itself," wrote Carlyle in his 1832 Note Book.[42] Most of Carlyle's heroes through *Cromwell* are the articulate expression of what their followers desire—their wills flow concurrently. None of Carlyle's

historical heroes, however, hesitated to use coercion when coopera-
tion failed, and if the combination of the voluntary principle and
floods of unemployed Irish threatens anarchy, then Carlyle is pre-
pared to call, in the prime minister's speech in "The Present Time,"
for what in 1832 he thought impossible: "mere soldierly obedience,"
after due incitement if possible, under threat of whip and gun if nec-
essary.

Like the other calls to order in the *Latter-Day Pamphlets,* the violence
of the prime minister's speech is an impotent violence. It is impotent
not because of some psychological failing on Carlyle's part, but be-
cause, as the context of the speech makes clear, Carlyle has little hope
that the speech will be given, let alone action taken. The nagging
repetitiousness of the *Pamphlets,* so poorly suited to the extremes of
their rhetoric, is that of a man who knows he is not being heeded.
The unlikely image of Sir Robert Peel, miraculously restored to
power, as Hercules cleaning the "Augean Stable of Downing Street,"
has none of the literary persuasiveness of figures like Abbot Samson
whose rise to power, sustained by the imagery of organic develop-
ment, is made to seem both just and inevitable. Significantly, the
contemporary lives Carlyle chooses to commemorate at length are
those of heroes that might have been, men like John Sterling and
Edward Irving, good and talented men whose potential was some-
how baffled by the age. These Carlyle memorializes in prose strip-
ped of most of the excesses of "Carlylese."[43]

In the conversion recorded in *Sartor* Carlyle rejected the concept of
the universe as amoral and mechanical, relying on the inner convic-
tion, sustained by his reading of German transcendentalism, that if
life was not a total absurdity the universe must be living, purposeful,
and organized according to moral as well as physical law. Such an
individual belief can only renew religion if it is shared, religion being
a product of society, of man's collective imagination. While Carlyle
may not have been aware of the degree to which his late essays reflect
personal disappointment, he presented the inorganic, atomized, dis-
gusting world of filth, decay, disease, and death of the *Latter-Day
Pamphlets* as a revelation not of his own imagination, but rather of
what the collective imagination of his countrymen had called into
being. It is the product of what he and Ruskin saw as the religion of
Mammonism.

If in *Sartor* Carlyle is a prophet, however guarded, of hope, in the
Latter-Day Pamphlets he is a Jeremiah rejecting a people who have
whored after strange gods and chosen death over life. The faith that
freed Carlyle from spiritual paralysis for a lifetime of activity in

literature, the faith Carlyle hoped would free others for creative so-
cial action if they would but look honestly within themselves, proved
too personal in its combination of Protestant dualism and German
philosophy to be transmitted. Curiously unmindful of the length
and complexity of his own conversion, Carlyle thought he could
transmit the result without the process, and his "mysticism" re-
mained stubbornly mysterious even to so devoted a disciple as
Ruskin. The hope that Carlyle's early work held out for the next
generation was of a life of useful action sustained by a renewed relig-
ious faith. For Ruskin as for many others the faith failed, but he did
not lament with A. H. Clough that "Carlyle led us into the wilderness
and left us there."[44] Rather Ruskin rededicated himself to Carlyle's
work. He attempted the heroism of letters only to find it, as his mas-
ter had, of no avail. Then to Carlyle's sometime astonishment he at-
tempted to demonstrate the chivalry of labor himself.

Dove or Crow

It betrayed the guilt of Coronis to Apollo, and was made black
for ever. It is the seeker out of, and feeder on, death, moral or
physical.

Ruskin, "The Chough"

RUSKIN CAME TO Carlyle with his habit of mind and general social
outlook already formed. It was primarily in matters of faith that
Ruskin hoped for guidance. But whether he approached Carlyle di-
rectly, or indirectly (as when sending him a copy of Lyell's *Manual of
Elementary Geology* in hopes that the older man would confront di-
rectly the kind of science that had proved such a burden to the faith
of Ruskin's generation) he was turned aside. Carlyle, despite his
early study of German geology and geognosy, was not interested in
reading that might threaten the special faith with which he had laid
his questioning self to rest by the time of *Sartor*.

The areas of difference between the two men in temperament and
interests were at least as conspicuous as their similarities. Carlyle had
little use for the aesthetic side of Ruskin's thought. He was never
drawn to visual art and when Ruskin met him had long since made a
public show of closing his Byron, had dismissed Wordsworth,
mocked the "picturesque tourism" from which so much of Ruskin's
love of art and landscape had sprung,[45] and was regularly

expressing his hostility to most fiction—indeed to aesthetic pursuits generally. Ruskin, for his part, had use for few things German after the death of Dürer, and as he lost his faith he achieved, partly through Carlyle's influence, a religious broadmindedness that led him to reject some of his master's fixed judgments, particularly his anti-Catholicism. The same prejudice had been one of the blights on Ruskin's early love, and his study of art together with his own spiritual longings had long since led him to dismiss it as the bad product of a parochial upbringing and a blemish on his early work. Moreover, Ruskin, like Burne-Jones, was basically southern in orientation, preferring France to Germany, and was caught up—like Elizabeth Barrett Browning—in the political and artistic fate of Italy. Carlyle, like Morris, was a man of the north who thought of the English as essentially Germanic and attributed what little good he could find in the French to the blood of the Franks.

During the estrangement of 1867 Ruskin wrote to Carlyle, attributing their conflict to divergent sets of mind: "I more and more wonder at your not being able to distinguish between your lava current of mind—tumbling hither & thither and *cooling* in the odd course of it at necessary periods—and my poor little leguminous—climbing—tendril of a vegetable mind—subduable and flexible by a touch—but utterly changeless of temperature."[46]

The picture of Carlyle's mind as a lava flow carrying all before it, but then settling as it cools into fixed positions, is singularly apt. Ruskin's view of his own vine-like mind is equally appropriate figuring not only his tendency to branch out into elaborate subarguments in the course of exposition, but also his capacity to replace old assumptions that had to be pruned away with compensatory new growth that maintained the structure of the old while altering the overall shape of the plant.

The personal relationship of master and disciple was buttressed however by their shared Scottish roots, strict Protestant upbringing, Platonic authoritarianism in politics, and faith in the ultimate unity of natural and moral law—that law corresponding to the ethics of the Bible. They were absolute in their historical judgments, whether artistic or political, and saw the world as a moral battleground that called out for heroic action. As the social and economic message in Ruskin's work grew more overt, he received encouragement from Carlyle deliberately couched in a shared language of combat against Mammon, Python, and like monsters of the spirit in what both men saw as a latter-day war of religion. It was only after the failure of *Unto This Last* to win an audience that Ruskin converted what he first

declared to be a parallel in their thinking to a direct and public decla-
ration of discipleship supported by quotations from Carlyle's
work.[47] But the parallels and the differences in their sets of mind
and, consequently, in their views of society are already evident in *The
Stones of Venice.*

The Stones of Venice is the pivotal work in the Ruskin canon. Though
digressive and bristling with notes and appendices, its three volumes
contain Ruskin's longest sustained argument and form at once the
capstone of the work grounded in his early faith and the basis of his
post-Evangelical, Carlylean work in social criticism. These two
aspects of *The Stones of Venice* meet in the chapter "The Nature of
Gothic" that William Morris called "one of the very few necessary
and inevitable utterances of the century."[48] Ruskin's powers of anal-
ysis and observation and the fruits of his Evangelical herit-
age—typologically based exegesis, the ethical concern, the literalism,
the urge to preach and to proselytize—are never in better balance
than in this chapter.

Ruskin was, of course, an essentialist in his art criticism as well as in
his science. The very title, "The *Nature* of Gothic," suggests the prac-
tice of essentialist critics as defined by E. H. Gombrich.

> They presuppose that the historian who looks at a sufficient
> number of works created in the period concerned will gradu-
> ally arrive at an intellectual intuition of the indwelling essence
> that distinguishes these works from all others, just as pinetrees
> are distinguished from oaks. Indeed, if the historian's eye is
> sufficiently sharp and his intuition sufficiently profound, he
> will even penetrate beyond the essence of the species to that of
> genus; he will be able to grasp not only the common structural
> features of all gothic paintings and statues, but also the higher
> unity that links them with gothic literature, law and philoso-
> phy.[49]

Of all the broad stylistic categories current in the midnineteenth cen-
tury, Gothic was the one whose essence was most often associated
with imitation of the particular forms of nature. The association be-
tween Gothic and raw nature undisciplined by the rules of art that
are "nature methodiz'd" has roots both in the use of the term in the
Renaissance and the neoclassical period as what Gombrich calls a
"term of exclusion," (an epithet for the incorrect, the nonclassical)
and in the belief that its forms were copied from nature: that the
Gothic arch, for example, "was derived from trees, not yet cut down,

whose branches were bent over and made to form pointed arches when tied together."[50] So powerful were the associations between the Gothic and natural forms that they persisted long after the theory of simple derivation had been discredited. To Ruskin imitation of natural forms was not the origin of Gothic but one of its great achievements.

> It was no chance suggestion of the form of an arch from the bending of a bough, but a gradual and continual discovery of a beauty in natural forms which could be more and more perfectly transferred into those of stone, that influenced at once the heart of the people, and the form of the edifice. The Gothic architecture arose in massy and mountainous strength, axe-hewn, and iron-bound, block heaved upon block by the monk's enthusiasm and the soldier's force Gradually, as that monkish enthusiasm became more thoughtful, and as the sound of war became more and more intermittent beyond the gates of the convent or the keep, the stony pillar grew slender and the vaulted roof grew light, till they had wreathed themselves into the semblance of the summer woods at their fairest, and of the dead field-flowers, long trodden down in blood, sweet monumental statues were set to bloom for ever, beneath the porch of the temple, or the canopy of the tomb. (X:237-38)

The essence of Gothic, Ruskin wrote to his father in February 1852, lies "in the workman's heart and mind—but its outward distinctive test is the *trefoiled* arch. . . . I shall show that this Distinctive test of Gothic architecture is so by a mysterious ordainment, being first a type of the Trinity in unity, Secondly of all the beauty of Vegetation upon earth—which was what man was intended to express his love of, even when he built in stone—lastly because it is the perfect expression of the strongest possible way of building an arch" (LV:192). Ruskin does not begin his chapter as one might expect with the thesis he advanced to his father. In fact, he never directly invokes the Trinity at all. Rather he allows an underlying trinitarian aspect to emerge without any but the most careful reader being aware of it by conducting most of his analysis in triplets as if bound by a critical equivalent of that Law of Three evident in *The King of the Golden River*. At the time he was writing "The Nature of Gothic," Ruskin was reading both Dante and Spenser carefully. While he does not discuss number symbolism in his appendix on the theology of Book One of *The Faerie Queene*, that poem continually combines dualistic conflicts and

choices with various triplets: three aspects of the Redcross Knight, three Sans brothers, three mountains, three days of dragon battle, etc. In 1870 he was to write: "of course the numbers, two, three, four, seven, nine, twelve, and forty, are continually used vaguely in all mythic art; nevertheless, every writer makes his own 'three,' or his own 'four,' or his own 'seven' express some special division of the subject in his mind" (XX:382), and certainly Ruskin's earlier work bears out his suggestion.

The two divisions of his topic, the equivalents of soul and body, are, as Ruskin told his father, the mental power or character of the builder and its manifestation in his work. Ruskin finds six characteristics of Gothic (twice three—compare the decorated fringe from Rouen, X, plate 21, fig. 1.), which apply to the building in order of importance as: Savageness, Changefullness, Naturalism, Grotesqueness, Rigidity, and Redundance. The same attributes in the builder are: Savageness or Rudeness, Love of Change, Naturalism, Disturbed Imagination, Obstinacy, and Generosity. While all these criteria need not be expressed in every Gothic building there must be at least three or the building cannot be Gothic.

Gothic triplets, a foliated window fringe, Rouen Cathedral (X:262).

Under the heading of Savageness Ruskin describes the three types of ornament: Servile (Egyptian, Mesopotamian, and Classical), Constitutional (Gothic), and Revolutionary (Renaissance). Here, as in many of Ruskin's analyses at this stage of his development, the triple division implies that the middle term is a mean between extremes—in this case the extremes of ancient servility and Renaissance specialization. Modern manufacture is a recrudescence of paganism, a new form of slavery that can be combatted by following three rules: never encourage uninventive and unnecessary articles; never demand high finish for its own sake; never encourage imitation except for historical record. The discussion of naturalism leads to the tripartite classification of artistic men: on the left, the men of design; on the right, the men of facts; and in the center the Gothic in spirit who combine fact and design in the best proportions. A similar division under the category pursuit of truth yields three classes of painters: purists who strive to paint only the good, sensualists who emphasize evil, and naturalists, who paint the morally mixed world we necessarily confront in our daily lives.

It is only after Ruskin has spelled out his subdivisions of the Gothic spirit in some detail that he turns to structural forms, to the three great architectural systems: the Greek of the lintel, the Romanesque of the rounded arch, the Gothic of the gable. The Gothic love of nature expressed on the surface of the building in the decorative application of leaf and vine is incorporated into the structure of the building itself in the most perfect form of the Gothic arch, the trefoil. Thus the building and decoration together express the principle of growth in the natural world: "not that the form of the arch is intended to *imitate* a leaf, but *to be invested with the same characters of beauty which the designer had discovered in the leaf*" (X:257). The analogue between Gothic and leaf form is not a matter of the imitation of surface forms, but an expression of essence, a renewal in the fallen world in which man must labor of his initial mission to tend the garden of God. The products of the Gothic mentality (which in its love of leaf and vine suggests Ruskin's later image of his own mind) in the most communal of art forms, architecture, form a high point of civilization, a partial recovery from the fall.

> The goodly building is then most glorious when it is sculptured into the likeness of the leaves of Paradise; and the great Gothic spirit, as we showed it to be noble in its disquietude, is also noble in its hold of nature; it is, indeed, like the dove of Noah, in that she found no rest upon the face of the

waters,—but like her in this also, *"Lo, in her mouth was an olive branch, plucked off."* (X:239)

The buildings of Gothic Venice are as suited to the mind as nature itself and preempt any need for a school of realistic landscape painting. Ruskin's medieval Venice was a virtual earthly paradise at once garden and city. But like Tyre, whose king "hast been in Eden the Garden of God," Venice grew proud and violent in its riches and was cast "profane out of the mountain of God" (Ezekiel 28). The prophetic, typological triple equation of Tyre, Venice, England that opens *The Stones of Venice* was Ruskin's symbolic announcement of his turn to social criticism, as he later made clear in *St. Mark's Rest*.

If the trinitarian argument of "The Nature of Gothic" and the suggestion of the possibility, through recovery of the essence of Gothic, of a partial redemption from the fall represent the climax of Ruskin's Evangelically based criticism, the contrast between the medieval and modern worker in the discussion of Gothic Rudeness points to Ruskin's future as a social critic, the dubious historical argument being clearly subordinate to its contemporary application.

> To every spirit which Christianity summons to her service, her exhortation is: Do what you can, and confess frankly what you are unable to do; neither let your effort be shortened for fear of failure, nor your confession silenced for fear of shame. And it is, perhaps, the principal admirableness of the Gothic schools of architecture, that they thus receive the results of the labour of inferior minds; and out of fragments full of imperfection, and betraying that imperfection in every touch, indulgently raise up a stately and unaccusable whole. (X:190)

To Carlyle and Ruskin one of the most reprehensible things about the English economic system was that it left men idle who were able and willing to work. Even modern economic historians note that: "mass unemployment, definitely unconnected with any personal shortcomings of the unemployed was unknown in the Middle Ages except as a consequence of social catastrophies such as devastation by wars, feuds and plagues."[51] The concept of *unemployment* as we use the term, had not been developed when Carlyle and Ruskin wrote on political economy. Indeed the neofeudal economics of Carlyle, and, more directly, Ruskin through his writings and his influence upon such economists as John Hobson deserve at least some measure of credit for drawing attention to unemployment as a social and

Natural and architectural forms in the lost Eden of fallen Venice.

economic problem that was visited upon the worker and not the product of his laziness or moral turpitude.

Carlyle and Ruskin's analysis of the causes of unemployment, of the complex interrelationship between population increase, the growth of cities, and the dislocations caused by shifts from one mode of production to another was overly simple, but they were not alone in their inadequate understanding. That John Stuart Mill, for example, did not fully realize the nature of unemployment is indicated by his Malthusian approach to the problem. While commendable on other grounds, his advocacy of birth control as a means of lowering the amount of surplus labor and thereby insuring employment and higher wages was no answer to the unemployment caused by swings in the business cycle that could within the space of a few years convert a labor surplus to a labor shortage and back again. (Ruskinian "sentimentality" aside, a migrant labor force that can be imported and exported has proven a much more flexible instrument.)

Like most middle-class Victorians, Carlyle and Ruskin saw idleness as a sin. But whereas the majority of their contemporaries, whose will was expressed in the draconian Poor Law of 1834, failed to distinguish between voluntary and enforced idleness, Carlyle (at least until 1848) and Ruskin did. Consequently their wrath fell not upon the unemployed workmen but upon the employers, the economic system, and the political economy invoked to justify it. Carlyle's Gospel of Work was more than a moral reflex triggered by the sight of idleness. It was also a response to what he saw as the excesses of romantic self-consciousness, Byronic *Weltschmerz*, and the paralyzing struggle with religious doubt, all of which, Carlyle felt, never issued in constructive action. An overindulgent self-consciousness, however, is a pitfall for the intellectual or the man of leisure. The Gospel of Work, and the contempt for the pursuit of happiness with which Carlyle links it, wear a different aspect when applied to the working class. "All work, even cotton-spinning, is noble; work is alone noble" (*P&P*:153). Idleness and allowing men to be idle are the great sins compared to which the nature of the labor is decidedly secondary. "The mandate of God to His creature man is: 'Work!' " "Look around you," Carlyle says to the captains of industry he hoped might form the new nobility of a neofeudal industrial order:

> Your world-hosts are all in mutiny, in confusion, destitution; on the eve of fiery wreck and madness! They will not march farther for you, on the sixpence a day and supply-and-demand principle; they will not; nor ought they, nor can they.

Ye shall reduce them to order, begin reducing them. To or-
der, to just subordination; noble loyalty in return for noble
guidance. Their souls are driven nigh mad; let yours be sane
and ever saner. Not as a bewildered bewildering mob; but as a
firm regimented mass, with real captains over them, will these
men march any more. All human interests, combined human
endeavours, and social growths in this world, have, at a certain
stage of their development, required organising: and Work,
the grandest of human interests, does now require it. (*P&P*:
275-76)

On January 10, 1887, between bouts of recurring madness, Ruskin
sent his copy of *Past and Present* to a young admirer, remarking: "I
have sent you a book which I read no more because it has become a
part of myself—and my old marks in it are now useless because in my
heart I mark it all."[52] The "old marks" are ample evidence of
Ruskin's devotion, for passage after passage is enthusiastically under-
lined or marked in the margin. There is, however, one passage that
the disciple rejects with an emphatic "no": that passage in chapter 17
of Book II in which Carlyle asserts that "habit is the deepest law of
human nature" (*P&P*:126). Carlyle's emphasis upon habit and his
abhorrence of self-consciousness meshes with his vision of a regi-
mented working class in hero-worshipful obedience of worthy cap-
tains of industry, that if stripped of Carlyle's assumption about the
justice of nature would come uncomfortably close to Fascist theory.
While Ruskin placed similar emphasis upon the need for hero wor-
ship and a military model for the organization of labor, and fre-
quently expressed his disdain for liberty, his conception of the
nature of work led him to a profound criticism of industrialism that
could be no more content with Carlyle's vision of an undifferenti-
ated, proletarian army directed by captains of industry than with the
unemployment problem it was supposed to solve.[53]
 For Carlyle the essence of the Middle Ages was expressed in its sys-
tem of secular and religious government. The style of Abbot Sam-
son's architecture is of no great moment. Of the many buildings he
had constructed we learn only that they "were useful while they
stood" (*P&P*:118). Concern for the preservation of the Abbey Gate-
way is a matter of dilettantism. The only message of the ruins that
matters is the reminder of the religious life that went on there in the
days when men "had a *soul*,—not by hearsay alone, and as a figure of
speech; but as a truth that they *knew*, and practically went upon"
(*P&P*:48). To Ruskin the style of decoration of the architecture

would have represented the state of the Abbot's soul and that of his workmen.

Had Ruskin followed Carlyle in taking a leader as his representative medieval man he might have emphasized the organization of labor required to build the great cathedrals or their economic role as public works employing great numbers of men. But his typical medieval man is an artisan, and he emphasizes his conviction that the Christian architect of the Middle Ages recognized that each worker has a soul which by its very nature desires to express itself in work: to do what it can and confess freely what it cannot do. In another of his trinitarian images he points out: "imperfection is in some sort essential to all that we know of life. It is the sign of life in a mortal body, that is to say, of a state of progress and change. Nothing that lives is, or can be, rigidly perfect; part of it is decaying, part nascent. The foxglove blossom,—a third part bud, a third part past, a third part in full bloom,—is a type of the life of this world" (X:203).

To be human is to strive always to improve your work, to be inventive and forever at the edge of failure. To repeat the same task over and over again until it can be done perfectly without thought, until it is a form of habit, is to be a machine, "an animated tool" (X:192). This mechanical perfection is, of course, the goal of almost all factory labor, particularly on the assembly line—that perfected form of the division of labor celebrated in the passage on pin and nail making in *The Wealth of Nations* that Ruskin particularly assails. His contention that: "It is not, truly speaking, the labour that is divided; but the men: —Divided into mere segments of men—broken into small fragments and crumbs of life; so that all the little piece of intelligence that is left in man is not enough to make a pin, or a nail, but exhausts itself in making the point of a pin or the head of a nail" is one of Ruskin's foremost contributions to social and economic literature.

> And the great cry that rises from all our manufacturing cities, louder than their furnace blast, is all in very deed for this,—that we manufacture everything there except men; we blanch cotton, and strengthen steel, and refine sugar, and shape pottery; but to brighten, to strengthen, to refine, or to form a single living spirit, never enters into our estimate of advantages. And all the evil to which that cry is urging our myriads can be met only in one way: not by teaching nor preaching, for to teach them is but to show them their misery, and to preach to them, if we do nothing more than preach, is to mock at it. It can be met only by a right understanding on

the part of all classes, of what kinds of labour are good for men, raising them, and making them happy; by a determined sacrifice of such convenience, or beauty, or cheapness as is to be got only by the degradation of the workman; and by equally determined demand for the products and results of healthy and ennobling labour. (X:196)

Ruskin extends Carlyle's sympathy for the unemployed worker into sympathy for the misemployed worker and attacks what Marx called the alienation of labor.[54] Ruskin saw the perfection of Gothic in its combination of fact and design. The failures of the individual workmen who in striving to do their utmost inevitably fell short of perfection can be found in the details of the building, but the cathedral itself remains an "unassailable whole." The weakness of modern manufacture is from this perspective a failure to understand design that, as already noted, Ruskin believed could be alleviated by teaching the consumer to demand only properly manufactured articles, and reject those that were overfinished or mere copies. Ruskin's rules for consumers indirectly invoke the law of supply and demand, but in the specifically Ruskinian terms that William Morris reduced in "The Beauty of Life" to the following aphorism: *"Have nothing in your houses which you do not know to be useful or believe to be beautiful"* (M22:77).[55] Demand is the product of conscious choice, as Ruskin explains in *Unto This Last*, not the equivalent of a law of nature that must be obeyed willy-nilly.

As long as Ruskin clung to his religious faith, he could see a continuous historical thread, however frail, between England's Gothic past and the present. The nature of the link and its tenuousness are evident in the three-way comparison in chapter 4 between St. Mark's and the Venetian present, St. Mark's and the Venetian past, and St. Mark's and a typical English cathedral having most of the characteristics of Salisbury. The grey English cathedral, whose facade Ruskin describes, is still used for services, though the religion it serves, however superior spiritually it may be to modern Catholicism, is one that has needlessly found its eye offensive and torn it out. Just a few statues stand in the countless niches of the west front, the broken survivors of Puritan iconoclasm. The grey is only relieved by the effects of lichen "melancholy gold." Black, restless, raucous birds drift by the traceries and settle among the bosses. Its "drowsy felicities" are yet felicities, and its towers rising over the wooded plain suggest the "noble picturesque" of *Modern Painters IV*. In contrast to the rural calm surrounding the grey English cathedral, the environs of St.

Mark's are cut by canals and narrow lanes teeming with commercial activity—generally of a low sort. Ruskin leads the reader as a guide might a tourist through those streets until St. Mark's itself rises like "a vision out of the earth."[56] Its colors are gold, opal, and mother of pearl. Its alabaster statues are intact. The iconographic lessons of its art, within and without, are still there for anyone prepared to read them.

> Between that grim cathedral of England and this, what an interval! There is a type of it in the very birds that haunt them; for, instead of the restless crowd, hoarse-voiced and sable-winged, drifting on the bleak upper air, the St. Mark's porches are full of doves, that nestle among the marble foliage, and mingle the soft iridescence of their living plumes, changing at every motion, with the tints, hardly less lovely, that have stood unchanged for seven hundred years. (X:84)

By calling attention to the doves and then to the tradesmen at the very foundations of St. Mark's pillars, making them seats "not of them that sell doves for sacrifice, but of the vendors of toys and caricatures," Ruskin suggests the decadence of the modern Venetians, implying that their spiritual condition is worse than the sellers of doves whose seats in the Temple Jesus overthrew. They have substituted for the Levitical sacrifice not the contrite heart of the (Protestant) Christian, but a commercialism even more debased than that of the men who exploited the sacrifice required of the poor.[57]

If the dove with all its positive religious connotations is the type of St. Mark's, of the surviving monument of a vanished Venetian faith, what are we to make of the unnamed, black, restless birds (presumably rooks) of England's cathedral? The contrast of a black bird and the dove inevitably brings to mind that between the raven, who when sent from the ark stayed away to feed on carcasses of the dead, and the dove that brought the olive twig back to Noah. This scene, as Ruskin noted in his 1846 *Diary*, is depicted in the Deluge Mosaic of St. Mark's, and Ruskin chose the emblematic contrast between the olive-bearing dove and the restless raven on a wall of the Cà Trevisan as his example of neo-Byzantine Renaissance ornament (IX:425). In *The Stones* Ruskin let the contrast stand without explanation; but twenty years later in his lecture on the chough, Ruskin recounts the Christian and pagan legends of the bird cursed with black plumage and makes explicit the significance of the earlier imagery.

The opposition between the dove and raven extends through every expression of human mind; from the earliest trace of it in the east, down to the Renaissance architecture of Venice, from which I chose the 20th plate of wall decoration of Cà Trevisan—the white loving bird expressing peace and life; the black and devouring one, restlessness and death; at first physically, but far more deeply, mental peace, opposed to mental pain and death, so that the raven and vulture in their uttermost power feed on the living, not the dead—as in the myth of Prometheus; while the spirit of Consolation, the Comforter, rests, in the form of a dove, on the head of the Christ, who is to bring on earth peace and good pleasure, not towards men, but among them and in them. (XXV:166)

It is the England of restlessness and death that Ruskin assails in his vitalistic political economy.[58] In his own version of Carlylean historical romance he presented the history of Venice as expressed in her art in a cycle of "sea stories" at once tales and the stories of buildings, the architectural equivalent of geological strata yielding their message to the adept interpreter, who could see in them parallels to her successor as mistress of the seas. Ruskin was led, as he noted with some exaggeration years later, to expand upon the prophecy uttered at the beginning of the *The Stones of Venice*: "virtually quitting my pursuit of art altogether that I might teach her [England]—so far as she would hear—what likeness she bore to the condemned Queen of the Deep" (XXIV:448).

3

The Ruskin Crusade

Ruskin seemed to be catching the fiery cross from his hand, as his own strength was failing.

J. A. Froude, *Carlyle's Life in London*

I am not an unselfish person, nor an Evangelical one; I have no particular pleasure in doing good; neither do I dislike doing it so much as to expect to be rewarded for it in another world. But I simply cannot paint, nor read, nor look at minerals, nor do anything else that I like . . . because of the misery that I know of, and see signs of, where I know it not, which no imagination can interpret too bitterly. . . .

I must clear myself from all sense of responsibility for the material distress around me, by explaining to you, once for all, in the shortest English I can, what I know of its causes; by pointing out to you some of the methods by which it might be relieved; and by setting aside regularly some small percentage of my income, to assist, as one of yourselves, in what one and all we shall have to do; each of us laying by something, according to our means, for the common service; and having amongst us, at last, be it ever so small, a National Store instead of a National Debt.

Fors, Letter 1

Knight and Death

> But it is still at our choice; the simoom-dragon may still be served if we will, in the fiery desert, or else God walking in the garden, at cool of day. (VII:459)

RUSKIN'S IDENTIFICATION OF himself with the romantic characters of militant holiness goes back to childhood.

> "I am the bravest Knight of all,
> My armour is of gold;
> O'er all the field death spreads his pall
> When I my wrath unfold." (II: xxxiii)

So speaks George of England in "The Puppet Show" Ruskin wrote and illustrated for his father in 1829. Ruskin's first instinct as a critical writer was polemical, an attempt by turns to advance his cause and discomfort the opposition, to argue for victory. While Ruskin did not assume the voice of St. George again until the days of his Guild, it is hardly hyperbolic to say that in the abortive reply to *Blackwoods* and in the first volume of *Modern Painters* Ruskin presented himself as champion of Turner and defender of faith. Looking back in *Fors* on the idea of a revived chivalry he locates its source in his reading of Scott:

> a painful wonder soon arose in my child-mind, why the castles should now be always empty. Tantallon was there; but no Archibald of Angus Deep yearning took hold of me for a kind of "Restoration," which I began slowly to feel that Charles the Second had not altogether effected, though I always wore a gilded oak-apple . . . on the 29th of May And as I grew older, the desire for red pippins instead of brown ones, and Living Kings instead of dead ones, appeared to me rational as well as romantic; and gradually it has become the main purpose of my life to grow pippins, and its chief hope, to see Kings. (XXVII:170-71)

The desire to grow pippins and see living kings, to edit life into literary shape, to realize romance, grew with the decline in Ruskin's faith and brought his work in both form and content closer to

Carlyle's. Even in his early work Ruskin, like Carlyle, employed a modified form of embedded narrative. The famous evocation of Turner's *Slave Ship* in *Modern Paintings I*, for example, is in terms of argument only a demonstration of Turner's command of sea painting, a matter that could be treated by analysis alone. What we get, however, is the recreation in prose of the implicit narrative of the painting presented not as Ruskin's interpretation, but as Turner's testimony, Turner's thought.[1] Such narrative interpretations carry the same vertical perspective as symbolic episodes in romance and in Carlyle's histories. Interpretation as embedded narrative grows more frequent in Ruskin's later work. Increasingly he attempts to prove points through the narration of history, myth, anecdote, and his own travels creating arguments with subplots. As Ruskin's work began to emphasize the possible creation of an earthly paradise over hope for a heavenly one, his prose moved in the direction of narrative, becoming on the whole more directly expressive of experience than of system, and made more frequent reference to romance and use of its motifs. Without the faith that had once allowed Salisbury Cathedral to mediate between the past and present contrasted in *The Stones of Venice,* such antitheses in Ruskin's work grow even more absolute and Carlylean.

Ruskin's first invitation to lecture to a general audience came during the fateful trip to Scotland in 1853. He rejoiced in his chance to extend his influence, as Carlyle had done, beyond the readers of his books; to expand upon the teaching of *Modern Painters* and *The Stones of Venice,* and to champion the Pre-Raphaelites. For Carlyle lecturing had been a painful necessity, more a testimony to financial need and the power of his will than any urge to personally lead a crusade. He much preferred holding audiences in Chelsea to addressing them elsewhere. Ruskin, however, was more comfortable extending his role as performer from the family to the public stage than he was in meeting individual strangers. He was quite prepared to conduct a public crusade despite parental objections.

Ruskin's first lecture series contained a defense of the romantic and quixotic. He told his Edinburgh audience that the enthusiasm for the conflict of the hero and dragon, the admiration for the exercise of human virtue in the battle of Agincourt or Bannockburn (as opposed to the unromantic Italian campaign to drive out the Austrians in 1848-49), the enthusiasm and admiration that "practical men" try to restrain, is in truth one of the holiest parts of their being.

A man's conscience may be utterly perverted and led astray;

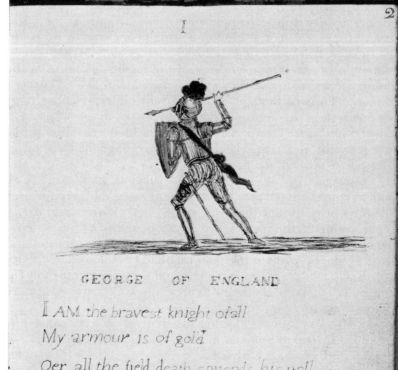

I

GEORGE OF ENGLAND

I AM the bravest knight of all
My armour is of gold
Oer all the field death spreads his pall
When I my wrath unfold

2
Of beauteous purple is my crest
A dragon on my shield
With greatest wrath my foes I prest
And bloody was the field

My purple plume was stained with gore
Of all the foes I hate

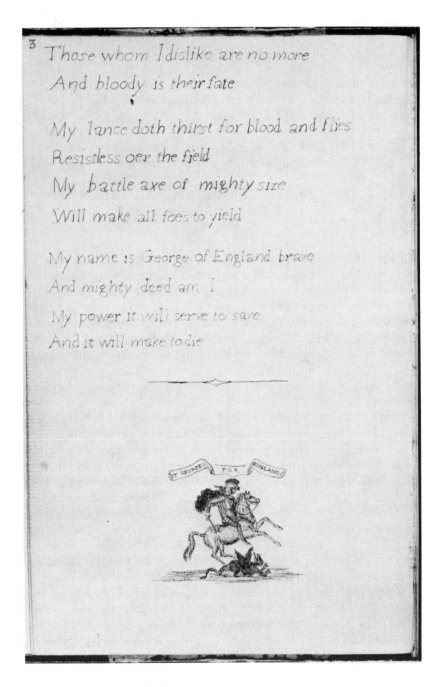

3

Those whom I dislike are no more
And bloody is their fate

My lance doth thirst for blood and flies
Resistless oer the field
My battle axe of mighty size
Will make all foes to yield

My name is George of England brave
And mighty deed am I
My power it will serve to save
And it will make to die

George of England in "The Puppet Show."

but so long as the feelings of romance endure within us, they
are unerring,—they are as true to what is right and lovely as
the needle to the north; and all that you have to do is to add to
the enthusiastic sentiment, the majestic judgement. . . . But the
great evil of these days is that we try to destroy the romantic
feeling, instead of bridling and directing it. Mark what Young
says of the men of the world:—

> "They, who think nought so strong of the romance,
> So rank knight-errant, as a real friend."

And they are right. True friendship is romantic, to the men of
the world—true affection is romantic—true religion is roman-
tic. (XII:55)

Ruskin takes Cervantes to task for mocking the virtues of knight-
hood, insisting that *Quixotism* and *Utopianism* are among the devil's
pet words, for they encourage people to give up if they see that a de-
sired end seems impossible of accomplishment rather than acting to
bring it even some small measure closer: "the Utopianism is not our
business—the *work* is." Ruskin would eventually call upon his com-
panions of St. George to be knights of the ploughshare rather than
the sword; to take up the work with whatever of time, money, or ef-
fort they can spare however distant a goal the restructuring of society
may seem.

Ironically enough it was probably in the hours Ruskin secluded
himself from the rest of his Highlands party to prepare these lec-
tures that Effie had the time alone with Millais that permitted her to
reveal to him the unhappy state of her marriage, stirring in him un-
erring feelings of romance of a sort different from those Ruskin had
in mind. As their romance unfolded with Effie the captive maiden
and Millais the knight, there was no role left for Ruskin but that of
the dragon.[2]

In "The Two Boyhoods" in *Modern Painters V*, the Venice of
Giorgione, a city of marble and emerald, becomes man's creation on
the face of the waters. It is more explicitly paradisiacal than it was in
The Stones of Venice and expresses a religion of which Ruskin is now
prepared, in Carlylean fashion, to stress the sincerity and vitality
rather than measure the degree of truth. Ruskin presents a Venice
of knights and maidens, a city that must have seemed to Giorgione to
be eternal, a world in which an artistic St. George could paint only
loveliness and yet paint truth.

As it happens the English Giorgione was born on St. George's day and in an urban garden—Covent Garden. No knights and maidens there, but the sons of squires seen by moonlight out drinking and whoring in the vicinity of Turner's Maiden Lane birthplace. In Venice Giorgione found a religion that was "powerful in human affairs" and, though its influence was not always to the good, it was "in large measure, sincere, believing in itself, and believed: a goodly system, moreover, in aspect; gorgeous, harmonious, mysterious;—a thing which had either to be obeyed or combatted, but could not be scorned" (VII:381). Turner, by contrast, grew up with a religion discredited, cowardly, neither obeyed nor combatted, but scorned. The contrast between Venice and London is, in short, that of dove and crow. "St. Mark ruled over life; the Saint of London over death; St. Mark over St. Mark's Place, but St. Paul over St. Paul's Churchyard" (VII:383).

Giorgione saw the strength of men and painted the beauty of their presence and their pride. Turner found his beauty in solitude and humiliation and became the painter of nature and of man's labor, sorrow, and death—death without the hope of resurrection that St. Paul, in addressing the Corinthians, had likened to the sprouting of a seed. His is a seedless harvest: "Put ye in the sickle, pale reapers, and pour hemlock for your feast of harvest home" (VII:388).

Ruskin locates in art the virtues to be cultivated in the face of death without hope of resurrection. The model of necessary fortitude is Dürer's *Knight and Death (Knight, Death, and Devil)*. Ruskin's interpretation of the engraving takes the form of embedded narrative. The knight "rides quietly, his bridle firm in his hand . . . his horse trots proudly and straight." He has passed the type of sin by and is keeping his eyes fixed steadfastly ahead, though the pale horse of Death has hooked the bell hanging "from the knight's horse-bridle, making it toll as a passing-bell" (VII:311). In Dürer's *Melancholia I* he detects a kindred virtue in what he reads as a history of human labor. The figure of Melancholy is derived from the traditional depiction of Geometry and still has many of her attributes. It is not surprising that Ruskin, who considered, referring to his skill in geometry, "a clear mathematical head" to be the first of his mental characteristics, should identify himself with her (XXXVI:238). Her message to Ruskin is Carlylean: find strength in labor and sorrow. (Ruskin in fact gave an impression of the *Melancholia* to the Carlyles in 1859 and one of *Knight and Death* in 1860, both fit tokens of discipleship). The images of hourglass and bell carried over to *Melancholia* from *Knight and Death* recall to him the text: "whatsoever thy hand findeth to do," a

favorite of both men. As so often in Ruskin the tag line quoted must bear the burden of the entire passage: "Whatsoever thy hand findeth to do, do it with thy might; for there is no work nor device, nor knowledge nor wisdom, in the grave, whither thou goest" (Ecclesiastes 9:10).

It is in this mood that Ruskin gives his last analyses of Turner in *Modern Painters,* his readings of the *Garden of the Hesperides,* and of *Apollo and Python.* Interpreting the Hesperides and their fruit in light of Spenser's treatment of them in *The Faerie Queene,* Ruskin finds in the picture the antithesis of the assumption of the Virgin: assumption of the dragon of Mammonism, for Ruskin as for Carlyle the false religion of the latter day. He then marries the English domestic Andromeda to the sea-serpent rather than Perseus: "No St. George any more to be heard of; no more dragon-slaying possible; this child, born on St. George's Day, can only make manifest the dragon, not slay him, sea-serpent as he is; whom the English Andromeda, not fearing, takes for her lord" (VII:408).

Turner's Discord Ruskin calls the troubler of household peace. The concept of household is, as we shall see, as essential a part of Ruskin's ideal polity as it was of Carlyle's organic social order. The triumph of Apollo over Python is the moral equivalent in oils of the victory of the Christian Knight Dürer had etched. But just as in his interpretation of the Dürer Ruskin ignored the city on the hill that he might, in more hopeful days, have seen as a type of the heavenly Jerusalem, so here he seizes on the fact that the victory of Apollo, which he reads as the victory of youth and manhood over sin,the triumph of purity over corruption, is incomplete. He detects a serpent rising out of the blood of Python suggesting to him that while sin can be conquered, death cannot. Turner, Ruskin finds, was without hope. Even his natural world is death haunted. Turner is "the painter of the loveliness of nature, with the worm at its root: Rose and canker-worm,—both with his utmost strength; the one *never* separate from the other" (VII:422). Such is Ruskin's genius that the discovery of his own mood in Turner not only transforms the interpreter of nature into a mythopoetic social critic but also produces some of his most impressive commentary on the painter of "The Fallacies of Hope."

By contrast "The Hesperid Aeglé," the personification of brightness and cheer in a world reclaimed from the fall, is the product of a hopeful, coherent society. She is not part of Turner's vision, but Giorgione's. Though Ruskin claims that what Venice won of "faithful light and truth" will never fade away, the works reputed to

be Giorgione's greatest, the frescoes on the Fondaco de' Tedeschiare, are almost entirely effaced. The figure Ruskin chooses to call "The Hesperid Aeglé" for her glowing color is little more than a scarlet cloud to be preserved in a line engraving as a reminder to a darker world of a lost paradise.

The central theme of *Modern Painters V* is of life against death.[4] Already in *The Stones of Venice* he had protested against the degradation of the modern workman, but as long as Ruskin held to his early faith in the heavenly reward possible for those who suffer in this life he could at least temper his horror. He was tormented after 1858 by the thought that after this life he, with all the pleasures of his prosperous existence, should merely cease to be. In consequence the lives of the degraded poor, who had no such pleasures now and only the illusion of reward hereafter, struck him with redoubled force as a moral outrage of unexampled dimension. Where a lesser man might have looked away and accepted the rationalization of the present economic order (and his own prosperity), Ruskin vowed to do all in his power to change it. Like Cassandra, he could not avert his eyes. He was both gifted and condemned to see misery and prophesy woe.

Ruskin shared with Carlyle the conviction that at root England's social problems were a matter of belief. Both were convinced that whatever its nominal religion, established or otherwise, the dominant faith of the day was Mammonism. Carlyle and Ruskin both interpreted action as the manifestation of ideas and saw the changing of minds as the essential business of the reformer. For their writing to have any social effect Carlyle and Ruskin had to assume either that people act on the views they espouse, in which case you can attempt to change their views by demonstrating where they are in error; or they are hypocrites, something you can at least point out. Nevertheless Carlyle and Ruskin were very aware of the way in which a climate of opinion can help people sustain what would, if examined dispassionately, be incompatible beliefs. Both men perceived the inconsistency between the conduct enforced by Victorian capitalism and the behavior required by anything approaching a literal interpretation of Gospel ethics. Consequently they attacked the political economists for, in their view, making that disjunction rationally defensible.

The analyses of the Dürer etchings and Turner paintings that conclude *Modern Painters* announce in symbolic form the crusade on which Ruskin was about to embark with the composition of *Unto This Last* and the spirit in which he hoped to carry it out. Turner and even Carlyle may have only had the power to make the dragon of Mammonism manifest, but Ruskin, as the disciple of both men, hoped to

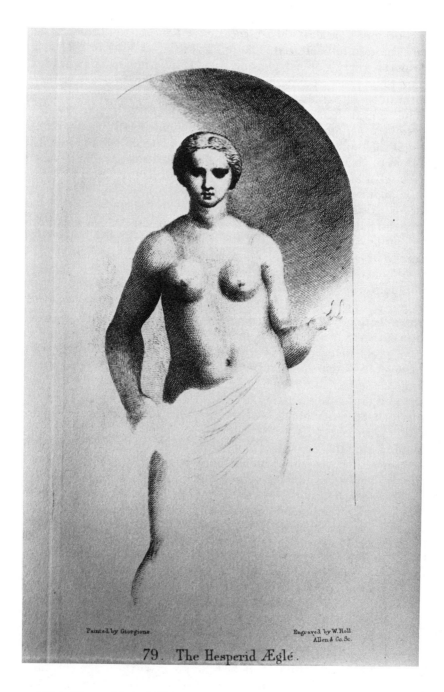

Painted by Giorgione.

Engraved by W. Holl.
Allen & Co. Sc.

79. The Hesperid Ægle.

"The Hesperid Aeglé" (VII:409).

do more. Indeed in his interpretation of the *Garden of the Hesperides* Ruskin fuses the influence of his two masters and makes their battle his own, carrying it on into the 1870s in both public and private life. ("Just now I'm more beaten than I thought I should be, at the beginning of the New Year—the sense of the fearfulness of the battle with Python and Mammon is heavy on me.")[5]

Wealth or Illth

The poor man, indeed, if he steal the rich man's goods is hung. The rich man is not punished at all for seizing the goods of the poor, even when he is worthy for the gallows. Wherefore says Chrysostom, . . . "If it were possible to give the rich their deserts, you would see the world's prisons everywhere full of them."

John Bromyard *Judicium Divinum* c. 1400

I have set before you life and death, blessing and cursing: therefore choose life, that both thou and thy seed may live.

Deuteronomy 30:19

THE IMMEDIATE PRELUDE to his direct attack upon the political economists in *Unto This Last* was the series of lectures on art, design, and manufacture that Ruskin gave in the late 1850s and published as *A Joy Forever* and *The Two Paths*. Driving from Rochdale to Burnley in 1859 Ruskin saw quite starkly the design of modern England—the picturesque overwhelmed by the industrial sublime: "The cottages so old and various in form and position on the hills—the rocks so wild and dark—and the furnaces so vast and multitudinous, and foaming forth their black smoke like thunderclouds, mixed with the hill mist" (to JJR, XVI:336).

In his lecture "Manufacture and Design" this juxtaposition of England's past and present grows into a contrast between what the designer in the modern industrial England sees through the sulphurous smoke of Rochdale and what Nino Pisano and his men saw in Gothic Pisa. Ruskin does not call for a revival of medieval Italian art which was based, he confesses, upon "pride of life" and "supported itself by violence and robbery"; rather: "The circumstances with which you must surround your workmen are those simply of happy modern English life, because the designs you have now to ask

for from your workmen are such as will make modern English life beautiful" (XVI:341).

Ruskin called on English manufacturers to make strong, well designed, and durable goods, and to form, rather than to follow, the market. He argued for industrial development conscious of the overall appearance of the landscape and respectful of the record of human history already built upon it. He urged the broadest possible education for workmen so that their designs and workmanship could reflect a life "neither oppressed by labour nor wasted in vanity" (XVI:342).

> The steel of Toledo and the silk of Genoa did but give strength to oppression and lustre to pride: let it be for the furnace and for the loom of England, as they have already richly earned, still more abundantly to bestow, comfort on the indigent, civilization on the rude, and to dispense, through the peaceful homes of nations, the grace and the preciousness of simple adornment, and useful possession. (XVI:345)

Ruskin's all-encompassing concept of design, later developed by William Morris, linked the natural and domestic surroundings of the workman with the practice of his craft. It limited manufacture to what is both needed and well made. Naturally he was called impractical—either scornfully, as in the *Athenaeum* (whose reviewer called Ruskin's rejection of increased specialization of labor as ridiculous as a redistribution of land), or with a touch of ironic regret, as in the *British Quarterly Review*:

> If the public seeks for coarse, staring patterns in carpets, and female taste in the purchase of a new shawl demands, as we lately heard, "something out of the way," it is almost too much to expect that the producer should rigidly keep to graceful patterns which nobody will look at, and faultless shawls which nobody will buy. We may rightly call upon men to exercise a martyr-spirit in things of solemn moment; but self-denial for the cause of good taste, absolute loss for Art's sake, is rather too high a prize to give.[6]

Behind both the scorn and the regret lay the equation of economic laws with the laws of nature, and it was upon that stronghold of mid-Victorian values that Ruskin next focused his attack, combining Carlylean denunciation with his own process of analysis.

Ruskin's writings on political economy and social reconstruction extend the battle between life and death presented in the symbolic terms of art interpretation in the fifth volume of *Modern Painters*. Like Carlyle, Ruskin rooted social action in the Christian concept of individual moral responsibility and, in the tradition of philosophic realism, saw current economic practice in the light of the theory that seemed to sustain it. Consequently he combined polemical assault upon current economic opinion with presentation of his own views. Ruskin's attack on the prevailing school of economics (of which he takes John Stuart Mill to be the primary representative) has two aspects. The first is Ruskin's contention that modern economics is based on faulty premises and consequently, however consistent it may be as an abstract system, it has no proper application to the behavior of actual people in actual situations. It is thus like "a science of gymnastics which assumed that men had no skeletons" (XVII:26). Ruskin's proposal on the basis of this premise is to advance proper definitions of the basic terms of economics and demonstrate thereby the genuine nature of political economy.

Ruskin's second premise is that the so-called political economy of his day is really mercantile economy, "the economy of 'merces' or of 'pay' " (XVII:44), and that even in this more restrictive field, the ecomomics of Ricardo and Mill, if taken literally, prove internally inconsistent as well as contrary to the Scriptures. It is this second premise that has done so much to obscure Ruskin's contribution to economic and social thinking, for it immediately raises the question of whether Ruskin has properly understood the arguments of rival economists: whether a point that may be valid if applied to a popularizer like Mrs. Marcet holds against Nassau Senior, if a point that holds against Nassau Senior holds against John Stuart Mill, and so forth.

Ruskin further complicated the issue by mixing quotations from Mill and Ricardo with statements of what he claims conventional economists teach that are not paraphrases but in themselves *reductio ad absurdum* formulations. Reviewers seized with glee upon Ruskin's assertion that economics teaches the science of getting rich, the reviewer in *Fraser's* quoting J. R. McCulloch to the effect that the economist only inquires into the means by which fortunes are made to ascertain their general operation and is concerned solely with national rather than individual prosperity—and so, indeed, McCulloch states at the outset. But at the end of his treatise McCulloch gives as his purpose: "to show the close and indissoluble connection subsisting between private and public opulence—to show that whatever has any tendency to increase the former, must, to the same extent,

increase the latter."[7] Surely the Victorian lay reader looking for a personal application of economic principles could be excused for pursuing whatever McCulloch pointed to as tending to make him rich—all the more in that such private pursuit is proclaimed a public virtue.

Nassau Senior states as the first principle of his elementary propositions of the science of political economy: *That every man desires to obtain additional Wealth with as little sacrifice as possible.*[8] Mill's hypothetical economic man is "a being who desires to possess wealth."[9] Analysis is not, of course, identical with advocacy, but the opening for polemical attack was very tempting. Ruskin was hardly unique in asserting that economics taught the science of getting rich; nor was he the most sweeping and careless in his attack.

> So long as they are making money it is a matter of complete indifference to the English middle classes if their workers eat or starve. They regard hard cash as a universal measuring rod. Anything that yields no financial gain is dismissed as 'stupid', 'impractical', or 'idealistic'. That is why these petty Jewish chafferers are such devoted students of economics—the science of making money. Every one of them is an economist. . . . As Carlyle says, the middle classes can conceive of no relationship between human beings other than the cash nexus.[10]

Just as no political economist announced as his purpose teaching individuals how to become rich, neither, as John Fain points out, did any of them state honesty to be, as Ruskin claims, "a disturbing force, which deranges the orbits of economy." The economists of the day did, however, formulate laws on the hypothetical assumption of "the inertia of other forces"[11] and Ruskin's claim is a satiric *reductio* of that assumption. If, after all, the object of every commercial transaction is to make the maximum profit, and if every labor contract is an attempt on the part of the men to get more pay and the employer to give less, then surely there is every encouragement for dishonesty. Ruskin's picture of the ideal commercial exchange on current principle is that of a needle for a diamond with a savage who has no knowledge of the European social arrangements that make the diamond particularly valuable. The exchange would be perfect, Ruskin says, if the needle so exchanged proved to have no eye. The fact that the classical economists tacitly assumed transactions to be honest and allowed for some interference in the marketplace does not refute

Ruskin's point, but demonstrates it; for, as Sherburne points out, if the disturbing forces "are organically, not mechanically, related to the original premises, the method of postponing their consideration until the train of deduction has been completed will fail."[12] The classical economists were not laissez-faire dogmatists, but Ruskin interpreted any indication on the part of Mill of the need to regulate self-interest to make it conform to public interest as an unwitting contradiction of his own principles.

Ruskin's specific criticism of those who, like Mill, Senior, and Cairnes argue that the abstract hypotheses of a morally neutral science of economics can be brought to bear upon business practice through an art of political economy or social morality is that their approach is backwards. For Ruskin, the first things to determine are the proper relations between human beings, how people ought to behave in relation to one another. Political economy should be the study of how those proper relationships can best be advanced in the economic sphere. Far from being ethically neutral, political economy should teach proper economic behavior: hence Ruskin's criticism, so outrageous to the reviewers of *Unto This Last*, that the inability of standard political economy to show the means of preventing strikes was evidence of its failure. The end of political economy should be social harmony.

Ruskin's frequent assertion that honesty is incompatible with classical economic theory and much current business practice is then simply a statement of fact with the parameters of *Ruskin's* definitions. According to Ruskin the cost and value of any item, though not easy to determine accurately, are "both dependent on ascertainable physical circumstances" (XVII:185). There is also an ascertainable standard of quality for a given item. (Ruskin advocated government workshops that would produce items to set that standard.) Price, however, is dependent on will: on what the purchaser is willing to give up and the seller accept, though it is generally proportional to the cost of the item, i.e., the labor and materials that went into it (XVII:187-89). There is, consequently—with some latitude— a fair price for any given item regardless of market conditions. Competition, however, inevitably works against the establishment of that price either by encouraging the adulteration of goods so that profits can be raised, or the competition undercut; or by encouraging customers through advertising, packaging, or other means of persuasion to buy what they don't need, or pay more than the just price.

Ruskin and economists of his time agree that profit is not really a matter of money, but a product of labor, so that profit "depends on

the cost of labour."[13] Under this condition, it is obviously in the in-
terest of anyone governed solely by the profit motive to keep wages
at the lowest level compatible with steady production. Thus, Ruskin
argues, the power wealth gives a man is really power over other men,
and wages at or below subsistence levels are nothing less than rob-
bery of the poor by the rich. Citing the wisdom of that "Jew mer-
chant, . . . reported to have made one of the largest fortunes of his
time" (King Solomon), Ruskin warns

> "Rob not the poor because he is poor; neither oppress the af-
> flicted in the place of business. For God shall spoil the soul of
> those that spoiled them."
> This "robbing the poor because he is poor," is especially the
> mercantile form of theft, consisting in taking advantage of a
> man's necessities in order to obtain his labour or property at a
> reduced price. The ordinary highwayman's opposite form of
> robbery—of the rich, because he is rich—does not appear to
> occur so often to the old merchant's mind; probably because,
> being less profitable and more dangerous than the robbery of
> the poor, it is rarely practised by persons of discretion.
> (XVII:58)

Ruskinian honesty, that "disturbing force," amounts to the elimina-
tion in commerce and employment of the idea of competition, which
was always for Ruskin the law of death opposed to cooperation and
government, the laws of life.

Ruskin believed that man, *by nature*, was a cooperative, affectionate
being and that the rules of cooperation were to be found in the Bible.
He believed that the "science" of political economy was at once inap-
plicable (because it omitted from its account of economic behavior
the essential affective elements) and immoral. Presupposing compe-
tition instead of cooperation, it set man against his nature and
against the rules that should govern his behavior. Man's economic
behavior is part of a whole system, not a system unto itself. Having
been raised with biblical typology even before he was exposed to Eu-
clid, Ruskin had no sympathy with what we now look back upon as
pioneer attempts at economic model making. The "whole system" of
his political economy had incarnate form. The contrast between
Ruskin's approach to economics and that of his chosen opponent,
John Stuart Mill, sets his method clearly apart from that of even pro-
gressive orthodox economists. Ruskin, as I have already indicated, is
a teleological thinker and an essentialist or philosophic realist. Mill

is, in his *Principles of Political Economy,* an inductive thinker and a nominalist, using a method he calls "induction and ratiocination."[14] Mill's essay "On the Definition of Political Economy" is devoted in large measure to drawing a distinction between a science of political economy and the art of morality that must be taken into account in any attempt to practically apply the conclusions of that science. The moral elements Mill considers as modifying circumstances standing between the science and its applications are such matters as "the *affections,* the *conscience,* or feeling of duty, and the love of *approbation,*"[15] that is, the moral and ethical considerations that Ruskin held to be first principles of any economic science.

Like other philosophic realists from the time of Plato, Ruskin feels free to draw examples of his principles in operation, or the consequences of failure to apply them, from the world of experience, and he hopes to see his ideas practically applied. But the essential definitions themselves are logically a priori, and not generated from examination of the present working of the economy. Mill also feels free to suggest that present economic practices be modified (the full title of his treatise is *The Principles of Political Economy with Some of Their Applications to Social Philosophy,* and he gives whole chapters to "Means of Abolishing Cotter Tenancy," and "The Probable Futurity of the Labouring Classes"). He derives his definitions of economic terms and principles, however, from an examination of the previous literature on the subject in relation to the operation of the existing economy. He objects to the common identification of wealth with money not, as Ruskin does, because it falsely represents the idea of money, but because it makes a false assumption about the actual economic function of money. It is not wealth itself but a means of commanding those "useful or agreeable things which possess exchangeable value" that do constitute wealth. Mill's "wealth" excludes anything that can be obtained in the desired quantity without labor or sacrifice and any immaterial quality or skill ("I shall therefore, in this treatise, when speaking of wealth, understand by it only what is called material wealth").[16] To Ruskin *"there is no wealth but life,"* not mere existence, but: "Life, including all its powers of love, of joy, and of admiration. That country is the richest which nourishes the greatest number of noble and happy human beings; that man is richest who, having perfected the functions of his own life to the utmost, has also the widest helpful influence, both personal, and by means of his possessions, over the lives of others" (XVII:105).

Such is the definition of wealth Ruskin tried to embody in his own life after the death of his father in 1864 made him a rich man; such

was the definition Ruskin hoped to persuade his countrymen was not
a mere moral sentiment but an essential, scientific definition which
implied a system of political economy. If wealth is life, its material
forms must be things that "avail towards life" (XVII:84). A thing can-
not avail towards life unless the possessor can make use of it; hence
the "stock of useful articles" central to Mill's definition of wealth
Ruskin expands into a definition derived from the *Economist* of
Xenophon: "the possession of useful articles, *which we can use*"
(XVII:87).

> If a thing is to be useful, it must be not only of an availing na-
> ture, but in availing hands. Or, in accurate terms [i.e., in terms
> of his derivation of "value" from the same root as "valor"] use-
> fulness is value in the hands of the valiant; so that this science
> of wealth being, as we have just seen, when regarded as the
> science of Accumulation, accumulative of capacity as well as of
> material,—when regarded as the Science of Distribution, is
> distribution not absolute, but discriminate; not of every thing
> to every man, but of the right thing to the right man. (XVII:88)

Ruskin's primary economic experience was in the art market where
the forces of supply and demand are supplemented by considera-
tions of quality and the knowledge and the taste of the consumer far
more than in the average commercial transaction. (Similar factors
were important in his father's wine business as well.) From the be-
ginning Ruskin's attention was, from the economic point of view,
directed towards consumption, whereas the primary interest of the
orthodox economists (excepting, in part, Mill) was upon produc-
tion.[17] "Value in the hands of the Valiant" turns the creation of util-
ity into an economic chivalry of social and self-improvement.

As in his art criticism wherein the opposite of good art is bad art,
art turned to an evil purpose, and not merely unskillful art, so in
economics the opposition of wealth is not poverty, but what Ruskin
calls *illth*. If material wealth consists of things that avail towards life,
useful things we are capable of using (a book is not wealth to an illit-
erate person) so illth consists of death-dealing things, things that
cannot be consumed or whose consumption is harmful. According
to Ruskin's labor theory of cost developed from Adam Smith: "true
labour, or spending of life, is either of the body, in fatigue or pain; of
the temper or heart . . . or of the intellect. All these kinds of labour
are supposed to be included in the general term, and the quantity of
labour is then expressed by the time it lasts" (XVII:184).

Since labor is the destructive element in work it follows that "if production cost outweighs consumption utility, the nation loses by the unit of commercial wealth produced, and this commercial wealth then becomes illth."[18] Illth can thus be relative. This may, in relation to the problems of modern economies, be Ruskin's most brilliant economic insight. The aggregate wealth produced in a country is its "Common-Wealth": the national store of things that avail life. There can be, and too often is, a "Common-Illth, and Public-Nothing" (XXVII:122). Everyone who owns property has a duty according to "meristic law" to contribute to the common wealth rather than the common illth: "that land shall not be wantonly allowed to run to waste, that streams shall not be poisoned by the persons through whose properties they pass, nor air be rendered unwholesome beyond given limits" (XVII:239-40).

The problems arise, to stick to Ruskin's example of air and water, when an enterprise can make a profit on production in itself destructive without incurring an expense of restitutions or cleaning up after itself—when an industry can, for example, pollute a river without being responsible for compensating those who might have derived their income from its fish, those who suffer from pollution related disease, those who must, whether individually or as a local government, take additional steps to purify their drinking water, etc. It is quite possible that the production of a private profit can lead, on balance, to a public debt. (Socialism does not provide an automatic answer to this problem since it is not a question of who owns the means of production, but how they are used, and how costs are distributed within the system.)

Far from equating wealth with life, Mill equates it, for the purposes of economic analysis at least, with material wealth and exchange value. Value to Ruskin is intrinsic, and a valuable thing becomes wealth when combined with the capacity of the consumer. The people of a country whose climate and vegetation provide sufficient food so that its population can feed itself without labor or expense is to Ruskin, in this one area at least, wealthy; to Mill it is not. In addition, according to Mill's definitions a man can become wealthy by producing what Ruskin calls illth either as a product, or as a by-product of manufacture or packaging. The manufacture of bombs and bayonets, Ruskin points out, can be productive labor under Mill's definitions; under his, it cannot. Moreover, Ruskin's vital definition of wealth leads him to the acute observation that the production of modern weapons is inflationary. ("Our European amusements in the manufacture of monster guns and steel 'backings' lower the value of

money far more surely and fatally than an increased supply of bul-
lion, for the latter may very possibly excite parallel force of produc-
tive industry" [XVII:490].) Finally, Ruskin's insistence that "wealth"
includes qualitative factors, such things as great works of art and the
capacity to enjoy them, have no place in Mill's scheme, which recog-
nizes only skills that contribute directly to production.

The point made by critics of Ruskin, from the reviewers of *Unto
This Last* down to the present day, that the orthodox political econo-
mists did believe that there was such a thing as value apart from ex-
change value, but that consideration of it lay outside the ken of
economics is, of course, true, but amounts to no more from a Ruski-
nian point of view than a confirmation of his criticism. To under-
stand that there are immaterial constituents of wealth and to
recognize the power of human affections and emotions to influence
economic decisions and then deliberately leave such things out of the
discussion of political economy merely changes the nature of
Ruskin's charge from one of ignorance to that of perfidy.

Significantly it was a biologist, Patrick Geddes, someone who dealt
with "open systems," who in the first important exposition of
Ruskin's economics in 1887 predicted that his "clear enunciation of
the essential unity of economics and morals in opposition to the dis-
cord assumed as a deductive artifice would remain especially and
permanently classic."[19] The examination of the problems of eco-
nomic development from an ecological perspective confirms his
judgment. Barry Commoner's writings, for example, are strikingly
Ruskinian. In his chapter "The Social Issues" in *The Closing Circle*,
Commoner reaches for an economic vocabulary that will adequately
describe the connection between the present pattern of American
economic development, pollution, and the need to include value
judgments about the human cost of development in economic plan-
ning. He calls each of the by-products of coal-burning power plants
a "*non*good" that costs someone something. He speaks of their
"*hidden* costs" and "*social* costs," and invokes the notions of
"externalities" and "diseconomies" to account for economic effects
not based on exchange.

> No scientific principle can guide the choice between some
> number of kilowatt hours of electric power and some number
> of cases of thyroid cancer, or between some number of bushels
> of corn and some number of cases of infant methemoglo-
> banemia. These are *value* judgments; they are determined not
> by scientific principle, but by the value that we place on

economic advantage and on human life or by our belief in the wisdom of committing the nation to mass transportation or to biological warfare.[20]

The distinctions Commoner is making are precisely those between wealth and illth. The movement from "pure" science into that of social application is inevitably a move into the realm of moral judgment from which Ruskin had started his progress in the direction of analysis. The economist in whose work Commoner finds the nearest approach to an ecologically sound economics is K. William Kapp, who in 1950 called for economists to reexamine the basic definitions of their science in terms that come close to a recapitulation of the principles of true political economy that Ruskin tried to establish a century earlier.

> Thus, only by abandoning the philosophical premises of the seventeenth and eighteenth centuries, by reformulating and enlarging the meaning of its basic concepts of wealth and production, and by supplementing its study of market prices by a study of social value, will economic science finally achieve an impartial and critical comprehension of the economic process, not only in the private enterprise economy but under any form of economic organization. Indeed, by including social costs, social returns and social value within the range of its analysis, economic science would become "political economy" in a deeper and broader sense than even the classical economists conceived of the term.[21]

Ruskin coined the term *illth* as he developed an analogy intended to explain the importance of the circulation of money, the evil of oversaving and underconsumption later developed by John Hobson, and the error of equating money with wealth.

> Many of the persons commonly considered wealthy, are in reality no more wealthy than the locks of their own strong boxes are, they being inherently and eternally incapable of wealth; and operating for the nation, in a economical point of view, either as pools of dead water, and eddies in a stream (which, so long as the stream flows, are useless, or serve only to drown people, but may become of importance in a state of stagnation should the stream dry); or else, as dams in a river, of which the ultimate service depends not on the dam, but the miller; or

else, as mere accidental stays and impediments, acting not as
wealth, but (for we ought to have a correspondent term) as
"illth," causing various devastation and trouble around them
in all directions; or lastly, act not at all, but are merely ani-
mated conditions of delay. (XVII:89)

The analogy between the circulation of money and that of water is a
common one in economic literature. Ruskin's mind, however, is rad-
ically different from that of the average economist in that he tends to
think in metaphor, demonstrate by narrative, and feel the literary
heritage behind what would be to most people a mere analogy or il-
lustration.
 The circulation of water in the body of the earth is like the circula-
tion of blood in the human body. ("This power over each other
which you call money, is blood. It is not linen you are wearing out,"
wrote Ruskin in his 1862 diary when working on the *Munera Pulveris*
essays.) Behind this analogy between rivers and arteries lies the long
tradition of metaphoric equations between the earth and the human
body.

> The tide of blood in me
> Hath proudly flow'd in vanity till now.
> Now doth it turn, and ebb back to the sea,
> Where it shall mingle with the floods.[22]

There is a direct metaphoric logic in Ruskin's movement from the
idea of wealth (which is life and, implicitly, health; as opposed to
illth) to the circulation of water in the earth's body, to circulation of
blood in man's body, and to circulation of currency in the body poli-
tic. The concept of body politic is connected in Ruskin's thought, as
in Carlyle's before him, to the biblical image of the church as "the
body of Christ, and members in particular" (1 Cor. 12:27). Ruskin
knew that his comparison of action of wealth to the flowing of a
stream could be interpreted as a defense of laissez faire, a rejection
of interference with the "natural" law of supply and demand (this
imagery is implicit in McCulloch's objection to interference with the
flow of capital in its proper channel, for example).[23] To forestall
that interpretation Ruskin insists that whether the stream will be a
curse or a blessing "depends upon man's labour and administering
intelligence" (XVII:60). The imagery recalls once again man's task in
the fallen world of restoring paradise whether in the natural decora-
tion of buildings as advocated in *The Stones of Venice* or in literal

application of the image by restraining the floods of the Alpine torrents.

Ruskin rejected the gold standard recognizing that "all money, properly so called, is an acknowledgment of debt" (XVII:50). The value of gold is not intrinsic but the product of culture, whereas the products of agriculture are of life-sustaining, and hence true, value. Given Ruskin's definition of wealth, it is natural that he advocated limiting fluctuations in the value of money by pegging it to commodities of intrinsic value, particularly food. Ruskin spells out the items of the national store he would substitute for a gold reserve in the 58th *Fors:* "grain, wine, wool, silk, flax, wood and marble." They are the materials essential for life, materials that Ruskin, building off the list of necessities found in Adam Smith, considers the birthright of every citizen—food, clothing, shelter and fuel. Such currency in circulation, increasing with the national store, would truly be as blood is to the political body.

Whatever its degree of practicality, the idea of linking the value of currency to a commodity standard is not simply one of Ruskin's vagaries. In 1828 the anti-Malthusian Thomas Rowe Edmonds argued in his *Practical Moral and Political Economy* that: "there is, I believe, a tolerably correct universal measure of value for all commodities: which is, a given quantity of Corn." He argued that a given amount of labor (the source of value) will in all countries produce a given amount of grain so that "*a given quantity of corn will be a universal measure of value.*"[24] In *The Wealth of Nations* corn is the chief regulator of prices throughout the economy, chiefly because it regulates the price of labor. Granting Smith's argument it was naturally tempting to go on to argue that stable currency could be obtained by substituting as a base unit for gold and silver either corn, as Edmonds does, or, in the days before the mechanization of farm labor, the market price of farm labor itself. If not perfectly invariable, farm labor seemed the base least subject to fluctuation, as in John Rooke's *Inquiry into the Principles of National Wealth* (1824).

Ruskin attacks what he takes to be the value theory of the classical economists, asserting that Ricardo's connection of price with the labor theory of value rests on the false assumption of a single variable in what is in fact a double variable formula: when demand is constant price varies according to labor (y constant; xy varies as x), but y is in fact never constant. In fact Ruskin goes as far as to suggest that price is determined by a complex ratio between, on the one hand, what the seller *must* get to meet his costs and beyond that *hopes* to sell for and, on the other hand, how much of what the buyer can *afford* to

pay he is *willing* to offer. As Sherburne points out, Ruskin is on the verge of the concepts of demand schedules and marginal utility, but it was not Ruskin's purpose to correct the prevailing theories of value, but to replace them, and having sufficiently wounded the labor theory of value for that purpose Ruskin moves on to his own, entirely different definitions.[25] In consequence Ruskin tumbles from what might have been a significant place in the corpus of conventional economic theory into a dismissive, almost querulous, footnote as the representative type of those who ought to have known better in Joseph Schumpeter's majesterial *History of Economic Analysis.*

Words and Things

> The great old wrathful legislator's name, Draco, the Dragon, fits exactly as I want—legislation or law of the *worm* and of death—the worm that dies not.
>
> Ruskin to J.J.R., March 12, 1863

RUSKIN'S ATTACK ON the labor theory of value and the nature of his substitute for it is a signal instance of his uncanny ability to arrive at progressive conclusions by regressive methods. Ruskin approached political economy as he had art and architecture by attempting to define and name the first principles from which he could, on the covert model of Euclidian geometry, deduce conclusions.[26] In the abstract, Ruskin's approach resembles that of Nassau Senior. But Senior's aim is to define the limits of a science, and his meanings, therefore, are restricted, as nearly as the traditional vocabulary will allow, to assigned definitions within a closed realm of discourse. He is constructing a model. Ruskin looks for the real meaning of economic vocabulary to the roots of the words and, by extension, their use by the best writers. He even refers to their symbolic representation by great artists. This approach leads quite naturally to discussion of the contexts in which the words appear, thus forming a bridge between definition and situation or narrative.

Early in the nineteenth century Ruskin's approach would have seemed less retrograde. Adam Smith quotes at least fourteen classical authors for illustrative material in the *Wealth of Nations,* and McCulloch actually opens his *Principles of Political Economy* by defining his subject in terms of the roots of *economy* from the Greek for house or family and law: "Hence Political Economy may be said to be

to the State what domestic economy is to the single family,"[27] a proposition which later economists found dubious at best and with which Ruskin, of course, entirely agrees. As early as 1831 Archbishop Whately realized that the attempt to reconcile whatever "houselaw of the polity" might be with the accepted matter of political economy served only to sow confusion. He suggested that economics be called "Catallactics, or the Science of Exchanges."[28] There are later suggestions that the term *political economy* be dropped (by J. E. Cairnes for example), but the process that prevailed as far as the traditional terms of economic analysis are concerned was a gradual wearing away in economic contexts of the other connotations of such words as *value*. Then, as the study grew more and more technical, the historical terms found in modern textbooks were coined, and the blessedly neutral language of mathematics came to the fore.

This gradual emergence of economics from a branch of moral philosophy into a distinct, technical discipline Ruskin resolutely opposed. That Ruskin should have chosen to assail classical economics by defining the "real," that is, root, meanings and consequent implications of its terms reflects, to be sure, the shift in his personal search for certainties from the word of God to the science of words; but it was also in rhetorical terms a highly effective line of attack. There is, in fact, a high degree of dissonance between the general meaning of many traditional terms of economics and their technical definitions. While Ruskin's realistic view of language had been superseded by the most advanced thinkers in the field, the appeal to etymology carried authority, particularly to an audience respectful of the classical languages. Indeed it is regularly revived down to this day.[29] What after all becomes of Mill's reasonable, nominalistic distinction in the "Preliminary Remarks" to his *Principles* between what it is to be rich and what it is to be brave if *value* is really a brother, in meaning as well as lineage, of *valiant*?

While Ruskin's etymologies are at times, as even his editors point out, dubious, the procedure he follows resembles not only that of his master, Carlyle, but that of such esteemed pioneers in the history of English linguistics as Richard Chenevix Trench. Trench looked upon etymological study as a way of purifying the native language "from the corruptions which time brings upon all things." Indeed passages of *The Study of Words* could be easily transposed into Ruskin's work, as when Trench plays upon the relationship of the words *kind* and *kin* to advance the idea of an all-embracing human family concluding that "man*kind* is man*kinned*" or that:

"husband" is properly "house-band," the *band* and *bond* of the house, who shall bind and hold it together. . . . And the name "wife" has its lessons too. . . . It belongs to the same family of words as "weave," and "woof," "web," and the German, "weben." It is a title given to her who is engaged at the web and woof, these having been the most ordinary branches of female industry, of wifely employment, when the language was forming.[30]

By linking his economics to the great teachers of the past and to Greco-Roman mythology Ruskin could present his arguments as a continuation of a central thread of Western culture. Standard political economy becomes, from this perspective, an aberration. Thus, having assailed the profit motive in the chapters "Coin-Keeping" and "Commerce" in *Munera Pulveris,* and argued that the same idea of justice should prevail in commercial exchanges as between members of the same family, Ruskin invokes *The Merchant of Venice* as the fable best illustrating the opposition of the just and corrupt merchant (Antonio and Shylock).

"This is the fool that lent out money gratis; look to him, jailor," (as to lunatic no less than criminal) the enmity, observe, having its symbolism literally carried out by being aimed straight at the heart, and finally foiled by a literal appeal to the great moral law that flesh and blood cannot be weighed [such weighing is what Ruskin argues unjust transactions amount to, as the unfair profit is extracted from someone's necessity], enforced by "Portia" ("Portion") the type of divine Fortune, found, not in gold, nor in silver, but in lead, that is to say, in endurance and patience, not in splendour; and finally taught by her lips also, declaring, instead of the law and quality of "merces," the greater law and quality of mercy, which is not strained, but drops as the rain [pure water again]. . . . "Gratia," answered by Gratitude . . . that is to say, it is the gracious or loving, instead of the strained, or competing manner, of doing things, answered, not only with "merces" or pay, but with "merci" or thanks. And this is indeed the meaning of the great benediction "Grace, mercy, and peace." (XVII:223-24)

From this extraordinary passage, which is at once an embedded narrative illustrating Ruskin's concept of commerce and a brilliant interpretative summary of the heart of Shakespeare's play, it is but one

step to the three Graces: one step that is from the Hebrew Bible to the Greek one, from the Latin Grace to the Greek Charis (root of "charity") fit wife of Vulcan (who is labor), indicating that grace and dignity should be part of all work. Such grace in labor implies both a certain freedom of action and self-discipline.

At this pont Ruskin indulges in some myth-making of his own and "as Grace passes into freedom of action, Charis becomes Eleutheria or Liberality." (Ruskin claims no etymological link between these two aspects of Grace.) It is discussion of this liberality, which is the self-discipline prized by the Greeks (and the conscious, moral use of demand and supply advocated by Ruskin) that must control malignity, lest the dishonest control the marketplace, that forms the transition from Ruskin's chapter on "Commerce" to the one on "Government." "The examination of this form of Charis must, therefore, lead us into the discussion of the principles of government in general, and especially of that of the poor by the rich, discovering how the Graciousness [a chivalric virtue] joined with the Greatness, or Love with Majestas, is the true Dei Gratia or Divine Right, of every form and manner of King" (XVII:229). Arguments of this kind in which the grammar of embedding seems to run amok have proven frustrating to otherwise sympathetic critics of Ruskin's economic and social thought. They have found them at best playful and at worst symptomatic of Ruskin's eventual mental collapse. But the figurative argument is coherent and consistent with the more convential one, and Ruskin meant it seriously. Though he came to realize the argument was too condensed for its original audience, Ruskin never doubted that his combination of definition and derivation made sense, and denied that it was frivolous:

> the first point in definition is to fix one's idea clearly; the second to fix the word for it which the best authors use, that we may be able to read *them* without mistake. If the reader knows the essential difference between "cost" and "price," it does not matter at present which *he* calls which but it matters much that he should understand the relation of the words *Consto,* and *Pretium,* in Horace; and the relation between "for it *Cost* more to redeem his brother," and *"a* goodly *price* that I was prized at of them" in the Bible. (To Norton, XXXVI:588-89)

Granted that Ruskin could make his apparent divagations into mythology bear upon his economic argument for the careful reader, there was nevertheless a rhetorical danger inherent in the method.

To take Ruskin's own metaphor, if the sources of words are like those of rivers, pursuit of them may take us so far from the mainstream and into so many separate tributaries that the central argument may be lost in the intrinsic interest of the exploration. The discussion of roots and myths in the chapter "Coin Keeping" in *Munera Pulveris*, for example, suggests analogies that are never followed up. Thus the reader, like the reviewer in the *Weekly Review*, is more apt to wonder how the fig tree above Charbydis to which Ulysses clings can be the same type as the cursed fig tree of the Gospels than to appreciate the connection Ruskin has established between contention for riches and the song of the sirens as understood by Dante and Homer.

The Greco-Roman concept of economics that Ruskin invokes by tracing economic vocabulary back to such writers as Xenophon, Plato, Horace, and Cicero puts the emphasis of political economy on the first term, on the concept of polity, once again the reverse of the trend of the times. The exercise of the martial virtue of valor, and the soldier's duty to defend the state, to give his life if need be, Ruskin extends to a list of the "intellectual professions." That list includes, after soldier, pastor, physician, and lawyer, the merchant (including the manufacturer) whose social obligation is provision, not profit. Ruskin advocates not only the professionalization of the role of the employer and producer, but a broadening of the whole class of gentlemen to include such as John James Ruskin. He includes, in other words, the newly rich in trade and industry whose social ambition was to have their children rise through education, or marriage, or both, from mere prosperity into the conventional Victorian gentility that Carlyle and Ruskin denounced as parasitic. With the merchant's true gentility would come, of course, noblesse oblige of the sort Ruskin associates with the knightly merchants of medieval Venice:

> in his office as governor of the men employed by him, the merchant or manufacturer is invested with a distinctly paternal authority and responsibility. In most cases, a youth entering a commercial establishment is withdrawn altogether from home influence; his master must become his father, else he has, for practical and constant help, no father at hand: . . . the only means which the master has of doing justice to the men employed by him is to ask himself sternly whether he is dealing with such subordinate as he would with his own son. (XVII:41-42)

The archaic cast of Ruskin's proposal: its paternalism, its extension of the preindustrial form of apprenticeship in a workshop that is either literally a household or modeled on one, its implicit basis (as in Carlyle's concept of industrial organization) in the social extension of the Fifth Commandment, its assumption of small scale and personal authority, all these make it seem more anachronistic than it was. The law governing labor regulation was as old-fashioned in its vocabulary as Ruskin, taking the form of masters and servants acts. While the emphasis of the popular histories of the industrial revolution is quite naturally on the major transformations wrought by machinery in the textile industry, by railways in transportation, and the like, most British business and industry throughout the nineteenth century was in fact on a small scale and largely managed by owners. As late as 1885 "with only a few exceptions, most industrial firms were owned and run by individuals or partnerships." Though by 1914 the number of companies had increased sevenfold, 77 percent were still private, usually small, with "control still in family hands—in 1915 the average capital per British company was only £41,000." The great family firms like Huntley & Palmer, or J & J. Coleman were exceptions and "the size of the business unit often remained much smaller than in competing countries."[31]

Early in this century Prince Kropotkin defended the plausibility of his proposed industrial villages by citing similar statistics, noting that nontextile factories in the England of 1897 employed on the average only thirty-five operatives, and other workshops but eight.[32] William Morris' firm, while it may have been unusual in its Ruskinian objectives and organization, was in its scale a typical English enterprise of the time.

Ruskin and Morris made a direct contribution not only to English socialism and the arts and crafts movement, but also to the idea of small-scale, decentralized production of the sort E. F. Schumacher lately advocated. Indeed the so-called Buddhist Economics of Schumacher is almost point for point in the Ruskin-Morris tradition.

> The Buddhist point of view takes the function of work to be at least threefold: to give a man a chance to utilise and develop his faculties; to enable him to overcome his ego-centredness by joining with other people in a common task; and to bring forth the goods and services needed for a becoming existence. . . . Work and leisure are complementary parts of the living process and cannot be separated without destroying the joy of work and the bliss of leisure.[33]

For work and leisure to be a single complementary process the workman, as Ruskin clearly saw, must have adequate pay, leisure time, and some form of social security that would relieve the dread of unemployment, illness, and retirement. He must whenever possible have work of the kind Ruskin associates with the medieval stone carver, work that calls upon his human potentialities, so that he can be a man and not an animated tool. By contrast, the attitude toward the working man implied by the thoroughly rationalized labor of assembly line production was bluntly stated by Henry Ford: the average worker "wants a job in which he does not have to put forth much physical exertion—above all, he wants a job in which he does not have to think."[34]

While Ford's assembly line may have been the fulfillment of Adam Smith's vision, Smith saw the workman not as desiring mental and physical incapacity, but as doomed to it, having:

> no occasion to exert his understanding, or to exercise his invention in finding out expedients for removing difficulties which never occur. He naturally loses, therefore, the habit of such exertion, and generally becomes as stupid and ignorant as it is possible for a human creature to become. . . . His dexterity at his own particular trade seems, in this manner, to be acquired at the expense of his intellectual, social and martial virtues. But in every improved and civilized society this is the state into which the labouring poor, that is, the great body of the people, must necessarily fall, *unless the government takes some pains to prevent it.*[35]

The italics are mine, but the emphasis was very likely Ruskin's as well. Even the casual reader is apt to respond to the contrast between Smith's praise of the virtues of the division of labor in his first volume and the picture of its human costs in the second by at least asking: "What price progress?" Moreover, to accept the division of labor in these terms seems to contradict the second part of Smith's own *Theory of Moral Sentiments* ("Of Justice and Beneficence") which Ruskin's mother was drilling into him at the age of ten (*FL*:186).

> Society, however, cannot subsist among those who are at all times ready to hurt and injure one another. The moment that injury begins, the moment that mutual resentment and animosity take place, all the bands of it are broke assunder, and the different members of which it consisted are, as it were,

> dissipated and scattered abroad by the violence and opposition
> of their discordant affections. . . . Society may subsist, though
> not in the most comfortable state, without beneficence; but the
> prevalence of injustice must utterly destroy it.[36]

While Smith's examples make it clear that he has criminal activity
primarily in mind, this and other passages approximate Ruskin's
views of the effects of competition and the exploitation of the poor
by the rich, the worker by the owner, in that process of accumulation
he liked to compare to the one employed by Dick Turpin (XVII:559).

Just as Ruskin is willing to do without the benefits of standardiza-
tion and maximum output if in exchange the worker may express his
skill and imagination, so he insists that the government should take
pains to prevent his degradation. It was Ruskin's goal to provide
everyone with the means to begin a productive life in the social
sphere into which he or she was born; that is, to be raised in a house-
hold guaranteed the necessities of life and, if deserving, to have the
chance to establish a new household at an appropriate age. Implicit
in this conception is a national store to which each household con-
tributes and from which, if needful, it can draw, and a mechanism of
supervision. The supervisors are to be bishops who truly oversee
their flocks (one per one hundred citizens) to distinguish those who
are in genuine need of aid from those who will not work.

While Ruskin cannot resist embroidering his supervisory proposal
with details of costume and ritual that are projections of his private
tensions and thus peripheral, personal, and fantastic (a twice yearly
celebration of permission to marry echoing ancient Venetian custom,
for example), the moral point he repeatedly makes is absolutely cru-
cial. There can be no legitimate distinction between the deserving
and the undeserving poor, no properly discriminate as opposed to
indiscriminate charity, until everyone has sufficient food, clothing,
and shelter available. Only then may we say with St. Paul: "If any
man will not work, neither should he eat." On the whole, bishops
aside, we have come closer to satisfying Ruskin's demand for super-
vision than to meeting his prior condition to judgment.[37]

Together with the combination of provision and regulation by the
state for the individual and his household Ruskin foresaw a regu-
lated mixed economy that would prevent failures in investment or
speculation from dragging down the innocent. (Ruskin considered
bank failures to be criminal.)

Neither does a great nation send its poor little boys to jail for

stealing six walnuts; and allow its bankrupts to steal their hun-
dreds of thousands with a bow, and its bankers, rich with poor
men's savings, to close their doors "under circumstances over
which they have no control," and with a "by your leave"; and
large landed estates to be bought by men who have made their
money by going with armed steamers up and down the China
Seas, selling opium at the cannon's mouth, and altering, for
the benefit of the foreign nation, the common highwayman's
demand of "your money *or* your life," into that of "your money
and your life." (XVIII:82)

Large scale economic enterprises providing essential services, such
as railroads, would be developed as national utilities, expanded only
to provide necessary service with the minimum of disturbance to the
landscape. Housing would be similarly planned, and even develop-
ment of private property regulated in the interest of the environ-
ment and the community. In sum, Ruskin, believing in private
property, but having no ideological commitment to free enterprise,
saw an economy that would be regulated as a whole system. At vari-
ous points in developing his arguments he anticipated, to use mod-
ern terminology: free public education and vocational training;
public works employment for the jobless; public assistance and hous-
ing for the aged, disabled, and destitute; a graduated income tax;
minimum wage laws (in the form of fixed wages) together with in-
come ceilings for the wealthy; guaranteed medical care for the
needy, green belts around urban areas; regulation of economic de-
velopment for the protection of the environment and the public
health; creation of a national store including grain reserves that
would prevent starvation and the exploitation of short supplies for
financial advantage in years of bad harvests; flood control projects;
and the development of pollution-free power by the harnessing of
wind and tide.[38] Surely Ruskin, for whom the scientific evidence
that "all mortal strength is from the Sun" meant that "men rightly
active are living sunshine" (XXVI:183), would have welcomed solar
power.

New Tactics

Many, many are the Phoebus Apollo celestial arrows you still
have to shoot into the foul Pythons and poisonous

> Megatheriums and Plesiosaurians that go staggering about,
> large as cathedrals in our sunk epoch.
>
> Carlyle to Ruskin

THE MUNERA PULVERIS essays in *Fraser's* were to be the preface of a
work that would link Ruskin's proposals for specific reforms to an
elaborated theory of political economy. When he finally published
Munera Pulveris in 1872 Ruskin blamed "loss of health, family dis-
tress, and various untoward chances" (XVII:143) for the fact that the
body of the treatise was never written, alluding to the death of his
father in 1864 and, less explicitly, his relationship with Rose La
Touche—"the woman I hoped would have been my wife"
(XXVIII:246). By 1872 his work as Slade Professor and the publica-
tion of *Fors* were absorbing his energy. While in retrospect the fragmen-
tary political economy and social criticism running through *Unto This
Last, Munera Pulveris, Time and Tide*, the lectures of the 1860s and
Fors Clavigera may look like a broken effort to be explained by refer-
ence to Ruskin's eventual mental collapse, it is hard to imagine
Ruskin at any stage of his career writing an extended work as spare
as the opening chapter of *Munera Pulveris*, let alone a treatise to rival
Mill's or even Senior's.[39] Even Ruskin's most coherent long works
are more like conglomerate rocks than crystals, and after the binding
agent of religion was removed it became obvious that the essay, lec-
ture, and epistle were the prose forms most congenial to him for rea-
sons that engage the entire configuration of his mind and not merely
his susceptibility to swings in mood.

After losing faith Ruskin came to see truth as a polygon that could
only be examined one side at a time. A lifetime of sketching encour-
aged Ruskin to think more in terms of gestalts than of sequences.
(Ruskin's confidence in geometry came from his ability to picture the
diagrams eidetically.) There is a remarkable consistency between the
style of Ruskin's drawings of architecture and landscape in his mid-
dle years and his discursive essays and epistles on political economy.
In the drawings the eye is led from sketchy outline at the margins
into consideration of the object upon which Ruskin wishes to focus
attention, which is rendered in detail and often full color. The essays
and letters on political economy focus upon conceptual fragments,
often rendered in great detail, set in the outline of a larger system.
He frequently expounds, in effect, types for which there is no Scrip-
ture but Ruskin's own.

Although Ruskin knew that the *Unto This Last* essays would encoun-
ter opposition and might even have to be published with an editorial

disclaimer, he clearly did not foresee the storm of protest that drove them from the magazine. He commented with some bitterness and, characteristically, with an eye on the *Cornhill* sales figures, that "I do not allow reviewers to disturb me; but I cannot write when I have no audience. Those papers on Political Economy fairly tried 80,000 of the British public with my best work; they couldn't taste it, and I can give them no more."[40] Nevertheless, with the approval of Carlyle and the support of Froude, who invited him to continue his essays in the pages of *Fraser's*, Ruskin tried again. Again it proved a broken effort, broken once more over the content of his political economy, not the digressiveness which has been the subject of much critical comment. (Indeed Froude commended Ruskin for his long footnote on Ulysses—an embedded narrative as interpretation once again [XVII:216]).

It seems rather too much to expect that Ruskin should have devoted years of work against the natural bent of his mind to produce a systematic polemical treatise on political economy that had no immediate prospect of an audience.

The problem that confronted Ruskin in the 1860s was less how to find the mental stability necessary to write a treatise on economics, than how to reach as many people as possible with his message: how to persuade them, how to confront them, how to do something to alleviate the suffering around him without losing himself in the process. The need to act became more acute in 1864 when the death of his father suddenly made him a man of independent means. From this perspective, the lectures to audiences ranging from girls and boys, to working men, to military cadets, to the burghers of Bradford; the sets of published letters and the letters to the press; the public testimony on matters relating to the working class ranging from what hours art galleries and museums should keep for them, and what sorts of displays they would appreciate, to the legitimacy of trade unions all take on the appearance of a deliberate propaganda campaign. Ruskin served whenever possible on committees investigating the problems of the working class even when suspending all other avocations: "Decline *all* business of any kind, on the same grounds [work], except that connected with the Committee on the Employment of the Destitute Poor.—I am on the Sub-Committee specially on unemployment, and mean to do all I can upon it."[41]

The results that in retrospect look so scattered cohere if their end is kept in view, the more so in that Ruskin did not advocate a single course of action. While the kind and number of changes he advocated amounted to a radical restructuring of society, he, like Carlyle,

Ruskin sent this study of an arch of St. Mark's to "his Sorella," Francesca Alexander, whose work with the Tuscan poor he admired and whose illustrated collection of *Roadside Songs of Tuscany* he purchased through the Guild and edited (XXXII). The subject, the Gabriel half of an annunciation, may be an indirect tribute, for Ruskin counted her among his saving women.

saw that reformation not as the product of revolution but as a means of forestalling one. Despite Ruskin's polarized outlook, his was not in its specifics a simple call to arms. He had no single legislative panacea like Henry George's tax on land. Rather he challenged the members of each audience first to recognize the general system of exploitation and their own place in it, and then to take such action as they could within their own sphere of activity to alleviate suffering and move society in the direction of increased mutual responsibility.

One way Ruskin could assure contact with an audience was to write on specific controversies involving political economy as they came up in the public press. Hence came the series of letters to the *Daily Telegraph* in 1864 in which he disputed with "Economist" on the question

of supply and demand; the series of letters to the *Pall Mall Gazette* in 1865 in which he and the editorial writers matched definitions and derivations over the questions of work and just wages; the letters to the *Daily Telegraph* (1865, 1868, 1870) on the perpetual servant question and on the railways—Ruskin wanted them nationalized and rationalized.[42] The letters that became *Time and Tide* combined address to a specific audience, Thomas Dixon, "a working man of Sunderland,"[43] with publication in scattered newspapers followed by a collection into a book. While the result in book form is digressive, the familiar style makes the individual letters easy to follow.

Unto This Last and *Munera Pulveris* had been written in the isolation of Switzerland and Ruskin knew that he had made mistakes in his presentation. In *Unto This Last* he had introduced the concept of uniform wages implicit in his title (in the Parable of the Vineyard Laborers the householder pays a full day's wage to those hired at the eleventh hour over the objections of the other workmen) early in the first essay, though it was a subordinate part of his total scheme. The seemingly outlandish paradox of paying the good and the bad workman alike and rewarding the good with work itself (implicitly the kind of work approved by Ruskin and Morris that requires skill and is in some measure its own reward) caught the attention of reviewers at the expense of his central arguments against the political economists and the Manchester School. In *Munera Pulveris*, he discovered, his "affected concentration of language," the product of his isolation in Switzerland together with the classical studies to which he was devoting much of his time, stood in the way of a clear perception of his ideas.

Though miscellaneous as a collection and certainly unique as a response to the debate over the second Reform Bill, the *Time and Tide* letters, with selections of Dixon's replies, are individually coherent. Even a subject so seemingly outlandish for a work on social organization as the existence of the devil, a topic which modern readers (particularly those aware of Ruskin's imagined struggle against the Fiend during his first attack of mania) might see as a psychological aberration, was common enough at the time to give no pause to reviewers who concentrated their fire on Ruskin's fanciful scheme for regulating marriage on the old Venetian model.[44]

Ruskin's primary way of expanding the audience for his economic views in the 1860s was to work them into lectures. After losing his Evangelical faith Ruskin consciously addressed himself to a double audience: an audience of doubters and unbelievers whom he hoped to convince through logic and rhetoric; and an audience of at least

nominal Christians whom he hoped to persuade to follow literally their professed religion, a religion he believed could only be understood through deeds. To the skeptics Ruskin argued (as Carlyle had) that biblical ethics are natural, and consequently have their reflection even in pagan religion and mythology, as he demonstrated by mixing Christian and pagan myths and texts in his economic writings. To the Christian he pointed to the conflict betwen religious belief and commercial practice.

The broad strokes of the lecture "Traffic," Ruskin's response to the request of the citizens of Bradford for advice as to the style of their new wool exchange, the temple of the local deity, illustrates Ruskin's basic rhetorical strategy, an adaptation into his own idiom of the later Carlyle (cf. "Hudson's Statue").

> Now, we have, indeed, a nominal religion, to which we pay tithes of property and sevenths of time; but we have also a practical and earnest religion, to which we devote nine-tenths of our property, and six-sevenths of our time. And we dispute a great deal about the nominal religion; but we are all unanimous about this practical one; of which I think you will admit that the ruling goddess may be best generally described as the "Goddess of Getting-on," or "Britannia of the Market." . . . It is long since you built a great cathedral; and how you would laugh at me if I proposed building a cathedral on the top of one of these hills of yours, to make it an Acropolis! But your railroad mounds, vaster than the walls of Babylon; your railroad stations, vaster than the temple of Ephesus . . . your warehouses; your exchanges!—all these are built to your great Goddess of "Getting-on" . . .
>
> Pallas and the Madonna were supposed to be all the world's Pallas and all the world's Madonna. They could teach all men, and they could comfort all men. But, look strictly into the nature of the power of your Goddess of Getting-on; and you will find that she is the Goddess—not of everybody's getting on—but only of somebody's getting on. This is a vital, or rather deathful, distinction. (XVIII:447-48, 452-53)

Judging from the local reviews, Ruskin's lecture seems to have had some of the desired effect on his audience. The commentators pondered his assertion that the eclectic styles of contemporary architecture indicate a division of the spirit and accepted his attack upon Britannia of the Market as morally justified, though they evaded the

consequences of accepting it.[45] Reviewers of the whole *Crown of Wild Olive* in the national magazines fervently wished that Ruskin would return to paintings and landscapes, but their rejection of Ruskin's arguments unintentionally demonstrated his skill in flushing out the rationalizations of injustice. Thus Anthony Trollope in the *Fortnightly*, ignoring Ruskin's pointed allusions to biblical passages on idolatry, cries foul because Ruskin uses the term *goddess* in two senses. Confronted in the preface with a denunciation of the useless iron bars that decorate pub fronts, he declares in the name of the general reader that "the author is here denouncing, not only these unfortunate rails, but all working in mines, all working at furnaces, and all attempts of sedentary students to make designs for iron-rails," and states boldly: "that mines and iron furnaces are essentially necessary, that they have been given by God as blessings, that the world without them could not be the world which God has intended."[46] Momentarily at least startled into the role of a Pangloss, Trollope implies that there is but one way to work the mines and forges, and one end for the labor, the present one; therefore, God blesses a system in violation of the ethical principles of His Scriptures. Ruskin saw that political economy could be used as a means of rationalizing such contradictions. In the inelegant language of modern sociology, it could be used to define a "symbolic universe"; one of the "bodies of theoretical tradition that integrate different provinces of meaning and encompass the institutional order in symbolic totality."[47]

In a pluralistic society the symbolic universe of a given individual may be provided by one of a number of religions or ideologies that compete among one another for adherents. Among the more important functions of the symbolic universe is that it:

> provides the highest level of integration for the discrepant meanings actualized *within* everyday life in society. We have seen how meaningful integration of discrete sectors of institutionalized conduct takes place by means of reflection, both pretheoretically and theoretically. Such meaningful integration does not presuppose the positing of a symbolic universe *ab initio*. It can take place without recourse to symbolic processes, that is, without transcending the realities of everyday experience. However, once the symbolic universe is posited, discrepant sectors of everyday life can be integrated by direct reference to the symbolic universe. . . . The symbolic universe orders and thereby legitimates everyday roles, priorities, and

operating procedures by placing them *sub species universi,* that is, in the context of the most general frame of reference conceivable.[48]

The main challenge Ruskin posed the manufacturers of Bradford when he delivered the "Traffic" lecture was to reconcile the ethics of their ostensible religion with their business practices. As Berger and Luckmann suggest, that challenge could simply be rejected as impractical. "It would be nice, but the world simply doesn't work that way." On the other hand, a manufacturer who admitted the challenge (and perchance, had read reviews of *Unto The Last*), might very well reply by reference to the symbolic universe provided by popular contemporary economics:

> The competitive economic system, while imperfect, does provide the greatest possible good for the greatest number. If wages are not kept within bounds it will be impossible to generate the capital necessary to expand the industry that will provide more jobs. The relationship between owner and worker is an economic one and governed by the laws discovered by the political economists just as the acceleration of a falling body is governed by laws discovered by the natural scientist. As Thomas Hodgskin says: "The laws regulating the production of wealth are part of the creation, in which we trace only benevolence in the design," so that political economy, when understood will "Justify the ways of God to man." Attempts to violate those laws are futile and can only lead to economic disaster.[49]

Thus a symbolic universe can reconcile apparently conflicting or contradictory behaviors and beliefs.

The biblical ethics that Ruskin assumes are part of the natural order of things are the product of a culture in which religion provided the rules for all human relations including those in the economic sphere. It is this situation that Ruskin is so anxious to restore and, historically speaking, it is one of the anachronistic aspects of his own symbolic universe. Thus he pleads with his audience to build in one style, to live by one standard. The pluralistic reply tacitly restricts the applicability of biblical ethics. Economic matters are governed by their own, secular rules. From this point of view Ruskin has made a category error. He has simply confused two sets of rules.

The history of legitimating theories is always part of the history of the society as a whole. No "history of ideas" takes place in isolation. . . . This does not mean that these theories are nothing but reflections of "underlying" institutional processes; the relationship between "ideas" and their sustaining social processes is always a dialectical one. It is correct to say that theories are concocted in order to legitimate already existing social institutions. But it also happens that social institutions are changed in order to bring them into conformity with already existing theories, that is, to make them more "legitimate." . . . Definitions of reality have self-fulfilling potency.[50]

Business activities are not, as Ruskin often implies they are, merely the incarnation of the ideas of political economists, but that does not mean that Ruskin was simply naive in linking the two, for political economy did provide the symbolic universe that justified business practice. The attack upon classical political economy by Carlyle, Ruskin, Hobson, and critics from other traditions, including the Positivists and Marx and Engels, paved the way for changes in the British economic system, though the result does not reflect the triumph of any one thinker's viewpoint or prophecy.

Ruskin challenged the merchants of Bradford to live by a single heroic standard:

I never can make out how it is that a *knight*-errant does not expect to be paid for his trouble, but a *pedlar*-errant always does —that people are willing to take hard knocks for nothing, but never to sell ribands cheap; that they are ready to go on fervent crusades, to recover the tomb of a buried God, but never on any travels to fulfill the orders of a living one;—that they will go anywhere barefoot to preach their faith, but must be well bribed to practice it, and are perfectly ready to give the Gospel gratis, but never the loaves and fishes. (XVIII:450)

Genuine heroism of commerce might generate a good architecture for exchanges and true deeds "which might be typically carved on the outside of your building" (XVIII:448). Under present conditions the only proper carving for an exchange would be Turner's dragon of the Hesperides.

Fully aware of how quixotic this new knighthood sounds, Ruskin sets it against the ideal implicit in the economic behavior of his

audience: the laissez-faire Eden of the Goddess of Getting-On. He pictures a pleasant landscape with coal and iron everywhere beneath it; a park and mansion on high ground for "the English gentleman, with his gracious wife, and his beautiful family." Below lies the mill with four steam engines, a three-hundred foot chimney, and, in constant employment, "from eight hundred to a thousand workers, who never drink, never strike, always go to church on Sunday. . . . It is very pretty indeed, seen from above; not at all so pretty, seen from below" (XVIII:453). It is a manifestly self-contradictory ideal that divides its material ends from its equally material means, means that violate the human nature of the workman and turn the green fields "furnace-burnt into the likeness of the plain Dura." Ruskin is not simply trying to force on his audience his specific picture of just economic practice as couched in the language of the quest romance. Rather he is trying to make his audience think in terms of social ends, not merely private means. He calls upon members of his audience to posit "some conception of a true human state of life to be striven for—life, good for all men, as for yourselves" (XVIII:458) before the contradiction in their present practice produces a social explosion, and the shield of Britannia of the Market becomes their tombstone: "instead of St. George's Cross, the Milanese boar, semifleeced, with the legend, 'In the best market' " (XVIII:451).

Woman's Place

> She stretcheth out her hand to the poor; yea, she reacheth
> forth her hands to the needy.
>
> Proverbs 31:20

RUSKIN'S VIEW OF errantry, whether knight's or pedlar's, has its corrolary in his discussion of women and the home from which the errant one travels and to which he returns, whether he be a merchant in "Traffic" or soldier in "War." Ruskin treats that topic most directly in "Of Queens' Gardens," a lecture that has become one of the best known and least understood writings. Ruskin's rhetorical tactics in the lecture are basically the same as in his other addresses on social topics, a combination of accusation and exhortation. Unfortunately, in most works in which Ruskin is cited the accusations have been lost and a portion of his ideal mistaken for a self-satisfied description of the actual situation.[51] Ruskin's contemporaries knew better, the

Saturday Review's writer remarking of *Sesame and Lilies* as a whole that the lectures are "supposed to be on the subject of how and what to read but the real subject is, first, the villainy and the degradation of English people in general; and secondly, the selfishness and frivolity of the English women in particular."[52]

It is in his ideal picture of domestic relations that the romance structure of Ruskin's social vision shows most clearly. The all too solid reality of Effie Gray never seems to have altered his picture of what women ought to be. His ideal women remain the heroines of Shakespeare and Scott; Spenser's Una and Britomart; Dante's Beatrice and the ladies celebrated by the poets of the *dolce stil nuovo*. Her perfect pattern is Portia,[53] "the 'unlessoned girl,' who appears among the helplessness, the blindness, and the vindictive passions of men, as a gentle angel, bringing courage and safety by her presence, and defeating the worst malignities of crime by what women are fancied most to fail in—precision and accuracy of thought" (XVIII:114). In traditional romance the intercessionary, saving role of the heroine is not confused with that of the Virgin, but it takes on overtones of her role in much Victorian fiction.[54] Ruskin here, as so often, calls upon his readers to act out in life what they accept in books: the knight's devotion to his lady, the poet's to his mistress; the woman's courage to act in the name of the highest duty even as Cordelia is true to her father in defying his wishes.

Although it has become virtually *de rigueur* to quote Ruskin's praise of the ideal home in discussions of Victorian sexual attitudes and the domestic place (or lot) of Victorian women, Ruskin in fact urges women to emulate Portia and extend their influence beyond the home, and not entirely through their men either. In response to what he sees as the corruption of the male world of public action—economic, military, scientific—Ruskin argues for feminization of culture, continuing an attitude going back through his father to the late eighteenth-century "Age of Sensibility." It is that ideal, whatever one may think of it, that should be set against the liberation of women as advocated by John Stuart Mill and Harriet Taylor, and both contrasted with the prevailing conditions of the time.

Mill and Taylor are rightly perceived as progenitors of modern feminism. While their ideas about sexuality were decidedly Victorian, and Mill at least assumed—even hoped—that only a minority of women would take full advantage of the opportunities their program would offer lest wages be depressed—it was nevertheless a program of full equality in education, employment, and political life for women who desired it. As *Fors* shows, Ruskin was acutely aware that

most working women were not working out of choice but out of ter-
rible necessity and in degrading conditions. From his perspective the
advocacy of the right of educated women to work served to justify
the condition of working women who had no choice. His object was
to guarantee sufficient wages to men to allow them to support a wife
and children. The solution was radical economically and conserva-
tive socially, but it was not simply irrational or hysterical, however
sentimental the expression of his views at times became.

Ruskin's position is much more ambiguous than Mill's partly be-
cause "Of Queens' Gardens" and the later preface to *Sesame and Lilies*
carry an underlying special appeal to Rose La Touche, urging her
away from religious obsessions and toward the assumption of moral
authority in his own life. (Ruskin's Rose thus resembles those women
who at once child, wife, and mother are so common in Dickens.)
Most of the confusion arises, however, because he appeals, both in
his criticisms of women of means and in his arguments for action, to
what are for the most part accepted ideals. Mill argues for a change
both of principle and practice; Ruskin, as in his economic writing,
largely for the true acting out of what most of his contemporaries
already profess.

Perhaps the most startling assertion in "Of Queens' Gardens" con-
sidering both the history of his marriage and Ruskin's reputation as
chief spokesman of the Victorian domestic ideal is that:

> there is in the human heart an inextinguishable instinct, the
> love of power, which, rightly directed, maintains all the ma-
> jesty of law and life, and, misdirected, wrecks them.
>
> Deep rooted in the innermost life of the heart of man, and of
> the heart of woman, God set it there, and God keeps it
> there.—Vainly, as falsely, you blame or rebuke the desire of
> power!—For Heaven's sake, and for Man's sake, desire it all
> you can. But *what* power? That is all the question. (XVIII:137)

The power women are to exercise is that of the lady, a title, Ruskin
notes, that women of the middle class have lately claimed for them-
selves. Accepting that claim, Ruskin advances a conception of lady-
hood that, like his conception of the knightly merchant, is a curious
blend of the religious, the literary, and the literal; of the Bible, fic-
tions, and his experience of extraordinary women, who were ladies
indeed, with that independence of mind and action open to women
of high rank who chose to exercise it: Lady Trevelyan, for example,
and Mrs. Cowper-Temple (later Lady Mount-Temple) to whom

Sesame and Lilies was dedicated.

Ruskin expects the women who lay claim to the once restricted title of lady, like the men of business who would be gentlemen, to exercise the responsibilities of rank along with its privileges. To do so they must have a genuine education as girls. They should be turned loose in a library containing selected fictions chosen "not for their freedom from evil, but for their possession of good" and offering uncensored access to "old and classical books." (Ruskin knew that such a library was the foundation of Elizabeth Barrett's education.) Their lessons should be same as a boy would receive, though with a different end in view, and from as respected a teacher. "Is a girl likely to think her own conduct, or her own intellect, of much importance, when you trust the entire formation of her character, moral and intellectual, to a person whom you let your servants treat with less respect than they do your housekeeper (as if the soul of your child were a less charge than jams and groceries)?" (XVIII:133). Finally, in accordance with Ruskin's Greek conception of education, girls should have vigorous, outdoor, physical exercise. (The Winnington School, where Ruskin encouraged the study of natural science and classical languages, was unusual in permitting girls to play cricket and swing on ropes as well as dance.) Seeking stability here as in all things, Ruskin assumes that there is a clear and permanent set of basic principles and fundamental knowledge for each discipline, and it is to this thorough grounding that he would restrict formal education for women. Ruskin is thus a meliorist rather than a revolutionary in the Victorian movement toward equal education for women, but he is hardly a Mrs. Ellis conceding that "a young woman may with propriety learn even the dead languages, provided she has nothing better to do."[55]

The woman's firm foundation of learning in all that her husband knows and does is essential to her role as ruler of the household and moral guide to his action in hardening circumstances of the commercial world, or the ambiguities and perplexities of the intellectual one. The picture Ruskin paints of the mutual submission of the "active, progressive, defensive" man, the "doer, the creator, the discoverer, the defender"; and the woman, whose "power is for rule, not battle," and intellect "for sweet ordering, arrangement, and decision" is typical of one line of reformist sentiment in the mid-Victorian period.[56] Coventry Patmore celebrates a similar blending in marriage of the separate natures and divided roles of men and women in *The Angel in the House*, as Tennyson does at the end of *The Princess*: "For woman is not undevelopt man, / But diverse . . . / Yet in the long years liker must they grow; / The man be more of woman, she of man." In

fiction the woman's capacity for rule, her guiding but not determining function, are manifest in Esther as she assumes her queenship in *Bleak House* and, more complexly, in Dorothea who, to the regret of so many twentieth-century readers, finds satisfaction at the end of *Middlemarch* in giving Ladislaw home, children, and purpose while exercising her moral and intellectual gifts in the unremembered channels of private influence. In fact, the young wives of *Middlemarch*, Rosamond, Celia and, ultimately, Dorothea, roughly correspond to the three kinds of wives implicit in "Of Queens' Gardens": the "selfish and frivolous" English woman noted by the *Saturday Review*, who is the egocentric product of conventional upbringing and education; the purely domestic wife who cares for her own, but knows no larger obligation; and the ideal wife, who recognizes that while her primary duty is to her own family, home, and garden, they are part of a larger society to which she also has an obligation. (Though tucked into a subplot, Mary Garth, Fred Vincy's redeemer, is as sure a center of moral authority as Little Dorrit.) In popular contemporary historiography Carlyle's Madame Roland, his example of womanhood at once intellectual and domestic, was still being held up as the model of what educated women might be, suggesting that "reformed, woman will prove the most efficient reformer."[57] Contemporary lives came, of course, less neatly packaged than fiction or history and it is, ironically enough, hard to think of a more perfect example of work inspired and fruitfully guided as to its ends and moral implications by the thoughts and sentiments of a woman than that of John Stuart Mill by Harriet Taylor.

Ruskin's description of the ideal home transforms it from woman's sacred place, "a temple of the hearth," to her spiritual presence: "home is yet wherever she is." Similarly her private garden is transformed into the landscape of the country at large, and the flowers she tends, by way of an allusion to "Dante's great Matilda" (the type of the active life), into England's neglected children. Through metaphor, allusion, and analogy Ruskin comes to the real message of "Queens' Gardens," that the true lady or "loaf giver" must extend her influence beyond her home, beyond the gate of her well-ordered private garden, to the neglected public one. What is true for the wife is doubly true for the unmarried woman for whom the public obligation may be primary. It was to young women of the "upper, or undistressed middle classes" that *Sesame and Lilies* was primarily addressed (XVIII:51).

Thus by rhetorical sleight of hand Ruskin's praise of the home becomes an argument for getting out of the house; not to abandon the

home, but to extend its influence into a world in need of domestication, a world where children have not sufficient education to have heard of Jesus and, worse, have only rags to wear. Ruskin recommends that girls learn the meaning of Proverbs 31 (the praise of the virtuous woman) by literally practicing her crafts, making clothes, and giving them directly to someone in need:

> even though you should be deceived, and give them to the dishonest, and hear of their being at once taken to the pawnbroker's, never mind that, for the pawnbroker must sell them to some one who has need of them. That is no business of yours; what concerns you is only that when you see a half-naked child, you should have good and fresh clothes to give it, if its parents will let it be taught to wear them. If they will not, consider how they came to be of such a mind, which it will be wholesome for you beyond most subjects of inquiry to ascertain. (XVIII:40)

The last sentence is the important one. The clothes may be pawned, or spurned, but direct contact will have been made between the young lady and the victims of the economic system that produced her own prosperity, the prosperity that ordinarily screens her from such experiences. To recognize both the legitimate needs and legitimate resentments of the poor is the necessary first step to doing anything about them.

Sesame and Lilies was an enormously popular book with young women and, "beauties of Ruskin" aside, one reason surely was that it provided religious and moral sanction for socially significant action. The desire to be of service, an ideal associated with the Evangelical movement, but not confined to it, was a powerful current in Victorian life. With all due allowance for hypocrisy, for cant, for the connection between Protestant religion and the burgeoning of capitalism, and the frequent elevation of the letter over the spirit of the Word, there were a great many people who worried more about the literal practice of Christian ethics than the literal truth of Genesis. Ruskin was of them, and it was to them that he appealed. In "Of Queens' Gardens" and elsewhere he proposed a life of service to women who were more eager to hear that message and try to act upon it than to hear about their own subjection and militate against it. Ruskin was, in fact, trying to expand the Victorian concept of marriage so that it could contain and give expression to the kind of moral commitment expressed by Florence Nightingale in explaining

her determination to remain single—that to be restricted to domestic things would be "voluntarily to put out of my power ever to be able to seize the chance of forming for myself a true and rich life"[58] —and to justify social activism for the unmarried.

The emphasis of Ruskinian social action is upon that true wife of Vulcan, Charity. Charity was even then a much embattled concept. It was threatened on the secular side by those of a Malthusian bent who saw it as useless, together with believers in self-help and utilitarians who feared that charity sapped the independence of the poor leaving them dependent when they ought to be actively seeking employment. On the religious side it crossed a streak in the Puritan tradition that saw God's will in the distribution of wealth and insisted on a hard line between the deserving and the undeserving poor. (Ruskin grew fond of saying that he had to look twice before giving a penny to a beggar lest a clergyman might be looking.) Even so sympathetic a social observer as John Stuart Mill was capable of writing in regard to woman's charity work that: "She forgets that she is not free, and that the poor are; that if what they need is given to them unearned, they cannot be compelled to earn it."[59] Granting Mill's legal point as true and well taken as regards women of the prosperous classes, one wonders how many of the poor (male and female?) would have exchanged their compulsory freedom for the constraints of adequate food, clothing, and shelter.

When Ruskin's father died in 1864 he left £120,000 and property worth £10,000 more to a son who realized that the wealth was the result of what defenders of the current economic system liked to call:

> "a mutually benificent partnership," with certain labourers in Spain. These labourers produced from the earth annually a certain number of bottles of wine. These productions were sold by my father and his partners, who kept nine-tenths, or thereabouts, of the price themselves, and gave one-tenth, or thereabouts, to the labourers. In which state of mutual beneficence my father and his partners naturally became rich, and the labourers as naturally remained poor. (XVII:555)

This was a debt that Ruskin intended to repay, if not retroactively to these very workers, at least to those in need. He would do so in the spirit that made Charity not simply the distribution of surplus as alms, but the chief of the three cardinal virtues of Christianity.

As it happens Ruskin soon dissipated £52,000 of his inheritance in socially approved fashion; that is, he gave £17,000 to relatives not

mentioned in his father's will, lost £15,000 more in loans to relations and, on what he assures us was the best financial advice, lost another £20,000 on "entirely safe" mortgages.[60] His manner of giving direct help was in many instances imprudent, and could be made to seem ridiculous, even at times in his own eyes. It subjected him to endless appeals for aid. In retrospect his support of such major artists as Rossetti and Burne-Jones seems perfectly sensible, though it calls attention to his failure to help the admittedly prickly Ford Maddox Brown. The numerous copyists he employed created less the legacy to future generations he intended than a picture of the taste and methods of his own time—a record nevertheless worth having and a boon to the artists involved. Ruskin supported not only immediate servants but the families of his Alpine guides, Venetian gondoliers, and many more scattered through Europe. The gifts administered through his temporary factotum C. A. Howells and later assistants range from the anonymous gift of a pet bird to a child he had seen admiring it, to benefactions that could change the course of a life, such as the arrangements for a pauper boy's education. Though largely unrecorded, these acts may well be thought "that best portion of a good man's life. / His little, nameless, unremembered, acts, / Of kindness and of love."

When, of course, the seed of charity is broadcast on fertile ground and the generosity fully justified by its consequences, the extraordinary nature of the original act may well be obscured. Ruskin's relationship with Octavia Hill shows both his social ideas in action and his view of the role of women outside the home.

Octavia Hill's father made and lost two fortunes through no fault of his own in the virtually unregulated world of Victorian banking and commodity trading. His second bankruptcy, when Octavia was only two, precipitated a breakdown that rendered him incapable of work, and the women of the family, as was often the case in such circumstances, provided its meager income from that time forward. Thus, Octavia Hill, daughter of a businessman of progressive ideas and granddaughter on her mother's side of Dr. Thomas Southwood Smith, the sanitarian reformer, despite her middle-class background, was raised to work. Ruskin met her in 1853. She was supposed to be the artistic one of the family, and Ruskin offered to pay her as she learned to draw. Since she showed sufficient talent, he supplemented the £26 a year she earned as secretary to F. D. Maurice's Working Women's College (her religious beliefs were deeply Maurician) with commissions for copies of paintings and drawings, a few of which he used for illustrations in the last volume

of *Modern Painters*. Ruskin's words to her when he offered to support
her art study distinguished true charity from the kind of alms giving
that creates guilt and dependence: "You have power, you must be
given the means to use it. . . . I have been given means; take some of
them, live, set your mind at ease. But don't think I am doing you a
personal favour. . . . I am but carrying on the work I was sent to do. I
work for other generations. I work a great deal by educating other
workers; for personal selfish gratification."[61]

Octavia's power, Ruskin came to realize, was not primarily artistic.
When Ruskin's father died he asked her to what service his inheri-
tance might best be put. The answer was housing for the poor.
Ruskin challenged her to produce a practicable scheme that would
prove that provision of decent housing for the poor could be made to
pay. She did so and Ruskin agreed to finance her venture, advancing
an initial £1500 and adding another £1500 after the project got
under way. This was an enormous sum of money to entrust to some-
one twenty-six years of age whose business background was essen-
tially secretaryship of a school and the sale of toys produced by the
women's workshop. It was, moreover, put directly into the control of
a woman, and a woman of neither high rank nor of means, at that.
These circumstances were so startling that the first transactions had
to be handled through a friendly lawyer armed with special letters of
reference from Ruskin to allay suspicion both as to the source of the
money and the intent of the purchases. Octavia Hill proved a mod-
ern heroine such as Ruskin had called for. She made direct contact
with the tenants, collecting rents in person down alleyways where the
police only dared patrol in pairs. She and her sisters worked for and
with the tenants with their own hands and, as the rent accumulated,
fulfilled the promise of putting money back into improvement of the
dwellings.

The power of ladyhood, of Ruskinian queenship, involved, of
course, deference to Octavia Hill's class, not merely her per-
son—something that is bound to make anyone with an egalitarian
outlook uneasy. Such deference, is, however, part of the history of
the time and clearly demonstrates that Ruskin knew whereof he
spoke when he said that women of the middle and upper classes had
a power over the lives of others that existed whether they used it for
good or for ill. As donations from other sources flowed in and more
houses were acquired, the call for volunteers went out and young
women responded. (Octavia's sister, Miranda, began to call her St.
Ursula.) They were trained in Miss Hill's combination of real estate
management and social work. In fact, Octavia Hill's organization

became a training ground for many remarkable women now re-membered for their contributions in other areas. They included Emma Cons and her niece Lillian Baylis, whose entertainments for the poor of the Hill organization courts became the Old Vic; the Misses Potter, including the future Beatrice Webb, and Elizabeth Haldane, who at a restless and discontented twenty-one was recom-mended to Octavia Hill and promptly dispatched to Edinburgh with responsibility for establishing Hill methods there. Thus began a dis-tinguished career in public service interspersed with collaborative translations of Hegel and Descartes, a life of Descartes, and other works.[62]

It was Ruskin's hope to demonstrate that the poor would respond positively to management of their housing that maintained the prop-erty and demonstrated interest in their welfare, and that this demon-stration in turn would lead to a publicly financed housing program. This is, in effect, what happened, but it was an end Octavia Hill her-self opposed. Her work and her forceful accounts of it in magazine articles[63] paved the way for the Artisan's Dwellings Act of 1875, which in retrospect proved a first step on the road to public housing, but in itself belongs to the era of private development. She never lost faith in the methods that reflected her own history: self reliance, pri-vate philanthropy, largely volunteer help, and public spirited man-agement (at 5 percent). Nevertheless, she did prove that a class of the poor only one step above vagrants and criminals could respond to efforts made on their behalf. The paradox of the achievements of Octavia Hill and those like her in the late nineteenth century has been well summed up by David Owen:

> It was charitable and public-spirited individuals who first ex-posed the hideous squalor of the slums and who founded or-ganizations to improve the dwellings of the working classes. In the course of it, they accumulated a fund of experience on which statutory authorities have drawn, to the immense ben-efit of public housing projects. But it is also true that their rela-tive impotence in the face of a complex and vast problem offered an irrefutable argument for responsible action by the State.[64]

Through her work in housing and in the founding of the Com-mons Preservation Society, the Kryle Society, and the National Trust—all Ruskinian activities that the reputation she established in the housing work made possible—Octavia Hill provided an example

of the power Ruskin saw as potential in women. She was also a model of the kind of influence Ruskin hoped to have in general, an influence not over the course of legislation, but over the active lives of people engaged in the amelioration of social problems.

> You are beginning to hear something of what Miss Hill has done in Marylebone, and of the change brought about by her energy and good sense in the centre of one of the worst districts of London. It is difficult enough, I admit, to find a woman of average sense and tenderness enough to be able for such work; but there are, indeed, other such in the world, only three-fourths of them now get lost in pious lecturing, or altar-cloth sewing; and the wisest remaining fourth stay at home as quiet house-wives, not seeing their way to wider action. . . .
>
> But the best that can be done in this way will be useless ultimately, unless the deep source of the misery be cut off. (XXVII:175-76)

Although he hoped landlords would follow the model he set through Octavia Hill, Ruskin saw such efforts as palliatives. He found ever less hope in the efforts to deal with the deep source of the misery in the cities and turned his attention in his late years to the redemption of rural land and people.

His Own Hero

> I want to lead strongly now, in this Fors movement, for I see it must be done, not said.
> Ruskin to Carlyle, July 17, 1874

NOT SURPRISINGLY RUSKIN saw his appointment as the first Slade Professor of Art at Oxford in 1869 as a new opportunity to extend his influence. He wrote his mother immediately upon hearing of his appointment that "it will enable me to obtain attention, and attention is all that I want to enable me to say what is entirely useful instead of what is merely pretty or entertaining." Four days later, however, he was writing to his friend and champion at Oxford, Henry Acland, that the Doctor will be surprised at how he will "avoid saying anything *with the University authority* which may be questionable by, or offensive to, even persons who know little of my subject, and at the

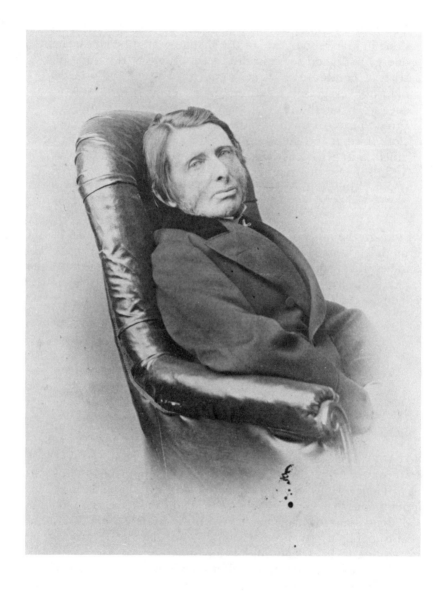

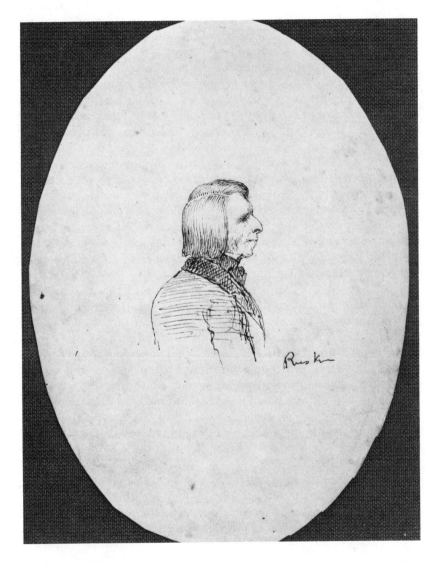

Ruskin in the 1870s as seen through the lens of Lewis Carroll
and in self-caricature.

generally quiet tone to which I shall reduce myself in all public duty" (XIX: lix, XX: xix-xx; italics mine). In 1866 when Carlyle proposed that Ruskin and Froude join him in founding a journal to oppose modern trends in politics, philosophy, and literature, Ruskin had been cool to the idea.[65] Now however, Ruskin saw that he could capitalize upon the prestige of his appointment in order to say what he thought was useful and still, as best as he was able, keep his promise to Acland, by complementing his university lectures with a separate, popular forum for the presentation of his more controversial views. His own forum would not be restricted by the proprieties of professorship, the pressure of subscribers and publishers, or even the constraints of commercial publication. He would follow in the footsteps of Dr. Johnson and, more closely, Coleridge, and produce his own periodical.

Ruskin watched the press for reports of his appointment and his lectures and, as he seems to have anticipated, accounts of his activities began to appear in the news and feature pages of the papers and periodicals as well as the book review columns. Additional encouragement to proceed with his publication came with the receipt in the summer of 1870 of a series of articles by Joseph Lawton, then the editor of a small, virtually one-man newspaper in Shropshire, who was writing Ruskinian pieces on the condition of the working class and related social issues.[66] Lawton's success must have reinforced Ruskin's decision to handle the publication and distribution of his journal himself through the agency of his former pupil at the Working Men's College, George Allen. Thus *Fors Clavigera* became at one and the same time a platform for Ruskin's views and a demonstration of his methods of doing business. The business arrangement, eventually expanded to all Ruskin's books, was at first sale at a fixed price to all comers (which had the initial effect of retarding sales), but in 1882 Ruskin made provision for a fixed discount to the trade. His experiment became the model of the "net book system" and guaranteed Ruskin a considerable income for the rest of his life (XXVII: lxxxii ff).

Perhaps only Ruskin in all the world would have combined the launching of a propaganda effort with a scheme that, however justified in the long run, had the immediate effect of limiting distribution of his work. And yet, in a curious way, the difficulty in getting copies of *Fors* may have contributed to its influence. It was quoted, usually negatively, in the papers, but part of the effect was to spread Ruskin's more inflammatory phrases to those disposed to be sympathetic.

Fors was addressed to "The Workmen and Labourers of Great Britain" and from Ruskin's time to our own he has been accused of addressing a working-class audience over its collective head. But not only is Ruskin's definition of workmen quite broad, taking in such men as Thomas Dixon, the accusation is in fact an insult to those workmen who against great odds managed to acquire an education. Some workers, as he knew from personal testimony, had sought that education in part for the purpose of reading Ruskin.

> Be it admitted, for argument's sake, that this way of writing, which is easy to me, and which most educated persons can easily understand, *is* very much above your level. I want to know why it is assumed so quietly that your brains must always be at a low level. . . . For my own part, I cannot at all understand why well-educated people should still so habitually speak of you as beneath their level, and needing to be written down to, with condescending simplicity, as flat-foreheaded creatures of another race, unredeemable by any Darwinism. (XXVII:181-82)

Ruskin's audience is not simply the laborer as he is, but as he might be—as reading the letter might help make him (XXVII:669).

Ruskin's apocalyptic tone, his denunciation of the capitalists, his urging of the workmen to reclaim the wealth they create became, when abstracted from their context, a marvelous rhetorical weapon for socialist labor leaders.

> "The wealth of the world is yours; even your common rant and rabble of economists tell you that: 'no wealth without industry.' Who robs you of it, then, or beguiles you? Whose fault is it, you cloth makers, that any English child is in rags? Whose fault is it, you shoe-makers, that the street harlots mince in high-heeled shoes and your own babies paddle bare-footed in the street slime? Whose fault is it you bronzed husbandman, that through all your furrowed England, children are dying of famine?"
> Many hundreds of times I made some portion of the above [the eighty-ninth *Fors*] serve as a text for my speech.[67]

Quotation by labor leaders like Tom Mann certainly spread Ruskin's reputation as a champion of the working man, albeit to ends Ruskin himself never endorsed. When William Morris began speaking as a socialist he was surprised to find such hearty feelings toward John

Ruskin among working-class audiences: "They can see the prophet in him rather than the fantastic rhetorician" (23:202). Morris always insisted to socialist intellectuals like Belford Bax who were scornful of Ruskin that he had made many socialists—one of them being, in part, Morris himself.

Ruskin's own propaganda aims were threefold. First, through *Fors* and through direct contact with his Oxford students Ruskin hoped to popularize his economic views. In this he largely succeeded. The arguments that had seemed so outrageous at the height of mid-Victorian prosperity fell on more sympathetic ears during the "Great Depression" of 1873-1886.[68] Ruskin developed a set of followers at Oxford that would have been unlikely a decade earlier. A group of socially concerned students joined him for discussions in his rooms and in 1874 carried out his most notorious demonstration of the dignity of manual labor, the construction of the road to Ferry Hincksey. Ridicule and lively replies appeared through the whole spectrum of the English press. Ruskin's defenders ranged from his old friend Dr. Acland, who wrote a spirited letter to the *Times*, to Mr. Punch: "The truth he has writ in *The Stones of Venice*/May be taught by the Stones of Hincksey too" (XX: xliii-xliv). The approval Ruskin must have treasured most however, came from Carlyle:

> I have heard a great deal also about your volunteer "young gentlemen, delvers & diggers" now busy about Oxford; really a most miraculous thing; such as was seen for long ages of the influence of an earnest man upon earnest youths at which even the penny-a-liner pauses for a moment uncertain what to say or do.[69]

The best efforts of the Oxford men and Ruskin's invaluable gardener-foreman, David Downs, were not sufficient to make a very useful road, but it was wonderful propaganda. One could not oppose what Ruskin was attempting without tacitly admitting a contempt for manual labor and the laborer. Enthusiastic disciples like his future editor Alexander Wedderburn kept Ruskin in touch with developments at Oxford when he was in London: "Perpetual visitors yesterday, chiefly, Ned [Burne-Jones] and Morris, and Wedderburn, who made me very happy by telling me I was gaining influence with the men, and repeating the end of [the] second chapter of *Unto this last*, by heart" (D:845, May 18, 1875). Sales of *Unto This Last* grew steadily into this century.

In addition to spreading his economic views, *Fors* was to continue

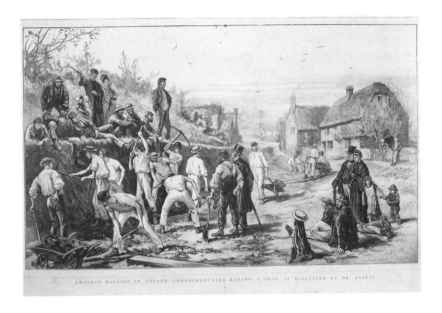

The Hincksey Dig as represented in *The Graphic*, June 27, 1874.

Ruskin's description of the ideal English social order begun in *Munera Pulveris* (which in 1872 he finally issued in book form) and *Time and Tide*—a social order in accord with what Ruskin, like Carlyle before him, saw as natural laws of social organization. Finally, Ruskin hoped to gather a group of contributors to a St. George's Fund for the purpose of eventually taking, through a St. George's Company, some first steps toward the realization of that renewed social order.

Fors Clavigera is Ruskin's most remarkable literary production. It is a work of such astonishing immediacy that Cardinal Manning compared it to "the beating of one's heart in a nightmare" (XXXVI: lxxxvi). The immediacy is in part a perfection of the informal epistolary style worked out in *Time and Tide*, in part a product of Ruskin's very discursiveness, which creates as perfect an *impression* of the movement of a mind and response of a sensibility to events and surroundings as can be found outside of stream-of-consciousness fiction. I stress *impression* because the letters are not simply confessional. Unlike Ruskin's personal letters, almost everything mentioned in a

Fors epistle has either a didactic function or forms part of a special appeal. Even the passages that are transposed from *Fors* into *Praeterita* in virtually the same words are largely transformed by their context. Thus in *Praeterita* Ruskin's account of his father's business partners, and of the pleasures of posting in Mr. Telford's chariot, is a charming remembrance of things past, an evocation of a leisurely mode of travel now superseded, an account of the effects of early scenes so visited on Ruskin's mind. In *Fors*, however, the passage goes on to enumerate seven classes of men, past and present, from vineyard peasant to castle stonemason, whose labor, but meagerly rewarded, made such luxurious travel possible. With the marvelous mocking wit he so often displays in *Fors* he imagines these dependents as passengers on the Ruskin carriage, carried on the backmost seat (the dickey) as his nurse used to be, as if they rode by leave of the wealthy and not the other way round.

> And it never once entered the head of any aristocratic person,—nor would ever have entered mine, I suppose, unless I had "the most analytical mind in Europe,"—that, in verity it was not I who fed my nurse, but my nurse me; and that a great part of the world had been literally put behind me as a dickey,—and all the aforesaid inhabitants of it, somehow, appointed to be nothing but my nurses; the beautiful product intended, by papa and mama, being—a Bishop, who should graciously overlook these tribes of inferior beings, and instruct their ignorance in the way of their soul's salvation. (*Fors* 56, XXVIII:393-94 and *Praeterita*, XXXV:26 ff)

The very title *Fors Clavigera*—Fors by turns Force, Fortitude, or Fate bearing in its different manifestations the club of Hercules, the key of Patience, the iron nails of Necessity[70]—is expressive of the unwilling fatalism that was Ruskin's lot in consequence of his loss of faith and the vicissitudes of his relation to Rose La Touche. Ruskin began *Fors* with a fixed set of mind and firm convictions (facts, he called them), but no set program. He knew only that he could not in good conscience continue his life and work in other areas without doing what he could to communicate and apply his principles. Consequently, the Third Fors, or Fate, proves more than just the title of the work, but a key to its contents and the actions undertaken in the name of St. George.

Fors is in good measure a journey through the labyrinth of Ruskin's own consciousness. He sets down his ideas, traces their evolution,

gives brief lives and fragments of wisdom from such of his teachers as Scott and Marmontel. It verges into autobiography and accounts of his movements and occupations that we may know and trust him the more. But a good deal of the material comes to him in the form of contemporary events—items quoted from the newspapers, letters from readers, immediate experiences. Time and again he tells us that the Third Fors has brought him the material he requires to prove his point just as he needed it[71] : "I have indeed directed my own thoughts, and endeavoured to direct yours, perseveringly, throughout these letters, though to each point as the Third Fors might dictate; that is to say, as light was thrown upon it in my mind by what might be publicly taking place at the time, or by any incident happening to me personally" (XXVII:382). Ruskin's submission to what he called the Third Fors accounts for much of the waywardness and much of the fascination of the letters as from the first Ruskin's constant convictions encounter random events triggering embedding within embedding.

Fors Clavigera was to be a vehicle for the bringing together of people of good will from all classes of society for the purposes outlined at the end of "The Mystery of Life and Its Arts": feeding people, dressing people, lodging people and "pleasing people, with arts, or sciences, or any other subject of thought" (XVIII: 182). But as the Third Fors would have it, the early numbers of the new venture coincided with the Prussian siege of Paris, the rise and fall of the Paris Commune, and the birth throes of yet another French Republic, this time to replace the sorry empire of the third Napoleon for whom Ruskin, like his friend Elizabeth Barrett Browning, once entertained hopes. (Napoleon's "Caesarian Democracy" was, in theory at least, the kind of elective authoritarianism Ruskin favored, his political ideal being the medieval doges of Venice.)

In the early months of 1871 the events in France filled the newspapers. The illustrated weeklies depicted the militant women of Montmartre as Carlyle's "Insurrection of Woman," the "menad march" reborn, and recoiled in horror.[72] Ruskin himself was serving with other distinguished citizens on the Paris Relief Committee to collect food for starving Parisians. The history of the Commune was so dominant a concern and so potent an example of what Ruskin feared would come to pass in England that comment on it and his view of its underlying cause were inevitably worked into the exposition of what he hoped might be done to prevent a like occurrence in England. Thus, *Fors* began its wandering way.

Even more than most Englishmen, Ruskin was prone to read

French revolutions through Carlylean spectacles as portents of the probable future of an unregenerate England. (In fact, Ruskin had recently reread *The French Revolution* while preparing his first series of Oxford lectures.) Ruskin saw war and revolution as the logical outcome of the social, scientific, and economic trends of his century. To him the destructiveness of the German assault on Paris was a direct result of the application of modern science to warfare. The impersonal nature of the artillery bombardment of civilian targets was the natural outcome of a science that had turned from the study of aspects, purposes, and meanings to the exclusive study of underlying structures. The consequences of modern atomistic thought in the study of living creatures was to reduce them first to dead things, a process Ruskin thought both unnecessarily destructive of the objects of study and ultimately dehumanizing for the scientist and the society in which he labored.

Like Carlyle before and Morris after him, he saw society being progressively broken apart by capitalism into warring camps of capital and labor. The capitalists, having all power save that of numbers, were functionally brigands rather than the knightly merchants Ruskin called for. The rise and fall of the Commune in France merely made overt and explicit what was implicitly true in England. But Ruskin's intense sympathy with the suffering people of Paris was never an endorsement of the aims of the Commune. In fact the newspaper caricatures of "ouvrier" and "pertroleuse" were so perfectly suited to his rhetorical purpose *and*, strangely enough, to what is genuinely radical in his understanding of the Commune, that he did not question them. Ruskin's radicalism takes Carlyle's turn. It lies in the fact that he places blame for the Paris uprising on the classes that so oppressed the poor as to drive them to revolt: the "Swine of the five per cent" (XXVII:138). Just as he implies that as a professor of art he has stake in the fate of the pictures in the Louvre, so do all members of the offending classes share blame for what has transpired in Paris whether they be French or English.

Ruskin sets the analysis of the events in Paris in the context of three papers, May, June, and July, under the aegis of three figures taken from Giotto and placed as the frontispieces to these issues. They are in deliberate sequence: Faith, *Envy*, and Charity. In May, the month of Faith, Ruskin makes his offer of a tithe of his wealth to begin what became St. George's Guild. In June, under the shadow of Envy, he explains that the cruelty in Paris has "been done by the kindest of us, and the most honourable" who worship "Covetousness, lady of Competition and of deadly Care." That people should be blown into

Elysium from a paved-over Champs Elysees, that the Tuileries
should become another kind of potter's field, that the Grenier d'A-
bondance should be burned along with the Louvre—grain and art
being Ruskin's two principle models of wealth—these are to Ruskin
the signs of the times. Report of the destruction of the Louvre
proved false, but Ruskin let it stand in its symbolic truth, adding in
the July *Fors* under the aegis of Dante's Charity, "so red of hue /
She'd scarce be noticed in the furnace flame,"[73] that:

> I am myself a Communist of the old school—reddest also of
> the red; and was on the very point of saying so at the end of
> my last letter; only the telegram about the Louvre's being on
> fire stopped me. . . . For we Communists of the old school
> think that our property belongs to everybody, and everybody's
> property to us; so of course I thought the Louvre belonged to
> me as much as to the Parisians, and expected they would have
> sent word over to me, being an Art Professor, to ask whether I
> wanted it burnt down. (XXVII:116)

Communism of the old school proves to be that of Lycurgus and
Theseus and Horace and Sir Thomas More; Ruskin's redness, that of
Charity. Through Ruskin's allusions to literature and art, his refer-
ences to contemporary and historical events, his puns, his derivations
and divagations, the picture emerges of Ruskinian communism. In
Ruskin's communist state there would be common wealth more
stately and richly endowed than "singular" wealth; rich public build-
ings, simple private ones; common (universal) labor and refresh-
ment—all themes developed in Morris's *News from Nowhere*. His
"dark-red Communists" who exist in giving, hate all thieving. Like
Carlyle and Morris, Ruskin preferred, if theft there be, the overt
theft and direct violence of medieval warfare as described by
Froissart to the modern "Occult theft" of the capitalists: "people who
live by percentages of the labour of others; instead of by fair wages
for their own. The *Real* war in Europe, of which this fighting in Paris
is the Inauguration, is between these and the workman, such as these
have made him. They have kept him poor, ignorant, and sinful that
they might, without his knowledge, gather for themselves the pro-
duce of his toil . . . and such as they have made him he meets them,
and *will* meet" (XXVII:127).

Against this striking prophecy of class rather than national warfare
Ruskin sets his hopes for cooperation declaring: "Utopia and its ben-
ediction are probable and simple things, compared to the Kakotopia

and its curse, which we had seen actually fulfilled" (XXVII:144). The commonwealth must begin with individual moral responsibility as expressed within the basic social unit of the family, then directed outward. Unlike Morris, who could freely accept the revolutionary slogan of liberty, equality, and fraternity, Ruskin could endorse only fraternity, which to him always implied paternity, benevolent authority (XVI:24).

Given Ruskin's sympathy for the suffering of the poor, his desire to redistribute wealth so as to provide everyone with the necessities of life, his hatred of the capitalist as the destroyer of man, nature, and art, it is natural to expect that an event like the Paris Commune would have forced Ruskin to choose sides. Thus Ruskin's irony has been disregarded and the July *Fors* read as the story of how Ruskin was stirred to momentary sympathy by the Communards only to lose heart at the threat to the Louvre and its art.[74] But Ruskin hardly expected the workers of Paris in their extremity to consult the Slade Professor before burning the Louvre.

To Ruskin the Commune did not present itself as an occasion for simply choosing sides. He was trying to combat the "Lord of Decomposition, the old Dragon himself," conducting "St. George's war, with a princess to save and win." In social terms that dragon is class warfare itself and its causes, not just the capitalists. Ignored by those who held real economic and social power—even by the individual readers he hoped to rally to his cause ("no one answers")—Ruskin felt increasingly condemned to wage a war for reconstruction he knew in his heart he could not win. His "definite dragon turned into indefinite cuttlefish, vomiting black venom into the waters of [his] life" (XXVII:293).

Written in the double awareness of necessity and impossibility, and against the backdrop of personal anguish—chiefly over Rose La Touche who was to have been the Princess Sabra to his St. George—*Fors* evolved in two incompatible modes: romance and irony. The progress Ruskin imagines when he projects it on the grand scale is the reverse of that of Tennyson's *Idylls of the King*. Tennyson depicts a parodic reversal of the scheme of romance, a fall from harmonious order built on trust and the imitation of perfected humanity ("The King will follow Christ, and we the King") into every form of infidelity. It is a fall from Arthur's to "Mark's way," from battle in the perfect clarity of a spring in which each feature of the landscape as well as friend and foe remain distinct, to that last battle in the mist of midwinter wherein "friend slew friend not knowing whom he slew"—the chivalric equivalent of Ruskin's picture of the

Victorian commercial ethos, the war of each against all.[76] Ruskin, influenced both by Christian patterns of type and imitation and Carlyle's concept of hero worship calls not merely for adherence to certain values in the abstract but for their personification. Only so can people who have been, despite themselves, pitted against one another be led into the paths of peace.

In projecting his social romance Ruskin applies the lessons of the masters of the past to present problems, polarizes good and evil, holds out the possibility of establishing justice through a fusion of human and natural order. As once men followed Sir John Hawkwood in "wise stealing" and that "son of St. George," Robert, Count of Flanders, in "setting the world to rights" by the sword, so might the same imitation of the brave and just be inspired by the giving of money away and, in true fulfillment of the type of St. George, by the beating of swords into plowshares in heroic husbandry and agriculture. If an English gentleman willing to preserve his mountain ground wild and give a few acres of fields over to human labor without steam, according to Ruskin's prescription, would do so, and "if, seeing the result of doing so much, he felt inclined to do more, field may add itself to field, cottage rise after cottage,—here and there the sky begin to open again above us, and the rivers to run pure. . . . girls will be taught to cook, boys to plough, and both to behave; and that with the heart" (XXVIII:237).

But the world romance must transform is at once hideous and intractable. Sometimes Ruskin surrounds reports of it with his own prose, but in this letter he simply appends an article from the *Daily Telegraph* to show what presently goes on in the fields.

> Two out of a party of young colliers coming from work found [the drunken tramp-woman] lying there, and they led her into a field. They then sent a boy named Slater to fetch the remaining eight. . . . two of them certainly, and others of the number in all probability, outraged the hapless creature, leaving her after this infernal treatment in such plight that next day she was found lying dead in the field. . . .
>
> 'Do you mean to tell me you did not think there was something wrong in outraging a drunken woman?'—'She never said nothing.' (XXVIII:251-52)

In *Modern Painters V* Ruskin had demythologized the picturesque by setting word pictures of an ideal Highland glen against a close-up revealing deathly detail, the bird picked carcass of a sheep

introducing a conversation with a Highlander reduced to bonepick-
ing (VII:168-71). In *Fors* Ruskin's ironic mode measures the ideal
against the actual yet more starkly whether, as here, by simple juxta-
position or in relation to his own efforts to effect practical change.
Unlike Dickens, who at the end of *Bleak House* presents a transforma-
tion of the "realistic" world of his omniscient narrator as a social pos-
sibility to the degree that it is enclosed by the romance realm of his
Queen Esther, Ruskin measures his effectiveness in terms of actual
social results, the actual transformation, to whatever degree, of the
outside world. Ironic juxtaposition and comment undercut the ro-
mance and issue in bitter mockery. Ruskin rarely completed a *Fors*
letter in a single mode.

Ruskin habitually presents such demonstration projects as his ef-
fort to keep a St. Giles street swept clean and to establish Mr.
Ruskin's Tea Shop in a self-deprecating manner. The tea shop was
to refuse to profit on subdivision and thereby offer small packets at
below the usual price, but was not prospering, Ruskin said, because it
took him months to design a proper sign. In the end his irony turns
and he presents himself not as a ditherer but as one of the few re-
maining human beings: "In the midst of this yelping, carnivorous
crowd, mad for money and lust, tearing each other to pieces, and
starving each other to death, and leaving heaps of their dung and
ponds of their spittle on every palace floor and altar stone,—it is
impossible for us, except in the labour of our hands, not to go mad
(XXVIII:207).

The only people who can survive in this world are pigs in spirit,
having what Leslie Stephen in criticism of *Fors* called the "greatest of
all blessings": "a thick skin and a good digestion." This porcine world
Ruskin then sets against the ideal "poorest farm" of the St. George's
Company (XXVIII:210). Although the irony turns on those who refuse
to see that streets can indeed be kept clean and good tea offered at a
fair price whether or not the shop has a gas-lit sign, the fact that
Ruskin initially presents his projects as failures of his own judgment
almost invariably colors discussion of them, all the more in that
Ruskin did, four years later, go mad. Had the tea shop been pre-
sented directly as what it was (a kindly way after his mother's death of
pensioning two of her superannuated servants and by the way con-
ducting a commercial experiment) it would not have been so persis-
tently tied to Ruskin's mental instability. It is not even certain that
the shop was an absolute failure commercially. Ruskin maintained
the shop until one of the servants died. Thereafter a tea shop pros-
pered on the site, but we don't know if it was conducted on Ruskin's

principles.[77] Ruskin's submission to the Third Fors and his double mode of composition make the best *Fors* letters powerful expressions of his unique point of view, but often bewildering propaganda. The rhetorical complexity of the letters led to confusion on the part of well-meaning readers anxious to learn what, specifically, to do; to confusion between what Ruskin hoped might eventually come of his work and the step he had immediately in mind. To those who took his abuse of railroads so literally as to abjure them personally and suspect him of inconsistency for using them, Ruskin impatiently replied that when necessary he was perfectly willing to *construct* a railroad. "The wisdom of life is in preventing all the evil we can; and using what is inevitable, to the best purpose" (XXVIII:247). The problem was exacerbated by the fact that Ruskin's move to direct action coincided with the foreshadowing and onset of his mental breakdown. The underlying pattern of bipolar swings in mood between depression and elation, relative (for him) inactivity and creative bursts, which in a subclinical form was lifelong, grew in the late 1870s into full-blown manic-depression. As the late 1870s pass, Ruskin's turn from topic to topic in *Fors* becomes increasingly kaleidoscopic, a brilliant literary improvisation; though always serious in purpose, a kind of pantomime or *commedia dell'arte* in prose. To readers who thought he wrote merely in jest he replied: "if I took off the Harlequin's mask for a moment, you would say I was simply mad" (February 1876, XXVIII:513). He told himself: "must write *Fors to get things out of my head*" (D:951).

Looking back on eighty issues of *Fors,* Ruskin explained that:

> *Fors is a letter,* and written as a letter should be written, frankly, and as the mood, or topic, chances. . . . True, the play of it (and much of it is a kind of bitter play) has always . . . as stern final purpose as Morgiana's dance [in "Ali Baba and the Forty Thieves"]; but the gesture of the moment must be as the humour takes me.[78] (XXIX:197)

The oppositions at the core of Ruskin's thought underlie the variety of *Fors* informing even those passages in 1876 and thereafter so personal as to preclude public understanding.

> All up and down my later books, from *Unto this Last* to *Eagle's Nest,* and again and again throughout *Fors,* you will find references to the practical connection between physical and spiritual light—of which now I would fain state . . . this sum: that

As the St. George of art Ruskin defends the Lady of the Lake
District against the incursions of the railways in the pages of
Punch, February 5, 1875.

you cannot love the real sun, that is to say physical light and
colour, rightly, unless you love the spiritual sun, that is to say
justice and truth, rightly. That for unjust and untrue persons,
there is no real joy in physical light, so that they don't even
know what the word means. That the entire system of modern
life is so corrupted with the ghastliest forms of injustice and
untruth, carried to the point of not recognizing themselves as
either—for as long as Bill Sykes knows that he is a robber, and
Jeremy Diddler that he is a rascal, there is still some of Heav-
en's light left for both—but when everybody steals, cheats, and
goes to church, complacently, and the light of their whole
body is darkness, how great is that darkness! And that the
physical result of that mental vileness is a total carelessness of
the beauty of sky, or the cleanness of streams, or the life of

animals and flowers: and I believe that the powers of Nature
are depressed or perverted together with the Spirit of Man;
and therefore that conditions of storm and of physical dark-
ness, such as never were before in Christian times, are devel-
oping themselves, in connection also with forms of loathsome
insanity, multiplying through the whole genesis of modern
brains. (XXVIII:614)

Here in summary form is Ruskin's central myth, his expression of
the natural unity of physical and moral laws and his personal trans-
formation of the age-old opposition between light and darkness.
The text on which Ruskin builds is Matthew 6:22-23, but the opposi-
tion draws upon his classical inheritance as well. "The light of the
body is the eye: if therefore thine eye be single, thy whole body shall
be full of light. But if thine eye be evil, thy whole body shall be full of
darkness. If therefore the light that is in thee be darkness, how great
is that darkness!"

It follows that a system built upon the dual exploitation of nature
and of workers should produce an illth, the "Storm Cloud of the
Nineteenth Century," that obscures the sun that is the source of life,
which is wealth. The very fact that we retain the word *pollution* in this
context indicates that we still feel a river of sewage or a dead lake to
be a perversion of the powers of nature. As for the insanity to which
he alludes, Ruskin's chief example was the arms race that fed the
Woolwich Infant (a 35-ton gun) while Wapping infants starved, and
that was to issue in the loathsome carnage in the trenches in World
War I, bringing to an end that upper-class way of life that often
seems to us, as it did to Ruskin, to be "the great Picnic Party"
(XXVII:43,41).

Ruskin advanced in place of the "Picnic Party" his "first principle of
all human economy—individual or political—to live, namely, with as
few wants as possible, and to waste nothing of what is given you to
supply them" (XVII:424) —sentiments that have gained a new cur-
rency. Ruskin's conviction that the industrial economy, in contraven-
tion of his principle, rested on a dual exploitation of nature and
mankind also has its modern echo is such works as *The Closing Circle*.

> The environmental crisis is somber evidence of an insidious
> fraud hidden in the vaunted productivity and wealth of mod-
> ern, technology-based society. This wealth has been gained by
> rapid short-term exploitation of the environmental system,
> but it has blindly accumulated a debt to nature . . . so large and

so pervasive that in the next generation it may, if unpaid, wipe out most of the wealth it has gained us.[79]

Having failed to convice others to live by his principles of human economy, Ruskin determined to describe the ideal polity that would incorporate them and to create an earthly approximation of it. Both bear the name of the Guild of St. George. Although Ruskin's editors index the heavenly Guild and its mundane counterpart separately, they are inextricably entwined in *Fors*. Ruskin's Guild was to demonstrate the creation of wealth and a national store instead of illth and a national debt. He imagined veteran soldiers leading an army of the unemployed to work the land and so provide everyone with the necessities of life.

Carlyle responded enthusiastically to the rhetoric of *Fors*. He quoted one of Ruskin's assaults on Liberalism in his *Early Kings of Norway* (XXVII:247) and said of the fifth letter: "Every word of it is as if spoken, not out of my poor heart only, but out of the eternal skies *Continue*, while you have such utterances in you to give them voice. They will find and force entrance into human hearts, *whatever* the "angle of incidence" may be" (XXVII: lxxxvi).

No doubt Ruskin's evocation of a pastoral land without liberty appealed to Carlyle, but the fifth *Fors* is precisely the issue in which Ruskin proposed to bring St. George's Company down from "the eternal skies" by endowing it with a tenth of his fortune. Carlyle did not care to recognize in the Guild itself "Carlyle's grander exhortation to the English landholders in *Past and Present*" (XXX:95). William Allingham recalls him coupling his admiration for Ruskin's "celestial brightness" with the remark: "The St. George's Company is utterly absurd. I thought it was a joke at first."[80] But the very fact that Carlyle's own words, no matter how loudly he shouted them and regardless of their "angle of incidence" had not had the desired effect, coupled with the failure of his own words to make any palpable change among those who held social and economic power, made Ruskin determined to act. His private life in near ruins, he would try to be the hero he and Carlyle had called for, however uncomfortable he felt in the role.

Despite Carlyle's dismissive remark, the Guild for all its medieval trappings did not look as absurd in its own time as it does today. The fact that two men of such wide public reputation and established political success as Sir Thomas Dyke Acland and Mr. Cowper-Temple (who was Lord Palmerston's stepson and, among other posts, had been parliamentary secretary to Lord Melbourne, president of the

Board of Health, and first commissioner at the Office of Works) should have agreed to serve as the Guild's trustees suggests that there was nothing prima facie insane about Ruskin's proposal. Although both men had personal ties to Ruskin, political leaders have never cared for ridicule. In fact the whole Guild scheme fits quite neatly with other aspects of the utopian "Rustic Vision" discussed by W. H. B. Armytage in *Heavens Below*.

Ruskin soon found that £7000 in consols would not in themselves launch a company. Obtaining the legal right for his St. George's Company to receive and administer gifts of property proved a major difficulty. The legality of even his initial tithe was questioned, and by 1875 the effort to get his Guild (he discovered that the law did not allow him the word *company*) legally established had grown so frustrating that he was forced to hire a distinguished solicitor, William Barber, in an attempt to speed approval of his scheme.[81] The attempt to legally establish a nonprofit company that nevertheless would hold and develop land was apparently unprecedented in English law and resulted in a swirl of complications to which only the creator of the Circumlocution Office could do justice. It was not until October 1878, after Ruskin's first attack of "brain fever," that the Guild was officially approved by the Board of Trade. This legal uncertainty must surely have given potential donors pause, just as knowledge of his mental state must have stayed the hands of close friends whose failure to support his venture hurt him deeply.

Ruskin knew himself to be primarily a literary and artistic man, and it was never his intention to devote himself to running an organization, though he did hope to create one and establish its rules. Ruskin demanded of his Companions a tithe (later reduced to one percent) "for the purchase of land in England to be cultivated by hand," but not that they cultivate the land themselves. They were to be "persons still following their own business, wherever they are" (XXVII:296). The same was to be true of Ruskin himself, who spent most of his effort in forming the Guild, establishing its principles, and in creating, commissioning, and gathering items for the St. George's Museum at Sheffield—doing, in short, the things he was best qualified to do.[82] Ruskin did not imagine himself as one administering a kingdom, but rather as the Master of a set of individual enterprises run on his principles that he could periodically inspect (as Prince Leopold once did the Sheffield Museum) while continuing the main pursuits of his life.

When Companion Egbert Rydings wrote to Ruskin about the plight of spinners on the Isle of Man who were being forced into the mines

for lack of a market for their yarn, Ruskin responded through the Guild with a gift to support the more destitute among them, and afterwards financed the construction of St. George's Mill, Laxey (XVIII:768). The store and water-driven mill under Mr. Ryding's management paid off its debt to the Guild and rescued the local wool industry by providing a market for the wool which was carded and then either returned for home spinning, or spun and then sold or bartered for more wool. This is the way in which the Guild was supposed to work practically in the area of industry, but there were few other instances.[83] Had Ruskin not so consistently undercut his efforts by contrasting them with his dreams, the St. George's Mill and the revival of the Langdale linen industry would be seen as genuine, if local, examples of creative social welfare that anticipate modern attempts to hold rural populations in place through application of "appropriate technologies" to existing industries.

Though the rehabilitation of waste land and the institution of a prosperous neo-Tyrolean peasantry upon it was the primary aim of the Guild, land management was something for which Ruskin knew he was unfit. It was for the occupants of the land to manage it. "[The Master's] knowledge does not qualify him, nor do the nature of his general occupations permit him, to undertake the personal direction of any farming operations, or management of any of the retainers of the Guild, in residence on their lands" (XXX:18). As one would expect, most of the land volunteered was of marginal value (a circumstance Ruskin with more bravado than good sense decided to cheer) and its development haphazard. Waste land is much more recalcitrant than brain workers like Ruskin, who relieve their mental tension by work with ax and spade, are apt to believe. No one of the ability of his former pupils at the Working Men's College, George Allen and Henry Swan,[84] aided Ruskin in his land dealings. Ruskin's insistence upon buying thirteen acres of marginal land at Totley in Derbyshire for a group of Sheffield workmen precipitated the resignation of his prestigious trustees. The poor land and the failure of the erstwhile Companions militant to produce either a practical plan of action or a forceful leader doomed the experiment that came closest to embodiment of the Guild's primary aim.

Despite the legal difficulties that delayed its birth, the Guild survived Ruskin's madness, it survived Ruskin's death and, indeed, still exists. It has never greatly expanded for a reason that can be illustrated by drawing a simple contrast with another very Ruskinian organization, the National Trust, two of whose three founders, Octavia Hill and Canon Hardwicke Rawnsley, were friends and

associates of Ruskin. Canon Rawnsley and his wife were Companions of St. George's Guild and he considered his participation in the foundation of the Trust to be work "for which again St. George is answerable."[85] The first donor of land to the Trust was Mrs. Fanny Talbot, who had also made one of the first gifts of land to the Guild of St. George. The Trust grew slowly until after World War I. The National Trust Act of 1907 which made the Trust a statutory body and gave it the power to declare its properties inalienable ultimately proved important, but did not spur any considerable wave of donations. The finance act of 1931 which exempted property given or devised to the Trust from death duties was really the key to its growth. The increases in property tax and death duties, particularly the spectacular increases after World War II, parallel the growth of the Trust from some 30,000 acres in 1931 to over 350,000 in 1968.[86]

In contrast with the National Trust, which was dedicated to preserving land and historically significant buildings and was, in effect, taxed *into* existence as it took over properties of national importance that could no longer be sustained by their owners, the Guild of St. George was dedicated to developing land, to making it productive, to increasing its economic value, and to employing people upon it. While it was not impossible that some nobleman with vast landholdings might, as Ruskin fondly hoped, have offered some potentially productive land for Ruskin's experiment, it would have been an act of pure altruism. Nor was it much more likely on the face of it that substantial numbers of even unemployed workmen would find hope in subsistence farming according to rules laid down by someone as remote from both them and the primary economic powers of the day as Ruskin.

As William Morris saw, Ruskin's economic principles implied a revolution that he was powerless to effect. He still hoped to accomplish by demonstration, preaching, and conversion what Morris believed could only come by means of a revolt by the victims of the present order. If certain of Ruskin's proposals have gained in cogency, it is because the rejection of industrialism as we have known it by nature itself has begun to seem a real probability rather than the logical, but remote, possibility it was in Ruskin's time.

Ruskin disclaimed any attempt to establish a model community under his own direction, but by the turn of the century communal experiments were being set up in his name as far away as Tennessee.[87] However remote such communities may have been in practice from the creed Ruskin wrote for the members of his Guild, such attempts to create models of a future social order within the existing

one advance social change in Ruskinian fashion. The same may be said for those who were willing, as George Thomson of Huddersfield was, to convert their businesses into cooperative enterprises without regard to the practices of the trade as a whole (XXX:333-35). (While Mr. Thomson attributes his profit-sharing scheme to Ruskin, there were a number of such experiments in England from the 1880s on.)

In the 1880s Ruskin was prepared to call upon workers to organize a society within society on their own behalf, but it was a position to which he was driven by despair over the indifference of the classes in power, not one he freely endorsed. His own call for a reorganized society, while it focused attention on what many saw as evil, increasingly bore the aspect of a private myth. It lay to his disciple, William Morris, to link Ruskin's all-embracing view of art to a hope of social revolution that was already astir, the prospect of revolution that to Carlyle and Ruskin always boded a return to Chaos and Old Night.

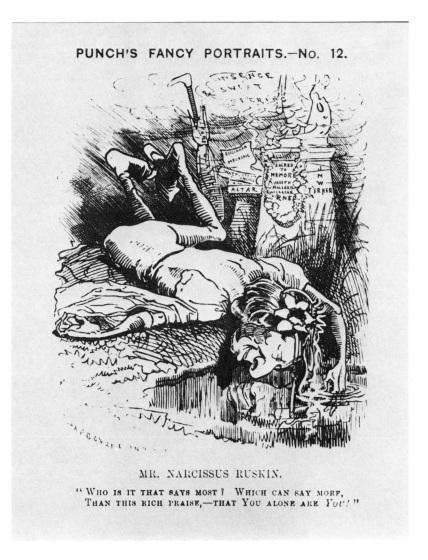

PUNCH'S FANCY PORTRAITS.—No. 12.

MR. NARCISSUS RUSKIN.

"Who is it that says most? Which can say more,
Than this rich praise,—that You alone are You!"

The increasing self-reference in Ruskin's work became obvious enough for *Punch* to mock, December 18, 1880. Turner's monument has been abandoned for Ruskin's own face and his hammer of fate, *Fors Clavigera*, has become a furled umbrella.

4

Morris:

Revolution as Realized Romance

You younger men must found a new dynasty—the old things
are passed away.

<div align="right">Ruskin to Morris, May 27, 1880</div>

There is our hope: the cause of art is the cause of the poeple.

<div align="right">"Art and Socialism" 1884</div>

Epping Forest

With a few words simply and casually let fall in conversation,
he would sometimes bring the young days before his listeners
as in a sudden vision, beautiful and poignant like all the inti-
mate things that have passed away.

<div align="right">May Morris</div>

IN HIS 1843 review of *Past and Present*, Engels expressed the hope that
Carlyle might become the native theoretician of British socialism. He
had "only *one* more step to take." Having declared history the "real
'revelation'," he had but to recognize that it revealed no god, con-
tained "only what is human." If all deities reside in the human breast,
"God is man." Knowing that, Carlyle would see that there was no
future religion possible, no need to depend upon heroes, and "the
identity of interests the only truly human state of affairs."[1] Carlyle
remained, of course, a believer in belief and, like Ruskin, in an
"identity of interests" that incorporated the class lines Engels meant
to overthrow. To Carlyle the revolt of the working class as embodied
in Chartism was legitimate only as a demand for justice, not power, a
view he passed on to Ruskin. Engels had to wait forty years for an
English man of letters to declare himself a revolutionary Socialist,
and instead of an essayist or historian steeped in German philosophy
he had to put up with a poet. "Morris is a settled sentimental socialist;
he would be easily managed if one saw him regularly a couple of
times a week. . . . And is he worth all that trouble even if one had the
time?"[2] Engels' impatience is as understandable as his judgment of
Morris' worth is dubious. Insofar as the Carlyle of *Past and Present*
was evident in the work that had made Morris' reputation, it ap-
peared to be largely the idealization of the past Engels disparaged
rather than the analysis of the present, in which he had once found
promise. But while it may have seemed peculiar that a writer whose
work Northrop Frye links with Spenser and Scott to form "the major
centers of romance in a continuous tradition" should have become a
communist, the progression has a generic logic. "Romance," says
Frye, "begins an upward journey toward man's recovery of what he
projects as sacred myth."[3] Substitute *abolition* for *recovery* and we
have the proposition Engels urged upon Carlyle. But romance, as
Frye also points out, has generally been "kidnapped" by the domi-
nant social class and has traditionally presented a hierarchical social

order tied to the past. The power of romance plotting to transform history into the working out of an ordered destiny, whether in Scott's historical fiction, Carlyle's histories, or such scattered brief narratives in Ruskin's criticism as "The Two Boyhoods," loses its vitality when transformed into a scheme for the literal reordering of the present according to an archaic social structure—the realization of romance advanced in *Fors.*

Fredric Jameson's description of romance as the expression of "nostalgia for a social order in the process of being undermined and destroyed by nascent capitalism, yet still for the moment existing side by side with the latter"[4] goes to the heart of Carlyle's and Ruskin's efforts to "realize" a social romance. Their negative criticism was based on an acute sense of the contradictions between the values of the past, to which most of their contemporaries gave formal allegiance, and present practice as dictated not only by personal choice but by the economic system. The result was a powerful moral critique of the theory and practice of capitalism. Implicit in this critique, however, was the general social structure assumed by the religion, history, and literature from which they took their values. Thus Ruskin's social crusade ended in the vain attempt to impose on the outer world his idiosyncratic version of the old order, first, as Carlyle had, by argument, then by example.

If the nostalgic tie to a past social order can be broken, however, then the humanistic ideal of romance adumbrated in Carlyle and Ruskin can fully emerge: "Romance's last vision seems to be that of fraternity, Kant's kingdom of ends The principle of the aristocracies of the past was respect for birth; the principle of fraternity in the ideal world of romance is respect for those who have been born, and because they have been born."[5] It was Morris who broke the structural tie to the past and so transformed the vision of realized romance despite the fact that he was more deeply engaged by the history of the Middle Ages than Carlyle and had a love of its creations at least as profound and wide-ranging as Ruskin's. The key to Morris' ability to fuse the tradition of realized romance with the Marxist "identity of interest" and prophecy of "an association, in which the free development of each is the condition for the free development of all"[6] lies in his childhood.

Like Ruskin, Morris remembered a childhood Eden that was refracted throughout his work, but its character, like Morris' own, was quite different. The order of the Ruskin household, confirmed by religion and paternal Toryism was hierarchical; and Ruskin, the only child, found the best freedom in perfect obedience. Morris, the third

surviving child and first son of William and Emma Morris, proved a born rebel. Morris' reminiscences are brief, and the documents surviving from his childhood are few. There is, however, a pattern in what survives that anticipates the parallels and divergences between Ruskin's social outlook and his own.[7]

Morris grew up in the lap of nature and the care of women and girls. At the age when Ruskin was studiously creating his puppet show St. George for the pleasure of his father, Morris, dressed in a child's suit of armor, was riding a flesh-and-blood pony through Epping Forest. The contrast suggests both the imaginative world they shared and the different ways they acted out their dreams. Mackail recounts Morris' pleasure in riding, fishing, and "rambling with his brothers," but the surviving records suggest an even closer relationship with his two older sisters, particularly the eldest, Emma. Morris had his early lessons from the girls' governess. His first rebellious flights from the schoolroom into nature were conducted in their company. Emma in particular seems to have shared his love of literary romance and encouraged his earliest poems and stories. "They used to read 'The Old English Baron' together in the rabbit warren at Woodford . . . till both were wrought up to a state of mind that made them afraid to cross the park to reach home."[8] The William and Emma of the younger generation had one of those intense sibling relationships common in Victorian England when the nursery in homes of the well-to-do was a world apart.[9] It was a relationship, in other words, of the kind Ruskin so lamented the lack of in his own life, and thought he would have developed with his cousin Jessie Richardson had she survived.

The Morrises were a conventionally pious Evangelical household, and Morris, like Ruskin, learned to dread the coming of Sunday. But what he later called "rich establishmentarian puritanism" failed to shape his mind and mark his soul as deeply as it had Ruskin's. He followed his sister Emma into a nominal High Church phase that lasted into his Oxford days; but in his maturity he called himself a pagan in religion, accepting all that the term implied without the perpetual anguish the same self-designation caused Ruskin. Consequently he was able to surrender the special priority of the Judeo-Christian Bible without evident agitation. The Hebrew Bible (not the New Testament) eventually took its place among like "bibles" of other peoples (Homer, Hesiod, *The Edda, Beowulf, Mahabharata*, etc.) on the list of best books Morris contributed to the *Pall Mall Gazette*. Morris' compilation is weighted even more than Ruskin's kindred list to works of romance and traditional history.[10] While he makes

exclusions reflecting personal taste, Morris, in effect, collects all imaginative literature (as distinct from what he terms books as "tools," e.g., philosophy, economics, critical history) into a single imaginative order, what Frye calls the "secular scripture" at the core of which is romance: "Being directly descended from the folktale it brings us closer to the sense of fiction, considered as a whole, as the epic of the creature, man's vision of his own life as a quest."[11] From this literature Morris drew the patterns of much of his personal, literary, and political life.

The Woodford Hall Morris knew as a boy still had much of the self-sufficiency of a medieval manor and was utterly remote from the commercial world wherein his father worked as a bill broker to maintain it. In the relatively unspoiled countryside near Walthamstow, Morris could blend his love of the landscape, its flora and fauna, with his appetite for literature of and about the past. He could restore in imagination the surviving monuments of preindustrial England and the people who created and used them. "I can't help thinking of tales going on amongst it all, and long so for more and more books," says the boy hero of one of Morris' early romances.[12] Grown wealthy through a fortuitous investment in Great Devon mining shares, Mr. Morris, like John James Ruskin, acquired a coat of arms with which to gild his new riches. Just as Ruskin's ambivalent identification of himself with the family boar is a clue to his set of mind, so too is Morris' wholehearted acceptance of the "horse's head couped argent" from the coat of Morris arms. "He considered himself," says Mackail, "in some sense a tribesman of the White Horse." As an adult he made regular pilgrimages to the great White Horse of the Berkshire Downs where as a boy he used to imagine himself contemplating that ancient monument from the perspective of the *fourteenth* century.[13] The White Horse became the weathervane atop Red House; "the foothills of the White Horse" the setting of the fourteenth-century village in *A Dream of John Ball*.

The break from "the days when I was a little chap" that Morris recalled with such pleasure came with a series of losses. First came the death of his father in 1847, followed in 1848 by removal to a "boy farm," Marlborough College, cutting him off from the regular companionship of his sisters and brothers. Then, in 1850, Emma married and Morris "felt deserted."[14]

Morris was nearly as reticent about his feelings as a child as Ruskin was garrulous, and he has left no direct record of how the loss of his father at the age of thirteen affected him. His father was associated with one of the most moving experiences of his childhood, a visit to

Canterbury Cathedral that he could recall in detail fifty years later but refused to relive (just as he refused ever to return to Red House after leaving it in 1865). But his father seems to have been emotionally distant. He was, moreover, part of the commercial world Morris grew to despise, but to which he was bound by his paternal legacy and then, as the value of his Devon Great Consols declined, by the need to make his firm profitable. It is impossible to judge how deeply the young Morris might have felt abandoned by his father, or what emotional balance he eventually struck between his father of Canterbury and his City father. However, in comparing the basic social and political attitudes of Morris with those of Ruskin, there is no more striking contrast than the elimination by Morris of the paternal element that so permeates Ruskin's work. It is a clear break from the need for authority so deeply rooted in the tradition Morris imbibed from Carlyle and Ruskin, and enabled him to revive the strain of egalitarian political radicalism in English romanticism.[15]

Separation from his mother and siblings coming on top of the death of his father must have exaggerated the traits that led more ordinary boys at Marlborough to call Morris "Welsh and Mad." His hands were never still, his body rarely. His most constant urge seemed to be to escape whether into the countryside, into literature and history, or into stories about knights and fairies of his own devising. But his fellows discovered that for all his dreaminess Morris was physically robust and had a quick temper—traits he carried with him to Oxford.

Since the elder Morris left his family well provided, there was never any question of young William having to give up his prospects to help support his mother, sisters, and brothers, but it is hard to believe that there was not at least an implicit feeling that he, the eldest son, would assume leadership of the family upon completion of his education. It is clear, however, that after the marriage of Emma to the Rev. Joseph Oldham and her removal to Derbyshire, Morris' relations with his family grew more distant. The breech was certainly widened when his decision to give up church for architecture, and then architecture for art, was capped by a declassé marriage. Morris remained to his mother a dutiful, even affectionate son, but his relationship with the rest of the family seems to have been more correct than cordial.

Like Ruskin, Morris carried forward in his life and art patterns established in childhood. His love of the English landscape and romance narratives, fused in imagination with his ever deepening knowledge of the Middle Ages, carried him out of an uncongenial

exclusions reflecting personal taste, Morris, in effect, collects all imaginative literature (as distinct from what he terms books as "tools," e.g., philosophy, economics, critical history) into a single imaginative order, what Frye calls the "secular scripture" at the core of which is romance: "Being directly descended from the folktale it brings us closer to the sense of fiction, considered as a whole, as the epic of the creature, man's vision of his own life as a quest."[11] From this literature Morris drew the patterns of much of his personal, literary, and political life.

The Woodford Hall Morris knew as a boy still had much of the self-sufficiency of a medieval manor and was utterly remote from the commercial world wherein his father worked as a bill broker to maintain it. In the relatively unspoiled countryside near Walthamstow, Morris could blend his love of the landscape, its flora and fauna, with his appetite for literature of and about the past. He could restore in imagination the surviving monuments of preindustrial England and the people who created and used them. "I can't help thinking of tales going on amongst it all, and long so for more and more books," says the boy hero of one of Morris' early romances.[12] Grown wealthy through a fortuitous investment in Great Devon mining shares, Mr. Morris, like John James Ruskin, acquired a coat of arms with which to gild his new riches. Just as Ruskin's ambivalent identification of himself with the family boar is a clue to his set of mind, so too is Morris' wholehearted acceptance of the "horse's head couped argent" from the coat of Morris arms. "He considered himself," says Mackail, "in some sense a tribesman of the White Horse." As an adult he made regular pilgrimages to the great White Horse of the Berkshire Downs where as a boy he used to imagine himself contemplating that ancient monument from the perspective of the *fourteenth* century.[13] The White Horse became the weathervane atop Red House; "the foothills of the White Horse" the setting of the fourteenth-century village in *A Dream of John Ball.*

The break from "the days when I was a little chap" that Morris recalled with such pleasure came with a series of losses. First came the death of his father in 1847, followed in 1848 by removal to a "boy farm," Marlborough College, cutting him off from the regular companionship of his sisters and brothers. Then, in 1850, Emma married and Morris "felt deserted."[14]

Morris was nearly as reticent about his feelings as a child as Ruskin was garrulous, and he has left no direct record of how the loss of his father at the age of thirteen affected him. His father was associated with one of the most moving experiences of his childhood, a visit to

Canterbury Cathedral that he could recall in detail fifty years later but refused to relive (just as he refused ever to return to Red House after leaving it in 1865). But his father seems to have been emotionally distant. He was, moreover, part of the commercial world Morris grew to despise, but to which he was bound by his paternal legacy and then, as the value of his Devon Great Consols declined, by the need to make his firm profitable. It is impossible to judge how deeply the young Morris might have felt abandoned by his father, or what emotional balance he eventually struck between his father of Canterbury and his City father. However, in comparing the basic social and political attitudes of Morris with those of Ruskin, there is no more striking contrast than the elimination by Morris of the paternal element that so permeates Ruskin's work. It is a clear break from the need for authority so deeply rooted in the tradition Morris imbibed from Carlyle and Ruskin, and enabled him to revive the strain of egalitarian political radicalism in English romanticism.[15]

Separation from his mother and siblings coming on top of the death of his father must have exaggerated the traits that led more ordinary boys at Marlborough to call Morris "Welsh and Mad." His hands were never still, his body rarely. His most constant urge seemed to be to escape whether into the countryside, into literature and history, or into stories about knights and fairies of his own devising. But his fellows discovered that for all his dreaminess Morris was physically robust and had a quick temper—traits he carried with him to Oxford.

Since the elder Morris left his family well provided, there was never any question of young William having to give up his prospects to help support his mother, sisters, and brothers, but it is hard to believe that there was not at least an implicit feeling that he, the eldest son, would assume leadership of the family upon completion of his education. It is clear, however, that after the marriage of Emma to the Rev. Joseph Oldham and her removal to Derbyshire, Morris' relations with his family grew more distant. The breech was certainly widened when his decision to give up church for architecture, and then architecture for art, was capped by a declassé marriage. Morris remained to his mother a dutiful, even affectionate son, but his relationship with the rest of the family seems to have been more correct than cordial.

Like Ruskin, Morris carried forward in his life and art patterns established in childhood. His love of the English landscape and romance narratives, fused in imagination with his ever deepening knowledge of the Middle Ages, carried him out of an uncongenial

present as a child and as a man. The obsessive theme of the triangular love affair that Morris sought out in the Arthurian and Norse stories he retold, projected into his original compositions, and so painfully acted out in life, can be traced, as Jack Lindsay has demonstrated, to his boyhood love and loss of his sister Emma. More generally, Morris seems to have recreated in his adult life his place among his brothers and sisters. He remained dependent upon women for sympathy and affection, but became a leader of men. The ideal of a relationship between men and women extending the comradeship he had known in childhood survived the emotional failure of his marriage to emerge politically in his support of equal opportunity for women through socialism and in the open relationship between the sexes in some of his late romances. Heroines like Ursula in *The Well at the World's End* have been freed from Victorian constraints upon the exercise of woman's mind and body to become fit companions for the heroes with whom they share love and adventure. Their sexual relationships thus become an expression of the primary value of companionship.

Janey

> When my hand forgets her cunning I will loose
> thee, Love, and pray
> —Ah and pray to what—For a never-ending day,
> Where we may sit apart, Hapless, undying still,
> With thoughts of the old story Our sundered
> hearts to fill.
> Morris, "Oh Far Away to Seek"

FOR MORRIS AS for Ruskin, the central failure of personal life was a failure in love. Ruskin's failures as husband and lover were pathetic, all too public, and had overtones of pathology, none of which was true of Morris. The failure of his marriage is nevertheless important for an understanding of Morris' politics, for marriage and the building of Red House were Morris' attempt to realize a dream, to live a life almost independent of the surrounding society he despised and to ignore its class divisions. The political activity that followed the collapse of the dream was dedicated to the destruction of bourgeois society and the removal of the barriers of class.

The stark prose of the marriage license itself tells part of the story.

The marriage joined "William Morris. 25. Bachelor. Gentleman . . . Son of William Morris decd. Gentleman" to "Jane Burden. Minor. Spinster. Daughter of Robert Burden. Groom."[16] From the marginal economic world Jane Burden had known as the daughter of an Oxford groom Morris took her into his palace of art, Red House. If marrying "beneath him" was for Morris a romantic defiance of family and convention, for Jane Burden marriage must have been the fulfillment of a more conventional dream. From the class that served, she suddenly commanded servants. However eccentric a gentleman Morris proved to be that was his status, artist or no.

For a time Morris seems to have realized his dream. The years at Red House were the years of Jane's good health, the childish practical jokes, the games, the pranks in which both Morrises participated. Certainly some of this playfulness on Jane's part, so unlike the manners of a proper mid-Victorian maiden of his own class and, perhaps, reminiscent of games with his sisters, must have been evident before the marriage and attractive to Morris, who was as shy as Ruskin and took his dislike of formal society to even greater length. Jane was fully involved in Morris' activities during the Red House years, playing her part with needle and brush in the communal decoration projects that led to the foundation of Morris, Marshall, Faulkner and Co. In a rather pathetic letter written while May Morris was relating the beginnings of the firm in her introductions to the *Collected Works*, Jane complains to her daughter that she has underplayed the importance of embroidery, her special skill. She recounts how Morris taught her decorative stitching, how they picked apart old work to recover traditional techniques, how *she* discovered the blue cloth they first used as a ground for the needlework.[17] The Morrises and the Burne-Joneses all found the Red House days Edenic in memory. Discord came after the failure of Morris' attempt to convert his unearned income into a paradise apart from the surrounding world. It came with the move from Red House, and the decline in Jane's health.

Jane's weakness may have predated the move. (Did she fully recover from bearing two children within fourteen months?) The first surviving record of her ailment, however, coincides with the move to Queen's Square in 1865. Morris had dreamed of a communal studio and workshop for the firm to be shared with the Burne-Joneses in an expanded Red House. It was to be the perfect blend of marriage, art, and the monastic schemes the Morris set had toyed with at Oxford. Instead there was illness in both families and a step downward in social status for Jane to the condition, however glamorized by art,

of a tradesman's wife living above the shop. By the end of 1868 both households were embroiled in emotional tangles: Burne-Jones was obsessed with his model, Marie Zambacco; Dante Gabriel Rossetti was in love with "funny sweet Janey"; Morris, reliant as ever upon female sympathy, was receiving it from other women and drawing ever closer to Georgie Burne-Jones. By 1869 Jane had taken to her bed. Whether Jane's illnesses were physical, psychosomatic, or both, she was periodically incapacitated for the rest of her long life.[18]

Morris seems in some measure to blame himself for the loss of his wife's affection, and an element of sexual frustration may have been involved in that feeling. But Morris, who used to remark, sardonically, that he was "bourgeois you know and without the point of honor,"[19] was not about to assert patriarchal authority and insist upon monogamy or his rights as a husband in the absence of reciprocal affection. Rather, as even the very proper Sir Sidney Cockerell points out, Morris' actions were in line with the principles enunciated in his socialist years and incorporated into *News from Nowhere*: that everyone in this complex emotional tangle should have the freedom to work out the happiest solution possible. What Morris seems to have found most upsetting about the arrangement that left Jane and the children at Kelmscott with Rossetti while he toured Iceland in 1871 is that it left the lovers, if lovers they were, still discontented.[20] His parting wish to Jane had been that she be happy.

Whatever the depth of her feelings for Rossetti, Jane Morris was not about to abandon her marriage. She seems never to have taken Rossetti's protestations of love for her entirely seriously. In 1878 he wrote protesting: "The supposition [that he would not want to see her "altered looks"] would be an outrage to my deep regard for you;—a feeling far deeper (though I know you never believed me) than I have entertained towards any other living creature at any time of my life. Would that circumstances had given me the power to prove this: for proved it *wd*. have been. And *now* you do not believe it."[21]

If Kelmscott gave Janey and Rossetti time and place together, so the taking of Horrington House, Turnham Green, in 1872 meant that the rooms above the shop were Morris' alone so that: "I can always see anyone I want at Queen Sq: quite safe from interruption."[22] Certainly the Morrises spent much of their married life apart after 1865. Although people who met Morris late in life remarked on his apparent indifference to considerations of sex, it is belied by the emphasis upon sexual freedom in his later writings and the heartfelt tone of his remark to Burne-Jones in 1886 at the height

of his political work: "If I were but twenty years younger. But then you know there would be the Female complication somewhere. Best as it is after all."[23] Although the intimate details of the situation in which Morris found himself remain obscure, the general nature of his frustration is clear enough. Victorian law, social conventions, and his consideration for others (including his children) kept him tied to a woman whose love he had lost, while forbidding fulfillment of the love he seems to have gained.

Morris was a man in almost constant motion. In those "stormy *Earthly Paradise* years" he was more given than ever before or after to outbursts of temper and violent responses to frustration that were hard on the crockery and, no doubt, on Jane's nerves as well. "At times he was so angry and impassioned he would tear things to pieces and behave just like an angry child," Jane told Mackmurdo.[24] In ill health and unable any longer to share much of Morris' active life, having two children to care for, in need of sympathy herself, but married to someone who required sympathy from women, it would not be surprising if Jane Morris felt as abandoned by William as he by her. Her intimacy with Rossetti developed reciprocally with Morris' increasing closeness to Georgie Burne-Jones, who was more than mere solace for an absent or rejecting Janey, being his fit spiritual and intellectual partner. Perhaps she was the "love" of "all the dear faces of wife & children, and love, & friends" to whom he returned after his second journey to Iceland.[25] In any event, Rossetti was able to offer what Morris by temperament and press of work could not: patient, sympathetic attention, adoring companionship, amusement. Without in the least discounting her affection for Rossetti, Jane could in sitting for him as often as health allowed feel doubly *useful* as someone Rossetti insisted was essential both to his art and his emotional well being.

The onset of Jenny's epilepsy in 1876 brought the Morrises back together at least in love of their daughter, and the fact that when Morris died Jane could not bear to keep the game board on which they had played draughts suggests that she at least came to treasure their private moments. But Jane was never in sympathy with Morris' turn to political action. His comrades brought her into even closer contact with the class from which she had risen than living above the shop had. Having left the working class behind her, having, no doubt with some effort, acquired the accomplishments appropriate to her new station, Jane characteristically made sure that no mention of her background appeared in Mackail's *Life*.

Though their personalities and the specifics of their situations were

very different, Jane Morris had one thing in common with Effie Ruskin. Both women wanted to live a normal, respectable, upper-middle-class life that their husbands, despite their class background, were unable or unwilling to share. How striking is the contrast in the correspondence of Rossetti, Jane, and Morris, between the conventional bourgeois social values of the latter-day Lancelot and Guinevere and the radicalism of Arthur.

Ruskin and the Design of Society

I do not like however to be praised at the expense of Ruskin, who you must remember is the first comer, the inventor; and I believe we all of us owe a hope that still clings to us, and a chance of expressing that hope, to his insight: of course to say that one does not always agree with him is to say that he and I are of mankind.

<div align="right">Morris 1883</div>

MORRIS' FIRST ENCOUNTER with Ruskin's work was at Oxford. Like all of the others of his set save Charles Faulkner, Morris was destined for holy orders, but they never spoke of it together, rather: "The bond was poetry, and indefinite artistic and literary aspiration: but not of a selfish character, or rather not of a self-seeking character. We all had the notion of doing great things for man; in our own way, however—according to our own will.[26]

They were all much taken with Tennyson's poetry, at least through *Maud*, but Morris seemed to have both a more critical and a deeper appreciation than the others, understanding it, Canon Dixon recalls, "as if the poems represented substantial things that were to be considered out of the poems as well as in them." Morris immersed himself in Ruskin's work from the early volumes of *Modern Painters* through *The Seven Lamps* and *The Stones of Venice* as if they too were substantial things, reading them aloud in a tone suited to Ruskin's combative manner of composition. He declaimed "the burden, 'Has Claude given this,' " so as to thunder it "on the head of the base criminal who had never seen what Turner saw in the sky." It was from Ruskin, Dixon recalls, "that strong direction was given to a true vocation."

One of the purposes of Ruskin's early work on architecture was to deny the equation of the Gothic with Catholicism and the English

High Church, and it is to reading of Ruskin that Morris attributes the end of his Puseyite leanings. It was not, however, to the fading sectarian Protestant side of Ruskin, still constructing sheepfolds, that Morris responded; but to his underlying humanism, the glimmerings of "the religion of humanity." It was the emphasis he found in "The Lamp of Life" and "The Nature of Gothic" upon architecture as the creation of the workman and the expression of an entire social order rather than a particular church doctrine that captured his imagination.

Acquaintance with Ruskin's works at Oxford was soon supplemented by contact with the man himself, who was introduced to the second generation of Pre-Raphaelites by Rossetti. In 1856 Ruskin even took to spending Thursday evenings with the younger men at Red Lion Square after giving his drawing class at the nearby Working Men's College.[27] The deep friendship Ruskin cemented in those years, however, was not with Morris but with Burne-Jones, who was more given to direct hero worship than Morris and, as a painter of little means, in need of patronage that his friend could do without. Over the years the Burne-Joneses mediated between Ruskin and Morris who, despite their respect for one another, never became intimate friends. But when Morris took to arguing politics in the kitchen of The Grange with Georgie while Burne-Jones talked painting in the studio, Ruskin was almost surely a ghostly presence, for Lady Burne-Jones was giving copies of *Unto This Last* to likely seeming young people into this century.

Rossetti was the only man under whose personal spell Morris ever fell—a temporary condition roughly marked by his short-lived attempt to be a painter. It was in the days of Rossetti's sway that Morris wrote to Cormell Price that he could not enter into "politico-social subjects" having "no power or vocation to set them right in ever so little a degree. My work is the embodiment of dreams in one form or another."[28] Although the immediate context of Morris' remark is the art of painting, the idea of the dream embodied in many modes pulls all of Morris' work together. If we give *embodiment* a double meaning, the representation of dreams on the one hand, the realization of dreams on the other, Morris' comment extends even to his politics, for he came to dream a "politico-social" dream.

In painting, *embodiment* suggests Pre-Raphaelite practice and Ruskin's interpretation of it in the Edinburgh lectures that introduced the PRB to Morris' Oxford set: the placing of contemporary portraits against realistic natural backgrounds or in historically convincing domestic settings. Painting also converts the dream into a

physical object. But looking at Morris' surviving oil painting, the (one is tempted to say typological) portrait of his fiancée as Guenevere, one is struck in the decor of the queen's boudoir by the objects to be brought out of the painting and into life by Morris, or Morris and Co.: the furniture, the bed hangings, the embroidered coverlets, the carpet, Jane's embroidered, free hanging dress, the illuminated book. In the contemporary *Defence of Guenevere* volume, side by side with the dramatic monologues (the Middle Ages of Froissart and Malory as if seen and overheard), are, of course, dreams of another sort—decorative, musical lyrics of mood and pattern. They are poems of uncertain situation spoken by disembodied, if vaguely medieval, voices, suggesting not the realization of dreams but the very process or state of dreaming.

The "dreamer of dreams, born out of my time," the Morris without power to set things straight, reappears in the Apology to *The Earthly Paradise*. Although Morris evokes Chaucer as the model for his cycle of stories, his posture as a tale teller is very different, being infused with nostalgia for Chaucer's times. He sets in Ruskinian fashion a dirty and dehumanized present against a clean and socially integrated past, as the kind of writing he imagines Chaucer doing indicates.

> Forget six counties overhung with smoke,
> Forget the snorting steam and piston stroke,
> Forget the spreading of the hideous town;
> Think rather of the pack-horse on the down,
> And dream of London, small and white and clean,
> The clear Thames bordered by its gardens green;
>
> . . .
>
> While nigh the thronged wharf Geoffrey Chaucer's pen
> Moves over bills of lading—mid such times
> Shall dwell the hollow puppets of my rhymes.
>
> (M3:3)

The deluded wanderers of Morris' frame story, deliberately distanced from their creator in time and space and in hopeless flight from death, invite contrast with Chaucer's pilgrims so solidly on their way to Canterbury in the interests of salvation. "There's," wrote Ruskin to Joan Agnew, "such lovely, lovely misery in this Paradise. In fact, I think it's—the other place—made pretty" (XXXVII:3) and so

it is. As Ruskin found the concrete embodiment and potential resolution of his inner conflicts in art and landscape, so Morris found objective equivalents of his situation in the tales he retold.

The escapism of *The Earthly Paradise* was multiform. Its very composition in the hours after shop work and before sleep seems to have offered Morris, who hated complaining in life, and public confession in poetry, a release from his double bafflement in love and the concomitant temptation to brood on death. To its readers it offered suspension of consciousness, an escape into old tales decorously retold. "Whither shall a reader turn in these days," asked *The Spectator*, rhetorically, "who longs to escape for a while from all the toil and clamour and strife of the world, and to roam at will in pleasant places, where nothing shall remind him of the doubtful battle-field where after a short breathing-space he must again bear his part?"[29] The craftsmanship of *The Earthly Paradise*, however, was part of Morris' revival of lost or dying arts—in this case the telling in verse narrative of traditional tales—carried on more aggressively in Morris' daytime work, the creation and creations of Morris, Marshall, Faulkner and Co. It was work he was to continue in different form in his late romances, which not only rework the motifs of England's northern heritage, but do so in language that links modern English to its Anglo-Saxon roots, reaching back past the effects of the Norman Conquest insofar as it was possible (and intelligible) to do so.

Looking back in the late 1880s on the work of his firm and his conversion to socialism, Morris found a root of each in Ruskin. Faced with the failure of his attempt to design and inhabit an independent private world (on the basis of his unearned income), having no faith in, nor yearning for, a disembodied immortality, Morris found salvation in art-labor, the work of hand and mind together, as Ruskin had prophesied in "The Nature of Gothic." But just as Ruskin, when deprived of his faith in immortality, was forced to confront the misery in which most people were condemned to pass their one life, so Morris was uneasily aware that it was the luck of being born rich that gave him the chance to find joy in his labor. It was money that put him in a living room full of books and works of art and not on the other side of the window among brutalized "ruffians" (M22:170-71). Ruskin's writing on work and design in "The Nature of Gothic" and its extensions in the lectures of the 1850s collected in *"A Joy Forever,"* (*And Its Price in the Market*) and *The Two Paths* made art the potential salvation of society. As long as Morris, however vaguely, could feel that the work in which he took such joy was at least in some small

physical object. But looking at Morris' surviving oil painting, the (one is tempted to say typological) portrait of his fiancée as Guenevere, one is struck in the decor of the queen's boudoir by the objects to be brought out of the painting and into life by Morris, or Morris and Co.: the furniture, the bed hangings, the embroidered coverlets, the carpet, Jane's embroidered, free hanging dress, the illuminated book. In the contemporary *Defence of Guenevere* volume, side by side with the dramatic monologues (the Middle Ages of Froissart and Malory as if seen and overheard), are, of course, dreams of another sort—decorative, musical lyrics of mood and pattern. They are poems of uncertain situation spoken by disembodied, if vaguely medieval, voices, suggesting not the realization of dreams but the very process or state of dreaming.

The "dreamer of dreams, born out of my time," the Morris without power to set things straight, reappears in the Apology to *The Earthly Paradise*. Although Morris evokes Chaucer as the model for his cycle of stories, his posture as a tale teller is very different, being infused with nostalgia for Chaucer's times. He sets in Ruskinian fashion a dirty and dehumanized present against a clean and socially integrated past, as the kind of writing he imagines Chaucer doing indicates.

> Forget six counties overhung with smoke,
> Forget the snorting steam and piston stroke,
> Forget the spreading of the hideous town;
> Think rather of the pack-horse on the down,
> And dream of London, small and white and clean,
> The clear Thames bordered by its gardens green;
>
> . . .
>
> While nigh the thronged wharf Geoffrey Chaucer's pen
> Moves over bills of lading—mid such times
> Shall dwell the hollow puppets of my rhymes.
>
> (M3:3)

The deluded wanderers of Morris' frame story, deliberately distanced from their creator in time and space and in hopeless flight from death, invite contrast with Chaucer's pilgrims so solidly on their way to Canterbury in the interests of salvation. "There's," wrote Ruskin to Joan Agnew, "such lovely, lovely misery in this Paradise. In fact, I think it's—the other place—made pretty" (XXXVII:3) and so

it is. As Ruskin found the concrete embodiment and potential resolution of his inner conflicts in art and landscape, so Morris found objective equivalents of his situation in the tales he retold.

The escapism of *The Earthly Paradise* was multiform. Its very composition in the hours after shop work and before sleep seems to have offered Morris, who hated complaining in life, and public confession in poetry, a release from his double bafflement in love and the concomitant temptation to brood on death. To its readers it offered suspension of consciousness, an escape into old tales decorously retold. "Whither shall a reader turn in these days," asked *The Spectator,* rhetorically, "who longs to escape for a while from all the toil and clamour and strife of the world, and to roam at will in pleasant places, where nothing shall remind him of the doubtful battle-field where after a short breathing-space he must again bear his part?"[29] The craftsmanship of *The Earthly Paradise,* however, was part of Morris' revival of lost or dying arts—in this case the telling in verse narrative of traditional tales—carried on more aggressively in Morris' daytime work, the creation and creations of Morris, Marshall, Faulkner and Co. It was work he was to continue in different form in his late romances, which not only rework the motifs of England's northern heritage, but do so in language that links modern English to its Anglo-Saxon roots, reaching back past the effects of the Norman Conquest insofar as it was possible (and intelligible) to do so.

Looking back in the late 1880s on the work of his firm and his conversion to socialism, Morris found a root of each in Ruskin. Faced with the failure of his attempt to design and inhabit an independent private world (on the basis of his unearned income), having no faith in, nor yearning for, a disembodied immortality, Morris found salvation in art-labor, the work of hand and mind together, as Ruskin had prophesied in "The Nature of Gothic." But just as Ruskin, when deprived of his faith in immortality, was forced to confront the misery in which most people were condemned to pass their one life, so Morris was uneasily aware that it was the luck of being born rich that gave him the chance to find joy in his labor. It was money that put him in a living room full of books and works of art and not on the other side of the window among brutalized "ruffians" (M22:170-71). Ruskin's writing on work and design in "The Nature of Gothic" and its extensions in the lectures of the 1850s collected in "*A Joy Forever*," (*And Its Price in the Market*) and *The Two Paths* made art the potential salvation of society. As long as Morris, however vaguely, could feel that the work in which he took such joy was at least in some small

measure contributing to the vision Ruskin advanced in "Manufacture and Design," the vision of the manufacturer as the creator both of reformed taste and of a redeemed working class in a restored landscape, Morris could push aside thoughts of the condition of the working class as a whole.

If Morris himself was the incarnation of Ruskin's idea of the designer-craftsman, his works at rustic Merton Abbey and his treatment of the workmen there became the embodiment of Ruskinian manufacture. But at the very point of realizing this vision, its inadequacy was inescapably thrust upon him.

> It was a big job that I had taken in hand; no less than the regeneration of popular art as it used to be called. I was not fully conscious how big a job it was for a long time; though I was fully conscious of the complete degradation of the arts in general. Well the time came when I found out that those unpleasant thoughts about the greater part of the population were intimately connected with the very essence of my work, and at last that I had undertaken a job quite impossible under the present conditions of life. . . and there was the greater part gone of my pleasure in my work. . . . Well I cannot tell you whether it was about this time that I first heard of socialism as a definite movement, but I know that I had come to these conclusions a good deal through reading John Ruskin's works, and that I focussed so to say his views on the matter of my work and my rising sense of injustice, probably more than he intended, and that the result of all that was that I was quite ready for Socialism when I came across it in a definite form, as a political party with distinct aims for a revolution in society.[30]

In "The Nature of Gothic" and his later lectures on art and industrial design Ruskin subsumes all the decorative arts—from the high arts of painting and sculpture to the "lower" arts; from the glass that adorned the cathedrals, down to furniture, the details of interior decoration, pottery, glass, metal work, jewelry, even, implicitly, cloth and clothing—under the broad category of architecture. The offerings of Morris & Co, from the mural decoration, carving, stained glass, metal work (including jewelry), furniture, and embroidery listed in their first advertisement, to the later wallpapers and woven and printed textiles, makes a corresponding list of "lesser arts"—as Morris preferred to call them. In Ruskin's ideal workshop, goods would be made by men doing various, easy, and lasting work (XVI:36).

The workers would, in the terms of *Unto This Last*, be both making and becoming wealth, that is, happy, healthy, human beings. This too was Morris' ambition, for he saw wealth, as opposed to riches, in Ruskinian terms as consisting of the things which satisfy the needs of the body and the needs of the mind.[31] Likewise Morris saw the accumulation of capital in Ruskinian terms (later reinforced by Marx) as power over the lives of other people, power generally abused.

In the Ruskinian historical analysis adopted by Morris, Gothic architecture and the arts subsidiary to it were the organic expression of the convictions, values, and talents of a whole people. This organic development was broken in the Renaissance and further fragmented by industrialism. The decadent state of contemporary architecture and manufacture so destructive of the natural environment and the human nature of the workers were the manifestations of that fragmentation. But there was a contradiction implicit in the proposals for reform of the situation advocated by Ruskin that he could never solve to his satisfaction and that Morris was eventually forced to face. To appeal to consumers to demand only goods manufactured without degradation of the workman, to demand of architects and manufacturers that they reform taste as they supply it in order to create a proper, modern, organic order, looks terribly like trying to grow a tree from the branches downward. Even with the weight of established religion behind them, attempts to persuade people to act against their apparent material interest on moral grounds have had mixed results at best, and it was hard to see how a secularized version of the same strategy would do better.

Morris gave succinct expression to Ruskin's hope for the manufacturer and the consumer in the two italicized phrases that run through his lecture "The Beauty of Life"(1880): *"Art made by the people and for the people as a joy to the maker and the user"* and *"Have nothing in your houses which you do not know to be useful or believe to be beautiful."* Morris came to see that his firm could not realize even the first ideal, that of manufacture, let alone the second.

Morris' approach to manufacture was to pick up each craft at the point where he felt that the tradition coming forward from the Middle Ages had been broken—whether in embroidery, carpet making, glass design, natural dyeing, or tapestry weaving—and to master its techniques personally. He learned from workmen when possible, trained them when necessary, and created designs that carried on the tradition in modern terms according to his own aesthetic values. Although Morris' craft work was founded upon intense historical research in technique and design, neither he nor Ruskin cared to

create replicas of medieval work. Neither did the revival of handicraft imply a rejection of machinery, provided the man did not become part of the machine. The function of the machine should be to free the workman from drudgery, not to displace him nor to reduce skilled to unskilled labor, an aspect of mechanization Morris attributed to the competitive need to make the cheapest possible product. Morris in fact envisioned a revival of handicraft based on a freeing of the worker from degrading forms of labor by the substitution of automated machinery.[32]

The most obvious and frequently mentioned contradiction Morris faced in reviving the "popular" arts through his firm is that his goods were being made by employees, not guildsmen, not "the people," and could only be purchased by the classes whose wealth Morris saw as surplus value stolen (the rhetoric of Ruskin, Morris and Marx is at one here) from the working class. In his first lecture he addressed the members of the Trades Guild of Learning as people like himself "engaged in the actual practice of the arts that are, *or ought to be,* popular (M22:8; my italics). But there is a more subtle contradiction. Morris hoped not only to revive medieval crafts but, in a sense, medieval men, whole men. Like Ruskin he saw the power to design and create as the product of general culture expressed in traditional skill. In his particular work he found himself trying to revive through conscious effort skills that had once been passed down from generation to generation and absorbed, in Morris' view, almost unconsciously as part of the workman's inheritance. He complained to the Royal Commission on Technical Instruction of the *"general ignorance"* of the London workmen he employed, not just their lack of specific skills.[33]

Morris followed Ruskin in wishing to educate broadly all workmen and to found their skill on drawing of the figure and, secondarily, natural objects. Ruskin did not, as has often been said, claim that every workman should be a designer except in such crafts as glass-blowing, in which conception and execution are inseparable. He felt, on the contrary, that while the designer should be the master of every skill required for the execution of his design, he ought not be tied to the mechanical reproduction of it (as in weaving). Morris became the embodiment of the Ruskinian master workman. He accepted so thoroughly Ruskin's belief that "the workman ought often to be thinking, and the thinker often to be working, and both should be gentlemen, in the best sense" (X:201) that he tried as far as possible to encourage his men to become like himself. Workmen who were willing and able he trained in design. Morris knew that division of

labor could not be eliminated, but by the rotation of tasks he could reduce its tendency to alienate labor.[34] As a practical matter Morris was also concerned that he should not train workmen exclusively in old skills not utilized elsewhere and thus limit their ability to seek other employment. His ideal workman had to be the organic product of his culture—he could not be trained individually without becoming *sui generis* and consequently bound to Morris' firm or to a career in craft with no guarantee of a market.

Of the hope of converting the consumer through the production of quality goods, less need be said. Morris' goods became fashionable. As such they were imitated, and the imitations could be made more cheaply by the means of mass production he generally deplored. Put bluntly, Morris and Co. made a large place for itself in the history of taste, and in the revival of crafts Ruskin had called for as early as 1847 in *The Seven Lamps*, but a small one in the history of manufacture. One could get the appearance of Morris' results without his expensive means. Hence, Morris came to see his own work as he viewed the painting of the PRB and Burne-Jones; that is, as work created and appreciated by isolated individuals and, therefore, likely to die with them.

Although it was largely these negative factors that forced Morris to conclude that a social revolution was a prior condition to the kind of production and values regarding consumption he thought necessary to fulfill human nature and bring it into harmony with the natural world, there were positive factors that should not be overlooked. His direct contact with the workmen of London, particularly the ones taken on as boys, convinced him that the potential for craft production in line with his principles was indeed there: that what was largely theory in Ruskin he could bring about. One of these boys, J. H. Dearle, eventually became a partner in the firm and like Morris' daughter, May, created new Morrisian designs.[35]

The establishment of the Morris Workshop at Merton Abbey in 1881 became not only, as Philip Henderson says, "the realization of a Ruskinian dream" with its watermill, orchards, garden, and weather-worn buildings, but the promise of "A Factory as It Might Be," if the general lot of the worker could be improved. Morris saw the factory as the potential center of a vital community combining production, education, and relaxation with richly functional architecture in harmony with natural surroundings. It could be done but only if the change would come, if the surrounding society were transformed.

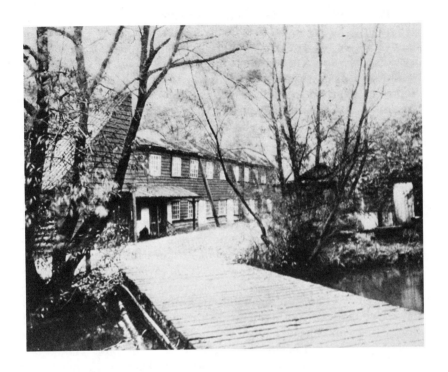

The Merton Abbey Workshop of Morris and Co.

Realizations

In the various awkward and unfortunate efforts which the French have made at the development of a social system, they have at least stated one true principle, that of fraternity or brotherhood. Do not be alarmed; they got all wrong in their experiments, because they quite forgot that this fact of fraternity implied another fact quite as important—that of paternity, or fatherhood.

<div align="right">Ruskin, A Joy Forever (1857)</div>

> We are working *for* equality and brotherhood for all the world,
> and it is only *through* equality and brotherhood that we can
> make our work effective.
>
> Morris, *The Manifesto of the Socialist League*

IN HIS ACCOUNT "How I Became a Socialist" published in *Justice* in
1894, Morris paid tribute to the two who were in open rebellion
against "Whiggery" in the days before "the uprising of *modern* social-
ism," Carlyle and Ruskin, exclaiming: "How deadly dull the world
would have been twenty years ago but for Ruskin! It was through
him that I learned to give form to my discontent, which I must say
was not by any means vague. Apart from the desire to produce beau-
tiful things, the leading passion of my life has been and is hatred of
modern civilization" (M23:279).

By all accounts Ruskin was a force in shaping Morris' discontent
from his first reading of *The Stones of Venice* at Oxford through the
founding of his firm. But those days were from the time of the
Justice article some forty years back, not even a loose twenty, suggest-
ing that Morris had followed Ruskin's crusade against that hated
modern civilization in the 1860s and early 70s and found some satis-
faction in it. He certainly approved of Ruskin's attacks on capitalism,
though E. P. Thompson is surely correct in saying he found no hope
in Ruskin's proposed neofeudal replacement.[36] In the firm and the
creation of *The Earthly Paradise* Morris found a way of combining his
hatred of modern civilization with his love of producing beautiful
things that compensated him for the failures of his private life—a
balance of tensions Ruskin could never achieve and Morris could not
indefinitely sustain. Like Ruskin, Morris needed to convert his pri-
vate frustation into public action against its external equivalent.

It was not only the contradiction implicit in the Ruskinian hopes he
conceived for his firm that moved Morris in the direction of social
action. There was, as his political biographers have emphasized, a
turn in Morris' life that begins with a new literary and historical
model, a turn to the North and saga literature. At first what he
found there was his old story of love and passion, the triangular af-
fair of "The Lovers of Gudrun," but the value Morris eventually de-
rived was not love: "What a glorious outcome of the worship of
Courage these stories are."[37]

Failure in love had left him no refuge from death. "Face to face
seemed I to a wall of stone, / While at my back there beat a boundless
sea."[38] Morris seemed determined upon returning from his second
Iceland journey in 1872 to take command of his life. In poetry he

moved from *Love Is Enough* to *Sigurd the Volsung*. At the cost of considerable unpleasantness he dissolved the original partnership and brought Morris and Co. under his complete personal control. His old ability, noted by Canon Dixon at Oxford, to respond to a poetic world as a substantial entity found a new focus. Like a saga hero he seemed determined not to "die deedless." Like Ruskin, who tried to become his own idea of St. George, Morris, with more success, lived out a literary role, becoming the Victorian equivalent of the warrior bard. "Think of the joy we have in praising great men, and how we turn their stories over and over, and fashion their lives for our joy!—and this also we ourselves may give to the world."[39]

Morris' first three ventures into political action all have Ruskinian roots. First came the Eastern Question which, however complex it may seem in diplomatic and political history, took the popular form of a polarized moral issue to which Ruskin, Morris, and Burne-Jones could all respond. Ruskin had long urged that foreign policy, like private morality, be based on doing the just rather than the expedient thing. Apparently at Burne-Jones' request, Ruskin sent in his name from Venice in 1876 to become a convener of the Eastern Question Association. He wrote to the *Times* hoping they would print the "four little myths that contained what [he] had to say on the question." As the *Times* would not print them, Ruskin did in *Fors*:

> I. St. George of England and Venice does not bear his sword for his own interests; nor in vain.
> II. St. George of Christendom becomes the Captain of her Knights in putting off his armour.
> III. When armour is put off, pebbles serve [David and Goliath].
> IV. Read the Psalm "In Exitu" [Psalm 114].

In the next *Fors* he translates:

> A wise head of the English Government, for instance (Oliver, had he been alive), would have sent word, a year ago, to the Grand Signior, that if he heard a word more of "atrocities" in Bulgaria after next week, he would blow his best palace into the Bosphorus. . . .
> That, I repeat, was the one simple, knightly, English-hearted thing to be done; and so far as the "Interests of England" are concerned, her first interest was in this to *be* England; and not a filthy nest of tax-gatherers and horse-dealers. . . . But the

horse-rider and the man-ruler, which was England's ancient notion of a man, and Venice's also. . . have interests of a higher kind. (XXIX:46,60-61)

Ruskin, however, proceeds to pull the discussion of the Eastern Question into the pattern of his Venetian concerns. He ends the very letter in which he encourages Burne-Jones and Morris in their political effort and hopes "neither Morris nor you will retire wholly again out of such spheres of effort" by telling Burne-Jones: "But the great joy to me was the glimpse of hope of seeing you here [Venice] in the spring" (XXII: xxxviii).[40]

Morris' response to the Eastern Question has the same polarization as Ruskin's. His letter on "England and the Turks" and his pamphlet *Unjust War* castigate those who would "elevate interest over justice" in international affairs, a regular theme of Ruskin's lectures. He condemns the so-called "saviours of England's honour" as Ruskin did:

> Greedy gamblers on the Stock Exchange, idle officers of the army and navy (poor fellows!) worn-out mockers of the Clubs. . . and over all their captain, the ancient place-hunter [Disraeli]. . . . O shame and double shame, if we march under such a leadership as this in an unjust war against a people who are *not* our enemies, against Europe, against freedom, against nature, against the hope of the world.[41]

But whereas Ruskin's denunciation of false leaders is also a Carlylean call for firm ones, Morris' appeal to the Liberal party for leadership is perfunctory compared to his appeal to the working class to come forward to act in its own and the nation's interest, to be collectively its own hero. He supplemented his appeal to "The Working-Men of England" by direct contact with their radical leadership.

Gladstone commanded the loyalty of most of the Victorian intelligentsia, including Morris, as he swept down on Disraeli from the North armed with *The Bulgarian Horrors and the Questions of the East*. Once pulled into the ordinary mechanisms of parliamentary politics and made a Liberal issue, however, the seemingly absolute rights and wrongs of the Eastern Question were absorbed into party maneuvers. To Morris the exercise of Gladstone's political double nature, moral and tactical, amounted to a betrayal of the workmen's cause and he withdrew from Liberal politics feeling besmirched and

discredited. Henceforth, even within the socialist movement, he would be true to the anti-parliamentary stance of Carlyle and Ruskin, so much better suited to the romance polarization of his imagination.

While still embroiled in the Eastern Question (Anti-Turk), Morris began an even more Ruskinian project, the Society for the Protection of Ancient Buildings (Anti-Scrape). This time it was he who wrote to Ruskin, urging Burne-Jones to do likewise, to solicit Ruskin's blessing, which was given as regards the use of his name and writings.[42] Ruskin had argued against restoration from the time of *The Seven Lamps* and even rejected the Gold Medal of the Royal Institute of Architects in 1874 on the ground that its members were contributing to the destruction of Europe's architectural heritage. But from the time he was a young man Ruskin had felt he was born to mourn over what he could not save. He had protested individual outrages, and as Master of St. George's Guild he was employing artists to preserve the record of doomed or decaying buildings, but he never created an organized resistance. Morris in his present mood determined to go beyond letters to the papers and case by case protests to the offending authorities. Despite his feeling that it was really too late, he established the SPAB and served as its first secretary.

The third and most directly Ruskinian action that Morris took in 1877 was to begin giving public lectures linking art and social issues. In "The Beauty of Life" (1880) Morris makes his relationship to Ruskin and the tradition I call "realized romance" explicit, giving one of his many histories of the necessary decline and possible rebirth of art, and in the process his own understanding of the sources of his radicalism. Following Ruskin, he dates the death of popular art from the Renaissance. The potential for genuine rebirth, however, he attributes to the hope "lighted by the torch of the French Revolution," hardly Ruskin's view. That hope had led to the revival of poetry and the English language (with Blake and Coleridge taken as the pioneer figures). "With that literature in which romance, that is to say humanity, was re-born, there sprang up also a feeling for the romance of external nature, which is surely strong in us now, joined with a longing to know something real of the lives of those who have gone before us; of these feelings united you will find the broadest expression in the pages of Walter Scott" (M22:59).[43]

This tradition rooted in Scott, when extended into ostensibly non-fictional history and converted into a model of social reorganization, becomes realized romance. Morris connects this tradition of reborn humanity to the rebellion of the Pre-Raphaelites and of John Ruskin

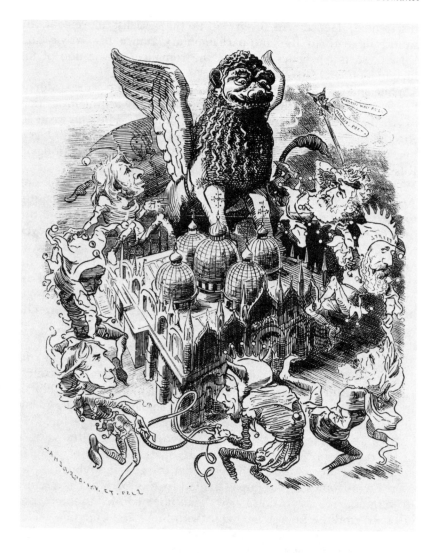

"The Morris Dance Round St. Mark's." The SPAB protests a proposed restoration of the west front, Morris and Ruskin flanking the lion of Mark (*Punch*, January 10, 1880).

himself, whose words Morris says "I am echoing." (Morris, of course, only "echoes" what he takes to be Ruskin's essential message, quietly eliminating the authoritarian and puritanical element incongruous with his own beliefs and character.) And the effect of this

"turning-point of the tide" in "the direction of art"? "There are some few artists who have, as it were, caught up the golden chain dropped two hundred years ago, . . . there are a few highly cultivated people who can understand them; and that beyond these there is a vague feeling abroad among the people of the same degree, of discontent at the ignoble ugliness that surrounds them" (M22:60).

More direct than Ruskin, egalitarian where Ruskin is sympathetic, Morris addresses the discontented in the name of "the Democracy of Art." He looks for ways to break down the barriers between classes, including means Ruskin could recognize and, in his way, endorse: industrial cooperation, universal education tied to vocational training, the foundation of museums (like St. George's Museum), the preservation of ancient buildings and unspoiled natural areas. All is spoken in a direct style Morris was at some pains to forge. Allusions remain, but Ruskin's constant religious and mythic parallelism and his embedding of illustrative narrative have been stripped away. His posture is equally combative, but the dragon he and Ruskin opposed still seems more powerful, and his horror of it more compelling, than anything he can at this point suggest doing about it. Museums and art education can give "people back the eyes we have robbed them of," but, he admits: "it is clear they cannot get at the great mass of people" (M22:138).

Morris presents in more straightforward language Ruskin's picture of commerce as covert warfare. He goes so far as to welcome the interclass warfare Ruskin both predicted and dreaded if it would bring an end to the present order and allow mankind a chance to start over, making class conflict, as E. P. Thompson points out "a species of Götterdämmerung." But the barrier of class remained. Like Ruskin's lectures, Morris' early ventures had no audience below the level of the artisan. He had reached an impasse.

If there was ever anyone ripe for a conversion it was William Morris in the early 1880s. Having, as it were, come out of his version of the Everlasting No and dedicated himself to action, Morris was looking for the new mythus, the belief that would link his personal quest with a social one, his personal faith with a public one. Not content to urge others to action, he longed to join an organization that could now, like the Jacobin Club in *The French Revolution*, send organic filaments through the one vital part of the social order, the working class, and raise it into effective opposition to the forces that oppressed it. He found that faith in Marxism. Marx combined the polarization his imagination demanded with an historical analysis that converted the reaching backward for a social ideal into a

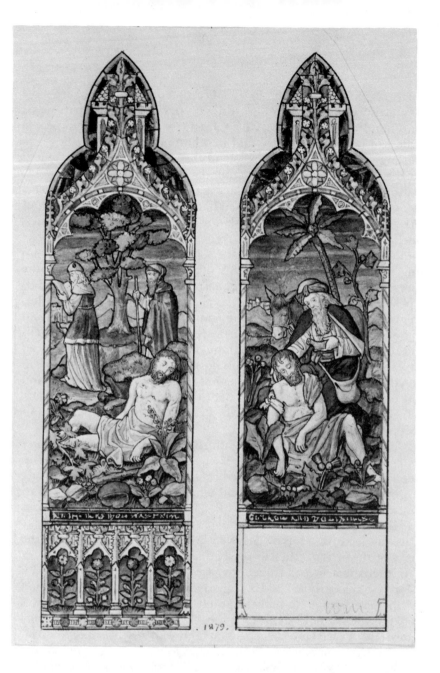

William Morris' design for a stained glass window depicting the good Samaritan (1879). Drawn at the point of transition between his careers in art and social activism, the theme suggests both Ruskinian charity and the emphasis of Morris' socialism on brotherhood.

dialectical progression.

In the historical sections of *Capital* Morris found a different and more hopeful version of the paradigm he had adapted from Ruskin. The very forces that precipitated the English working class "from its golden into its iron age" at the end of the fifteenth century, and led to the slow death of art, contained within it the seeds of its own destruction. The process of capitalist accumulation was effecting both the dispossession and the organization of the working class, thus begetting "with the inexorability of a law of Nature, its own negation."[44] If Morris is "one of the few Marxists who have understood, as Marx did, that in political economy we deal not only with forces outside men's control—the exploiting side of production, in which alienation and reification are concentrated—but also with the very life process of men, in which what is produced and reproduced is not merely commodities, but is men themselves and nature,"[45] it is because of his grounding in Ruskin.

It was in looking back from a socialist perspective that he saw "the *pessimistic* revolt of the latter end of this century led by John Ruskin against the philistinism of the triumphant bourgeois, halting and stumbling as it necessarily was" as showing "that the change in the life of civilization had begun."[46] Looking back to the Paris Commune, Morris, unlike Ruskin, could simply choose sides. "It is for boldly seizing the opportunity offered for thus elevating the mass of the workers into heroism that we now celebrate the men of the Commune of Paris. . . . they quickened and strengthened the ideas of freedom by their courageous action and made our hope of today possible; . . . we honor them as the foundation-stone of the new world that is to be."[47] He inaugurated *Commonweal* with a serial romance in which the unhappy lovers in the triangular situation that haunted Morris' imagination are converted into *The Pilgrims of Hope*. In the heroic measure Morris created for *Sigurd the Volsung* they resolve their personal unhappiness in the cause of the Commune, and the lone survivor, the husband, returns to England bearing the seeds of revolution.

Morris expressed the continuity he found between Ruskin and Marx (and implicitly their differences) directly to his early master in the lecture he gave at University College Oxford in 1883 with Ruskin in the chair, "Art Under a Plutocracy." "ART IS MAN'S EXPRESSION OF HIS JOY IN LABOUR. If those are not Professor Ruskin's words they embody at least his teaching on this subject. Nor has any truth more important ever been stated. . . . For since all men not dishonest must labour, it becomes a question either

of forcing them to lead unhappy lives or allowing them to live unhappily" (M23:173).

Fresh from his reading of *Capital,* Morris explains how changes in the means of production made this unhappiness of the workmen an inevitable part of industrialism, yet at the same time "has welded them into a great class" antagonistic to the capitalist class. Thus, paradoxically, it is only with the overthrow of capitalism and its class distinctions that the middle-class dream of a general revival of art might be possible. Capitalist means of production and class division necessarily destroy art which is, to Morris, the expression of pleasure in labor. He concludes with an appeal to his academic audience couched in the language of romance to choose sides, to cast their lot in with that of the workmen: "organized brotherhood is that which must break the spell of anarchical Plutocracy" (M23:191), the enchantment of social evil.

Ruskin defended Morris' purpose and argument in the uproar that followed his lecture, but chose to recall in print only the portions that advocated joyous labor and opposed plutocratic Oxford to the Oxford of old (XXXIII:386,90). Ruskin had been forced to confront the differences between his views and Morris' as early as 1877 when Lady Burne-Jones sent him a copy of "The Art of the People," but he preferred not to acknowledge them.[48]

Engagement in active politics soon opened gaps between Morris' hopes and his expectations. He found himself willy-nilly thrust into leadership of what was supposed to be a workers' party only to find that his ability to communicate with working-class audiences was circumscribed by the very gap between classes he was striving to close: "it is a great drawback that I can't *talk* to them roughly and unaffectedly. . . . This great class gulf lies between us."[49] He discovered his vision of the future, of man in a state of nature, to be a special one, and the very queston of ends easily lost in debates over means. He realized both the intractability of the opposition and the potential of palliative measures to forestall complete polarization of the classes and so blunt that commitment to revolutionary change he likened to a religion.[50]

Like Ruskin, Morris was engaged in a double effort: to influence both the course of events and the perception of history. He used all the means at his command—journalism, lectures, pamphlets, fiction—both to convert people to the cause and hold up the ideal for which socialists should fight, the pleasure of unalienated labor. Having chosen sides in the class struggle and having found a sustaining ideology, Morris could keep action and vision working together as

Ruskin could not; and while subject to disappointment as prospects of an immediate social transformation faded, he was not subject to despair. He transformed the illusion of summer in December conjured up by the wizard in the Apology to *The Earthly Paradise* into a utopian vision. He turned the poet's "apology" for striving "to build a shadowy isle of bliss" into an assertion of faith in a social revolution that would change the perpetual urban winter of the present order into a pastoral summer. He turned his definition of romance, "the capacity for a true conception of history, a power of making the past part of the present," into a political effort to make the essence of the past, as he understood it, part of the future.[51] His involvement in active politics developed reciprocally with a reworking of romance material rather than a retelling of the old stories.

In the first of his visions of summer, *A Dream of John Ball*, Morris goes back to his version of Ruskin's "Gothic Eden" and confronts his revolutionary progenitor, the preacher of a religion of this earth. Morris built upon Froissart's versions of the sermons that make Ball one of the first to place the Golden Age in the near future rather than the distant past.[52] Like Morris himself, Ball has transformed the communion of the church and hope of heaven into a communion of fellowship and yearning for an earthly paradise fit for the descendants of Adam and Eve, all of whom come into and leave the world theoretically equal. Unlike Morris, Ball can communicate his vision across class lines and cause the "shame and fear" to fall from his listeners despite their oppression because he and his audience are still part of a single cultural community. The very art work of the church in which Ball and the dreamer hold their dialogue reflects both church doctrine and the viewpoint of the artisans who created it. The battle of St. Michael and the dragon above the south porch has an earthly as well as religious implication. In the spirit of John Bromyard who preached of the last judgment as the vengeance of the poor upon their oppressors, the "Doom of the Last Day" is a covert political statement featuring kings, bishops, and lawyers in the clutch of the devil (M16:263).

Morris goes back to John Ball as Carlyle did to Abbot Samson and Ruskin to his historical types of St. George for a model of heroic action. But the message he carries to Ball is disheartening. The movement for individual freedom for which he is to give his life will necessarily lead to the loss of community and exploitation of the "free workman." Because he knows what Ball cannot, the relationship of the dreamer to his hero is necessarily ironic. One by one he undercuts Ball's dreams with Victorian realities. The effect would be

as bitter as any in Ruskin's *Fors* were it not for Morris' conviction that the loss of this flawed medieval paradise is the precondition for the gaining of a perfected one. Through Ball, Morris faces the possibility of at least seeming failure, of disillusionment with the cause. But the fact that community once existed reminds him that commonwealth is possible. That John Ball is himself remembered not as a failure, but as one who embodied "the hope of the Fellowship of Men," gives him renewed courage. Morris is awakened by factory "hooters" from his dream of John Ball rededicated both to John Ball's dream and to his own work rooted in that of Ball's time: "my day's 'work' as I call it but which many a man besides John Ruskin (though not many in his position) would call 'play' "(M16:288).

When Ruskin faced his failure to restore even a piece of English ground to its Edenic state, his crusade gave way to a review of his own life as a series of paradises lost and failed conversions. The pictures of his early life that Ruskin put in *Fors* to help explain his vision of the future became pure retrospection in *Praeterita*. His pleas for conversion of the adult world into a second childhood in which work, like play, can be its own reward became a reversion to his own childhood. Morris took a different turn. He transformed the account of the battles and failures of his own life into his vision of mankind's second childhood in his other vision of summer, *News from Nowhere*.

Morris' political romances had up to this point followed his formula of making the past part of the present whether directly, as in *John Ball*, or by implicit analogy, as in *The House of the Wolfings*. The message brought forward from the recent past in *The Pilgrims of Hope* and the fourteenth century in *John Ball* was of renewed dedication to the struggle. The end of that struggle as Morris imagined it, however, was to make the vital part of the past, all that Morris meant by art, part of the world to be. Morris' quest in *News from Nowhere* is to bring back hope from the future.

"Romance" says Frye, "is nearest of all literary froms to the wish-fulfilment dream. . . . The perenially child-like quality of romance is marked by its extraordinarily persistent nostalgia, its search for some kind of imaginative golden age in time or space." It is "the search of the libido or desiring self for fulfilment that will deliver it from the anxieties of reality but still contain that reality."[53] Certainly *News from Nowhere* is a romance in these terms. Its narrator is alienated at the outset, standing outside himself watching himself function as an angry faction of one pitted against like factions in what is supposed to be a party of comrades. He emerges in the future as *I*, and wakes from his dream in the same condition. The powers that divided him

are objectified once again in the external conditions of life. His struggle against those conditions has been justified though he will never see the great rebellion he places on the centenary of his Oxford matriculation and the writing of "The Nature of Gothic."

In his Marxist critique of Frye, Fredric Jameson locates the historical occasion of romance as those transitional moments when society seems torn between past and future rather then by internal conflicts of class: "Its contemporaries must feel their society torn between past and future in such a way that the alternatives are grasped as hostile but somehow unrelated worlds. The social antagonism involved is therefore quite distinct from the conflict of two groups or classes *within* a given social order." Jameson ties romance generically to an archaic mentality and political reaction, concluding that "the persistence of romance poses problems even graver than those suggested to Marx by the 'normal childhood' of Greek art."[54] Morris, however, belies Jameson's formula. His Marxist faith makes him, as it were, nostalgic for the future. He portrays class conflict as the equivalent of the conflict of Germanic tribesmen against the Romans in *The House of the Wolfings*. His future is, of course, a perfected form of the past. (It could hardly be otherwise.) It is Morris' dream, expressive, as he says all utopias are, "of the temperament of the author." It is easy to see in *Nowhere* the resolution of crises and longings of Morris' personal life. As Old Hammond commenting on the separation and reunion of Dick and Clara he works out in theory and practice the triangular love affair, seeming to account in turn for his marriage, Rossetti's idealization of Jane, and his own attachment to Georgie Burne-Jones.

> "Calf love, mistaken for a heroism that shall be life-long, yet early waning into disappointment; the inexplicable desire that comes on a man of riper years to be the all-in-all to some one woman, whose ordinary human kindness and human beauty he has idealized into superhuman perfection, and made the one object of his desire; or lastly the reasonable longing of a strong and thoughtful man to become the most intimate friend of some beautiful and wise woman, the very type of the beauty and glory of the world." (M16:57)

He dramatizes through the separation and reunion of Dick and Clara the substitution of free companionship for the legal institution of the family. He eliminates paternal authority, and extends family values into communal values—a keystone of Ruskin's economics.

(The tobacco pouch Morris' daughters once made and gave to him reappears in Nowhere the model of "commercial" exchange.) Unlike Ruskin, he can express the erotic impulse of romance without insisting that it be realized only in a controlled, sublimated form. The family as a social institution seems to have disappeared.[55] Here too, stripped of the puritanism and paternalism Morris despised, is Ruskin's vision of unalienated manual labor at harvest and even, shades of the Hincksey Dig, in road building. The countryside is a garden; the people in various and lovely dress in harmony with nature and architecture. "I was having my fill," says Guest, expressing the deepest longing Morris shared with Ruskin,

> of the pleasure of the eyes without any of that sense of incongruity, that dread of approaching ruin, which always beset me hitherto when I had been amongst the beautiful works of art of the past, mingled with the lovely nature of the present; both of them, in fact, the result of the long centuries of tradition, which had compelled men to produce the art, and compelled nature to run into the mould of the ages. (M16:141)

Here enjoyment is free from the thought of injustice, leisure from the thought of others' toil. Love of history need no longer be a compensation for dullness of existence. "The tyranny and the struggle full of fear and mishap which went to make up my romance" have vanished.

The way to utopia is opened by revolution, not reaction. But Morris' revolution is an ideological displacement of romance that, like the fiction of his beloved Dickens, encloses and transforms a demonic "reality." Jameson to the contrary notwithstanding, its central struggle is precisely the division between capital labor imagined as a conflict between those with a common identity and "otherness," between good and evil. Nor is it surprising that Morris should translate Marx into romance. What Robert Tucker terms "myth" in Marx has a romance plot.

> There emerges in *Capital* a vision of class-divided society as two great class-selves at war—the infinitely greedy, despotic, exploiting, viscious, werewolf-self of capital (*Kapitalseele*) on the one hand, and the exploited, enslaved, tormented, rebellious productive self of labour on the other. . . . Thus society is a self-system after all, a collective dual personality.
> Its life-process. . . is an inner drama projected as a social

drama. The *dramatis personae* are My Lord Capital and the Collective Worker . . . [who] wrests the world of wealth away from My Lord Capital [and] the monster is thereby destroyed.[56]

Just as the failures of Morris' personal life find imagined resolution in Nowhere, so do the frustrations of his political life. Bloody Sunday blends with accounts of the Commune to emerge as the first stage of the revolution Marx predicted. An intelligently led, well-disciplined, working-class movement takes collectively the role of St. George and slays the dragon of Capital that had laid waste the land. Marx and Magic transform England into a garden in a blending of personal and political desire. (The heavy barges gliding effortlessly on the Thames of Nowhere are a socialist version of the magic boats of romance and romantic yearning, though, to be sure, imagination necessarily precedes technology.) The distinction between an internal "human" nature and external nature has become a bad memory. Morris imagines men and women free to live simply as self-conscious social animals, able to satisfy every instinctual need—including that of intellectual curiosity—within the limits set by the needs of the community. The urge, not the necessity, to labor has been freed to express itself in art. The future, like the essential part of the Middle Ages, will be the creation of those who make things, not those who control their fellows.

The end of *News from Nowhere* is surprisingly moving. As Guest feels an ever stronger impulse to make physical contact with Ellen, Morris' "new woman" of Utopia, the new Helen who despite herself troubles men's minds, the realization grows that he is the only "otherness" in Nowhere: Morris the alien in his own vision. Ellen is not only a perfected form of the female companion he had sought since the loss of Emma, she is in a complex sense his daughter. In her strength and her direct speech she resembles May Morris, but she is also Morris' daughter in that she embodies the values Morris hoped the revolution would bring forth in her love of the earth and her acceptance of her place upon it as a self-conscious, socially-conscious being.[57] Ruskin's ideal woman, his epipsyche, was forever lost; Morris' yet to be. When the perfected form of the Morris family's communal trip up the Thames arrives at Kelmscott Manor, the symbol of the continuity of past and present in Morris' own life, the dreamer must wake to his own place and function in history. He is destined to labor at the beginning of the change while spreading a vision of its end. He must recover the essence of the past for the sake of the future. Morris' hope for that future fuses his own vocabulary,

which stresses the tribe or nation over the individual family, with the vocabulary of *Unto This Last*. He imagines an England peopled with a "happy and lovely folk who had cast away riches and attained to wealth" (M16:200).

Looking Forward

Cassie:Its all got to do with the work of another socialist furniture maker, William Morris.
Esther: A yiddisha fellow?
Cassie: He was a famous person. He used to say "Machines are all right to relieve dull and dreary work, but man must not become a slave to them."
Esther: So?

Arnold Wesker, *I'm Talking About Jerusalem*

THE "CONDITION OF England" to which Carlyle had called such pointed attention in *Past and Present* was one of inanition in the midst of plenty—of more than adequate production, but inequitable distribution. New methods of production had resulted in new methods of organizing labor, which, in turn, seemed to be disorganizing society, turning human nature against itself. It was a sign of the times that among the unemployed, parents were being driven to feed their families by poisoning the children one by one "to defraud a 'burial society' " (*P&P*, 4). The only constructive alternative Carlyle, and Ruskin after him, could see to this social nightmare that they called in their polemics "laissez-faire" was the imposition of a new form of the old order. Feudalism for all its faults at least recognized mutual responsibility as a social ideal.

For both Carlyle and Ruskin the revival in new form of the old social order was a tale of heroic action. Carlyle called upon industrial dukes to establish permanent contracts with their worker-retainers. Ruskin pleaded for a true nobility to take the place of the pillager: "Knights;—Equites of England . . . who still retain the ancient and eternal purpose of knighthood, to subdue the wicked, and aid the weak" (XVIII:499). That leadership would provide not "every man his chance," the current slogan of the working man, but "every man his certainty" (XVIII:509). Certain of livelihood, the whole people would be free to develop "all the powers of the fingers, and the limbs, and the brain" in hand labor (XVIII:508). To demonstrate that this could

indeed be so, Ruskin determined to be both the prophet of a new order and the hero of his social romance. He created the Guild of St. George with himself as Master to provide what Robert Hewison calls a "counter-image of harmony and plenty" in "contrast to the city of dreadful night in which people were living."[58] Ruskin had no doubt that England had the physical means for providing universal subsistence, shelter and, in the literal sense, social security. All that seemed lacking was the act of collective will that calls hope into being and makes "Man, one harmonious Soul of many a soul / Whose nature is its own divine controul,"[59] the act of will so easy to imagine, yet so very difficult to precipitate. Finally, the difference between a private myth and a social or political movement comes down to converts, and Ruskin's Companions were few.

The genesis of Morris' vision of a future order was as private as Ruskin's. But lacking Ruskin's deep need for external authority, he saw in the emerging class struggle that Ruskin repudiated a chance to link his own discontent with that of an entire social class and make their hopes one. Unlike Ruskin, he was willing to commit himself to an organization that was not of his own imagining, and act heroically in the socialist cause even to the point of risking violence and arrest. Standing before Judge Saunders in 1885 he echoed, perhaps unconsciously, the words of Carlyle's Danton before Fouquier: " 'What are you?' Mr. Morris—'I am an artist, and literary man, pretty well-known I think throughout Europe.' " (My name is Danton, he answers, "a name tolerably known in the Revolution.")

Morris was convinced that capitalism could only be destroyed by those it oppressed, and until it was destroyed the ideal of "every man his certainty" of livelihood and rewarding labor was impossible. "The importance of Morris in this tradition," writes Raymond Williams, looking back on Morris with the same mixture of ironic advantage and respect Morris had in relation to John Ball, "is that he sought to attach its general values to an actual and growing social force: that of the organized working class. This was the most remarkable attempt that had so far been made to break the general deadlock."[60] The result was a theoretical breakthrough but a practical failure, and it must be emphasized that it was not so much a failure in organization as in communication of those "general values" of the Ruskin tradition. The organization of the working class went ahead on other lines, stressing the material reward for labor over its nature, and the creation of an electoral labor party.

Morris' political activity evolved together with his career as a writer of original romances, the action of means together with the literature

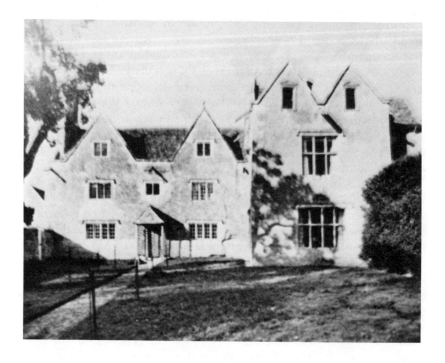

Life into art: Kelmscott Manor, Oxfordshire; Kelmscott
Manor, Nowhere.

of ends. Finally the two could not be held together and Morris re-
mained true to his dream. He ended his socialist days still writing
romances of individual heroism and collective life and telling his
story of how the change might come and what the future could be
like to enthralled listeners at the Hammersmith Socialist Society—an
organization as much his own as the Guild of St. George was
Ruskin's, and one only marginally more successful in directly shap-
ing the future of England. By an ironic twist of history, many young
men went to the front in World War I with the deeds of Morris'
questing heroes in mind, but unlike Ralph, they never passed
through the blasted landscape to the well at the World's End, but
perforce remained amid such scenes as the corpse-clotted canal at
Ypre which recalled to Hugh Quigley "the poison pool under the
Dry Tree in Morris, around which lay the bodies of men with 'dead

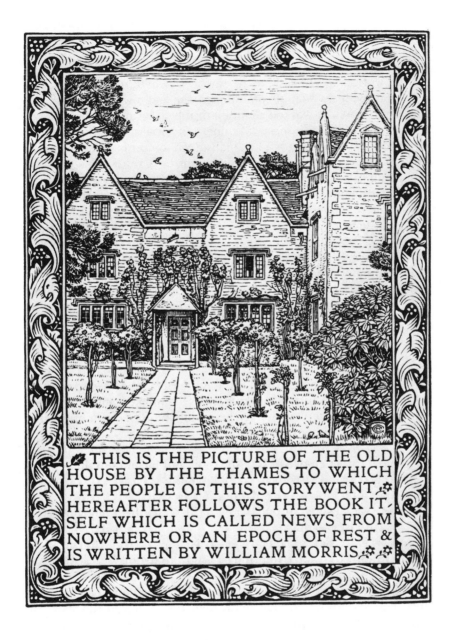

THIS IS THE PICTURE OF THE OLD HOUSE BY THE THAMES TO WHICH THE PEOPLE OF THIS STORY WENT HEREAFTER FOLLOWS THE BOOK ITSELF WHICH IS CALLED NEWS FROM NOWHERE OR AN EPOCH OF REST & IS WRITTEN BY WILLIAM MORRIS

leathery faces . . . drawn up in a grin, as though they had died in pain.' "[61]

Like Ruskin, Morris had begun with the assumption that capitalism and industrialism were one and the same, that to destroy capitalism

would be to destroy the division of labor and with it the self-divisions
of the workman. His task, as he saw it, was both to make socialists
and to provide a vision of communism, the end toward which social-
ism aspired. As he worked so indefatigably at his double task he be-
gan to realize that the social machinery of socialism might take over
the productive machinery of capitalism without in fact destroying it,
that the movement to communism might be arrested by a concern
for productive rather than human potential. The fact that Morris'
specific influence is more often discussed in artistic *rather* than politi-
cal terms suggests Morris' failure to convince many outside of his
class or the world of art that the cause of art was indeed that of the
people.

In *I'm Talking About Jerusalem,* Arnold Wesker dramatizes through
Dave Simmonds the nature of Morris' influence and his dilemma as a
propagandist. A Pilgrim of Hope who had fought against Franco,
fought against the Axis powers, Simmonds returns from the War at
the moment of the Labour party's triumph, determined to live his
socialism by making things with his hands. The Morris dream has
become Ruskinian quixotism. Before his ultimate surrender to the
economic and social order in which he is condemnned to live,
Simmonds faces the failure Morris felt so often as he tried to present
his vision of the future to working men. Simmonds cannot convince
his own apprentice that the joy he admits he found in design and
creation is more important than regular day wages.

> *Dave:* . . . you enjoyed using the tools and making up that de-
> sign. I can remember watching you. . . .
> *Sammy:* Hell, that were only messing around.
> *Dave: Not* messing around, Creating! For the sheer enjoyment
> of it just creating.
> *Sammy:* . . . but I want to get on [shades of the Athena of
> Bradford]—don't you think I ought to get on?[62]

While the futures that Ruskin and Morris imagined were very dif-
ferent in social organization, both men responded to the sense of
overcomplexity and inner division in their lives and times by imagin-
ing the future as a new Eden of romance, an epoch of rest after one
of restlessness and anxiety; of simplicity and necessities after com-
plexity and, for the few, luxury. It may be true that "such a union of
past and future in a present vision of a pastoral, paradisal, and radi-
cally simplified form of life obviously takes on a new kind of urgency
in an age of pollution and energy crisis, and helps explain why

romance seems so contemporary a form of literary experience."[63] It does not follow from this, however, that "if the earth is not to be a radioactive waste, it will surely become something like Morris' garden forest."[64] Neither Ruskin nor Morris imagined mankind being driven *into* Eden by a fiery sword, and the circumstances that have brought their visions of harmony with nature back into vogue are not those from which they began. *Ecology* is not their word. Morris himself was wiser: "I pondered all these things, and how men fight and lose the battle, and the thing that they fought for comes about in spite of their defeat, and when it comes turns out not to be what they meant, and other men have to fight for what they meant under another name" (M16:231-2).

My concern has been with what Ruskin fought for and what he meant. I have tried, insofar as one can, to look past the modern circumstances that at once keep his thought alive and necessarily distort it, to examine it in its Victorian context. To that end I have selectively examined its personal and historical genesis, its relationship to the thought of one who came before, and its bearing on the life and thought of one who came after. Ruskin's crusade thus takes its place in a particularly Victorian strain of social criticism that sought to heal the splits within man and between mankind and nature by leading England into a literal Eden at the end of a realized romance.

Notes

Introduction

1. "Accounts of St. George's Guild," for 1877-79. Ruskin had left Denmark Hill for Brantwood in 1872. R. H. Wilenski plausibly suggests that the phrase was "an oral image of long standing." *John Ruskin* (London: Faber & Faber, 1933), p. 176.

2. Northrop Frye, *The Secular Scripture* (Cambridge: Harvard University Press, 1976), p. 173.

3. Gaylord LeRoy, *Perplexed Prophets* (Philadelphia: University of Pennsylvania Press, 1953), pp. 89, 91.

4. W. G. Collingwood, *The Life of John Ruskin* (London: Methuen, 1900), p. 381.

5. Henry Melvill, "Nehemiah before Artaxerxes," *Sermons on . . . Less Prominent Facts and References in Sacred Story* (London: Rivington, 1843), p. 124.

6. John Holloway did not include Ruskin in *The Victorian Sage* (New York: Norton, 1965), but his thesis applies to Ruskin as well as the writers he discusses. "What [the sage] has to say is not a matter just of 'content' or narrow paraphrasable meaning, but is transfused by the whole texture of his writing as it constitutes an experience for the reader," p. 10. See also George Levine, *The Boundaries of Fiction* (Princeton: Princeton University Press, 1968).

7. "He *raves* in the same clear voice and exquisite inflection of tone, the most unmeaning words—modulating them now with sweet tenderness, now with fierceness like a chained eagle—short disconnected sentences, no one meaning anything, but beautiful to listen to for the mere sound, like the dashing of Niagara." Sir Henry Acland to Mrs. Gladstone, March 10, 1878 in Mary Drew, *Mrs. Gladstone* (New York: Putnam, 1920), p. 162. Only the mad Ruskin is pure style.

8. Raymond Williams, *Culture and Society* (London: Penguin, 1963), p. 152.

9. *The Spirit of the Age*, F. A. von Hayek, ed. (Chicago: University of Chicago Press, 1942), pp. 35-36, 81.

10. E.g., Alice Chandler, *A Dream of Order* (Lincoln: University of Nebraska Press, 1970).

11. Harold Bloom, "The Internalization of Quest Romance," in *The Ringers in the Tower* (Chicago: University of Chicago Press, 1971), p. 16.

12. Matthew Arnold's story of social renewal, by comparison, has a comic structure emphasizing the reconciliation of classes and conflicting points of view under the aegis of sweetness and light rather than the victory of one

class or system. Its contrary is not irony but tragedy, the failure of "the saving remnant," the rejection of genius that then "foams itself away / Upon the reefs and sandbanks of the world," and dies "fruitless, having found no field." ("Fragments of 'Lucretius' "). The "possible Socrates" in each of us may be offered no drink but hemlock. To be sure, in his urge to avoid social tragedy Arnold was prepared to conclude his comedy with something close to a shotgun wedding—force until right (or *Zeit*) is ready. But the fact that discussion of Arnold's authoritarian streak has so often concentrated on whether or not it is consistent with his liberalism is a result of the mode in which he presents his work as well as its political content.

For an extended comparison of Ruskin and Arnold as social critics see Edward Alexander, *Matthew Arnold, John Ruskin, and the Modern Temper* (Columbus: Ohio State University Press, 1973).

13. For Carlyle and *A Tale of Two Cities* see Michael Goldberg, *Carlyle and Dickens* (Athens: University of Georgia Press, 1972), pp. 100-29; for romance, realism, and redemption in the structure of Dickens' plots see Edwin M. Eigner, *The Metaphysical Novel in England and America* (Berkeley: University of California Press, 1978); for the mixture of genres in Victorian fiction generally see Peter K. Garrett, *The Victorian Multiplot Novel* (New Haven: Yale University Press, 1980). For romance and irony as literary mythoi, see Northrop Frye, *The Anatomy of Criticism* (Princeton: Princeton University Press, 1957), ch. 3.

14. The Book of Chronicles was sometimes called *Praeterita* because it recorded "things passed over" in Kings.

Growth and Losses

1. C. E. Norton, ed., *Letters of John Ruskin to Charles Eliot Norton* (Boston: Houghton Mifflin, 1905), 2:62.

2. *An Introduction to the Critical Study and Knowledge of the Holy Scriptures*, 2d ed., 4 vols. (London: Cadell, 1821).

3. *John Ruskin*. Wilenski is probably correct in asserting that Ruskin suffered from manic-depression, but not in making this diagnosis the key to his thought—particularly in the years in which Ruskin's swings in mood were subclinical.

4. Letter to Mrs. Simon in *BD*:541.

5. There is a fascinating example of the multiple perspectives *Dilecta* might have afforded us in Ruskin's account of Frederick Denison Maurice and the lesson of Jael with the letter of reply by J. M. Ludlow and Tom Hughes (XXXVI:486-91).

6. *D*1:332. For an account of *Praeterita* as a sequence of failed conversions and new perspectives revealing a basically unchanging sensibility see Elizabeth K. Helsinger, "Ruskin and the Poets: Alternations in Autobiography," *MP* (November 1976), 74:142-70. Avrom Fleishman focuses on garden and fall topoi in "*Praeterita*: Ruskin's Enclosed Garden," *Texas Studies in Literature and Language* (Winter 1980), 22:547-58. Jay Fellows reads all of Ruskin's

work as variations of a phenomenological autobiography in *The Failing Distance* (Baltimore: Johns Hopkins University Press, 1975).

7. John D. Rosenberg, *The Darkening Glass* (New York: Columbia University Press, 1963), p. 1.

8. Ruskin to Mrs. Carlyle, July 18, 1865, in George Allen Cate, ed., *The Correspondence of Thomas Carlyle and John Ruskin* (Ann Arbor: University Microfilms, 1967), p. 233. Though incomplete, this Duke University Ph.D. dissertation is the largest collection of Carlyle-Ruskin correspondence available pending publication of a revised version and will be cited hereafter in the text as Cate.

9. One difference between Mrs. Ruskin's example and her son's later ideal is Ruskin's emphasis upon the wife's influence beyond the home in active charity. See chapter 3.

10. Ruskin to Dr. Acland, J. L. Spear, ed., *TLS* (February 10, 1978), p. 167. Also in Virginia Surtees, *Reflections of a Friendship* (London: Allen & Unwin, 1979), p. 271.

11. Such memorable early experiences in *Praeterita* as Ruskin's learning the principles of architectural engineering from his building blocks have their model in Maria Edgeworth's *Frank*.

12. *FL*:173. When Mary died in 1849, however, shortly after her marriage to Parker Bolding, her loss was lamented by all the Ruskins, for she had been a living link to the past.

13. "I would calculate the rainfall on the entire acreage of it [the mountain side]—and raise embankments across hollow spaces in its flanks, which would give me reservoir enough to let off double the rainfall into: then I would run terraced trenches along the firm rocks, which should stop all the rain on the sound surfaces and carry it to the reservoirs—and nothing (but what fell exactly over their area and into them) should get into the gullies of loose gravel;—in them I would sow bent grass—and secure the slopes gradually—until instead of the drainings of a whole mountain side gathered into one rotten gulph of ravine, and sent down in a thunderous deluge, I had mere threads of soft stream led into reservoirs at different heights—and a month's verdure at my command in future drought." To John Simon from Milan, May 7, 1864, unpublished, Morgan Library. Ruskin wrote in a like vein to Norton, the Cowper-Temples and other friends. To compare Ruskin's proposals with current flood control measures and problems see Dr. H. Aulitzky, *Endangered Alpine Regions and Disaster Prevention Measures* (Council of Europe, 1974), pp. 32-94 passim.

14. Ruskin did, in fact, design a functional water system for the village of Fulking, Sussex: see XXXIV:719.

15. The struggle to keep the stream pure finally failed when the water commissioners ran a storm sewer into it (XXII:533).

16. Northrop Frye, *The Secular Scripture* (Cambridge: Harvard University Press, 1976), p. 173.

17. Helen Viljoen grounds the social uneasiness of the elder Ruskins, which was necessarily conveyed to Ruskin even as he was being brought up to overcome it, in the circumstances of their own upbringings. *Ruskin's Scottish*

Heritage (Urbana: University of Illinois Press, 1956).

18. Pride here mingled with legitimate worry about the entrance exam for commoners. Derrick Leon, *Ruskin, The Great Victorian* (1949; reprinted Hamden Conn.: Achron, 1969), p. 41. Dean Kitchen thought Ruskin, who had not been to public school and so knew no games, benefited from a measure of tolerance among the gentlemen that he would not have found among the commoners. G. W. Kitchen, *Ruskin in Oxford* (New York: Dutton, 1904), pp. 6-9. See also two new biographies: Joan Abse, *John Ruskin, The Passionate Moralist* (New York: Knopf, 1980) and John Dixon Hunt, *The Wider Sea* (London: Dent, 1982), the finest interpretive biography of Ruskin since Leon's.

19. *Clownish* still carried the sense of ill-bred rusticity.

20. Ruskin seems to have blended this episode in the telling with memory of Miss Edgeworth's Frank, who learned about being sent to Coventry, but not about the etiquette of essay reading. *Frank* (New York: Harper, 1856), 2:191. Ruskin wrote to his father about the essay episode, but none of the remarks he quotes mention his being sent—or not sent—to Coventry.

21. Ruskin's account of his Oxford years was colored by the disappointment with which his professorship ended and his not entirely unjustified feeling that the university had not been properly grateful for the works of art and the School and Mastership of Drawing with which he had endowed it. He expresses similar sentiments in an abandoned Preface to *St. Mark's Rest* in the Princeton University Library.

22. Mrs. Ruskin's letters from Oxford are studded with references to lords and the social status of her son's associates.

23. Cannon Scott Holland quoted in George Wyndham, ed., *Letters to M. G. and H. G.* (Mary and Helen Gladstone) (New York: Harper, 1903), p. 121.

24. "I never think anybody likes me—I fancy the best they can do is to put up with me—somehow I never feel as [if] they *could* like me. I always thought you fond of my father, and that you endured me a good deal for his sake" (XXXVI:473) —this in 1864 to George Richmond, a man but ten years older than himself with whom he had been on close terms since 1840.

25. Ruskin told Collingwood that he called Mrs. Cowper-Temple Isola "because she is so unapproachable," but Collingwood knew, having seen Ruskin's letters to her, that he found "haven and rest in her sympathy." In the letter in which he seems first to address her as Isola he adds: "bella understood, of course—and the lago—che si fa sempre maggiore" (cf. Tintoretto on painting, IV:27). Ruskin was writing in early 1870, at a time when accounts of his marriage were being used to influence Rose La Touche against him. Having visited the Isola Bella several times, he surely knew from the guidebooks that it was the isle of refuge for the landscape painter Tempesta who fled there when accused of murdering his wife. Mrs. Cowper-Temple was a refuge both as comforter and as an intercessor with Rose on his behalf. Ruskin's personification of Mrs. Cowper-Temple thus has the same multivalence as the titles of his later books. W. G. Collingwood, "Ruskin's 'Isola' " in *Ruskin Relics* (New York: Crowell, 1904), pp. 215, 225; *M-T*:252.

26. February 4, 1880. For the complete text see my selected edition of Ruskin-Norton correspondence, "My Darling Charles," in J. D. Hunt, ed., *The Ruskin Polygon* (Manchester: University of Manchester Press, 1982), p. 275.

27. See *The Golden Legend*. Ruskin's Victorian fondness for pet names gradually degenerated into maudlin baby talk.

28. To Norton, February 23, 1874 in "My Darling Charles." The painting is Carpaccio's *St. George*. Ruskin's diary for that date makes it clear that this particular dragon was his anger at Mr. La Touche.

29. *Praeterita*, XXXV:392 ff, *Fors*, Letter 26, "Crocus and Rose" (originally "St. George's Story"), XXVII:473 ff. Ruskin, in true medieval fashion, claimed for his patron, St. Anthony of Padua, the domestic animals of St. Anthony Abbot, specifically the pig (see XXVII:328, XXXV:392 for the saint and representative pig rhymes). In the depiction of St. Anthony Abbot, the pig is either a foe, the embodiment of one of the lusts to be overcome, or his positive attribute as patron of the Hospitalers and swineherds. Ruskin began to receive messages from Rose as St. Ursula when he was in Venice in 1876-77. January 7: "she has helped me ever since, but I had a terrible fight with my piggish disbelief and with the devil's trials yesterday" (*D*:929).

30. "Last night as John was going to bed some of your musical friends came to the gate and began playing very sweetly. John sent down to beg I would not send them away he was so delighted I indulged him by letting them play a few times . . ." *FL*:245. Mr. Ruskin, moreover, seems to have offered a tacit alliance to his son in subversion of his wife's high moral tone: "Our letters may be strictly *Confidential*—you know you & I are often greatly amused by trifles—we can unbend from our severe studies, unknit our learned Brows & be vastly entertained whilst others [Mrs. R?] only wonder at our seeming folly," March 8, 1831, *FL*:236). I owe this suggestion to John Dixon Hunt.

31. See for example the story of Turner's "Splügen," lost to Mr. H. A. J. Munro of Novar, and which Ruskin's father was never able to obtain for him (XXXV:310). It was ultimately purchased for Ruskin by public subscription and presented to him when he recovered from his 1878 illness (XXXVII:245-46).

32. Sermon X, unpublished MS, Morgan Library. These views are not precisely those Ruskin came to hold, but they anticipate his mature rejection of the gold standard and his investigation of the true meaning of *value*. George Landow quotes other passages of this sermon in *The Aesthetic and Critical Theories of John Ruskin* (Princeton: Princeton University Press, 1971).

33. Frank Kermode discusses the distinction between *Chronos* and *Kairos* time in relation to fiction in *The Sense of an Ending* (London: Oxford University Press, 1968), p. 46 ff.

34. Patrick Fairbairn, *The Typology of Scripture*, 2 vols., 9th ed. (New York: N. Tibbals, n.d.), 1:130. George Landow explores this topic in chapter 5 of *The Aesthetic and Critical Theories* and in "There Began To Be a Great Talking About the Fine Arts," in Josef Altholz, ed., *The Mind and Art of Victorian England* (Minneapolis: University of Minnesota Press, 1976), and most recently in *Victorian Types, Victorian Shadows* (London: Routledge, 1980).

35. Fairbairn, *Typology*, 1:117.

36. Hans Frei, *The Eclipse of Biblical Narrative* (New Haven: Yale University Press, 1974), pp. 4-5.

37. Henry Melvill, *Sermons*, 2 vols. (New York: Stanford and Swords, 1849), 1:338. Cf. Landow, *Victorian Types*, chapter 7.

38. The network of texts and interpretations suggested by Ruskin's references to "vile figs" illustrates the allusive nature of Ruskin's references to works he constantly reread and knew virtually by heart, especially the Bible. Such quotations imply far more than they state. Fairbairn discusses the figs passage in Jeremiah in an earlier edition of *The Typology of Scripture* (Philadelphia: Daniels & Smith, 1852), p. 300.

39. John Brown's *The Self-Interpreting Bible* was commonly used in the Scottish Secession churches, so Carlyle was probably familiar with it. Brown was the author of a book on typology and his annotations frequently expound on types. Herbert L. Sussman notes this common element in the work of Carlyle and Ruskin but does not examine its divergent sources: *Fact into Figure* (Columbus: Ohio State University Press, 1979), pp. 5-30.

40. June 25, 1870, Morgan Library; XX:liii. For other examples of Ruskin's identification with his historical namesakes see Alice Hauck, "John Ruskin's Uses of Illuminated Manuscripts: The Case of the Beaupré 1853-56," *Arts Magazine* (Spring 1981), 56:79-83.

41. Karl Popper, *The Open Society and Its Enemies*, 5th ed. (London: Routledge, 1966), 1:32.

42. *Geology and Minerology Considered with Reference to Natural Theology* (London: William Pickering, 1836), p. 25.

43. Fairbairn, *Typology*, 1:78, 81. Landow cites this passage against "students of Victorian culture . . . accustomed to considering Evangelicalism and evolutionary theory as inevitably conflicting with each other" (*Victorian Types*, pp. 10-11), but the doctrine of "successive creations" is *not* evolutionary in the modern, post-Darwinian sense of the word, only with reference to God's plan for creation in the earlier Victorian sense of "unfolding" as from a seed. It involved no transmutation from one species into another. See Peter J. Bowler, "The Changing Meaning of 'Evolution'," *Journal of the History of Ideas* (January-March 1975), 36:95-114. Darwin's theory was incompatible with essentialism because natural selection requires no teleological purpose. This was poorly understood by those like the Duke of Argyll who tried to advance a "providential evolution." See Neal C. Gillespie, *Charles Darwin and the Problem of Creation* (Chicago: University of Chicago Press, 1979), chapter 5. Ruskin too insisted on purpose and was hostile to Darwinism even when he grudgingly admitted its likelihood. Darwin, of course, like Ruskin, was a student of Lyell, but he never let his religious misgivings stop his inquiry. See Michael T. Ghiselin, *The Triumph of the Darwinian Method* (Berkeley: University of California Press, 1969); Thomas Kuhn, *The Structure of Scientific Revolutions* (Chicago: University of Chicago Press, 1970), pp. 171-73.

44. Ruskin's quotation of his early poem indicates once again how deeply rooted was his conviction that moral and physical law were ultimately one.

45. For other instances, see *The Queen of the Air* (XIX:296 ff) and *Proserpina* (XXV:415).

26. February 4, 1880. For the complete text see my selected edition of Ruskin-Norton correspondence, "My Darling Charles," in J. D. Hunt, ed., *The Ruskin Polygon* (Manchester: University of Manchester Press, 1982), p. 275.

27. See *The Golden Legend*. Ruskin's Victorian fondness for pet names gradually degenerated into maudlin baby talk.

28. To Norton, February 23, 1874 in "My Darling Charles." The painting is Carpaccio's *St. George*. Ruskin's diary for that date makes it clear that this particular dragon was his anger at Mr. La Touche.

29. *Praeterita*, XXXV:392 ff, *Fors*, Letter 26, "Crocus and Rose" (originally "St. George's Story"), XXVII:473 ff. Ruskin, in true medieval fashion, claimed for his patron, St. Anthony of Padua, the domestic animals of St. Anthony Abbot, specifically the pig (see XXVII:328, XXXV:392 for the saint and representative pig rhymes). In the depiction of St. Anthony Abbot, the pig is either a foe, the embodiment of one of the lusts to be overcome, or his positive attribute as patron of the Hospitalers and swineherds. Ruskin began to receive messages from Rose as St. Ursula when he was in Venice in 1876-77. January 7: "she has helped me ever since, but I had a terrible fight with my piggish disbelief and with the devil's trials yesterday" (*D*:929).

30. "Last night as John was going to bed some of your musical friends came to the gate and began playing very sweetly. John sent down to beg I would not send them away he was so delighted I indulged him by letting them play a few times . . ." *FL*:245. Mr. Ruskin, moreover, seems to have offered a tacit alliance to his son in subversion of his wife's high moral tone: "Our letters may be strictly *Confidential*—you know you & I are often greatly amused by trifles—we can unbend from our severe studies, unknit our learned Brows & be vastly entertained whilst others [Mrs. R?] only wonder at our seeming folly," March 8, 1831, *FL*:236). I owe this suggestion to John Dixon Hunt.

31. See for example the story of Turner's "Splügen," lost to Mr. H. A. J. Munro of Novar, and which Ruskin's father was never able to obtain for him (XXXV:310). It was ultimately purchased for Ruskin by public subscription and presented to him when he recovered from his 1878 illness (XXXVII:245-46).

32. Sermon X, unpublished MS, Morgan Library. These views are not precisely those Ruskin came to hold, but they anticipate his mature rejection of the gold standard and his investigation of the true meaning of *value*. George Landow quotes other passages of this sermon in *The Aesthetic and Critical Theories of John Ruskin* (Princeton: Princeton University Press, 1971).

33. Frank Kermode discusses the distinction between *Chronos* and *Kairos* time in relation to fiction in *The Sense of an Ending* (London: Oxford University Press, 1968), p. 46 ff.

34. Patrick Fairbairn, *The Typology of Scripture*, 2 vols., 9th ed. (New York: N. Tibbals, n.d.), 1:130. George Landow explores this topic in chapter 5 of *The Aesthetic and Critical Theories* and in "There Began To Be a Great Talking About the Fine Arts," in Josef Altholz, ed., *The Mind and Art of Victorian England* (Minneapolis: University of Minnesota Press, 1976), and most recently in *Victorian Types, Victorian Shadows* (London: Routledge, 1980).

35. Fairbairn, *Typology*, 1:117.

36. Hans Frei, *The Eclipse of Biblical Narrative* (New Haven: Yale University Press, 1974), pp. 4-5.

37. Henry Melvill, *Sermons*, 2 vols. (New York: Stanford and Swords, 1849), 1:338. Cf. Landow, *Victorian Types*, chapter 7.

38. The network of texts and interpretations suggested by Ruskin's references to "vile figs" illustrates the allusive nature of Ruskin's references to works he constantly reread and knew virtually by heart, especially the Bible. Such quotations imply far more than they state. Fairbairn discusses the figs passage in Jeremiah in an earlier edition of *The Typology of Scripture* (Philadelphia: Daniels & Smith, 1852), p. 300.

39. John Brown's *The Self-Interpreting Bible* was commonly used in the Scottish Secession churches, so Carlyle was probably familiar with it. Brown was the author of a book on typology and his annotations frequently expound on types. Herbert L. Sussman notes this common element in the work of Carlyle and Ruskin but does not examine its divergent sources: *Fact into Figure* (Columbus: Ohio State University Press, 1979), pp. 5-30.

40. June 25, 1870, Morgan Library; XX:liii. For other examples of Ruskin's identification with his historical namesakes see Alice Hauck, "John Ruskin's Uses of Illuminated Manuscripts: The Case of the Beaupré 1853-56," *Arts Magazine* (Spring 1981), 56:79-83.

41. Karl Popper, *The Open Society and Its Enemies*, 5th ed. (London: Routledge, 1966), 1:32.

42. *Geology and Minerology Considered with Reference to Natural Theology* (London: William Pickering, 1836), p. 25.

43. Fairbairn, *Typology*, 1:78, 81. Landow cites this passage against "students of Victorian culture . . . accustomed to considering Evangelicalism and evolutionary theory as inevitably conflicting with each other" *(Victorian Types*, pp. 10-11), but the doctrine of "successive creations" is *not* evolutionary in the modern, post-Darwinian sense of the word, only with reference to God's plan for creation in the earlier Victorian sense of "unfolding" as from a seed. It involved no transmutation from one species into another. See Peter J. Bowler, "The Changing Meaning of 'Evolution'," *Journal of the History of Ideas* (January-March 1975), 36:95-114. Darwin's theory was incompatible with essentialism because natural selection requires no teleological purpose. This was poorly understood by those like the Duke of Argyll who tried to advance a "providential evolution." See Neal C. Gillespie, *Charles Darwin and the Problem of Creation* (Chicago: University of Chicago Press, 1979), chapter 5. Ruskin too insisted on purpose and was hostile to Darwinism even when he grudgingly admitted its likelihood. Darwin, of course, like Ruskin, was a student of Lyell, but he never let his religious misgivings stop his inquiry. See Michael T. Ghiselin, *The Triumph of the Darwinian Method* (Berkeley: University of California Press, 1969); Thomas Kuhn, *The Structure of Scientific Revolutions* (Chicago: University of Chicago Press, 1970), pp. 171-73.

44. Ruskin's quotation of his early poem indicates once again how deeply rooted was his conviction that moral and physical law were ultimately one.

45. For other instances, see *The Queen of the Air* (XIX:296 ff) and *Proserpina* (XXV:415).

46. Like the German Romantics, Ruskin creates what Frye (after Schiller) calls a sentimental version of the fairy tale. Like the Germans, Ruskin makes the landscape of his tale morally significant, and the valley female. But unlike the Germans, whose tales usually involve some form of adult sexuality, Ruskin's tale restores the pregenital paradise from which the hero of romance is usually permanently expelled. In the story from which Ruskin takes the basic pattern of his tale and the stone motif, "The Golden Water" in the Arabian Nights, (a tale, Ruskin said, that had immense, but unexplained, power over his own life) the third sibling, the model of Ruskin's Gluck, is a girl (XXXV:679). For Ruskin as Eve in Eden see p. 59.

47. The "law of three" was formulated by Axel Olrik in "Epic Laws of Folk Narrative," translated and reprinted in Alan Dundes, ed., *The Study of Folklore* (Englewood Cliffs: Prentice Hall, 1965), pp. 129-41.

48. Charles T. Dougherty develops this opposition in Bernice Slote, ed., "Ruskin's Gardens," *Myth and Symbol* (Lincoln: University of Nebraska Press, 1967).

49. Cf. "Of Kings' Treasuries," XVIII:70 ff. and *Time and Tide*, XVII:376 ff. George Landow rightly objects to crudely didactic readings of *The King of the Golden River*, but by insisting that "the understanding of these ideas is at most a secondary experience and not the primary one intended" he seems to perpetuate an un-Ruskinian split between the moral and the imaginative. See "And the World Became Strange: Realms of Literary Fantasy," *Georgia Review* (Spring 1979), 32:14. Fairy tales in their original, unmoralized form are "the remnant of a tradition possessing true historical value,' Ruskin argued, hence their demons and fairies "keep both an accredited and vital influence upon the character and mind" (XIX:236,38). In publishing his own fairy story Ruskin must have hoped for a like effect.

50. Ruskin was refused by Charlotte Lockhart; indeed whether he ever went so far as to actually propose marriage is uncertain. See *EV*:7-13.

51. Male only children have a higher than average rate of broken engagements, separations, and divorces. "The only child often seems to marry with even more idealistic and sometimes unrealistic expectations about what the marital relationship is to be than the average person." Lucille Forer, *Birth Order and Life Roles* (Springfield: Charles Thomas, 1969), p. 87. According to Walter Toman's *Family Constellation*, 3rd ed. (New York: Springer, 1976), the male only child is particularly attracted to older sisters of brothers (Effie) and may be attracted to younger sisters provided they are much younger than he (Rose).

52. Even during their courtship Effie had a smile that Ruskin somehow distrusted, even feared: "Only pray tell me what it means—or I shall be *so* frightened when I see it lest it should mean that I have been naughty." Sir William James, *The Order of Release* (London: John Murray, 1947), p. 58. After Effie left him Ruskin was to complain that when he married he had no skill in reading faces except on canvas. Ruskin's drawing of Effie in the Ashmolean (1850?) is remarkably cold in expression. The drawing is reproduced in *RG* and Robert Hewison, *Ruskin and Venice* (London: Thames and Hudson, 1978).

53. In the terminology of Walter Toman's *Family Constellation*, Effie was definitely a "senior." Toman's composite portrait of the older sister of brothers fits Effie quite closely:

> She loves to take care of men. . . . She gladly provides whatever she can contribute to make life and work more pleasant for them. If something big is at stake, she does not take it, nor the men involved in it, very seriously. She does, however, consider their subjective well-being and their belief in the project as being important. . . . The men in her charge are her main concern but she does treat them like little boys. . . .
>
> What she cannot bear, however, is solitude. Being separated from or rejected by a man whom she respects can hurt her deeply. She may not show it, but she will suffer from this sort of thing for a long time and may, under certain circumstances, turn into a man-hater. The first male, however, who is willing to listen to her and to trust her can change her mind. . . .
>
> "Her best partner would be the youngest brother of sisters." (pp. 177-79)

We see some of these traits in glimpses of how Effie managed George in Ruskin's diary, December 12, 1843. Effie from the start felt that Ruskin ignored and rejected her; Ruskin, that Effie had no intrinsic interest in his work. Millais was the youngest brother of a sister and a brother, and called her, half in jest, "the Countess" on the fateful journey to Scotland. Her skill in managing things great and small for Millais was evident as soon as they married.

54. March 6, 1848, partially transcribed in Sotheby's *Catalogue of Valuable Autograph Letters . . .* for December 1979, p. 155.

55. Janet Dunbar gives a brief description of the medical responsibilities of the Victorian wife in her chapter "Home and the Family" in *The Early Victorian Woman* (London: George Harrod, 1953).

56. James, *Release*, pp. 84, 82.

57. June 10, 1849, Sotheby's *Catalogue*, p. 156.

58. As early as June 1853 Effie seems to have presented her entire case against the Ruskins, save only the nonconsummation of the marriage, to Chichester and Harriet Fortescue. See D. W. Hewett, ed., ". . . And Mr. Fortescue," *A Selection from the Diaries 1851-1862* (London: John Murray, 1958), pp. 50-57.

59. Mary Lutyens gives a vivid picture of the extreme tensions under which Effie labored at this time in *MR.*

60. *TLS*, February 10, 1978. Also Surtees, *Reflections of a Friendship*, p. 274; for Effie as Lady Olivia, p. 272.

61. *Ibid.*, Ruskin's initial response when she threatened him with the law was "And if I was to take all the blame?" (*MR*:156). The defense Ruskin prepared for his solicitor, but never used, is reprinted in J. H. Whitehouse, *Vindication of Ruskin* (London: Allen & Unwin, 1950), p. 15.

62. To F. J. Furnivall, Whitehouse, *Vindication*, p. 28.

63. To Lady Trevelyan, May 8, and June 5, 1854, *Reflections*, pp. 79, 81.

64. Raleigh Trevelyan, *A Pre-Raphaelite Circle* (London: Chatto & Windus, 1978), p. 103.

65. *D*:503 (September 1, 1854). For evidence of Dr. Acland's uncertainties based in part on the divorce passage in Matthew 5:32, see *MR*:208-25 passim.

66. Virginia Surtees, ed. *Sublime and Instructive* (London: Michael Joseph, 1972), pp. 101-102. Effie remained disturbing enough to drive Ruskin from the lecture platform when, for reasons unexplained, she and Millais arrived in the middle of his 1861 lecture "On Tree Twigs" and took front-row seats. See Derek Hudson, *Munby, Man of Two Worlds: The Life and Diaries of Arthur J. Munby, 1818-1910* (London: John Murray, 1972), p. 97.

67. ". . . And Mr. Fortescue" p. 192, Diary entry for March 28, 1862. If for no other reason, as a man long in love with a married woman Fortescue naturally sympathized with Effie from the first. He and Ruskin were never close, but Ruskin's praise of Harriet Fortescue Urquhart was ingenuous. Ruskin had been fond of her.

68. J. F. C. Harrison, *A History of the Working Men's College* (London: Routledge, 1954), p. 44. Furnivall stood by Ruskin and was rewarded with a brief account of his married life.

69. For a comparison of Ruskin's two accounts of his un-conversion, see Landow, *Aesthetic and Critical Theories*, p. 280 ff.

70. John Hayman, ed., "John Ruskin's Unpublished Letters to His Oxford Tutor on Theology," *Etudes Anglais* (avril-juin 1977), 30:204.

71. Hayman, p. 205. The letter is undated, but is probably from the early 1850s, as Hayman conjectures.

72. *Nemesis* (London: Chapman Hall, 1879), pp. 158, 163, 226.

73. See *LV*:244, and Francis G. Townsend, *Ruskin and the Landscape Feeling*, Illinois Studies in Language and Literature (1951), vol. 35, no. 3.

74. "I had loved Rose since she was ten years old—I saw her first in 1858" (*M-T*:133). Ruskin says she was nine in *Praeterita*, but in his late years he often made errors in dates. He consistently conflated his first two trips to Italy, for example. The three-year wait Rose imposed on Ruskin was from February 2, 1866 to January 3, 1869, when she would be twenty-one (*M-T*:88). With regard to his other loves, Adèle Domecq, who was two years younger than Ruskin, had been fifteen when Ruskin fell in love with her; there is no evidence that he felt anything more than an appreciation of Effie's good looks and good spirits until she was eighteen (1846). His last love, Kathleen Olander, was twenty when Ruskin, then old and infirm, first encountered her.

75. Ruskin to George MacDonald, February 13, 1865: Rosie's "the only living thing in the world—since my white dog died—that I care for—and I nearly died myself when she got too old to be made a pet of anymore—which was infinitely ridiculous—but I never had any right people to care for—and one can't get on with stones only—unless one shuts oneself right up at the great St. Bernard. I tried that plan too—last year—but it was too late—and I

only disgusted myself with the mountains." Typescript, Yale Library. As printed in MacDonald's *George MacDonald and His Wife* (New York: Dial, 1924), p. 333, the phrase "in the world" is missing and the punctuation is slightly regularized.

76. *Poems and Translations* (London: Oxford University Press, 1926), p. 205. Ruskin composed the following poem at the time of his proposal to Rose, giving her power not only over himself but even his mother.

> Ah, sweet lady, child no more,
> Take thy crown, and take thy pride
> Golden, from the great sea shore
> Now the sands of measuring glide.
>
> Thrice they count the natal hour
> Thrice—to changing spirits given—
> Once to life—and once to power
> Last, to judgment light of heaven.
>
> The shells that haunt the eternal sea,
> And in God's garden, trees of God,
> For thee have dyed, and born for thee
> The purple robe and almond rod.
>
> And what thou wilt shall be, in deed
> And what thou sayest shall be sooth
> *And wisdom of the old give heed*
> *To counsel of thy holy youth.*
>
> Ah, put away thy childish things
> And take thy sceptre, dovelike mild—
> They must, on earth, be more than Kings
> Who would, in heaven, be as a child.

Transcribed from the manuscript, Ruskin Galleries (my italics). James Dearden edited a twelve copy edition (Bembridge: Yellowsands Press, 1968).

77. From Rose's 1867 diary, Van Akin Burd, ed., *John Ruskin and Rose La Touche* (Oxford: Clarendon Press, 1979), p. 160.

78. The most detailed and sympathetic account of Mr. La Touche is in Burd's Introduction to *John Ruskin and Rose La Touche*, pp. 27-35.

79. See "The Brides of Venice" in Rogers' *Italy* and IX:138 Appendix 8.

80. In Ruskin's circle of acquaintances alone, his friend and biographer, the Positivist Frederic Harrison, selected a cousin some twenty years his junior while she was still a child, and educated her to be a fit wife. The painter Frederick Shields married his sixteen-year-old model when he was forty and sent her to Winnington School in its latter days. Ruskin's dear friend Lady Paula Trevelyan was twenty-six years younger than Sir Walter. Her friend

"Loo" **Stewart-Mackenzie** was twenty-seven years younger than Lord Ashburton, as was Ruskin's one-time art pupil Frances Strong when, in a truly spectacular misalliance, she married the Rector of Lincoln College, Oxford, Mark Pattison.

81. Burd, *John Ruskin and Rose La Touche*, p. 159.

82. See his letter to Mrs. Cowper-Temple of March 1868, (*M-T*:133-36), itself "a mere cry of stupified pain." Ruskin's letters to the Cowper-Temples and to George MacDonald record the virtual destruction of his affective life as Rose changed her aspect, sometimes day to day, from saint, to fiancée, to Dolores, "Our Lady of Pain."

83. Letter to Robert Horn, November 22, 1870, Leon, *Ruskin*, p. 483.

84. Remarriage would have been illegal if Ruskin had been found at fault in a *divorce* proceeding, but annulment left both parties free unless there was evidence of collusion. The fact that a man might be impotent with one woman and not with another was legally recognized. See Leon, *Ruskin*, p. 402 ff.

85. In addition to the biographies, see Sheila Birkenhead's *Illustrious Friends* (London: Hamish Hamilton, 1965), and Arthur Severn's recollections, in James S. Dearden, ed., *The Professor* (London: Allen & Unwin, 1967), pp. 38-46, for details of Ruskin's Matlock illness.

86. "Be not by trials dismayed, but go the more bravely to meet them, / Up to the limits thy fates permit" (XXII:447). The translation of the Sibyl's words to Aeneas, which includes the end of the Latin sentence that Ruskin quotes later, is from Harlan Ballard's *The Aeneid* (New York: Scribner, 1930), p. 129.

87. The progression of illustrations in the lecture was from the abstract Irish angel, to an androgynous Anglo-Saxon angel (it is beardless and wears a garment like Eve's but has no distinguishable female characteristics), to a distinctly female Angel of the Stars by Baccio Baldini. In the printed text this contrast was reduced to one between a Lombardic Eve who knows she is wrong and the Irish angel who thinks *himself* all right. In his first reference to this angel in *The Two Paths*, only the artist and not the creation is treated as self-conscious (XVIII:170-72, XVI:274 ff).

88. From a letter to Ruskin sent by Rose care of George MacDonald, June 19, 1872, Beinecke Library, Yale. Other passages are printed in Leon, *Ruskin*, p. 488. The letter stayed in MacDonald's possession and may not have been shown to Ruskin, but its substance was almost surely passed on to him. On July 5th Ruskin was writing to MacDonald: "Kindly set down . . . the precise things R. says of me—or has heard said of me." Typescript, Beinecke Library, Yale.

89. Greville MacDonald, M.D., *Reminiscences of a Specialist* (London: Allen & Unwin, 1932), p. 121. MacDonald, who was a child at the time, was present at those meetings of Rose and Ruskin that took place at his parents' home.

90. Birkenhead, *Illustrious Friends*, p. 240.

91. Although Ruskin had been counting the days until her twenty-first birthday, Rose seems to have sent no word on January 3, 1869, or the anniversary of her proposed three-year wait, February 2, but a year later, on

January 7, 1870, Ruskin saw Rose at the Royal Academy only to have her refuse to speak to him (*M-T*:247).

92. *D*:732, and repeated to Mrs. Cowper-Temple on September 28, (*M-T*:735).

93. These Christmas Letters of 1877 in the Morgan Library are being edited for publication by Van Akin Burd.

94. *BD*:92 ff.

95. Letter to George MacDonald transcribed from the original in the Yale Library. The letter appears in Leon, *Ruskin*, p. 510, with some errors in transcription, and Bruno assigned to Ruskin. Willie is William Cowper-Temple.

96. Rayner Unwin, ed., *The Gulf Years* (London: Allen & Unwin, 1953), p. 78. In all probability Ruskin's tendency to manic depression was inherited, and his eventual breakdown inevitable. His illness seems to have been of a type now commonly stabilized by lithium treatments. There is no necessary causal link between this illness and the psychological problems manifest in his relationship with his parents, with Effie, or with Rose, but Ruskin and his doctors naturally looked for causes in the content of his thoughts and sought to keep his mind off dangerous topics. The result is a complex mix indeed. For a survey of various approaches to manic-depression from Emil Kraepelin's descriptions (1904, 1921) to the present day see Edward A. Wolpert, ed., *Manic-Depressive Illness: History of a Syndrome* (New York: International Universities Press, 1977). To date, all attempts to understand Ruskin through clinical diagnosis simply assign the competence denied his mind to his "genius." See for example, R. J. Joseph, "John Ruskin: Radical and Psychotic Genius," *Psychoanalytic Review* (Autumn 1969), 61:425-41.

97. In the dark of the tomb, you who have consoled, / Restore Posilipo and the Italian sea to me, / The *flower*, once such pleasure to my grieving heart, / And the trellis where the vine and rose lace.

Papa Carlyle

1. Summary of "The General Principles of Colour," XII:507, Letter to Carlyle, XXXVI:184.

2. "What puzzles me, is how you all [thoughtful young persons] take things so quietly—and rest content in doubt, and perpetual questioning—with no answer." To Mary Aitken, August 18, 1874, in George Allen Cate, ed., "The Correspondence of Thomas Carlyle and John Ruskin" (Ann Arbor: University Microfilms, 1967), p. 361.

3. July 6, 1850 as recorded in the Journal of John Welsh quoted by Leonard Huxley, "A Sheaf of Letters from Jane Welsh Carlyle," *Cornhill* (November 1926), NS 41:629-30.

4. Cate, "Correspondence," p. 344.

5. "Ruskin's Discipleship to Carlyle," in John Clubbe, ed., *Carlyle and His Contemporaries* (Durham: Duke University Press, 1976), p. 230.

6. June 25, 1867, Ruskin Galleries.

7. See particularly Peter Laslett's first chapter: "English Society Before and After the Coming of Industry" in *The World We Have Lost* (New York: Scribner's, 1971).

8. Charles Richard Sanders et al., ed., *The Collected Letters of Thomas and Jane Welsh Carlyle* (Durham: Duke University Press, 1970), 6:104; hereafter cited as *Letters*.

9. Charles Eliot Norton, ed., *Reminiscences* (London: Macmillan, 1887), 1:49.

10. Charles Eliot Norton, ed., *Two Note Books of Thomas Carlyle* (New York: Grolier Club, 1898), p. 211.

11. Northrop Frye, *Anatomy of Criticism* (Princeton: Princeton University Press, 1957), p. 193.

12. See C. F. Harrold, *Carlyle and German Thought 1819-1834* (New Haven: Yale University Press, 1934) and his introduction and notes to *Sartor;* Rene Wellek, *Confrontations* (Princeton: Princeton University Press, 1965); G. B. Tennyson, *Sartor Called Resartus* (Princeton: Princeton University Press, 1965), ch. 2, "The Voice of Germany."

13. Friedrich Schelling, *On University Studies*, Norbert Guterman, tr. (Athens, Ohio: Ohio University Press, 1966), p. 107.

14. John Bourchier, Lord Berners, preface to *The Chronycle of Sir John Froissart* (London: David Nutt, 1901), W. E. Henley, ed., *The Tudor Translations*, 27:3.

15. Frye, *The Secular Scripture*, pp. 49-50.

16. Sir Walter Scott, *The Antiquary*, ch. 3. For the attribution to Horace see XXVII:106.

17. The revolutionary mob invaded Ruskin's dreams in the years after the Paris Commune, e.g., *D*:759.

18. May Morris' Introduction to *M*22:658.

19. George Levine, after Frye, calls *Sartor* a "confession-anatomy-romance" with romance "undoubtedly the ur-form of the Teufelsdro'ckh biography." *The Boundaries of Fiction* (Princeton: Princeton University Press, 1968), p. 23.

20. Carlisle Moore contends that Carlyle followed Goethe's lead in attempting "to unite science, poetry and religion in a total perception." "Carlyle and Goethe as Scientist" in Clubbe, *Carlyle*, p. 34.

21. See Marianne Thalmann, *The Literary Sign Language of German Romanticism*, H. A. Basilius, tr. (Detroit: Wayne State University Press, 1972), p. 44 ff.

22. *Note Books*, p. 54.

23. For the importance of Carlyle in forming Arnold's views, for example, see David DeLaura, "Arnold and Carlyle," *PMLA* (1964), 79:104-29.

24. Cf. Jonathan Arac, *Commissioned Spirits* (New Brunswick: Rutgers University Press, 1979), especially ch. 7, "Heroism and the Literary Career: Carlyle and Melville."

25. *Note Books*, p. 203.

26. *The Book of Common Prayer*. Most dissenting churches held to similar extensions of the fifth commandment that made it the governor of the final five under the rubric of "duty towards thy Neighbor."

27. For the probable source of Carlyle's term "organic filaments" and the

analogies Carlyle builds upon it, see my "Filaments, Females, Families and Social Fabric," in James Paradis and Thomas Postlewait, eds., *Victorian Science and Victorian Values* (New York: New York Academy of Sciences, 1981). For the place of organic fiber theories in the history of biology see Thomas S. Hall, *Ideas of Life and Matter*, 2 vols. (Chicago: University of Chicago Press, 1969). It is the power of "organic filaments" to spin themselves that distinguishes them from the threads of life Fable spins under the aegis of the constellation Phoenix in Novalis' *Henry Von Ofterdingen*, Putnam Hilty, tr. (New York: Ungar, 1964), pp. 133-34. Novalis' fragmentary *Erziehungsroman* influenced both the structure and symbols of *Sartor*.

28. *Letters*, 6:418.

29. According to Steven Marcus "the imaginary line that runs from Dr. Alison's Irish widow in Edinburgh to Matthew Arnold's 'Wragg is in custody' may be considered as axial in the intellectual consciousness of the period. It is as close as nineteenth-century English critical prose comes to writing or language as praxis." *Engels, Manchester, and the Working Class* (New York: Random House Vintage, 1975), p. 108. Surely Ruskin even more than Arnold belongs on this axis: cf. the Coroner's inquest quoted in "Of Kings' Treasuries" concerning one Michael Collins: *"deceased died from exhaustion from want of food and the common necessaries of life; also through want of medical aid. . . . 'Why would witness* [Mrs. Collins] *not go into the workhouse?' you ask. Well, the poor seem to have a prejudice against the workhouse which the rich have not; for of course everyone who takes a pension from Government goes into the workhouse on a grand scale: only the workhouses for the rich do not involve the idea of work, and should be called play-houses. We make our relief either so insulting to* [the poor], *or so painful, that they rather die than take it at our hands"* (XVIII:93-4).

30. Michael Scott the wizard was said to have conquered an indefatigable demon by having him spin ropes of sand. See note XIV to Canto II of Scott's *Lay of the Last Minstrel*.

31. See William Lovett's *Chartism: A New Organization of the People*. An exception was G. J. Harney, who invoked Robespierre to cheers at the Festival of Nations in London in 1845. Harney forms a link between "physical force" Chartism and the later Socialist movement. For Engels' report of Harney's speech see *Karl Marx and Frederick Engels Collected Works* (London: Lawrence & Wishart, 1976), 6:8-11, hereafter cited as *Works*. For the didactic purpose and literary context of *The French Revolution* see Patrick Brantlinger, *The Spirit of Reform* (Cambridge: Harvard University Press, 1977), ch. 3, "The Lessons of Revolution"; Arac, *Commissioned Spirits*, ch. 6 and passim.

32. *Letters*, 6:446; 7:306.

33. J. P. Seigal, ed., *Thomas Carlyle, The Critical Heritage* (London: Routledge, 1971), p. 52.

34. *Thomas Carlyle: A History of His Life in London* (New York: Scribner's, 1884), p. 69; *Letters*, 7:245.

35. The paradigm case of narrative embedding cited by Tzvetan Todorov is the *Arabian Nights*: Scheherazade tells that, Jaafer tells that, the tailor tells that (etc.). "The embedded narrative is the image of that great abstract narrative of which all the others are merely infinitesimal parts as well as the

image of the embedding narrative which directly precedes it." Todorov here practically defines Carlylean historiography. Richard Howard, tr., *The Poetics of Prose* (Ithaca: Cornell University Press, 1977), pp. 70-73.

36. Hayden White, *Metahistory* (Baltimore: Johns Hopkins University Press, 1973). White's example of this mode is Michelet's *History of the French Revolution*, not Carlyle's, but what he says about Michelet applies to Carlyle almost point by point. This resemblance has been noted before: 'C'est presque la même manière de voir, d'évoquer, de peindre, d'émouvoir, d'étonner. On dirait le même lyrisme, et surtout si on se reporte au texte anglais, trop souvent intraduisible, le même procédé de style, presque la même façon de couper ou disloquer la phrase, les mêmes figures littéraires, surtout l'exclamation ou l'apostrophe." F. V. A. Aulard cited by Alfred Cobban, "Carlyle's French Revolution," *History* (October 1963), 48:315. Albert LaValley treats *The French Revolution* as an epic, but finds, paradoxically, that it is also "a true epic in reverse." *Carlyle and the Idea of the Modern* (New Haven: Yale University Press, 1966), p. 142. John Farrell calls it, after Froude, a tragedy, in *Revolution as Tragedy* (Ithaca: Cornell University Press, 1980). White's formula seems to me to capture best the nature of *The French Revolution*, but epic and tragic readings can be supported by citations from Carlyle, who uses generic terms more for their connotations than their strict application to his work. The traditional genres were to Carlyle like Johnsonian English—obsolete.

37. Review of the *Latter-Day Pamphlets* from *Neue Rheinishche Zeitung*, *Works*, 10:306.

38. Laslett, *The World We Have Lost*, p. 165.

39. M. W. Flinn, ed., for the Surtees Society (London: Bernard Quaritch, 1957); M. W. Flinn, *Men of Iron* (Edinburgh: Edinburgh University Press, 1961).

40. Thomas Pinney, ed., *Essays of George Eliot* (New York: Columbia University Press, 1963), p. 213.

41. E. L. and O. P. Edmonds, eds., *I Was There: The Memoirs of H. S. Tremenheere* (Eton Windsor: Shakespeare Head Press, 1965), p. 38. The scion of a landed Whig family, Tremenheere was of the class Carlyle and Ruskin hoped to rouse to assume in new form their traditional social responsibility.

42. *Note Books,* p. 205.

43. George Levine wrestles with the moral implications of Carlyle's style and the question of his development (or degeneration) in "The Use and Abuse of Carlylese" in George Levine and William Madden, eds., *The Art of Victorian Prose* (New York: Oxford University Press, 1968).

44. Emerson told Edward Everett Hale that Clough's remark was typical of what many young Englishmen told him in 1848. See Hale's *James Russell Lowell and His Friends* (Boston: Houghton, Mifflin, 1899), p. 136.

45. John Dixon Hunt traces the influence of the picturesque on Ruskin's work in "*Ut pictura poesis*, the Picturesque and John Ruskin," *MLN* (1978), 93:794-818.

46. June 12, 1867, Ruskin Galleries.

47. Cate documents this change in "Ruskin's Discipleship to Carlyle," in *Carlyle and His Contemporaries*, pp. 243-45. Defending *Unto This Last* against the strictures of his friend Dr. John Brown, Ruskin made clear the connection he saw between his work and Carlyle's, and in his Master's tones: "The value of these papers on economy is in their having for the first time since money was set up for the English Dagon, declared that there never was nor will be any vitality nor Godship in him. . . . For the first time, I say, this is declared in purely accurate scientific terms; Carlyle having led the way, as he does in all noble insight in this generation" (XXXVI:349).

48. Preface to the Kelmscott Press *Nature of Gothic* reprinted in XI:460. See also John D. Rosenberg, *The Darkening Glass* (New York: Columbia University Press, 1963), pp. 49-55.

49. E. H. Gombrich, *Norm and Form* (London: Phaidon, 1971), p. 88.

50. *Letter* by the Pseudo-Raphael (c. 1500), translated in Paul Frankl, *The Gothic* (Princeton: Princeton University Press, 1960), p. 273. For other evidence tracing the association of Gothic architecture and natural forms back to the Renaissance, see Erwin Panofsky, *Meaning in the Visual Arts* (New York: Anchor Books, 1955), p. 176 ff.

51. Joseph Schumpeter, *History of Economic Analysis* (New York: Oxford University Press, 1954), p. 270.

52. To Alfred Macfee, XXVII:179. The letter and Ruskin's marked copy of the second edition of *Past and Present* are in the British Library (c. 61a, 14).

53. *Liberty* was, of course, one of the watchwords of defenders of the free market and this economic context should be borne in mind when reading Ruskin's later work. Before he began his economic analyses Ruskin occasionally used the word favorably. But in an economic context, as he frequently pointed out, *liberty* meant the freedom to starve without burdening the conscience or the pocketbook of the larger community. Ruskin's belief that liberty and justice are incompatible has a cogency in the sphere of economics that mere repetition of "liberty and justice for all" cannot refute. Ruskin never confused the workman's liberty of expression with political liberty as implied by those who argue that Ruskin grew sharply more authoritarian with age, e.g., James Clark Sherburne, *John Ruskin, or the Ambiguities of Abundance* (Cambridge: Harvard University Press, 1972), pp. 219-22.

54. See David Meakin, *Literature, Man and Culture in Industrial Work* (London: Methuen, 1976) for a survey of work and alienating labor as treated in modern literature. Ruskin was not alone in equating the division of labor with dismemberment. David Urquhart declared: "To subdivide a man is to execute him, if he deserves the sentence, to assassinate him if he does not," an observation William Morris naturally seized upon with delight when he came across it in the French translation of *Das Kapital*. Urquhart also argued that "the unit of the nation is not the man, but the family." Ruskin was acquainted with Urquhart who first published these observations in 1844. Urquhart's *Familiar Words* (London: Trubner, 1856), from which these quotations are taken (pp. 118-19), also anticipates in part Ruskin's use of etymologies in social criticism. For Morris' reaction to the Urquhart quotation in Marx, see E. P. Thompson, *William Morris: Romantic to Revolutionary*

(London: Merlin Press, 1977), 2nd ed., p. 38.

55. Ruskin had elaborated his rules for manufacturers and consumers in "Manufacture and Design" in *The Two Paths*.

56. There is an excellent discussion of this vision in relation to Ruskin's theories of art and their narrative exposition in Richard L. Stein, *The Ritual of Interpretation* (Cambridge: Harvard University Press, 1975), p. 83 ff.

57. According to Levitical law the dove could be substituted by the poor for sacrifice of the more expensive herd animals (Leviticus 5:7, 12:8).

58. In his diary account of Salisbury, on which his description of the English cathedral is partially based, the only bird nests he mentions are those of martins. The substitution of rook for martin suggests the imagery of *Macbeth*. Banquo notes, as he and Duncan approach Macbeth's castle, that it is home to the "temple-haunting martlet" that breed and haunt where the air is delicate (I:6). But after the murder of Duncan the martin disappears and Shakespeare associates Macbeth and his castle with most every member of the crow family he can name. It may also be worth recalling that Salisbury was the scene of the first major quarrel between John and Effie, the split that eventually led to the collapse of their marriage. When Ruskin chooses to celebrate the martin as a bird of good omen, he cites these lines from *Macbeth* in justification of calling the bird Monastica, but he never mentions Salisbury, rather noting: "I have seen it in happiest flocks in all monastic Abbeville" (XXV:136).

The Ruskin Crusade

1. This recreation in prose rather than the painting itself becomes the "referent" created by the critic for his reader, according to G. Robert Stange, "Art Criticism as a Prose Genre" in George Levine and William Madden, eds., *The Art of Victorian Prose* (New York: Oxford University Press, 1968), pp. 39-52.

2. Ruskin understood Millais' decision to marry Effie in chivalric terms: "Feeling he had been the Temptation to the woman, and the cause of her giving up all her worldly prospects, he may from the moment of our separation—have felt like something of a principle of honour enforcing his inclination to become her protector" (*MR*:257).

3. Not only is St. Paul's Churchyard, in contrast to St. Mark's Square, merely a street, but "the route from St Paul's Churchyard to Regent's Park through Fleet Street, the Strand, the Haymarket, Regent Street, and Portland Place—was a thoroughfare for harlots. . . . To conduct a wife or daughter through these streets at night was to encounter dozens of unmistakeable prostitutes." Eric Trudgill, "Prostitution and Paterfamilias," in H. J. Dyos and Michael Wolff, eds., *The Victorian City* (London: Routledge, 1973), 2:696.

4. Robert Hewison develops this theme in *John Ruskin: The Argument of the Eye* (Princeton: Princeton University Press, 1976).

5. To Mrs. Cowper-Temple, *BD*:497.

6. *The Athenaeum* (May 28, 1859), p. 704; *British Quarterly Review* (October 30, 1859), p. 584.

7. J. R. McCulloch, *The Principles of Political Economy* (Edinburgh: C. Tate and Longman, 1825), pp. 417-18.

8. Nassau Senior, *An Outline of the Science of Political Economy* (London: Allen & Unwin, 1938; 1st ed., 1836), p. 26.

9. John Stuart Mill, "On the Definition of Political Economy," in J. M. Robson, ed., *Collected Works of John Stuart Mill* (Toronto: University of Toronto Press, 1963) 4:319; hereafter cited as Mill. Quotations from Mill's *Principles* will be from the first edition (London: Parker, 1848), the text Ruskin knew.

10. Friedrich Engels. *The Condition of the Working Class in England in 1844*, W. O. Henderson and W. H. Challoner, trs. (Stanford: Stanford University Press, 1958), p. 312. Although he had his share of prejudice regarding Jews, Ruskin's redactions of Carlyle disregard the master's anti-Semitism, concentrating on the wisdom of Solomon rather than the baleful influence of the Rothschilds.

11. John T. Fain, *Ruskin and the Economists* (Nashville: Vanderbilt University Press, 1956), p. 105.

12. James Clark Sherburne, *John Ruskin, or the Ambiguities of Abundance* (Cambridge: Harvard University Press, 1972), p. 117.

13. Mill, 2:500. Ruskin defines profit in his own way, however, based on the Latin *Proficio*, as the value added to raw material by labor. He calls profit in the ordinary sense—the difference between selling price and total costs—*acquisition* (17:40).

14. When I call Mill's method inductive I refer to the derivation of his definitions, not to their application, which is deductive. A purely inductive treatise would have always to argue from particulars and conclude with a generalization. Mill assumes the induced generalizations as postulates and deduces his science. "The first of these methods is a method of induction, merely, the last a mixed method of induction and ratiocination. The first may be called the method *a posteriori*, the latter, the method *a priori*. We are aware that this last expression is sometimes used to characterize a supposed mode of philosophizing, which does not profess to be founded upon experience at all. But we are not acquainted with any mode of philosophizing, on political subjects at least, to which such a description is fairly applicable" ("On the definition of Political Economy," Mill, 4:325).

15. Mill, 4:319.

16. *Principles*, 1:11, 61.

17. Sherburne, *Ambiguities*, p. 147 ff.

18. Fain, *Ruskin*, p. 87.

19. "John Ruskin," in H. Bellyse Baildon, ed., *The Round Table Series* (Edinburgh: William Brown, 1887), p. 42. For "open systems" and their possible extension from biology into the social sciences, see Ludwig von Bertalanffy, *General Systems Theory* (New York: George Braziller, 1968), chs. 7 and 8.

20. Barry Commoner, *The Closing Circle* (New York: Bantam, 1971), pp. 192, 193, 251, 196.

21. K. William Kapp, *The Social Costs of Private Enterprise* (Cambridge: Harvard University Press, 1950), p. 261. The fact that Kapp brings to mind some of Ruskin's central points is not simply coincidental. Kapp's work is indebted to Hobson, particularly to his *Work and Wealth*. He is, moreover, nearly as unfair to the classical economists here as Ruskin was. The case for the social concerns of the classical economists is judiciously stated in D. P. O'Brien's *The Classical Economists* (Oxford: Clarendon Press, 1975).

That Ruskin's distinction between wealth and illth has particular applicability to our affluent society, in which quantity of production and consumption is all too often the measure of prosperity without regard to the quality or human value of either, was noticed by John D. Rosenberg, *The Darkening Glass* (New York: Columbia University Press, 1963), and James Clark Sherburne has developed that observation at considerable length in *John Ruskin, or the Ambiguities of Abundance*. Sherburne's study is the most complete examination of the debts Ruskin's social thought owes his immediate predecessors and contemporaries, as well as the most wide-ranging application of Ruskin's ideas to problems of the present day. To Sherburne, Ruskin is the Victorian prophet of abundance, and this is true *if* by abundant one means a society which produces enough so that every citizen can obtain food, clothing, fuel, shelter and a chance to be educated for his station in life. The potential for that degree of abundance Ruskin presupposes, as Carlyle had. The society Ruskin envisions, however, is quite austere by our standards, and he is quite prepared to forego efficiency in the name of humanity.

22. *Henry IV, Part Two*, Act V, sc. 2, ll. 129-33. Leonard Barkan, *Nature's Work of Art* (New Haven: Yale University Press, 1975) gives a history of depicting the human body as an image of the world.

23. McCulloch, *Principles*, pp. 190-93.

24. Thomas Rowe Edmonds, *Practical Moral and Political Economy* (New York: Augustus Kelley, 1969, reprint of the 1833 edition), p. 100. Sherburne cites other possible sources, *Ambiguities*, p. 143.

25. Sherburne, *Ambiguities*, p. 37. For Schumpeter's critique of the classical theory of value from which Ruskin's potential place can be inferred see *value*, p. 588 ff.

26. Ruskin's love of playing Adam instead of using much of the accepted vocabulary in its accepted senses has led to misunderstanding of his work in almost every field. Many an architect must have thrown down the first volume of *The Stones of Venice* in disgust after running into "wall veils" and the like. Ruskin's broad definition of ornament has virtually obscured his understanding of architectural structure. See John Unrau, *Looking at Architecture with Ruskin* (Toronto: University of Toronto Press, 1978).

27. McCulloch, *Principles*, p. 1; Ruskin, XVII:19.

28. Ruskin savages the idea in *Unto This Last* without mentioning the archbishop by name, but his suggestion that the proposed science is the opposite of a divine science, that is, a science fathered by the devil, suggests an awareness of the clerical status of the first and only *catallactition* (XVII:92).

29. Ruskin's very derivation of *value* is cited in E. S. Schwartz's *Overskill: The Decline of Technology in Modern Civilization* (Chicago: Quadrangle, 1971), p.

299.

30. Richard Chenevix Trench, *The Study of Words*, 2nd ed. (New York: Renfield, 1852), p. 54. (Cf. *Ethics of the Dust*, XVIII:337.) F. J. Furnivall introduced Ruskin to contemporary philology, sending him *The Study of Words* in 1853 (XXXVI:146-47). For Trench's place in the history of linguistics and the background of *The New English Dictionary*, see Hans Aarsleff, *The Study of Language in England* (Princeton: Princeton University Press, 1967) pp. 229-47. See also Marc Shell's chapter on Ruskin in *The Political Economy of Literature* (Baltimore: Johns Hopkins University Press, 1978); and Kurt Heinzelman, *The Economics of Imagination* (Amherst: University of Massachusetts Press, 1980), a detailed study of the interplay between the language of literature and economics published since my manuscript was completed.

31. Trevor May, *The Economy, 1815-1914* (London: Collins, 1972), p. 177.

32. Prince Peter Kropotkin, *Fields, Factories, and Workshops* (New York: Benjamin Blau, 1913, reissue 1968), p. 254.

33. E. F. Schumacher, *Small is Beautiful* (New York: Harper, 1973), pp. 51-52.

34. Henry Ford, *My Life and Work* (New York: Doubleday, 1922), p. 103.

35. Adam Smith, *Wealth of Nations*, 2 vols., Edwin Cannan, ed. (Chicago: University of Chicago Press, 1976), vol. 2, book 5, ch. 1, p. 303, my italics.

36. Adam Smith, *The Theory of Moral Sentiments*, 2 vols. (Edinburgh: J. Hay, 1813), 1:195.

37. Ruskin's most eloquent presentation of his case is in "The Mystery of Life and Its Arts," XVIII:82 ff. As was often the case, Ruskin mixed small beginnings that have gone little noticed with his declaration of ends and principles. His contribution of 100 pounds was crucial to the beginning of the Charity Organization Society. He was a vice-president of the COS from its founding in 1869 until his death, but took no active role in matters of policy after the debates at the time of its establishment. For Ruskin's donation, see Helen Bosanquet, *Social Work in London, 1869-1912* (London: John Murray, 1914), pp. 20-22; for a modern history, Charles C. Monat, *The Charity Organization Society* (London: Methuen, 1961), for its intrusive powers, Judith Fido, "The Charity Organization Society and Social Casework in London 1869-1900," in A. P. Danajgrodzk, ed., *Social Control in Nineteenth-Century Britain* (London: Crown Helm, 1977).

38. Ruskin's anticipation of the welfare state is spelled out in detail by Rosenberg, *The Darkening Glass*, and Sherburne, *Ambiguities;* his anticipation of some modern social critics by D. R. Cherry, "Ruskin—Unacknowledged Legislator of the Social Sciences" in *Thought from the Learned Societies of Canada* (Toronto: W. J. Gage, 1961).

39. Rosenberg makes the strongest cause and effect argument linking Ruskin's waywardness as a political economist with his mental collapse, but necessarily finds the "sane" and "insane" works overlapping. The mind and its products are indisputably connected. At issue is the question of when we must turn to pathology, the explanation of last resort.

40. Letter to his father (XVII:1). Richard Altick gives 84,000 as the average circulation of *Cornhill* in its first two years, citing *Publisher's Circular*, May 1,

1862. *The English Common Reader* (Chicago: University of Chicago Press, 1957), p. 395.

41. To C. A. Howell, September 8, 1868, in Jay W. Claiborne, ed., "John Ruskin and Charles Augustus Howell: Some New Letters," *Texas Studies in Language and Literature* (Fall 1973), 15:488.

42. These letters are among the eleven sets appended to XVII. There are others in *Arrows of the Chace* and, of course, numerous references to political economy in private letters.

43. Thomas Dixon was a largely self-educated cork cutter and entrepreneur, who earned enough from his trade to retire comfortably and devote himself to the advancement of his class. He was an indefatigable correspondent with great men and the English "discoverer" of Walt Whitman.

44. Letter 20, XVII:417 ff. See the sixteen pages of sarcasm in *Blackwood's* (June 1868), 103:675 ff.

45. Igor Webb places "Traffic" and the dispute over the style of the new exchange in historical context in "The Bradford Wool Exchange: Industrial Capitalism and the Popularity of Gothic," *Victorian Studies* (Autumn 1976), 20:45-69. For the rhetoric of "Traffic" see George Landow, "Ruskin as Victorian Sage" in Robert Hewison, ed., *New Approaches to Ruskin* (London: Routledge, 1981).

46. *Fortnightly* (June 2, 1866), 5:382-83.

47. Peter Berger and Thomas Luckmann, *The Social Construction of Reality* (New York: Anchor, 1967), p. 95.

48. *Ibid.*, pp. 98-99.

49. *Popular Political Economy* cited by Scott Gordon, "The London *Economist*,' *Journal of Political Economy* (December 1955), 63:461-88.

50. Berger and Luckmann, p. 128.

51. The most often quoted, reprinted, and extreme misreading of Ruskin is Kate Millett's polemic on "Ruskin and Mill," in *Sexual Politics* (New York: Doubleday, 1970), pp. 188-98. David Sonstroem supplies fourteen pages of polite corrections in "Millett versus Ruskin," *Victorian Studies* (September 1970), 14:283-97, but one might as well "correct" Ruskin on Gustave Doré—or Carlyle's picture of Quashee up to his ears in pumpkin.

52. *Saturday Review* (July 15, 1865), 20:83.

53. XVIII:114. Portia is a romance heroine coming to Shakespeare from Ser Giovanni's *Il Pecorone*, perhaps by way of a lost play, *The Jew*. See the introduction and appendix I, a translation of *Il Pecorone*, in John R. Brown's Arden Edition of *The Merchant*.

54. Alexander Welsh gives an extensive portrait of the saving heroine in part 3 of *The City of Dickens*, "The Bride from Heaven" (London: Oxford University Press, 1971).

55. Sarah Stickney Ellis, *Daughters of England* (London: Fisher, 1842), p. 68.

56. John Killham's *Tennyson and "The Princess"* (London: Athlone Press, 1958), gives a richly documented summary of the feminist controversy at midcentury.

57. Edwin Paxon Hood, *The Age and Its Architects* (London: Charles Gilpin, 1850), p. 391. Hood's sub-chapter on the "State of Woman the Test of

Civilization" has a number of striking parallels to Ruskin's views.

58. Quoted in Cecil Woodham-Smith, *Florence Nightingale* (New York: McGraw-Hill, 1951), p. 51.

59. Alice Rossi, ed., *The Subjection of Women: Essays on Sex Equality* (Chicago: University of Chicago Press, 1970), pp. 227-28. Dickens' ambivalence on the subject of charity, obvious in his novels, is set in this background by Alexander Welsh in *The City of Dickens*, p. 86 ff.

60. Ruskin gives a summary of his financial ventures and misadventures in *Fors*, XXIX:98-104.

61. Emily S. Maurice, ed., *Octavia Hill: Early Ideals* (London: Allen & Unwin, 1928), p. 121. C. Edmund Maurice, ed., *A Life of Octavia Hill as Told in Her Letters* (London: Macmillan, 1913) is the best published record of her personality. Like the Emily Maurice volume, it contains many excerpts from her correspondence with Ruskin and interesting records of his conversation. See also E. Moberly Bell, *Octavia Hill* (London: Constable, 1942).

62. For the frontispiece of her autobiography, *From One Century to Another*, the social worker and translator chose to represent herself at her spinning wheel. The full effect of Octavia Hill's organization on the women of her time has yet to be written. There is a summary account of her organization in Josephine Kamm's *Rapiers and Battleaxes* (London: Allen & Unwin, 1966), but the fact that she was neither a feminist nor a socialist seems to have discouraged sympathetic reevaluation.

63. Octavia Hill's articles are collected in *Homes of the London Poor* (London: Macmillan, 1875), which served to spread her influence to the United States and the Continent.

64. David Owen, *English Philanthropy* (Cambridge: Harvard University Press, 1964), p. 393. Anthony Wohl gives a chapter to Octavia Hill, "the most misunderstood and inadequately handled of the major Victorian social reformers," in *The Eternal Slum: Housing and Social Policy in Victorian London* (London: Edward Arnold, 1977), but adds little to our understanding of her. He repeats Owen's conclusions with less sympathy, finding Hill essentially a bone in the throat of progress toward municipal socialism.

65. J. A. Froude, *Carlyle's Life in London* (New York: Scribner, 1888), 2:276.

66. Lawton's name was not given by Ruskin's editors when they printed Ruskin's letters to him (XXXVII:14-17), but it survives on the envelope of one of them in the Morgan Library.

67. *Tom Mann's Memoirs* (1923; reprinted London: MacGibbon & Kee, 1967), p. 35.

68. Whether or not the "Great Depression" was a myth is unimportant in this context. What matters is the fact that the economic system was being questioned and alternatives seriously considered by people who even a few years earlier would never have done so. For the pros and cons of the "Great Depression" debate see Trevor May's *The Economy*, ch. 5.

69. June 20, 1874, Ruskin Galleries. "I am so glad of all you give me of encouragement and sympathy. The Oxford movement [Ruskin's] was, of course, long since planned by me; but I did not intend to begin it till the close of my drawing work. . . . But one or two of the men themselves asked me to

begin now—so I let them. . . . Next October, I go out myself with them."
Ruskin to Carlyle, June 24, 1874, George Allen Cate, ed., "The Correspondence of Thomas Carlyle and John Ruskin" (Ann Arbor: University Microfilms, 1967).

70. Ruskin's editors collate his various explanations of the title in XXVII:xx ff. As usual, Ruskin's word play has contemporary analogues, see chapter 1 of F. Max Müller's *Biographies of Words* (London: Longmans, 1888), "Fors Fortuna."

71. In the first volume of *Fors* (XXVII), for example, see pages 42, 81, 270, 315, 328, 360, 489, 522, 643, and 662.

72. For examples of these illustrations and an account of *Fors* as an illustrated monthly, see my " '*These* are the Furies of Phlegathon': Ruskin's Set of Mind and the Creation of *Fors Clavigera*" in John Dixon Hunt, ed., *The Ruskin Polygon* (Manchester: Manchester University Press, 1982).

73. Dante, *Purgatory*, XXIX, ll. 122-23, Dorothy L. Sayers, tr. (Baltimore: Penguin, 1955).

74. E.g., Thompson, *Morris*, p. 197.

75. Cf. Paul Sawyer, "Ruskin and St. George: The Dragon Killing Myth in *Fors Clavigera*," *Victorian Studies* (Autumn 1979), 23:5-28.

76. For an elaboration of this approach to the *Idylls*, see James R. Kincaid, *Tennyson's Major Poems* (New Haven: Yale University Press, 1975), ch. 8.

77. The former servants, Lucy and Harriet Tovey, ran the shop from 1874 until Harriet's death two years later, at which time Ruskin turned management of the property over to Octavia Hill. She expressed the belief that the property as a whole could be self-sufficient. W. G. Collingwood asserts that Ruskin's shop in fact prospered, but does not cite any evidence: *The Life and Work of John Ruskin* (Boston: Houghton Mifflin, 1898), 2:416. Arthur Severn recalled making the sign but not the notorious delay: see James S. Dearden, ed., *The Professor* (London: Allen & Unwin, 1967), p. 70. Dearden's note on pages 71-72 is the most complete account of the venture. Ruskin's insistence that only the best tea should be sold and his refusal to increase the unit price of sub-divided packets reflected his view of the merchant as a public servant. That may have made Ruskin a bad capitalist, but it hardly made him mad; nor is there anything irrational about providing useful employment to servants too old to be of use to the Severns, the new occupants of Denmark Hill, servants who would otherwise have had not wages but a dole. For the later shop see "Mr. Ruskin's Tea Shop: Marylebone Survival of a Great Experiment," *Times*, February 26, 1957, p. 10.

78. *Fors* becomes less fatalistic after Ruskin's return to faith in immortality in 1875. See *Fors*, Letter 76 (April 1877), for Ruskin's explanation of the fact that "*Fors* has become much more distinctly Christian in its tone during the last two years" (XXVIII:86).

79. Commoner, 294-95; see also his *The Poverty of Power* (New York: Knopf, 1976). Where Commoner sees hope in the crisis for the emergence of democratic socialism in the United States, many democrats and individualists see a threat to freedom. They conclude, against their own inclinations, that the coming ecological crisis, and the slow or no-growth economy of which recent

energy crises may be the prelude, will produce an absolute necessity for increased centralization of political power unprecedented in American political history outside wartime. The "postindustrial" society may of necessity place more emphasis upon public than private goals, and witness a reemergence of the stress upon tradition and ritual characteristic of preindustrial societies. Such an order might have more in common with Ruskin's ideal state than any democrat can find comfortable. (These conclusions are hotly contested by political conservatives and neoclassical economists who would exorcise the spectre of perpetual stagnation by return to a freer form of capitalism, less regulated, less taxed). Political speculation aside, the prospect of an all-but-static economy brings the central Ruskinian economic issue—distribution—to the front of controversy once again. See for example, Robert L. Heilbroner, *An Inquiry into the Human Prospect* (New York: Norton, 1974).

80. H. Allingham and D. Radford, eds., *Allingham's Diary* (London: Macmillan, 1907), p. 263.

81. The history of Ruskin's legal problems can be traced in *Fors*, but there is an excellent summary in Margaret D. Spence's "The Guild of St. George," *Bulletin of John Rylands Library* (September 1957), 40:147-201.

82. Hewison explains the rationale of the Museum in *Ruskin*, pp. 185-88.

83. See volume XXX for "Industrial Experiments in Connection with St. George's Guild."

84. Henry Swan was responsible for the day-to-day work that made the establishment of the Sheffield Museum possible, and he became its first curator.

85. Letter to Edith Hope Scott reprinted in her *Ruskin's Guild of St. George* (London: Methuen, 1931), p. 89.

86. My information about the history of the Trust is from Robin Fedden's *The Continuing Purpose: A History of the National Trust* (London: Longmans, 1968).

87. Ruskin, Tennessee, was founded by an American reader of *Fors*, Charles Waylands, in 1894. See James S. Dearden, *Facets of Ruskin* (London: Charles Skilton, 1970), p. 129.

Morris: Revolution as Realized Romance

1. "The Condition of England: *Past and Present* by Carlyle," Marx and Engels, *Works*, 3:464-67.

2. Engels to Laura Lafargue, September 13, 1886, quoted in E. P. Thompson, *William Morris: Romantic to Revolutionary* (London: Merlin Press, 1955, revised 1977), p. 471.

3. Northrop Frye, *The Secular Scripture* (Cambridge: Harvard University Press, 1976), pp. 6, 183.

4. Fredric Jameson, "Magical Narratives: Romance as Genre," *New Literary History* (Autumn 1975), 7:158.

5. Frye, *The Secular Scripture*, p. 173.

6. *Manifesto of the Communist Party, Works,* 6:506.

7. J. W. Mackail collected testimonials from the family, friends, and associates of Morris while preparing his *Life* (London: Longmans, 1899). These records with later additions are in the Morris Gallery in Walthamstow; most other family papers are in the British Library. For a modern overview of Morris' life and work see Philip Henderson's *William Morris: His Life, Work, and Friends* (New York: McGraw-Hill, 1967); the indispensible political study is E. P. Thompson's *Romantic to Revolutionary.* The most convincing psychological portrait is Jack Lindsay's *William Morris* (London: Constable, 1975 and New York: Taplinger, 1979).

8. Mackail, *Life,* p. 9. "Very early did he make couplets for his sisters to whom he told stories of his own invention." Manuscript recollections of Morris set down by A. H. Mackmurdo for Nikolaus Pevsner, Morris Gallery, J361.

9. See Lindsay, *Morris,* pp. 37-8.

10. Morris' list is reprinted in M22:xi-xvi, Ruskin's XXXIV:582-87.

11. Manuscript quoted by Mackail, *Life,* p. 21. Frye, *The Secular Scripture,* p. 15.

12. Mackail, p. 12.

13. Unpublished note of Mackail quoted by Lindsay, *Morris,* p. 29.

14. This theme is developed by Lindsay, *Morris.*

15. See Thompson, *Romantic to Revolutionary.*

16. From the marriage license transcribed in Mackail's Notebooks, 1:50, William Morris Gallery. The story of Morris' marriage has been told at some length by Thompson, Henderson, and Lindsay, so my account will go into detail only where I have something to add.

17. British Library Add. MS.35341.

18. Most modern commentators consider Jane Morris' malaise to be essentially psychosomatic. Certainly there were tensions enough in the air to account for a retreat into illness. But there is a clue unremarked upon. Morris' biographers note that in July, 1868 he took Jane to Bad Ems for the cure, but make no remark as to why this particular spa, which Morris found disagreeable, should have been chosen. Mrs. Morris, however, explained the choice to Susan Norton: "The new Doctor I saw after you left assured me I shall be cured by using the douche baths at Ems." Cured of what she does not say, but of all the spas in Europe it was the *douche ascendante* of Ems that was supposed to be of particular benefit in the treatment of "female complaints." The specific maladies said to cause a torpid state such as Jane suffered, and that the Ems bath was supposed to cure, were dysmenorrhoea and amenorrhoea perhaps coupled with hypertrophy of the uterus and "the neuralgic form of dysmenorrhoea, or uterine colic." The cure was only a partial success: "it gave me a great start on the way to health, it showed me how ill I was—and how to take care of myself at home—(which I am doing) [the Morrises installed a special bath], but it has not done what my London Doctor said it would—it has not cured me—still I am thankful to be at all better, and to enjoy life ever so little." Neither the kind of complaint suggested by Jane's journey to Bad Ems, nor the sciatic, neuralgic, and back pains she

so frequently complained of would preclude a consummated love affair with Rossetti. But a Jane chaste by reason of (or the excuse of) her medical condition explains the known circumstances at least as well without denying the importance of love and the affections to all involved. Letters to Susan Norton of July 13 and December 21, 1869, unpublished, Houghton Library. For Bad Ems see Edwin Lee, M.D., *The Baths of Rhenish Germany* (London: J. Churchill, 1856), pp. 66-68.

19. The phrase is among the "Dicta" Mackail collected in his *Life*. Morris Gallery, J163, p. 134.

20. The most scrupulous detective work on the question of who knew or thought what about the relationship between Jane Morris and Rossetti has been done by the PRB's bibliographer, W. E. Fredeman. See his two-part article, "Prelude to the Last Decade: Dante Gabriel Rossetti in the Summer of 1872," *Bulletin of the John Rylands Library* (Autumn 1970), 53:75-121; (Spring 1971), 53:272-328.

21. J. Bryson and J. C. Troxell, eds., *D. G. Rossetti and Jane Morris: Their Correspondence* (Oxford: Oxford University Press, 1976), p. 68. The precise sense in which circumstances prevented Rossetti from proving his regard for Jane, like so many details of their relationship, remains uncertain.

22. To Mrs. Coronio, January 23, 1873, in Philip Henderson, ed., *The Letters of William Morris to His Family and Friends* (London: Longman, 1950), p. 52, hereafter cited as *Letters*.

23. *Letters*, p. 248.

24. Mackmurdo's manuscript recollections.

25. *Letters*, p. 58 and Lindsay *Morris*, p. 198.

26. Canon Dixon's manuscript memoir, Morris Galleries, J189.

27. Georgiana Burne-Jones, *Memorials of Edward Burne-Jones*, 2 vols. (London: Macmillan, 1906), 1:147.

28. July 1856, *Letters*, p. 17.

29. Review of part 3 in Peter Faulkner, ed., *William Morris: The Critical Heritage* (London: Routledge, 1973), p. 112.

30. "How Shall We Live Then," Paul Meier, ed., *International Review of Social History* (1971), 16(2):217-40. Despite the remarks I have quoted, M. Meier makes a point of denying here, as he does in his *La Pensée Utopique de William Morris* (Paris: Editions Sociales, 1972), that Morris' socialism had its source in Ruskin, as though this were an either/or proposition. Meier's account of the relations between Ruskin and Morris is the most thoroughly researched to date, but an ideological purism as severe as the Evangelical Ruskin's forces the left hand to deny what the right hand has uncovered. Lindsay's sensible assertion that Morris "reached Marxism by the inner logic of the positions from which he began" (p. 380) is sustained by E. P. Thompson's revised version of his *William Morris: Romantic to Revolutionary*, which converts the connection between the Marxist Morris and the English Romantic movement so valuable in the first edition into an internal critique of Marxist orthodoxy.

31. See "The Origins of Ornamental Art," W. Eugene D. Lemire, ed., *The Unpublished Lectures of William Morris* (Detroit: Wayne State University Press, 1969), 137; "Art, Wealth and Riches" (M23:143-63). Morris gives his version

of craft as an extension of architecture in "Architecture and History" (M22:296 ff).

32. The reduction of skilled to unskilled labor was celebrated by Henry Ford in *My Life and Work* (New York: Doubleday, 1922), p. 89. On the freeing of skilled labor by the substitution of automated machinery for mechanical labor see "The Revival of Handicraft" (M22:131 ff).

33. Mackail, *Life*, p. 52.

34. See Lindsay, *Morris*, pp. 250-51.

35. Mackail, *Life*, 2:50. Dearle's "Seaweed" is reproduced in Ray Watkinson, *William Morris as a Designer* (London: Studio Vista, 1967).

36. Thompson, *Romantic to Revolutionary*, p. 201.

37. *Letters*, p. 84 (my italics).

38. "Near but Far Away." Whether this poem refers to Jane (Henderson, *Morris*, p. 92), or more likely, Georgie (Lindsay, *Morris*, p. 186), the implication is clear.

39. Morris' manuscript on Norse mythology, Morris Gallery, cited by Lindsay, *Morris*, p. 215.

40. Lady Burne-Jones chose to print only the two political paragraphs in her *Memorials*. Ruskin was a year from his breakdown. He was less and less able to externalize conflict and maintain normal contact and communication with others. Some *Fors* letters themselves were breaking into pieces that even his regular readers could not make cohere without knowledge of his inner life.

41. *Letters*, appendix 2, pp. 388-89.

42. ALS Fitzwilliam. Burne-Jones took the occasion of this letter to complain about the hanging of his work at the Grovesner Gallery, something he may have regretted if it led to Ruskin's visit. It was there Ruskin saw the paintings that precipitated Whistler versus Ruskin and forced a discomforted Burne-Jones, supported by Morris, into the witness box. The letter is undated but reference to Ruskin's return from Venice suggests late June 1877.

43. Cf. Ruskin's chapters "Modern Landscape," and "The Moral of Landscape," in *Modern Painters III*. This linking of medievalism, romance, and romanticism was common in the late nineteenth century. "Scott did more than any man of his generation to found the romantic school, the school whose ideal was that of Christian chivalry. . . . Another potent influence in the life of Ruskin was that of Wordsworth, whose view of nature, representing as it did a great advance upon, and expansion of that of the medieval world . . . was affecting the minds of all earnest men of that generation." Dame Elizabeth Wordsworth (daughter of the poet's youngest nephew, Bishop Christopher), "John Ruskin," in *Essays Old and New* (Oxford: Clarendon Press, 1919), pp. 82-83.

44. F. Engels, ed., *Capital*, M. S. Moore and E. Aveling, trs., (New York: International, 1967), pp. 719, 763.

45. Lindsay, *Morris*, p. 310.

46. William Morris, "Looking Backward," *Commonweal*, June 22, 1889 (my italics).

47. William Morris, "Why We Celebrate the Commune in Paris,"

Commonweal, March 19, 1887.

48. "There were two words missing in the address," said Ruskin, "those which Naboth was accused of blaspheming" (God and King). The blasphemy "does not exist in Morris' heart, and ought not to have been accusable in his work" (XXXVII:289) —but exist it did in heart and work, however Ruskinian the form of the work.

49. *Letters,* p. 237.

50. Raymond Williams calls Morris' fear that commercial society might "play a cat and mouse game with us Socialists" and grant the workers better material conditions and a role in government at the expense of genuine equality his most prophetic political insight—a sad enough prophecy from Morris' point of view ("Communism," 1893, M22:267). Morris' efforts to explain and justify his vision of the future to audiences within and without the Socialist movement produced his best political writing, the essays that Williams and others would promote at the expense of his imaginative efforts. But even Morris' late romances can be defended from an ideological point of view as "a formal response to the problems which are theoretically insoluble." John Goode, "William Morris and the Dream of Revolution," in John Lucas, ed., *Literature and Politics in the Nineteenth Century.* Goode rightly stresses the parallels between Morris' imaginative writing and his politics, beginning with *Sigurd,* and gives excellent political readings of *John Ball* and the Germanic romances.

51. May Morris, ed., *William Morris: Artist, Writer, Socialst* (Oxford: Blackwell's, 1948), 1:148. For another reading of Morris' view of history as romance see Frederick Kirchoff's *William Morris* (Boston: Twayne, 1979), pp. 117-18.

52. For contemporary contexts of Ball's sermons, see G. R. Owst, *Literature and Pulpit in Medieval England* (Cambridge: Cambridge University Press, 1933), ch. 5. Norman Cohn confirms the late Victorian assessment of Ball as a pioneer Communist in *The Pursuit of the Millennium* (New York: Oxford University Press, 1970), pp. 198-204.

53. Northrop Frye, *Anatomy of Criticism* (Princeton: Princeton University Press, 1957), pp. 186, 193.

54. Jameson, *Magical Narratives,* pp. 158, 161. Jameson cites Marx's Introduction to *Contribution to a Critique of Political Economy.*

55. For Morris on the future of the family see Meier's chapter on "L'Homme" in *Pensée* and Goode, p. 262 ff. Goode and Kirchoff discuss the parallels between Morris' views and those of Lewis Henry Morgan, the anthropological source of Engels' *Origin of the Family.*

56. Robert Tucker, *Philosophy and Myth in Karl Marx* (Cambridge: Cambridge University Press, 1967), pp. 220-22.

57. For Ellen as the symbol of the new society and "fille de sa raison," see Meier, *Pensée,* p. 742. May Morris' letters from this period, particularly those to G. B. Shaw now in the British Library, have an admirable strength, wit, and directness.

58. Robert Hewison, *Ruskin,* p. 182.

59. Shelley, *Prometheus Unbound,* ll. 400-401. *Shelley's Poetry and Prose,* D.

Reiman and S. Powers, eds. (New York: Norton, 1977), p. 205.

60. Raymond Williams, *Culture and Society*, p. 153.

61. Quoted in Paul Fussell, *The Great War and Modern Memory* (New York: Oxford University Press, 1975), p. 137.

62. *The Wesker Trilogy* (Harmondsworth: Penguin, 1964), pp. 191-92.

63. Frye, *The Secular Scripture*, p. 179.

64. Lindsay, *Morris*, p. 386.

Index